D0773372

Theater of Cruelty
Art, Film, and the Shadows of War

Theater of Cruelty
Art, Film, and the Shadows of War

Ian Buruma

NEW YORK REVIEW BOOKS

New York

Published by The New York Review of Books, 435 Hudson Street, Suite 300, New York NY 10014
www.nyrb.com

The David Bowie lyrics in Chapter 19 are © Used by Permission

Library of Congress Cataloging-in-Publication Data

Buruma, Ian.
 Theater of cruelty : art, film, and the shadows of war / by Ian Buruma.
 pages cm. — (New York Review books collections)
 ISBN 978-1-59017-777-8 (alk. paper)
 1. World War, 1939-1945—Motion pictures and the war. 2. World War, 1939-1945—Art and the war.
 3. World War, 1939-1945—Literature and the war. 4. War films—History and criticism. 5. National
 socialism in motion pictures. 6. Violence in motion pictures. 7. War in art. 8. National socialism
 in art. 9. Violence in art. I. Title.
 D743.23.B87 2014
 791.43'658405343—dc23
 2014005184

ISBN 978-1-59017-777-8

Available as an electronic book; 978-1-59017-812-6

Printed in the United States of America on acid-free paper

1 3 5 7 9 10 8 6 4 2

For
Jim Conte

Contents

Illustrations follow page 226

Introduction

PEOPLE SOMETIMES SAY to me: "You write about so many things." I think this is meant kindly and I take it as a compliment. But there is no special merit in writing about a large number of topics, as opposed to mining fewer veins ever more profoundly. I suppose the main reason for my relatively wide range of subjects is that I am naturally curious and easily bored.

Even though the subjects that pique my interest may be diverse, I do, however, have certain preoccupations, or passions, that I return to, like a dog to a favorite tree. (The none too complimentary word Germans use for a dilettante, who pees here, there, and everywhere, like a wandering hound, is *Pinkler.*) It would do me little good to start going too deeply into the reasons why I go back to certain concerns. That type of self-analysis can easily lead to self-consciousness and turn off the verbal tap.

But a limited number of personal interests have helped to lend a certain shape to this book of essays. First of all, I am fascinated by what makes the human species behave atrociously. Animals kill other animals for food, and some animals turn on their own kind out of rivalry. But only humans commit acts of extreme and often senseless violence, sometimes out of malign pleasure.

This interests me partly because, like most people, I fear violence. And one tries, perhaps illogically, to make sense of violence that appears to have none. Some cope with their fears by looking away. My own tendency is the opposite: when I see a big rat slithering along the rails in the New York subway, I cannot keep my eyes off it, mesmerized by the sight of something I dread.

So it is with other forms of horror: fear and fascination are disconcertingly close. I am not a believer in devils. Evil deeds are often committed by people who have convinced themselves that they are doing something good. When Heinrich Himmler told his audience of SS officers in Posen in 1943 that "exterminating" the Jews was a necessary duty carried out "for the love of our people," he was most probably sincere. No doubt he reveled in his own power, but I don't think he was evil for the sake of being evil. Himmler was not Satan but a repellent human being with the means to put mad and murderous fantasies into practice. And he had millions to do the dirty work, whether out of conformism or bloodlust. Some of these killers, in other circumstances, would have been perfectly normal people who wouldn't have hurt a fly.

I was born five years after the end of World War II in a country that had been conquered and then occupied by Nazi Germany, to a father who had been forced to work in a German factory and a mother who was Jewish, so it was easy when I grew up to take the moral high ground. I was born among the good guys. It was the Germans who were evil. Later, more awareness that German occupation had given license to many non-Germans in Europe to be actively complicit in Nazi crimes began to blur the distinctions between good and bad.

A common fixation among people of my generation, who grew up in the shadow of the war, is how we might have behaved under severe pressure. Would I have been brave enough to risk my life in the resis-

tance? Would I have kept my mouth shut under torture? These are unanswerable questions. But I am less interested in them than in a darker question, which is no easier to answer: What are the chances, in certain conditions, of me behaving atrociously?

The question of how a civilized, highly educated people, like the Germans in the 1930s, could follow a murderous demagogue into an abyss of moral depravity will never let go of me. But I am well aware that those Germans who followed Hitler were not unique. There are no eternal good guys or bad guys. Nor do I do take the easy cynical view that there is an evil Nazi in all of us, waiting to get out. I am convinced, however, that many people, if given the opportunity to wield absolute power over other human beings, will abuse it. Unlimited authority, often cloaked in the moralism of a great cause, leads invariably to the torture chamber.

A way to deal with our fearful fascination with power and cruelty and death is to act it out vicariously, in art. Hence the title of this book. This is not to say that all great art or drama has to deal with these sinister themes. But the art and drama that interest me most reveal something of what lies beneath the varnish of what we call civilized behavior. Which is one reason, I suppose, why I love the German art of the 1920s. My favorite artists of that time, such as Max Beckmann, George Grosz, or Ernst Ludwig Kirchner, witnessed the barbarism of which man is capable with their own eyes, in the trenches and field hospitals of World War I and later in the streets of Berlin, a capital made skittish by the horrors of war, poverty, crime, and moral collapse. They looked into the abyss and made art of what they saw.

Germany's wartime ally, Japan, is the other country responsible for some of the worst atrocities in the twentieth century. Many theories have been put forward about the possible reasons why: the "samurai spirit," a streak of "Oriental cruelty" unrestrained by Christian

guilt, or a culture of extreme insularity that loses its moral compass outside its own national borders. None of these explanations seems very convincing to me. The barbarism of Japanese troops in China and other parts of Asia arose from a specific set of circumstances, which doesn't excuse the brutality but needs to be properly understood.

My own reasons for spending six years in Tokyo during the 1970s had nothing to do with the war. Not quite knowing what to do at university, I chose to study Chinese language and history, subjects about which I knew nothing. The knowledge I hoped to acquire seemed appealingly exotic and of possible practical use. However, this was in the very early 1970s, when the utility of my chosen subject was not apparent. The Cultural Revolution was not yet over. Contemporary China was almost as remote as the moon. The idea that one might travel freely in China was no more than a fantasy.

While studying Chinese, I saw more and more Japanese films, as well as modern theater productions, in Amsterdam, Paris, and London. Japan looked a great deal more attractive than China in those days, especially for a young man bent on adventure. And so I applied for a scholarship to study cinema at a Japanese film school, which was part of the arts department of a large university in Tokyo.

The most common points of foreign interest in Japan, such as martial arts or Zen Buddhism, always left me rather cold. What I found most intriguing about Japanese cinema or theater, both traditional and modern, as well as my favorite writers, was precisely what I liked about German art of the Weimar years. The Japanese, perhaps more than other people, have a penchant in their arts for revealing our darker impulses that lurk under the surface of civilized behavior. That the daily social life of Japan is governed by stricter and more elaborate rules of etiquette does nothing to contradict this; indeed the two tendencies are probably linked. The more people feel constrained by rules and manners designed to limit human conflict or

the potential risks of our animal impulses, the more they feel the need to transform them into art. Japanese artists, writers, and dramatists have gone further than most in exploring the twin themes of sex and death. To me, this was never a mark of exoticism or peculiar "Oriental" cruelty but of a common humanity.

I did not stay in Japan for more than six years. Curiosity and the danger of boredom took me elsewhere, to Hong Kong, London, Berlin, and eventually New York. I did not want to be an "Asia hand," forever explaining the manners and mores of countries about which most of my readers would know even less than I did.

Other topics covered in this book came from my enthusiasms. It is often amusing to read (and write) critical put-downs, but one of the things I learned from Susan Sontag is that admiration is both harder to express intelligently and longer lasting. So here it is, a collection of my various fascinations. I owe many thanks to Michael Shae for editing this book. All the pieces appeared originally in *The New York Review of Books*, whose editor, Robert Silvers, has been the main guiding force of my literary life. Together, I hope, they will tell you something about the artists and filmmakers I have admired and the topics that have arrested me, as well as a few things, for better or for worse, about the author himself.

I

THE JOYS AND PERILS OF VICTIMHOOD

IN HIS BOOK *The Seventh Million*, the Israeli journalist Tom Segev describes a visit to Auschwitz and other former death camps in Poland by a group of Israeli high school students. Some students are from secular schools, others from religious ones. All have been extensively prepared for the visit by the Israeli Ministry of Education. They have read books, seen films, and met survivors. Nonetheless, after their arrival in Poland, Segev notes a degree of apprehension among the students: Will they suddenly collapse? Will they emerge from the experience as "different people"?[1] The fears are not irrational. For the students have been prepared to believe that the trip will have a profound effect on their "identities," as Jews and as Israelis.

These regular school tours to the death camps are part of Israeli civic education. The political message is straightforward: Israel was founded on the ashes of the Holocaust, but if Israel had already existed in 1933 the Holocaust would never have happened. Only in Israel can Jews be safe and free. The Holocaust was proof of that. So the victims of Hitler died as martyrs for the Jewish homeland, indeed

1. *The Seventh Million: The Israelis and the Holocaust* (Hill and Wang, 1993), p. 495.

as potential Israeli citizens, and the State of Israel is both the symbol and the guarantor of Jewish survival.

This message is given further expression, on those bleak and wintry spots where the Jewish people came close to annihilation, by displays of the Israeli flag and singing of the national anthem. But Segev noticed a peculiarly religious, or pseudoreligious, aspect to the death camp visits as well. The Israeli students in Poland, in his view, were like Christian pilgrims in Jerusalem, oblivious to everything except the sacred places. They marched along the railway tracks in Auschwitz-Birkenau like Christians on the Via Dolorosa. They brought books of prayers, poems, and psalms, which they recited in front of the ruined gas chambers. They played cassette tapes of music composed by a Holocaust survivor named Yehuda Poliker. And at one of the camps, a candle was lit in the crematorium, where the students knelt in prayer.

Some call this a form of secular religion. The historian Saul Friedlander was harsher and called it a union of kitsch and death. I felt the pull of kitsch emotion myself on my only visit to Auschwitz, in 1990. By kitsch I don't mean gaudiness or camp but rather an expression of emotion that is displaced, focused on the wrong thing, or, to use that ghastly word properly for once, inappropriate. I am not the child of Holocaust survivors. My mother was Jewish, but she lived in England, and no immediate relations were killed by the Nazis. And yet even I couldn't escape a momentary feeling of vicarious virtue, especially when I came across tourists from Germany. They were the villains, I the potential victim. But for the grace of God, I thought, I would have died here too. Or would I? An even more grotesque calculation passed through my mind: How did I fit into the Nuremberg laws? Was I a *Mischling* of the first degree, or the second? Was it enough to have two Jewish grandparents, or did you need more to qualify for the grim honor of martyrdom? When would I have been

2

deported? Would I have been deported at all? And so on, until I was woken from these smug and morbid thoughts by the sight of a tall man in American Indian dress, followed by young Japanese, Germans, and others of various nationalities banging on tambourines, yelling something about world peace.

All this seems far away from Primo Levi's fears of oblivion. One of the cruelest curses flung at the Jewish victims by an SS officer at Auschwitz was the promise that even if one Jew survived the camp no one would believe what had happened to him or her. The SS man was quite wrong, of course. We cannot imagine the victims' torment, but we believe it. And far from forgetting the most recent and horrible chapter in the long book of Jewish suffering, the remembrance of it grows in volume the further the events recede into the past. Holocaust museums and memorials proliferate. Holocaust movies and television soap operas have broken box-office records. More and more people visit the camps, whose rotting barracks have to be carefully restored to serve as memorials and movie sets.

In a curious way, the Jewish Holocaust has been an inspiration to others. For almost every community, be it a nation or a religious or ethnic or sexual minority, has a bone to pick with history. All have suffered wrongs, and to an increasing and in my view alarming extent, all want these wrongs to be recognized, publicly, ritually, and sometimes financially. What I find alarming is not the attention we are asked to pay to the past. Without history, including its most painful episodes, we cannot understand who we are, or indeed who others are. A lack of historical sense means a lack of perspective. Without perspective we flounder in the dark and will believe anything, no matter how vile. So history is good, and it is right that victims who died alone and in misery should be remembered. And minorities are still vulnerable to persecution, Christians by Muslims, Sunnis by Shiites, Shiites by Sunnis, Muslim Uighurs by Han Chinese, Bosnians by

Serbs, and on and on. What is alarming, however, is the extent to which so many minorities have come to define themselves above all as historical victims. What this reveals is precisely a lack of historical perspective.

Sometimes it is as if everyone wants to compete with the Jewish tragedy, in what an Israeli friend once called the Olympics of suffering. Am I wrong to detect a hint of envy when I read that Iris Chang, the Chinese-American author of a best seller about the 1937 Nanking Massacre, wishes for a Steven Spielberg to do justice to that event? (Her book bears the subtitle *The Forgotten Holocaust of World War II*.[2]) It is, it appears, not enough for Chinese-Americans to be seen as the heirs of a great civilization; they want to be recognized as heirs of their very own Holocaust. In an interview, Chang related how a woman came up to her in tears after a public reading and said that Chang's account of the massacre had made her "feel proud to be Chinese-American." A massacre seems a peculiar source of pride.

Chinese-Americans are not the only ones to be prey to such emotions. The idea of victimhood also haunts Hindu nationalists, Armenians, African-Americans, American Indians, Japanese-Americans, and homosexuals who have adopted AIDS as a badge of identity. Larry Kramer's book on AIDS, for example, is entitled *Reports from the Holocaust*. Even the placid, prosperous Dutch, particularly those now in their teens and twenties, much too young to have experienced any atrocity at all, have narrowed down their historical perspective to the hardship suffered under German occupation in World War II.[3] This is no wonder, since pre-twentieth-century history has been virtually abolished from the curriculum as irrelevant.

The use of Spielberg's name is of course telling, for the preferred

2. *The Rape of Nanking* (Basic Books, 1997).
3. This is perhaps less true now than when the article was written.

way to experience historical suffering is at the movies. Hollywood makes history real. When Oprah Winfrey played a slave in the movie *Beloved*, she told the press that she collapsed on the set, crying and shaking. "I became so hysterical," she said, "that I connected to the raw place. That was the transforming moment. The physicality, the beatings, going to the field, being mistreated every day was nothing compared to the understanding that you didn't own your life."[4] And remember, this was just a movie.

My intention is not to belittle the suffering of others. The Nanking Massacre, during which tens and perhaps hundreds of thousands of Chinese were slaughtered by Japanese troops, was a terrible event. The brutal lives and violent deaths of countless men and women from Africa who were traded as slaves must never be forgotten. The mass murder of Armenians in the Ottoman Empire cannot be denied. Many Hindu temples and Hindu lives were destroyed by Muslim invaders. Women and homosexuals have been discriminated against. The murder of a gay college student in Laramie, Wyoming, is a brutal reminder of how far we have yet to go. And whether or not they are right to call Columbus a mass murderer on his anniversary day, there is no doubt that the American Indians were killed in large numbers. All this is true. But it becomes problematic when a cultural, ethnic, religious, or national community bases its communal identity almost entirely on the sentimental solidarity of remembered victimhood. For that way lies historical myopia and, in extreme circumstances, vendetta.

Why has it come to this? Why do so many people wish to identify themselves as vicarious victims? There is no general answer. Histories are different, and so are their uses. Memories, fictionalized or real, of shared victimhood formed the basis of much nineteenth-century

4. *The Washington Post*, October 15, 1998.

nationalism. But nationalism, though not always absent, does not seem to be the main driving force for vicarious victims today. There is something else at work. First there is the silence of the actual victims: the silence of the dead, but also of the survivors. When the survivors of the Nazi death camps arrived in Israel on rusty, overloaded ships, shame and trauma prevented most of them from talking about their suffering. Victims occupied a precarious place in the new state of Jewish heroes. It was as though victimhood were a stain that had to be erased or overlooked. And so most survivors preferred to keep quiet. A similar thing happened in Europe, particularly in France. President de Gaulle built a roof for all those who had come through the war, former members of the resistance, Vichyistes, collabos, Free French, and Jewish survivors: officially all were citizens of eternal France, and all had resisted the German foe. Since the last thing French Jews wanted was to be singled out once again as a separate category, the survivors acquiesced in this fiction and kept quiet.

Even though the suffering of Japanese-Americans, interned by their own government as a "Jap" Fifth Column, cannot be compared to the destruction of European Jews, their reaction after the war was remarkably similar. Like the French Jews, they were happy to be treated as ordinary citizens and to blanket the humiliation they had suffered with silence. The situation in China was more political. Little was made in the People's Republic of the Nanking Massacre because there had been no Communist heroes in the Nationalist capital in 1937. Indeed there had been no Communists there at all. Many of those who died in Nanking, or Shanghai, or anywhere in southern China, were soldiers in Chiang Kai-shek's army. Survivors with the wrong class or political backgrounds had enough difficulty surviving Maoist purges to worry too much about what had happened under the Japanese.

It was left up to the next generation, the sons and daughters of the

victims, to break the silence. In the case of China, it took a change of politics: Deng Xiaoping's open-door policy toward Japan and the West had to be wrapped in a nationalist cloak; dependency on Japanese capital was compensated for by stabs at the Japanese conscience. It was only after 1982 that the Communist government paid any attention to the Nanking Massacre at all. But leaving China aside for the moment, why did the sons and daughters of other survivors decide to speak up in the 1960s and 1970s? How do we explain the doggedness of a man like Serge Klarsfeld, whose father was killed at Auschwitz, and who has done more than any Frenchman to bring the history of French Jews to public notice?

There is a universal piety in remembering our parents. It is a way of honoring them. But remembering our parents, especially if their suffering remained mute and unacknowledged, is also a way of asserting ourselves, of telling the world who we are. It is understandable that French Jews or Japanese-Americans wished to slip quietly into the mainstream by hiding their scars, as though their experiences had been like everyone else's, but to their children and grandchildren this was not good enough. It was as if part of themselves had been amputated by the silence of their parents. Speaking openly about the communal suffering of one's ancestors—as Jews, Japanese-Americans, Chinese, Hindus, etc.—can be a way of "coming out," as it were, of nailing the colors of one's identity to the mast. The only way a new generation can be identified with the suffering of previous generations is for that suffering to be publicly acknowledged, over and over again. This option is especially appealing when few or indeed no other tags of communal identity remain, often because of the survivors' desire to assimilate. When Jewishness is reduced to a taste for Woody Allen movies and bagels, or Chineseness to Amy Tan novels and dim sum on Sundays, the quasi authenticity of communal suffering will begin to look very attractive.

The scholar K. Anthony Appiah made this point in an analysis of identity politics in contemporary America.[5] The languages, religious beliefs, myths, and histories of the old countries tend to fade away as the children of immigrants become Americans. This often leads to defensive claims of Otherness, especially when there is little Otherness left to defend. As Appiah said about hyphenated Americans, including African-Americans:

> Their middle-class descendants, whose domestic lives are conducted in English and extend eclectically from *Seinfeld* to Chinese takeout, are discomfited by a sense that their identities are shallow by comparison with those of their grandparents; and some of them fear that unless the rest of us acknowledge the importance of their difference, there soon won't be anything worth acknowledging.

He goes on to say that "the new talk of 'identity' offers the promise of forms of recognition and of solidarity that could make up for the loss of the rich, old kitchen comforts of ethnicity." Alas, however, those forms too often resemble the combination of kitsch and death described by Friedlander. Identity, more and more, rests on the pseudoreligion of victimhood. What Appiah says about ethnic minorities might even be applied to women: the more emancipated women become, the more some extreme feminists begin to define themselves as helpless victims of men.

But surely nationalities are not the same as ethnic minorities in America, let alone women. Indeed they are not. By and large, people

5. "The Multicultural Misunderstanding," *The New York Review of Books*, October 9, 1997.

of different nations still speak different languages, have different tastes in food, and share distinct histories and myths. These distinctions, however, are becoming fuzzier all the time. To a certain extent, especially in the richer countries, we are all becoming minorities in an Americanized world, where we watch *Seinfeld* while eating Chinese takeout. Few nations are defined by religion anymore, even though some, such as Iran and Afghanistan, have busily been reviving that definition. National histories, celebrating national heroes, are fading away in favor of social studies, which have replaced patriotic propaganda based on historical continuity with celebrations of contemporary multiculturalism. Literary canons, though perhaps less under siege in Europe than they are in the United States, are also becoming increasingly obsolete. Combined with a great deal of immigration to such countries as Britain, Germany, France, and Holland, these developments have eroded what kitchen comforts of ethnicity remained in European nation-states.

Perhaps the strongest, most liberating, and most lethal glue that has bound national communities together is the way we choose or are forced to be governed. Some nations have been defined mainly by their political systems. The United States is such a place. Sometimes politics and religion are combined in monarchies. Nowhere is politics entirely without irrational elements: customs, religion, and historical quirks all leave their marks. It was an extreme conceit born of the Enlightenment and the French Revolution that political utopias could be based on pure reason. Nationalism, in the sense of worshiping the nation-state as an expression of the popular will, was part of this. Politics was destined to replace the bonds of religion, or region, or race. This did some good. It also did a great deal of harm. The twin catastrophes of communism and fascism showed how dangerous it is to see the nation-state as a pure expression of the people's will. In any

event, the ideological split between left and right, which was spawned by the division in the French National Assembly in 1789 and was eventually hardened by the cold war, effectively collapsed with the end of the Soviet Union. And the effects of global capitalism and multinational political arrangements, especially in Europe, have to some extent undermined the perception that nations are defined by the way they are governed. For it doesn't seem to matter anymore how they are governed: decisions always appear to be made somewhere else. The current English obsession with the culture of Englishness has come just at the time of increasing integration into European institutions.

So where do we go in this disenchanted world of broken-down ideologies, religions, and national and cultural borderlines? From a secular, internationalist, cosmopolitan point of view, it may not seem such a bad world. That is, of course, if one is living in the wealthy, liberal West. It is surely good that nationalistic historical narratives have been discarded, that homosexuals can come out and join the mainstream, that women can take jobs hitherto reserved for men, that immigrants from all over the world enrich our cultures, and that we are no longer terrorized by religious or political dogma. A half-century of secular, democratic, progressive change has surely been a huge success. We have finally been liberated from irrational ethnic comforts. And yet, after all that, a growing number of people seek to return to precisely such comforts, and the form they often take is the pseudoreligion of kitsch and death. Segev argues that the modern Israeli tendency to turn the Holocaust into a civic religion is a reaction against secular Zionism. The "new man"—socialist, heroic, pioneering—turned out to be inadequate. More and more, people want to rediscover their historical roots. To be serious about religion is demanding, however. As Segev says, "Emotional and historical

awareness of the Holocaust provides a much easier way back into the mainstream of Jewish history, without necessarily imposing any real personal moral obligation. The 'heritage of the Holocaust' is thus largely a way for secular Israelis to express their connection to Jewish heritage."[6]

The same is true for many of us, whether Jewish, Chinese-American, or whatnot. The resurgence of Hindu nationalism in India, for instance, is especially strong among middle-class Hindus, who are reacting against the Nehruvian vision of a socialist, secular India. Since many urban, middle-class Hindus have only a superficial knowledge of Hinduism, aggressive resentment of Muslims is an easier option. And so we have the peculiar situation in India of a majority feeling set upon by a poorer, much less powerful minority. But there is a larger context, too, particularly in the West. Just as the Romantic idealism and culture worship of Herder and Fichte followed the secular rationalism of the French philosophes, our attraction to kitsch and death heralds a new Romantic age, which is antirational, sentimental, and communitarian. We see it in the politics of Clinton and Blair, which have replaced socialist ideology with appeals to the community of feeling, where we all share one another's pain. We saw it in the extraordinary scenes surrounding the death of Princess Diana, when the world, so TV reporters informed us, united in mourning. Princess Diana was in fact the perfect embodiment of our obsession with victimhood. Not only did she identify with victims, often in commendable ways, hugging AIDS patients here and homeless people there, but she was seen as a suffering victim herself: of male chauvinism, royal snobbery, the media, British society, and so on. Everyone who felt victimized in any

6. *The Seventh Million*, p. 516.

way identified with her, especially women and members of ethnic minorities. And it says something about the state of Britain, changed profoundly by immigration, American influence, and common European institutions, yet unsure of its status in Europe, that so many people felt united as a nation only when the princess of grief had died.

This sharing of pain has found its way into the manner in which we look at history, too. Historiography is less and less a matter of finding out how things really were or trying to explain how things happened. For not only is historical truth irrelevant but it has become a common assumption that there is no such thing. Everything is subjective or a sociopolitical construct. And if the civic lessons we learn at school teach us anything, it is to respect the truths constructed by others, or, as it is more usually phrased, the Other. So we study memory, that is to say, history as it is felt, especially by its victims. By sharing the pain of others, we learn to understand their feelings and to get in touch with our own.

In *Bridge Across Broken Time*, Vera Schwarcz, a professor of East Asian studies at Wesleyan University, links her own memories as the child of Jewish Holocaust survivors with those of Chinese victims of the Nanking Massacre and the violent crackdown in 1989 on Tiananmen Square. With images of 1989 fresh in her mind, Schwarcz visits Yad Vashem, the Holocaust memorial outside Jerusalem. There she realizes

the immensity both of the suffering that could not be commemorated in China after 1989 and of the Nanking Massacre of 1937 with its countless dead that had yet to become imprinted upon communal memory in Japan and the United States. I also sensed the magnitude of my own loss that could not be as-

suaged by the light of a candle, even if it was reflected one mil-
lion times.[7]

Now, I don't doubt the nobility of Professor Schwarcz's sentiments,
but I do wonder whether this sort of thing—even Maya Angelou's
poetry makes a cameo appearance in her book—is enlightening in
any historical sense. In fact it is ahistorical, because the actual expe-
riences of historical victims get blended in a kind of soup of pain.
Although it is undoubtedly true that Chinese, Jews, gays, and others
have suffered, it is not so that they all suffered in the same way. The
distinctions tend to get lost. It is all too typical of our neoromantic
age that a well-known Dutch ballet dancer and novelist named Rudi
van Dantzig should announce in a pamphlet issued by the Resistance
Museum in Amsterdam that homosexuals and other minorities in
the Netherlands should take anti-Nazi resisters as models for their
struggle against social discrimination.

But intellectual enlightenment is probably not the issue here. In-
stead there is authenticity. When all truth is subjective, only feelings
are authentic, and only the subject can know whether his or her feel-
ings are true or false. One of the most remarkable statements along
these lines was written by the novelist Edmund White. In an article
about AIDS literature, he argues that literary expressions of the dis-
ease cannot be judged by critical standards. As he puts it, a trifle
histrionically: "I can scarcely defend my feelings beyond saying that
it strikes me as indecent to hand out grades to men and women on the
edge of the grave." He then stretches AIDS literature to encompass
multiculturalism in general, and states not only that multiculturalism

7. *Bridge Across Broken Time: Chinese and Jewish Cultural Memory* (Yale University
Press, 1998), p. 35.

is incompatible with a literary canon but that he'd "go even further and say multiculturalism is incompatible with the whole business of handing out critical high and low marks." In other words, our critical faculties cannot be applied to novels, poems, essays, or plays expressing the pain of Others. As White says about the AIDS genre, "We will not permit our readers to evaluate us; we want them to toss and turn with us, drenched in our night sweats."[8]

What makes us authentic, then, as Jews, homosexuals, Hindus, or Chinese, is our sense of trauma, and thus our status as victims, which cannot be questioned. The vulgar Freudianism of this view is remarkable in an age of debunking Freud. In fact, Freud's endeavors were themselves a brilliant product of late-nineteenth-century identity politics. To secular, bourgeois, assimilated German and Austrian Jews, psychoanalysis was a logical route to self-discovery. What Freud did for his Viennese patients is in a way what Edmund White and other identity politicians are now doing for their various "communities," and real politicians are borrowing their language.

Apart from the sentimentality that this injects into public life, the new religions of kitsch and death are disturbing for other reasons. For all Schwarcz's talk of building bridges between mourning communities, I think the tendency to identify authenticity in communal suffering actually impedes understanding among people. Feelings can only be expressed, not discussed or argued about. This cannot result in mutual understanding but only in mute acceptance of whatever people wish to say about themselves, or in violent confrontation. The same is true of political discourse. Ideology has caused a great deal of suffering, to be sure, particularly in political systems where ideologies were imposed by force. But without any ideology political

8. *The Nation*, May 12, 1997.

debate becomes incoherent, and politicians appeal to sentiments instead of ideas. And this can easily result in authoritarianism, for, again, you cannot argue with feelings. Those who try are denounced not for being wrong but for being unfeeling, uncaring, and thus bad people who don't deserve to be heard.

The answer to these problems is not to tell people to go back to their traditional places of worship, in an attempt to supplant pseudo-religions with established ones. I am not opposed to organized religion on principle, but as a secular person myself it is not my place to promote it. Nor am I against building memorials for victims of wars or persecution. The decision by the German government to build a Holocaust museum in Berlin is laudable, because it will also contain a library and document center. Without such a center it would just be a colossal monument. In the new plan memory will go together with education. Literature, of fact and fiction, about individual and communal suffering should have its place. History is important. Indeed there should be more of it. And it would be perverse to take issue with the aim of fostering tolerance and understanding of other cultures and communities. But the steady substitution of political argument in public life with the soothing rhetoric of healing seems wrong.

We can make a start toward resolving the problem by drawing distinctions where few are made now. Politics is not the same as religion or psychiatry, even though it may be influenced by both. Memory is not the same as history, and memorializing is different from writing history. Sharing a cultural heritage is more than "negotiating an identity." It is perhaps time for those of us who have lost religious, linguistic, or cultural ties with our ancestors to admit to that and let go. Finally, and I think this goes to the heart of the matter, we should recognize that truth is not just a point of view. There are facts that are not made up but real. And to pretend there is no difference between

fact and fiction, or that all writing is fiction, is to paralyze our capacity to distinguish truth from falsehood. And that is the worst betrayal of Primo Levi and all those who suffered in the past. For Levi's fear was not that future generations would fail to share his pain but that they would fail to recognize the truth.

2

FASCINATING NARCISSISM:
LENI RIEFENSTAHL

THAT LENI RIEFENSTAHL was rather a monster is not really in dispute. And if it ever was, two new biographies provide enough information to nail her. Bad behavior began early. Steven Bach tells the story of Walter Lubovski, a Jewish boy in Berlin who fell madly in love with Riefenstahl after meeting her at a skating rink.[1] In a fit of teenage cruelty, Leni and her girlfriends tormented the boy so badly that he slashed his wrists at the summer cottage of Riefenstahl's family. To stop her father from discovering what had happened, she shoved the bleeding boy under the sofa. He survived and ended up in a mental institution before escaping to America, where he went blind. All Riefenstahl had to say when she heard was: "He never forgot me as long as he lived."

Always a romantic about herself, Riefenstahl promoted the idea that all men were slavishly in love with her. Enough were, it seems. Working in a man's world, Riefenstahl made the most of her charms, and her tantrums; tears came easily to this tough operator. But in her casual and, it seems, often callous promiscuity she behaved more like a typical man than a woman of her time. Whether or not Béla Balázs,

1. *Leni: The Life and Work of Leni Riefenstahl* (Knopf, 2007).

the Hungarian critic and screenwriter, was one of her love slaves, he was smitten enough to write much of the screenplay for *The Blue Light*, Riefenstahl's first film as a director, and to direct several scenes as well. He even agreed to defer payment until the film earned money.

The movie, an overblown romance about a wild-eyed woman (Riefenstahl) scrambling up a mountain and communing with crystals above the swirling Alpine clouds, was dismissed in 1932 by Berlin critics as protofascist kitsch. Riefenstahl was furious: "What do these Jewish critics understand about our mentality? They have no right to criticize our work." Perhaps she had forgotten that Balázs was Jewish too; in any case, she would soon claim sole credit for the film. After 1933, her critics, Jewish or not, were silenced. Hitler hailed the film as a sublime manifestation of the German spirit, and it became a success. For the sake of racial purity, Balázs's name had by then been removed from the credits, and the man himself had relocated to Moscow. When he demanded his cut, Riefenstahl asked her friend Julius Streicher, the editor of *Der Stürmer*, to handle the matter. Balázs never saw a pfennig.

Still, great artists don't have to be nice. The question is whether Riefenstahl was really a great artist, as she claimed, and as many others, by no means all Nazi sympathizers, still believe. Or was her work so tainted by bad politics that it could never be regarded as good art, however technically inventive? This raises other questions: Can fascist or Nazi art ever be good? And what about the work Riefenstahl did before and after the Third Reich? If *The Blue Light* and other Alpine fantasies about the German sublime could be condemned by the eminent critic Siegfried Kracauer as "heroic idealism" that was "kindred to Nazi spirit," what about Riefenstahl's postwar photography of African tribesmen and marine life in the Indian Ocean? Susan Sontag famously detected a continuous sensibility in

all Riefenstahl's work, including the African pictures, which she described as "fascinating fascism."[2]

Sontag's argument was as much about the reception of Riefenstahl's work as the art itself. Enthusiasts, she believed, were attracted to a kind of kinky fascism, to the allure of hard men and black leather. Rock stars seem particularly susceptible to this kind of thing. The Rolling Stones guitarist Keith Richards once turned up in an SS uniform while Riefenstahl was photographing Mick Jagger. In an interview for a German newspaper, the British singer Bryan Ferry rhapsodized:

> "The way in which the Nazis stage-managed and presented themselves...! I'm talking about Leni Riefenstahl films and Albert Speer's buildings and the mass rallies and the flags—simply fantastic. Really lovely."[3]

QED, Susan. But might it still be possible, nonetheless, to separate the best of Riefenstahl's art from its sinister setting?

———

Leni Riefenstahl was born in 1902 in Wedding, a low-rent area of Berlin. Her father, Alfred, ran a plumbing business, was a despot at home, and strongly disapproved of his daughter's early artistic yearnings. Her mother, Bertha, was more encouraging. She may have been partly Jewish. As with other Nazi figures, such rumors have been circulated. But if so, it was well disguised in the various documents of racial provenance that could be a matter of life and death for citizens of the Third Reich.

2. *Under the Sign of Saturn* (Farrar, Straus and Giroux, 1972).
3. Quoted in *The Guardian*, April 16, 2007.

Riefenstahl's early yearnings ran to expressionist dancing. She was enrolled in a dance school that boasted Anita Berber as a former student. Berber liked to dance in the nude, in pieces with such titles as *Cocaine* or *Suicide*. These dances demanded great dramatic gestures of ecstasy and death. The young Riefenstahl once replaced Berber in a recital. *Three Dances of Eros*, *Surrender*, and *Oriental Fairy Tale* were the titles of her earliest dance performances. The style would stay with her.

Riefenstahl's sponsor in the early 1920s was Harry Sokal, a Jewish banker. He showered her with fur coats and money, and begged her to marry him. There were fights, threats of suicide (Sokal's), but the partnership was fruitful, until Sokal, like Balázs, was compelled to leave Germany (his name, too, disappeared from the credits of *The Blue Light*). Riefenstahl's dance performances, put on all over Germany and beyond, were admired for their enthusiasm and beauty. But one critic, John Schikowski, wrote in the Berlin *Vorwärts*: "All in all, a very strong artistic nature, that within its own territory is perfectly adequate. But that territory is severely limited and lacks the highest, most important quality: that of the soul."

It is an interesting observation, which might be applied to much of Riefenstahl's subsequent work in the cinema, even when, or perhaps especially when, it strived to express nothing but soul, the soul of mystical heroines on mountaintops, of the German nation, of the Führer and his paladins. Her mentor in soulful mountain movies was the specialist in this genre, Dr. Arnold Fanck. But her debut was in a film entitled *Ways to Strength and Beauty*, in which she appeared as a classical nude figure in the ancient world. The film, released in 1925, was in line with the German fashion for healthy naturalism, nude calisthenics, tough sports, male bonding, and the cult of "Germanness" (*Deutschtum*). The guiding idea, Bach informs us, was nothing less than the "regeneration of the human race."

Fanck's films are very much in this mold. In 1925, Riefenstahl starred in *The Holy Mountain* as a beautiful young woman caught in a love triangle on a mountaintop ("her life is her dance, the expression of her stormy soul"). Female temptation in this type of film is a danger that must be defied by a heroic act of male sacrifice. The two rivals for her affections choose to die as comrades, tumbling together into an icy abyss.

Why Fanck cast Riefenstahl as the star is not entirely clear. She herself never doubted the magic of her personal appeal. Fanck, too, allegedly threatened suicide when Riefenstahl shifted her amorous attentions to the leading man, Luis Trenker (Sokal had already been left pining in the cold, despite his largesse). "All of them were in love with me," she recalled. "Oh, it was a drama always!" But the fact that Sokal offered to finance the movie must have helped her get the part. More than that, Sokal bought out Fanck's company. After *The Holy Mountain*, Riefenstahl starred in *The Great Leap* (1927), *The White Hell of Pitz Palu* (1929), and *Storm over Mont Blanc* (1930).

Although none of these films rose above crude melodrama, Fanck had a real talent for visual effects. He was a great experimenter with different lenses, camera angles, and filters. Working with such superb cameramen as Hans Schneeberger (another Riefenstahl conquest), he was a master of dramatic cloud effects and backlighting that gave human figures as well as Alpine landscapes a mystical aura. The hyped-up drama of expressionism was fused in his work with a quasi-religious mood of German Romanticism. Sontag used the phrase "pop-Wagnerian," which seems about right.

Fanck himself became a keen Nazi, and the Nazis borrowed heavily from the same aesthetic sources. None of these, however, neither the Romanticism, nor the expressionism, nor the Wagnerism, let alone the avant-garde visuals of the Weimar period, can be called

inherently fascistic. To be sure, the stresses on physical perfection, heroic sacrifice, male discipline, power, purity, and the grandeur of nature lent themselves very well to the Nazi or fascist style. But so did the clean classical lines of some Bauhaus architecture. Joseph Goebbels, the author of a truly awful expressionist novel entitled *Michael*, initially favored expressionism as the most suitable style for the Third Reich. Hitler, whose taste ran more to sentimental nineteenth-century grandiosity, quashed that idea. He liked heroic nudes, Wagnerian bombast, and monumental classicist architecture.

It is tempting to see a direct link between Fanck's *The Holy Mountain* and Riefenstahl's quasi documentary of the 1934 Nazi rally in Nuremberg, *Triumph of the Will*. Bach comes close to this view. Jürgen Trimborn, a young German film historian, whose *Leni Riefenstahl: A Life* is more earnest and less amusing, but well worth reading, is almost painfully nuanced.[4] Yes, "the Darwinism underlying many of Fanck's films placed them in dangerous proximity to National Socialist propaganda." Yes, in the context of the "nationalistic elevation of alpinism, the films of Arnold Fanck were praised as a 'profession of the faith of many Germans.'" But, Trimborn writes,

> despite such arguments, it would be an oversimplification to consider the mountain films exclusively as prefascist creations, as this does not take into consideration the complex roots of the genre, including the literature of Romanticism, the alpinist movement, and the nature cult of the early twentieth century.

If this is right—and I think it is—it doesn't help to make the case for Riefenstahl. With her considerable talent, energy, and opportunism,

4. Translated from the German by Edna McCown (Faber and Faber, 2008).

she absorbed Fanck's technical innovations in camerawork and editing and used them to produce works of pure Nazi propaganda. What makes *Triumph of the Will* such a poisonous film is not the classicism and crude Romanticism of Weimar-period *Deutschtumelei* but the political manipulation of such aesthetics by Riefenstahl and Albert Speer, who designed the parade grounds at Nuremberg for the party rally.

They were much alike, Hitler's beloved architect and favorite filmmaker: young, ambitious, intoxicated by power, and more than a little unscrupulous. This doesn't mean that they were convinced Nazi ideologues. Speer wasn't the only architect who saw a main chance in German totalitarianism. Greater men than he, such as Ludwig Mies van der Rohe, fished for commissions from the Nazis. Just as there was an aesthetic link between Fanck's mystical mountains and the Nazi style, the cold, perfectionist modernism of Mies could lend itself to totalitarian aims. But happily for Mies, Hitler did not warm to his projects. He not only preferred Speer and Riefenstahl but, insofar as he had an emotional life at all, he seems to have adored them. Even though there is no evidence, in the case of Riefenstahl, that his feelings led to any physical entanglement, she did nothing to quell the rumors that they had.

Did she adore Hitler too? After the war, Riefenstahl fiercely denied any interest in politics, including Hitler's. She was a pure artist, she maintained, a political innocent. Yet she read *Mein Kampf* in 1931 and expressed her enthusiasm to, of all people, Sokal, her Jewish patron. "Harry," she said, "you must read this book. This is the coming man." A year later, she went to hear Hitler speak at the Sportpalast in Berlin. "It was like being struck by lightning," she recalled in imagery that could have been lifted straight from one of Fanck's mountain movies or, for that matter, from her own expressionist dance pieces:

I had an almost apocalyptic vision that I was never able to forget. It seemed as if the earth's surface were spreading out in front of me, like a hemisphere that suddenly splits apart in the middle, spewing out an enormous jet of water, so powerful that it touched the sky and shook the earth.

What makes this sinister is not the feverish Romantic sentiment per se but the object to which it is applied. When such yearnings are focused on a violent rabble-rouser whipping up mass hysteria in a sports stadium, any claim to innocence sounds hollow. This is precisely the problem with Riefenstahl's *Triumph of the Will*. The worship of Hitler is so overt, from the moment he descends in his plane from the Fanck-like clouds over Nuremberg to the sounds of the *Meistersinger* overture and the "Horst Wessel Song," that you know this "documentary" cannot have been made in a spirit of political naiveté.

It wasn't, of course, a documentary at all but propaganda staged as a kind of *Gesamtkunstwerk* by Riefenstahl and Speer. Although she denied it, we know from various witnesses, quoted in the biographies, that several scenes were reconstructed after the rally in a Berlin studio. We also know that far from being ordered to make the film, Riefenstahl longed to make it, indeed lobbied for it. As with Speer's architectural plans, Hitler took a personal interest in the project. He was the ultimate producer of his own spectacle (the title was his choice). As a result, whatever Riefenstahl wanted, she got. *Triumph of the Will* was made with the resources of a major Hollywood production: thirty-six cameramen, nine aerial photographers, a lighting crew of seventeen, and two still photographers, one of whom shot nothing but pictures of Riefenstahl herself. She was the only filmmaker in Nazi Germany who answered directly to the Führer and not to Goebbels's propaganda ministry.

This became very irritating to Goebbels, especially when Riefenstahl treated her budgets as though she had a direct line to the national treasury, which in effect she did. His exasperation was later used as evidence by Riefenstahl that he hated her because she wouldn't sleep with him. But no matter. Many great filmmakers go over budget, and annoying Goebbels was no sin. *Triumph of the Will* is a stunning achievement. She used all the editing techniques and camerawork learned from Fanck, but also came up with ideas of her own: cameras held by men on roller skates or installed in an elevator behind Hitler's podium, the brilliant crosscutting between crowds and performers, the extraordinary choreography of a cast of thousands. The problem is that her genius, in this film, is purely technical, applied to an unworthy subject. As Bach observes:

> She used her century's most powerful art form to make and propagate a vision that eased the path of a murderous dictator who fascinated her and shaped a criminal regime she found both inspiring and personally useful.

Was this because she was predisposed to Nazi ideology or a fascist aesthetic? Not necessarily. In the 1920s Riefenstahl desperately wanted to be a Hollywood star, and she pestered Josef von Sternberg to cast her in *The Blue Angel* instead of Marlene Dietrich. Thank goodness he didn't, for Riefenstahl had very little talent for acting. Nor did she have a gift for directing feature films. One of the most revealing statements she made was in Ray Müller's *The Wonderful, Horrible Life of Leni Riefenstahl*, a German documentary made about her in 1993. Repeating her claims of political innocence, she said about *Triumph of the Will* that she really didn't care whether she had to photograph SS men or vegetables; what interested her was the beauty of composition, of artistic effects.

This was almost certainly true. She would have made a fine director of Radio City Music Hall dance routines, or bathing beauty movies, or North Korean tableaux made up of thousands of anonymous people in stadiums holding up colored cards. But these were not her options in 1934. Perhaps the Faustian bargain she struck with Hitler was her only shot at immortality. Even if we leave aside her personal views and sensibilities, her talents were a perfect match for Hitler's grand project of turning his murderous vision into a mass spectacle, a kind of musical of death. But it was too kitschy, in the sense of false and misplaced emotion, to be great art. In Riefenstahl, Hitler had found his perfect technician.

What about *Olympia*, Riefenstahl's documentary of the 1936 Berlin Olympic Games, surely the best film she ever made? Divided into two parts, *Olympia: Festival of Nations* and *Olympia: Festival of Beauty*, the movie was first shown at the Ufa Palast am Zoo in Berlin on Hitler's forty-ninth birthday in April 1938. Everyone who was anyone in the Nazi pantheon—Hitler, Goebbels, Göring, Ribbentrop, Himmler, Heydrich, et al.—was there, as well as such luminaries as the conductor Wilhelm Furtwängler, the actor Emil Jannings, and the boxer Max Schmeling. Riefenstahl's name was up in lights. Hitler saluted her. The audience went wild over her. She was on top of the world, or at least on top of the Reich.

Riefenstahl told lies about this film, as she did about so much else. It was not an independent production, commissioned by the International Olympic Committee, as she claimed, but a film commissioned and financed by the Reich. There is also no doubt that *Olympia* was meant to burnish Germany's image in the world as a benign, hospitable, modern, efficient, peaceful nation of sports lovers. Riefenstahl

willingly helped to give Hitler's regime credibility. But what of the work itself? Is it an example of "fascinating fascism"?

Olympia: Festival of Nations begins with a familiar melange of the neoclassical cult of Greece and moody Fanck-like cloudscapes, suggesting a continuity between ancient Greece and modern Germany. The famous sculpture of Discobolus, the discus thrower, slowly dissolves into a nude athlete, shot in Delphi. This film image has been interpreted as a tribute to Aryan manhood. And Hitler was so keen on the sculpture (the original of which no longer existed) that he bought a Roman copy in 1938. In fact, however, the Romantic identification with ancient Greece started long before the Nazis appropriated such imagery, and the model chosen by Riefenstahl was not German but a dusky Russian youth named Anatol Dobriansky, whom, as Bach tells us, she briefly took as her lover after paying his parents a fee.

Riefenstahl was as anti-Semitic as most of her compatriots, that is, enough to turn a blind eye to the persecution of Jews without, so far as we know, necessarily welcoming their extermination. But *Olympia* cannot be described as a racist film, and Riefenstahl's personal taste in men was neither racist nor nationalistic; she had had Jewish lovers, and after she discarded the Russian boy, she took up with Glenn Morris, the American decathlon winner. If there is one heroic model of physical perfection in *Olympia*, it is Jesse Owens, the black American athlete.

Racism, however, is not an essential part of the argument that Riefenstahl's aesthetic was typically fascist. It is the cult of physical perfection itself that is considered to be a fascist attribute, for it implies that the physically imperfect are sick and should be treated as inferior human beings. The cult of physical perfection is linked to the Darwinian struggle, where the strong not only prevail but must be celebrated, even worshiped for their physical power. This would

apply to individuals in sporting contests, as well as to nations or races.

That the Nazis held such views is clear, and Riefenstahl herself was not immune to them. But *Olympia* is a film about athletes, about physical prowess, about using the body to achieve maximum power and grace. Riefenstahl's stated aim—and there is no reason to doubt her word on this—was "to shoot the Olympics more closely, more dramatically than sports had ever been captured on celluloid." And this, assisted by forty-five excellent cameramen and seven months' work in the editing room, is precisely what she delivered.

She went way beyond Fanck in visual experimentation: cameras were attached to balloons and light planes, suspended from the necks of marathon runners, and fastened to horses' saddles. Some of the action was filmed from specially dug trenches or from the top of steel pillars. She enraged Goebbels with her incessant demands and financial extravagance. Other camera crews were rudely pushed aside and the concentration of athletes was carelessly interrupted. Some scenes were restaged and spliced together with other footage. She broke all the rules and was a pain to everyone, but she produced a cinematic masterpiece. Jürgen Trimborn is right to call it "an aesthetic milestone in film history."

But if *Olympia* is indeed a tribute to physical perfection, it is a frosty perfection. Individual character, human emotion, none of this appears to have mattered to Riefenstahl. Bach talks about "the sensual, even erotic quality that pervades much of *Olympia*," and Sontag's critique was aimed at what she called the "eroticization of fascism." This might be a matter of taste, but the nudity in *Olympia* strikes me as oddly unerotic, even unhomoerotic, despite Riefenstahl's fascination with naked men frolicking in sauna baths and jumping into lakes. The film has the cold beauty of a polished white marble sculpture by Canova. Mario Praz's description of Canova as

the "erotic frigidaire" could apply to Riefenstahl as well, her own frolicking with many men notwithstanding.[5]

The Hellenistic and Romantic traditions echoed in *Olympia* can be found in official Nazi art, to be sure, but also in paintings by Jacques-Louis David, another opportunistic court artist and celebrator of revolutionary heroism. He, too, was fascinated with nude warriors, great leaders, and Romantic death scenes. But this does not diminish the beauty of his art. Just as one can admire David's paintings without being a Napoleon worshiper, it should be possible to separate the cold beauty of *Olympia* from its political context. *Triumph of the Will*, however skillfully contrived, is nothing but political context. Its only purpose was political. *Olympia* is essentially about sports.

———

The problem with Riefenstahl, and the main reason for her limitations as an artist, is that she was not just an erotic frigidaire but an emotional one too. Her lack of human understanding, or any feeling for human beings apart from pure aesthetics, does not matter so much in a film like *Olympia*. It matters hugely in a feature film about love, rejection, and intrigue. *Tiefland*, which took Riefenstahl more than a decade to finish, and was finally released in 1954, is exactly what Bach says it is, "a kitsch curiosity, as nearly unwatchable as any film ever released by a world-class director."

The theme of a child of nature (Riefenstahl) persecuted by the wicked denizens of decadent civilization is familiar. The sight of

5. Bach relates how in 1933 Riefenstahl was partying with a group of men in the sauna of a Swiss hotel when she took a phone call from Göring, who informed her that Hitler had become chancellor of the Reich.

Riefenstahl doing a pastiche of flamenco dancing surrounded by Spanish-looking extras is beyond camp; it is plainly embarrassing. That the extras were in fact Gypsies plucked by Riefenstahl from a camp in Salzburg,[6] where they were imprisoned before being sent to Auschwitz, added to her monstrous reputation. She lied about them too, claiming that they all happily survived the war. Most didn't. But the film fails artistically, not because it is fascist but because it is clumsily staged like a bad silent movie, with histrionic gestures (echoing Riefenstahl's expressionist dancing days) making up for plausible human emotions. It was as though nothing had changed since the 1920s.

Apart from everything else, the Nazi period did enormous damage to German artistic expression. The German language was poisoned by the bureaucratic jargon of mass murder, and art had been tainted so badly by the Nazi appropriation of Romanticism and classicism that aesthetic traditions had to be fumigated, as it were, by a new critical spirit. A younger generation of artists such as Anselm Kiefer, writers such as Günter Grass, and filmmakers such as Werner Herzog and Rainer Werner Fassbinder were able to do this. But a critical reinvention of German art was beyond the abilities of Riefenstahl. She was, in any case, too defensive about her own past to develop a critical attitude.

Let off by "de-Nazification" courts as a "fellow traveler," Riefenstahl couldn't stop playing the persecuted victim who had known nothing of the Nazi crimes, had been forced to make what she claimed were purely documentary films, and had adored her Gypsy extras. She was nothing but a pure artist in pursuit of beauty, and

6. The camp was in the fields near Schloss Leopoldskron, which had belonged before the Anschluss to Max Reinhardt, the theater director, and was later used as a location for *The Sound of Music*.

would sue just about anyone who contradicted her. Many projects were prepared, most of them in the Romantic Fanckian vein, none of them from a critical perspective: a remake of *The Blue Light*; yet another Alpine vehicle called *The Red Devils*; a paean to primitive Spain entitled *Bullfights and Madonnas*; and a movie about Frederick the Great and Voltaire, to be written by Jean Cocteau, who was one of the very few admirers of *Tiefland*. "You and I," he told Riefenstahl, "live in the wrong century." It was a rather charitable view of both their records in the mid-twentieth century.

Riefenstahl only made a comeback of sorts in the early 1970s, when she published two hugely successful photography books on the Nuba: *The Last of the Nuba* and *People of Kau*. The color photographs of nude wrestlers, men covered in ash, face paintings, and beautiful girls lathered in butter are competently taken but not works of artistic genius. The subjects are so striking that it would not have been difficult for Riefenstahl to come up with something interesting. Putting herself in a position to do so, however, was not so easy. The Nuba were distrustful of snoops. Riefenstahl, now in her sixties, had the energy, the perseverance, and the thick-skinned gumption to manage it.

The beauty of athletic young black people had always fascinated her; one of her failed projects was a film about the slave trade entitled *Black Cargo*. Capturing the Nuba on film was inspired by the spectacular black-and-white pictures of them taken by the British photographer George Rodger in 1951. When Riefenstahl offered to pay him for useful introductions, he replied: "Dear madam, knowing your background and mine I don't really have anything to say to you at all."

Rodger was with the British troops as a photographer for *Life* magazine when they liberated Bergen-Belsen. He was shocked to find himself "subconsciously arranging groups and bodies on the ground

into artistic compositions in the viewfinder." This is quite a good description of Riefenstahl's way of looking at the world, even though she never applied it to emaciated victims of torture and murder. As she said in an interview with *Cahiers du Cinéma*, quoted by Sontag: "I am fascinated by what is beautiful, strong, healthy, what is living. I seek harmony. When harmony is produced I am happy."[7] She meant: Jesse Owens, Nazi storm troopers, the Nuba.

Does this make her a lifelong fascist aesthete? Are her pictures of the Nuba infected by the same venom as the footage of SA men stamping to the sounds of the "Horst Wessel Song"? It is hard to maintain that they are. To be sure, the culture of the Nuba that interested Riefenstahl was not intellectually reflective, pacific, pluralist, or much associated with anything one would call liberal. But it is a stretch to see the tribal ceremonies of a people in the Sudan as a continuum of Hitler's rallies in Nuremberg. Nor is it fair to describe a viewer's enjoyment of Riefenstahl's color photographs of wrestlers and naked youths as politically suspect. The Nuba are what they are, or, more accurately, were what they were when Riefenstahl got to them. Their appeal to her was certainly of a piece with her views on urban civilization. Like the characters she portrayed in Fanck's mountain movies, she saw them as nature's children: this was condescending perhaps, Romantic absolutely, but hardly fascism.

Riefenstahl went on working almost to her dying day in September 2003. She sustained injuries from various crashes. Her morbid attempts to defy her age—the thick streaks of makeup, the straw-blond wigs, the hormone injections and facial surgery—gave her the appearance of an old man in drag. But there she was, celebrating her centennial in the company of Siegfried and Roy, from Las Vegas, and Reinhold Messner, the mountaineer, a week after the premiere on

7. *Under the Sign of Saturn*, p. 85.

television of her last work, entitled *Underwater Impressions*. As the oldest scuba diver in the world, she had spent the last two decades of her life photographing coral reefs and marine life with her much younger lover Horst Kettner.

The endless images of tropical fish and brightly colored sea anemones were not particularly well received. One reviewer, quoted by Bach, called *Underwater Impressions* "the world's most beautiful screen saver." Another spoke of "Triumph of the Gill." But Riefenstahl felt at home underwater capturing the silent beauty of a yet unblemished natural world. In her own words, it had sheltered her "from the outside world, removing all problems and worries." Perhaps best of all, it was a world entirely devoid of anything remotely human.

3

WERNER HERZOG AND HIS HEROES

IN HER MEMOIR about Bruce Chatwin, Susannah Clapp tells the following story. Not long before his death, already very ill, Chatwin was receiving guests in his room at the Ritz in London. Many of them left with a gift. One friend was given a small jagged object which Chatwin identified as a subincision knife, used to slit the urethra in an Aboriginal initiation rite. He had found it in the Australian bush, he said, with his connoisseur's eye: "It's obviously made from some sort of desert opal. It's a wonderful color, almost the color of chartreuse." Not long after, the director of the Australian National Gallery spotted the object in the grateful recipient's house. He held it up to the light and muttered: "Hmmm. Amazing what the Abos can do with a bit of an old beer bottle."[1]

Chatwin had the gift of polishing reality like Aladdin's lamp to produce stories of deep and alluring mystery. He was a mythmaker, a fabulist who could turn the most banal facts into poetry. To question the veracity of his stories is to miss the point. He was neither a reporter nor a scholar, but a raconteur of the highest order. The beauty of this type of writing lies in the perfect metaphor that appears to

1. *With Chatwin: Portrait of a Writer* (London: Jonathan Cape, 1997).

illuminate what lies under the factual surface. Another master of the genre was Ryszard Kapuściński, the Polish literary chronicler of third-world tyrannies and coups. One entire book of his, *The Emperor*, a poetic rendering of life in the court of Haile Selassie, is often read as a metaphor for Poland under communism—an interpretation denied by the author himself.

The German film director Werner Herzog was a friend of Chatwin's as well as Kapuściński's. He made a film—by no means his best —of one of Chatwin's books, entitled *Cobra Verde*,[2] about a half-crazed Brazilian slave trader in West Africa, played by a half-crazed Klaus Kinski. The match was a natural one, for Herzog, too, shares the gift of the great fabulators. In his many interviews—remarkably many for a man who says he would prefer to work anonymously, like a medieval artisan—Herzog often compares himself to the Moroccan spellbinders who tell stories in the marketplace of Marrakech. As was true of Chatwin and Kapuściński, Herzog feels a great affinity with what a friend of mine, much at home in Africa himself and quite critical of Kapuściński, has called "tropical baroque"—remote desert countries or dense Amazonian jungles.[3] Like them, Herzog— modestly of course, as if it's really of no great consequence—likes to tell tales of his own frightful hardships and narrowly missed catastrophes: filthy African jails, deadly floods in Peru, rampaging bulls in Mexico. In a BBC interview filmed in Los Angeles, Herzog, in his deep, mesmerizing voice, is just explaining how in Germany nobody appreciates his films anymore, when you hear a loud crack. Herzog doubles over. He's been shot by an air rifle just above his floral underpants, leaving a nasty wound. "It's of no significance," he says in his deadpan Bavarian drone. "It doesn't surprise me to get

2. The original novel was called *The Viceroy of Ouidah*.
3. John Ryle, academic, Africanist, writer.

shot at."[4] This is such a Herzogian moment that you would almost suspect that he directed the whole thing himself.

The suspicion is not entirely frivolous, for Herzog not only expresses no interest in literal truth; he despises it. Cinema verité, the art of catching truth on the run with an often handheld camera, he dismisses as "the accountant's truth." While Kapuściński always maintained that he was a reporter and denied making things up for poetic or metaphorical effect, Herzog is quite open about inventing scenes in his documentary films, for which he is justly famous. In fact, he doesn't recognize a distinction between his documentaries and his fiction films. As he told Paul Cronin in *Herzog on Herzog*[5]: "Even though they are usually labeled as such, I would say that it is misleading to call films like *Bells from the Deep* and *Death for Five Voices* 'documentaries.' They merely come under the guise of documentaries." And *Fitzcarraldo*, a fiction film about a late-nineteenth-century rubber baron (played by Kinski) who dreams of building an opera house in the Peruvian jungle and has a ship pulled across a mountain, has been described by Herzog as his most successful documentary.

The opposite of "accountant's truth" for Herzog is "ecstatic truth." In an appearance at the New York Public Library, he explained: "I'm after something that is more like an ecstasy of truth, something where we step beyond ourselves, something that happens in religion sometimes, like medieval mystics."[6] He achieves this to wonderful effect in *Bells from the Deep*, a film about faith and superstition in Russia—Jesus figures in Siberia and the like, another fascination he

4. The scene can be viewed on YouTube. The shooter fled and Herzog told the BBC producers to let him go.

5. Faber and Faber, 2002.

6. Herzog in conversation with Paul Holdengräber, "Was the Twentieth Century a Mistake?," New York Public Library, February 16, 2007.

shared with Chatwin. The movie opens with an extraordinary, hallucinatory image of people crawling on the surface of a frozen lake, peering through the ice, as though in prayer to some unseen god. In fact, as Herzog narrates, they are looking for a great lost city called Kitezh that lies buried under the ice of this bottomless lake. The city had been sacked long ago by Tartar invaders, but God sent an archangel to redeem the inhabitants by letting them live on in deep underwater bliss, chanting hymns and tolling bells.

The legend exists and the image is hauntingly beautiful. It is also entirely fake. Herzog rounded up a few drunks at a local village bar and paid them to lie on the ice. As he tells the story: "One of them has his face right on the ice and looks like he is in very deep meditation. The accountant's truth: he was completely drunk and fell asleep, and we had to wake him at the end of the take." Was it cheating? No, says Herzog, because "only through invention and fabrication and staging can you reach a more intense level of truth that cannot otherwise be found."

This is exactly what admirers of Chatwin say. And I must confess to being one of them. But not without some feeling of ambivalence. The power of the image is surely enhanced by the belief that these are real pilgrims and not drunks who are paid to impersonate pilgrims. If a film, or book, is presented as being factually accurate, there has to be a certain degree of trust in veracity that is not the same as the suspension of disbelief. Once you know the real unembellished story, some of the magic is lost, at least to me. And yet the genius of Herzog as a cinematic spellbinder is such that his documentaries work even as fiction. In defense of his peculiar style, it might be said that he uses invention not to falsify truth but to sharpen it, enhance it, make it more vivid. One of his favorite tricks is to invent dreams for his characters, or visions they never had, which nonetheless ring true because

they are in keeping with the characters. His subjects are always people with whom he feels a personal affinity. In a way the main characters in his films, feature and documentary, are all variations of Herzog himself.

Born in Munich during the war, Herzog grew up in a remote village in the Bavarian Alps, without access to telephones or movies. As a child he dreamed of becoming a ski jumper. Defying gravity, trying to fly, on skis, in balloons, in jet planes, is a recurring theme in his films. He loves Fred Astaire for that reason, airborne in his dancing shoes. And he made a documentary in 1974, entitled *The Great Ecstasy of Woodcarver Steiner*, about an Austrian ski jumper. Steiner is a typical Herzogian character, a monomaniacal loner, pushing himself to the limits, mastering the fear of death and isolation. Steiner is, in Herzog's words, "a close brother of Fitzcarraldo, a man who also defies the laws of gravity by pulling a ship over a mountain."

In 1971, Herzog made one of his most astonishing documentaries about another form of solitude, the most extreme form, of people trapped in the isolation of their blindness and deafness. The main character in *Land of Silence and Darkness* is a middle-aged German woman of tremendous courage, named Fini Straubinger, who can communicate only by tapping a kind of braille on another person's hand. Since she went blind after an accident in her teens, she still had visual memories, the most vivid of which, she recalls, was the look of ecstasy on the faces of ski jumpers as they soared through the sky. In fact, Straubinger had never seen a ski jumper. Herzog wrote those lines for her because he thought this "was a great image to represent Fini's own inner state and solitude."

Does this diminish the film, or distort the truth about Straubinger, even though she agreed to speak those lines? It is hard to give an unequivocal answer. Yes, it is a distortion because it is invented. But

it does not diminish the film because Herzog manages to make it look plausible. We can never really know the inner life of Straubinger, or of anyone else, for that matter. What Herzog does is imagine her inner life. The ski jumper story is part of how he sees Straubinger. It illuminates her character for him. That is another kind of truth, the portraitist's truth.

Herzog likes to think of himself as an artistic outsider, out on a dangerous edge, flying alone, as it were. In many ways, however, he is mining a rich tradition. The yearning for ecstasy, man alone in wild nature, deeper truths, medieval mystics, all this smacks of nineteenth-century Romanticism. Herzog's frequent use of Richard Wagner's music (in *Lessons of Darkness*, for example, his film about the burning oil wells of Kuwait after the first Gulf war), as well as his often professed love of Hölderlin's poetry, suggests that he is quite aware of this affinity. His loathing of "technological civilization," and his idealization of nomadism and ways of life as yet untouched by our blighted civilization, are of a piece with this. He can be quite moralistic, even puritanical. "Tourism is sin," he announced in his so-called Minnesota Declaration of 1999, and "walking is a virtue."[7] The twentieth century, with its "consumer culture," was a "massive, colossal and cataclysmic mistake." Meditating Tibetan monks, he claimed at his Goethe Institute talk, are good, but meditating California housewives "an abomination." Why? He didn't say. One imagines it is because he considered the housewives inauthentic, not true believers, only in it for the lifestyle.

As with many Romantic artists, landscape is an important element in Herzog's work and part of his striving for a kind of visionary authenticity. Few directors match his skill in depicting the fertile hor-

7. Traveling on foot was also one of Chatwin's enthusiasms. He bequeathed his custom-made leather rucksack to Herzog.

ror of the jungle, the terrifying bleakness of deserts, or the awful majesty of high mountains. He never uses landscapes as backdrops. Landscape has character. About the jungle he has remarked that it "is really about our dreams, our deepest emotions, our nightmares. It is not a location, but a state of our mind. It has almost human qualities. It is a vital part of the characters' inner landscapes." Caspar David Friedrich, an artist Herzog admires, never painted the jungle, but this description could easily be applied to his pictures of lone figures gazing at the stormy Baltic Sea or standing above the clouds on snowy peaks. Friedrich saw landscape as a manifestation of God. Herzog, who went through a "dramatic religious phase" and converted to Catholicism as a teenager, sees "something of a religious echo in some of my work."

Postwar Germans, for obvious reasons, sometimes feel uneasy with this kind of Romantic straining for the sacred. It smacks too much of the Third Reich, with its exultation of a bogus Germanic spirit. Perhaps this explains why Herzog's films have found an easier reception abroad (he now lives in Los Angeles, a city he loves for its "collective dreams"). In fact, Herzog himself is extremely sensitive to the barbarism unleashed in his country. He says, "I am even apprehensive about insecticide commercials, and know there is only one step from insecticide to genocide." Herzog certainly never toys with Nazi aesthetics. What he has done is more interesting: he has reinvented a tradition that was exploited and vulgarized by the Nazis. The kind of mountain films, for instance, that Leni Riefenstahl acted in and directed, full of ecstasy and death, fell out of favor after the war because, as Herzog says, they "fell in step with Nazi ideology." So Herzog set out to create "a new, contemporary form of mountain film."

To me, watching Herzog's films brings to mind a different, more popular kind of romance that long preceded Hitler: the novels of Karl May about intrepid German trappers in the American Wild

West.[8] May's most popular hero was Old Shatterhand, who roamed the prairies with his "blood brother," an Apache brave named Winnetou, the typical nineteenth-century Noble Savage. Apart from his trusted rifle, Old Shatterhand had no truck with our technological civilization. He used all his ingenuity to survive in the dangerous state of nature. Since May had never even visited America when he wrote his western novels in the 1890s, his descriptions were entirely invented, and at the same time were infused with realistic details culled from maps, travel accounts, and anthropological studies.

Of all Herzog's heroes, fictional or not, the closest to Old Shatterhand is not, as one might think, one of the obsessed visionaries played by Klaus Kinski: Aguirre, the Spaniard in search of El Dorado, or Fitzcarraldo. Nor is it Timothy Treadwell, the bear-hugging American in *Grizzly Man* (2005), who thought that he could survive in the icy wilds of Alaska because the grizzly bears would reciprocate his love instead of devouring him, as they end up doing. Old Shatterhand would not have been so sentimental about nature. He understood its perils.

No, a much more typical Karl May figure was a fighter pilot named Dieter Dengler. Born in the German Black Forest, Dengler became an American citizen, because ever since he saw a US fighter plane streak past his house at the end of World War II, he knew he wanted to fly. Since he couldn't fulfill his ambition just then in Germany, he became an apprentice clockmaker before boarding a ship bound for New York with thirty cents in his pocket. He joined the US Air Force and spent several years peeling potatoes before realiz-

8. Hitler was a keen reader of May, but so was Albert Einstein.

ing that he needed a college degree, which he completed while living in a VW bus in California. No sooner was he taken into the navy and trained to become a fighter pilot than he was shipped off to serve in the Vietnam War. He was shot down on a secret mission over Laos. Captured by the Pathet Lao, he was marched through the jungle and frequently tortured. It would amuse his captors to suspend their prisoner upside down with his face buried in an ants' nest, or drag him behind an ox, or drive bits of bamboo into his skin.

Locked up in a prison camp with other prisoners, Americans and Thais, he supplemented his diet of maggoty rice gruel with rats and snakes fished out of the latrine and eaten raw. Making good use of his technical ingenuity, as well as his almost superhuman survival skills, Dengler escaped with his buddy, Duane Martin. They hacked their way barefoot through the monsoon-soaked jungle toward the Mekong River, bordering Thailand. After they ran into hostile villagers, Martin's head was cut off with a machete. Not long after that, through sheer luck, Dengler, by then a skeletal figure, was spotted by a US pilot and rescued. "This was the fun part of my life," he would say to people who wanted to know how he could possibly have endured so much hardship.

Herzog feels drawn to strongmen, but is quick to add that this does not mean bodybuilders. For him bodybuilders are frivolous, inauthentic, like those meditating California housewives, "an abomination." Herzog's very first film, entitled *Herakles*, made in 1962, when he was twenty years old, splices together images of car crashes, bombing raids, and bodybuilders in a way that shows disapproval of gratuitous machismo. A Herzogian strongman can be a strongwoman too, like Fini Straubinger, or Juliane Koepcke, the lone survivor of an air disaster in Chile, whose story Herzog recounts in *Wings of Hope* (2000). The Herzogian strongperson is not just physically, but mentally tough, someone who knows how to beat the odds.

If Dieter Dengler hadn't existed, Herzog would have made him up. He is the perfect Herzogian strongman, and the subject of one of Herzog's best "documentary" films, *Little Dieter Needs to Fly* (1997), made for a German television series about journeys to hell. The very first shot is already an invention. We see Dengler enter a tattoo parlor in San Francisco, ostensibly to have an image of death driven by wild horses tattooed onto his back. But he decides against it. He could never have a tattoo like that, he says, for when he was close to dying and "the doors of heaven opened," he didn't see wild horses but angels: "Death didn't want me."

Dengler, in fact, never thought of having a tattoo at all. Herzog created the scene to make a point about Dengler's narrow escape. The next scene shows Dengler arriving in his convertible at his house north of San Francisco. The landscape is strangely reminiscent of the pre-war German mountain movies: misty, high up, seemingly remote from human civilization. He opens and closes the car door several times, a little obsessively, then does the same with his front door, which is unlocked. Some people, he says, might find this habit a little peculiar, but it has to do with his time in captivity. Opening doors gives him a sense of freedom.

In real life, Dengler was no more in the habit of fetishizing open doors than he was of getting tattooed, even though he did have a set of paintings on his wall showing open doors. He was acting himself in scenes contrived by Herzog. Later on in the movie, we hear about Dengler's recurring dream in the prison camp of the US Navy coming to rescue him, only to pass right by him while he frantically waves at the ships. An invention. And yet by the end of *Little Dieter Needs to Fly* we are left with an extraordinarily intimate portrait of a transplanted German hero like Old Shatterhand, who outshines his new American compatriots in such "typical German" virtues as efficiency, discipline, and technical competence. Dengler is himself a marvelous

narrator, whose German-inflected voice blends interestingly with Herzog's to the point of becoming almost indistinguishable. This is more than a simple case of the director's identification with his subject; he almost becomes Dengler.

One of Herzog's many talents as a filmmaker is his startling use of music. Matching up burning oil wells in Kuwait with Wagner's *Twilight of the Gods* is perhaps too obvious, but seeing jet fighters take off from a US aircraft carrier to the sound of Carlos Gardel's tango music is highly effective. A Mongolian throat singer is used to accompany footage of a bombing raid on villages in Vietnam, producing images that are both horrifying and beautiful. Wagner is used again in a scene where Dengler explains the experience of near death. He is posed in front of a huge aquarium filled with blue jellyfish floating grotesquely like rubbery parachutes. This is what death looks like, says Dengler, as we hear the *Liebestod* on the soundtrack. Again, the image of the jellyfish was Herzog's idea, not Dengler's, but it is undeniably powerful.

The fact that Herzog, when asked, is quite open about his inventions does not entirely dispel one's doubts about this kind of filmmaking. For if so much is invented, how do we know in the end what is true? Perhaps Dengler was never shot down over Laos. Perhaps he never even existed. Perhaps, perhaps. All I can say, as an admirer of Herzog's films, is that I believe he is true to his subjects. None of the inventions—the doors, the jellyfish, the dreams—changes Dengler's account of what happened. They are metaphors, not facts. And Dengler himself saw the point of them.

The best example of this comes at the very end of the film, after we have seen Dengler return with Herzog and his crew to the Southeast Asian jungle, where he walks again barefoot through the bush, and is again tied up by villagers (hired by Herzog), and recalls in precise detail how he escaped and his friend Martin got killed. We have also

seen him in his native village in the Black Forest, telling us about his grandfather, the only man in the village who refused to go along with the Nazis. And we have seen him back in the US, sharing a gigantic Thanksgiving turkey with Gene Dietrick, the pilot who rescued him from imminent death. After all that, in the last shot, before the epilogue about Dengler's funeral at Arlington Cemetery—he died of Lou Gehrig's disease—we see him walking around in wonder through the vast resting place for military aircraft in Tucson, Arizona. As the camera pans across row upon row of discarded jet fighters, helicopters, and bombers, he declares that he has arrived in pilot's heaven.

Herzog set this scene up too. Dengler had no intention of going to Tucson. But his wonder looks genuine. Flying had been his lifelong obsession. He did need to fly, and it doesn't matter who arranged for him to be in the Airplane Graveyard, for Little Dieter really does look as if he is in heaven.

Given the brilliant achievement of this documentary film, the notion of remaking the story as a feature film might strike one as eccentric. Dengler liked the idea, if only because he hoped to make a great deal of money out of it. (Unfortunately he died before the film was completed.) Herzog evidently was so taken with the man and his story that he couldn't let it go. So he managed to amass something like a minor Hollywood budget for *Rescue Dawn*, and set off to Thailand with his crew and cast, including two well-known young actors, Christian Bale (Dengler) and Steve Zahn (Martin). The production was beset by the usual Herzogian difficulties: bitter rows, furious producers, uncomprehending crews, trouble with local officials.[9] And uncommon hardships for some of the actors: Bale lost so much weight for the part that he looked as if he really did emerge

9. For a lively description of all this, see Daniel Zalewski's report in *The New Yorker*, May 13, 2006.

from an ordeal in the jungle. He is also, for the sake of authenticity, compelled to eat horrible-looking insects and snakes.

The actors are very good, especially in the minor parts. Jeremy Davies as Gene, one of the American prisoners who resists Dengler's plans to escape, is especially fine. And Herzog's eye for the beautiful terror of nature does not fail him. Yet much of what made *Little Dieter Needs to Fly* a masterpiece is missing. First of all Dengler himself. Somehow his story, reenacted in the feature film, fails to catch fire in the way it does in the documentary. It looks oddly conventional, even flat. And Dengler is much more American than in fact he was, although he still is tougher and more resourceful than anyone else in the movie. The ending, apparently close to the facts, showing Dengler being received back on his navy ship by his cheering buddies, is pure Hollywood schmaltz compared to the mesmerizing images in the Tucson Airplane Graveyard.

The difference, I think, has everything to do with Herzog's use of fantasy. In the documentary, his method is actually closer to that of a fiction writer than in the feature film. *Rescue Dawn* sticks to the facts of Dengler's story, without adding much background, let alone any hint of an inner life. It looks like a well-made docudrama. In the documentary, however, it is precisely the collage of family history, dream images, personal eccentricities, and factual information that brings Dengler alive as a fully rounded figure. This doesn't mean that the same effect cannot be achieved in a feature film. But it does show how far Herzog has taken a genre that is commonly known as documentary film but that he calls "just films." For want of a better word, that will have to do.

4

THE GENIUS OF BERLIN:
RAINER WERNER FASSBINDER

ALFRED DÖBLIN'S GREAT novel *Berlin Alexanderplatz*, published in 1929, is pretty much untranslatable. Much of it is written in the working-class argot of pre-war Berlin. A translator can ignore this, of course, and use plain English, but then you lose the flavor of the original. Or he can go for an approximation, adopting a kind of Brooklynese, for example, but this would not evoke Döblin's louche Berlin milieu so much as Damon Runyon's New York.[1] John Gay's *Beggar's Opera*, set in eighteenth-century London, was successfully reworked by Bertolt Brecht and Kurt Weill into a Weimar Berlin masterpiece, but that wasn't a translation; it was a transformation, of place and time.

Franz Biberkopf, the hero of Döblin's novel, is a pimp, not a bad sort but given to sudden helpless rages. He whipped one of his girls, Ida, to death with an eggbeater. But that is not how Döblin's epic tale begins. It begins when Biberkopf is released from Berlin's Tegel prison, paralyzed with fear at having to pick up his life again in the infernal

1. Eugene Jolas, who translated the novel in 1931, was an interesting man, an American who knew James Joyce and was active in modernist circles in Paris. But his translation is inadequate. He chose to use American slang: "Now I getcha, wait a minute, m'boy...." And so on.

metropolis. He meets a poor bearded Jew, who tries to comfort him with some Yiddish wisdom. Biberkopf's spirits are further revived by a rough sexual encounter with Ida's sister. He quickly finds a new girl, called Polish Lina. This time, he vows, Franz Biberkopf will be a respectable man, *ein anständiger Mensch*; this time, he will stay away from crime. But he can't. In Döblin's words (my translation):

Although he does all right economically, he is at war with an outside force, unpredictable, something that looks like fate.

Biberkopf wants to believe in human goodness. But the part of the metropolis he knows, concentrated in the mean streets around the proletarian Alexanderplatz ("Alex") in east Berlin, grinds him down. He is punished for his naive trust in others.

Biberkopf's fate, a sorry succession of shabby deals, drunken brawls, petty crime, and murder, is the stuff of a pulp novel or B movie. At key moments in the story, he is betrayed by men he regards as his closest friends. Otto Lüders, the uncle of Polish Lina, gives him a share in his business as a door-to-door salesman of shoelaces. Biberkopf has sex with one of his customers, a grieving widow, whose late husband he physically resembles. In exchange for her moment of consolation, she gives him a fat tip. After he tells Lüders about his good fortune, Lüders proceeds to rob her. When he hears about this, Biberkopf goes on a drunken binge. But he still trusts his friend Reinhold, a petty mobster, who can't bear to stay with the same woman for more than a week or two and insists on passing on one after another to Biberkopf. Since he grows fond of the women, Biberkopf calls a halt to these sordid transactions. Reinhold feels insulted.

Soon after, Biberkopf is tricked into taking part in a heist, and

Reinhold almost kills him by pushing him out of the getaway car, hoping he'll be run over. Biberkopf survives minus one arm. A new girlfriend, Mieze, moves into his room, passing on to him the money she makes in the streets. Reinhold, out of malice, envy, and contempt, wants to take Mieze away from Biberkopf. When she resists Reinhold's advances, he strangles her. Biberkopf, blamed for the murder, goes temporarily mad, but he is not prosecuted and he emerges a saner, less delusional, but also less interesting man. He is offered a job as a security guard in a factory. In Döblin's laconic words: "He accepts. There is nothing more to say about his life."

The greatness of Döblin's novel lies not in the plot but, as Rainer Werner Fassbinder observes in his essay on the book, in the telling.[2] Franz Biberkopf is one of the modern world's richest literary characters, as memorable as Woyzeck, Oblomov, or Madame Bovary. We get to know him not just from the outside, as a fat, muscular, working-class Berliner, a lover of schnapps, beer, and women, an "unpolitical" man, a denizen of the bars and cheap dance halls around the "Alex," but from the inside too, in a constant stream of interior monologues filled with his dreams, anxieties, confusions, hopes, and illusions.

Döblin has often been compared to Joyce, and *Ulysses* is sometimes cited as his model. But Döblin denied this. He wrote:

Why should I imitate anybody? The living language I hear around me is enough, and my past gives me all the material I need.

2. Fassbinder's essay, written in 1980, is included in *Fassbinder: Berlin Alexanderplatz* (Schirmer/Mosel, 2007), the catalog of a show at P.S.1 Contemporary Art Center in Long Island City, along with an essay by Susan Sontag, "Novel into Film: Fassbinder's *Berlin Alexanderplatz*" (1983).

He did read Joyce, however, after he had begun writing *Berlin Alexanderplatz*, and said that the Irishman's work had "put the wind in my sails."[3] In fact, both writers, living in the age of Freud and Jung, were attempting to do something similar: to break down the barriers between conscious behavior and subconscious drives by delving into the churning magma of their heroes' chaotic inner lives.

In a typical passage, Biberkopf talks to himself:

> You swore, Franz Biberkopf, to stay decent. You led a shitty life, ran off the rails. You killed Ida and did time for it. Terrible. And now? Nothing's really changed, Ida's called Mieze, that's all, you lost an arm, careful, you'll end up being a lush, and everything'll start all over again, only worse, and that'll be the end of you.... Bullshit, can I help it? Did I ask to be a pimp? Bullshit, I say. I've done all I could, all that's humanly possible....You'll end up in jail, Franz, you'll get a knife in your belly. Let them try. They'll first get a taste of mine.

Biberkopf is not the only one in Döblin's book to be turned inside out. All the main characters—Reinhold, Mieze, Lüders, a gangster named Meck, Eva, Biberkopf's former lover, and many more—reveal themselves in a mixture of salty Berlin speech and private thoughts. But it is not just the human characters whose consciousness, or subconsciousness, is opened up for the reader but the metropolis itself. *Berlin Alexanderplatz* is constructed as a collage of often random images that flicker into view, as though one were clattering through the teeming streets on an electric trolley, taking in advertising slo-

3. Quoted in the 1965 paperback edition of *Berlin Alexanderplatz* (Munich: Deutsche Taschenbuch Verlag).

gans, newspaper headlines, popular songs, bars, restaurants, hotels, neon signs, department stores, pawnshops, flophouses, cops, striking workers, whores, subway stations, and so on. Again, Fassbinder put this very well:

> More interesting than the question of whether Döblin was acquainted with "Ulysses" [is] the idea that the language in "Berlin Alexanderplatz" was influenced by the rhythm of the S-Bahn trains that kept rolling past Alfred Döblin's study.

Creating a collage of fleeting, fragmented impressions as a way to describe the modern metropolis is not unique to Döblin, of course. Walter Ruttmann's experimental documentary film *Berlin: Die Sinfonie der Großstadt*, made in 1927, did exactly that, through a montage of images as fast and cacophonous as the city itself. So did George Grosz in his drawings of Berlin, which don't simply break up the view of metropolitan life into a jumble of impressions but make the city dwellers look transparent, as though one could see through them to their most private desires, often of a violent sexual nature. And in their different ways, Picasso, Braque, and others were doing the same, fragmenting perspective in synthetic cubism.

Döblin adds his own all-seeing authorial voice to the patchwork of speech, songs, police reports, private thoughts, commercials, and other big-city noises. His voice is as complex as those of his characters. Sometimes it is didactic, like Brecht's theatrical texts, or dryly analytical like a doctor's analysis of his patients. Döblin was in fact a doctor, and practiced as a psychiatrist in Berlin, where he heard many crime stories firsthand. Sometimes the voice is ironic, even sarcastic, and often it is given to metaphysical musings, quoting from the Bible, especially the stories of Job and of Abraham's sacrifice of

Isaac. Sacrifice is one of Döblin's great themes: death as a necessary condition of rebirth.

Döblin was the son of a Jewish merchant in Stettin. While in American exile in 1941, he converted to Roman Catholicism, influenced, he said, by his reading of Kierkegaard and, more surprisingly, Spinoza. The questions of fate and personal choice, of man's place in an impersonal universe of unseen forces, natural as well as technological and political, are a philosophical leitmotif running through the entire story of Biberkopf's downfall and final redemption.

How to translate this great literary stew into a film? The first, not inconsiderable attempt was made in 1931 by Phil Jutzi, with a script cowritten by Döblin himself. Biberkopf is played by Heinrich George, one of the most admired actors of the time. Jutzi's *Berlin-Alexanderplatz* bears some resemblance to Ruttmann's documentary film, with its wonderful images. But the many layers of Döblin's expressionist novel cannot be compressed into an eighty-nine-minute feature film. George was a great actor, and the movie is a precious document of what Döblin's Berlin actually looked like, but the richness of the novel is lost.

When Fassbinder made his fifteen-hour-long film of *Berlin Alexanderplatz* for television in 1980, Döblin's city was mostly gone, destroyed by Allied bombs, Soviet artillery, and East German wrecking balls. And what little was left, in the east, was hidden behind the Berlin Wall and thus out of bounds for Fassbinder and his crew. A documentary approach was clearly impossible. And even if it had been possible to reconstruct the Alexanderplatz, Fassbinder felt that

how it really would look out on the streets [could be seen] better from the kinds of refuges people created for themselves,

what kinds of bars they went to, how they lived in their apartments, and so on.[4]

So he recreated the city as a kind of theater set, confined to a few interiors—Biberkopf's room, his local bar, Reinhold's apartment, an underground railway station, and a few streets—built in a Munich movie studio. Since panoramic views or even long shots of the city were impossible, Fassbinder chose details, close-ups, window frames, blinking neon signs, bar tables, and stoops, a technique we are familiar with from television soap operas; think of Seinfeld's Manhattan, constructed on a Hollywood backlot.

Fassbinder's film was in fact made very fast and very cheaply, using 16-millimeter film. As Susan Sontag pointed out, the length of the work, consisting of fourteen episodes, lends itself particularly well to the cinematic translation of a novel. The viewer, like the reader of a novel, has the time to immerse himself in the narrative, become thoroughly familiar with the characters, live in the story, as it were. Limiting the number of locations (in the book Biberkopf dwells in various places, not one, and frequents several bars) is another common feature of soap operas; after a while you get to know these places—think of Seinfeld's coffee shop, or his apartment—as though you have been there many times yourself. In some ways, the concentrated form of the soap opera is closer to theater than to cinema. This can be a virtue, as it is in Fassbinder's work. Highly stylized, it manages to combine theatricality with intimacy, which perfectly suits the tone of Döblin's narrative.

4. Interview with Hans Günther Pflaum, reprinted in *The Anarchy of the Imagination: Interviews, Essays, Notes*, edited by Michael Töteberg and Leo A. Lensing (Johns Hopkins University Press, 1992), p. 47.

Berlin Alexanderplatz is also a story that seems perfectly natural to Fassbinder himself. He first read Döblin's book when he was fourteen, in the grip, as he put it, of "an almost murderous puberty." Confused about his homosexuality, deprived of his father, who left when Fassbinder was still very young, and generally living in a state of adolescent terror, he read *Berlin Alexanderplatz* not just as a work of art but as a book that could help him deal with his personal anxieties. Because of this, he reduced it, on first reading, to a theme that is certainly there, though perhaps not quite so predominant as Fassbinder made it out to be: the violent, sadomasochistic, but always intimate relationship between Biberkopf and Reinhold. Fassbinder sees a purity in Biberkopf's love for his friend, a purity that is dangerous, even terrifying, but needs to be cherished despite, or perhaps because of, the deep suffering involved. This reading of the book helped the young Fassbinder cope with his own demons. In his life as much as in his films, love was often mixed with violence: two of his lovers committed suicide.

Biberkopf, a man in search of love and dignity in a squalid world, was in some ways Fassbinder's alter ego. There are references to Döblin's novel in several of Fassbinder's earlier movies. In his first feature film, *Love Is Colder Than Death* (1969), Fassbinder himself plays a pimp called Franz. He has a prostitute-lover named Johanna (Hanna Schygulla). But his deeper feelings are for a petty gangster named Bruno (Ulli Lommel). The power plays, the jealousies, the cruelty of love, the complex inner lives of marginal figures, all these reflect *Berlin Alexanderplatz*.

Franz turns up once more in *Gods of the Plague* (1970). Like Biberkopf, this Franz, played by Harry Baer, has various liaisons with women after being released from prison. But again, the most intense relationship is with another man, a violent gangster by the name of "Gorilla" (Günther Kaufmann). In *Fox and His Friends* (1975), one

of Fassbinder's few treatments of openly gay life, he plays a naive carnival worker named Franz Biberkopf, who wins the lottery and is viciously exploited by relatives, lovers, and friends. The German title, *Faustrecht der Freiheit* (First Right of Freedom), hints more directly at one of the themes that runs through Döblin's novel too: the struggle for survival of a man who wants to be decent in a dog-eat-dog world.

Fassbinder might have played Biberkopf in *Berlin Alexanderplatz*, but he chose Günter Lamprecht instead, who gives one of the most memorable performances in the history of film. First of all, he looks the part: large, shambling, like a performing bear, his pudding face a map of confusion, barely contained violence, and childlike innocence. Much of the movie is shot in close-up, registering every emotion. A drunken pimp who hero-worships a thug and beats up his lovers is not at first sight a prepossessing figure, yet Fassbinder, through Lamprecht's performance, gives an affectionate picture of Biberkopf. The story is brutal, but the telling is full of tenderness. We learn to love this sad loser.

If Biberkopf is the Job-like character, constantly tested by increasingly savage misfortunes, Reinhold, played beautifully by Gottfried John, is a Satanic figure, a brute, but a fascinating, even seductive brute. John, too, is often filmed in close-up, usually from a low side angle that brings out his sly malice. As is often the case in life, his slight physical disability—a stammer—adds something to his dangerous charm. Reinhold is described in the book as slim and disheveled, a sad-eyed man with a "long yellowish face" who walks "as though his feet are always getting stuck." John slinks and slouches, snakelike; you expect him to start hissing at any moment.

The third extraordinary performance is by Barbara Sukowa as Mieze, the provincial girl who came to Berlin "to have some fun" and ends up being Biberkopf's whore. Her mannerisms—the licking

of her fingers to smooth her eyebrows, the coltish hopping onto Biberkopf's lap, the giggly flirtations, the fits of hysterical screaming—are marks of a kind of innocent sluttishness, if such a thing can be imagined. Dressed in white, she looks the picture of innocence, just waiting to be sacrificed in this wicked world. When Reinhold tricks her into taking a walk with him in the dark, ominous, Hansel and Gretel–like woods outside Berlin, he takes off his shirt to show her his tattoo of an anvil. Why an anvil, she wants to know. "Because someone has to lie down on it," he says. "Why didn't you have a bed tattooed there instead?" she wonders. "No," he says, "I think an anvil is closer to the truth." "Are you a blacksmith?" she asks. "That, too, a little....No one should get too close to me...they will get burned right away." And she does. She flirts with Reinhold, then she curses him. Reinhold strangles her in a rage.

In these emotional cocktails, it is hard to get the balance just right between brutality and charm, sweetness and callous self-regard, innocence and sauciness. The brilliance of Fassbinder and his cast is in the way they manage to express all these feelings in a work that is so tightly structured, formal, aesthetic. Fassbinder composed every frame with the eye of a painter and manipulated his actors rather like a puppet master. Almost every scene is filmed in artificial light: yellow streetlamps and headlights glowing in the misty night; grays and sulfurous greens in the stuffy subway stations; oranges and shades of brown in the apartments. The only bright colors penetrating the gloom come from flashing neon signs. The sun shines rarely. To give the light a diffuse, 1920s feel, reminiscent of Josef von Sternberg's films, Fassbinder covered the camera lens with a silk stocking. The woods are filmed through a haze. Indoor scenes are sometimes lit through a veil of reflective particles stirred by rotating fans to blur and soften the light even further.

By pressing his characters into confined spaces, framed by win-

dowpanes or iron bars, crowded by furniture and objects in cluttered rooms, or reflected in mirrors, Fassbinder creates an atmosphere of claustrophobia, of people feeling caged in the metropolis. His great hero, the director Douglas Sirk, who often used similar effects, might have been an influence. The paintings of Max Beckmann, of human beings stuffed into narrow attics or pushed together in cramped dance halls, could have been another source of inspiration. The last shot of Biberkopf, before he goes mad, after he finally realizes what his friend Reinhold has done to Mieze, shows him laughing hysterically through the bars of a birdcage hanging from the rafters of his room. (The original inhabitant of this cage, a canary, had already been squeezed to death by the despairing Biberkopf.)

The narration is in Fassbinder's own voice, tender, ironic, poetic, and entirely faithful to the book. Fassbinder did not play Biberkopf. He played Döblin. But the movie is far from a literal translation of the text. Fassbinder made the story his own. First of all, he added a character who wasn't there in Döblin's version: Frau Bast, Biberkopf's ever-loyal, all-understanding, blindly loving, warmly maternal landlady. She is the consoling presence, always ready to excuse, to clean up, to arrange things. Frau Bast is also rather nosy. Like his Biberkopf, Fassbinder himself was deeply drawn to mother figures, first of all his actual mother, Liselotte (Lilo) Pempeit, who acted in several of his films, including *Berlin Alexanderplatz*, where she appears as the silent wife of a gang boss. In 1970, he actually married one of his muses, the singer Ingrid Caven. Juliane Lorenz was the last of his devoted women, who did everything from buying his groceries to cutting his films.

The most important departure from the original text, however, is Fassbinder's attempt to eroticize the male relationships, especially the one between Biberkopf and Reinhold. In his essay, Fassbinder makes it clear that the two characters in Döblin's book were "by no

means homosexual—they don't even in the broadest sense have problems in this direction." But in the last delirious episodes of the movie, when Biberkopf lies in the mental institution and Reinhold is in jail, where he falls in love with his Polish cellmate, Fassbinder makes explicit what in the book is barely even hinted at. In the book, Reinhold has strong feelings for the Pole. Though not impossible to imagine, there is no suggestion that these feelings are physical. In the movie, the camera lingers sensuously on the Pole's naked body as the two men kiss on their bunk bed.

The epilogue of the story, when Biberkopf goes through hell inside his own head, is described in some detail in the book. Biberkopf has visions of Death slashing him with an ax. In the movie, it is Reinhold, stripped to the waist, wearing black leather boots, who wields the ax, and, in another sequence, a whip, which he takes to Biberkopf while another man crawling on all fours is whipped by a blond beast. This looks less like Döblin's vision of hell than an orgy in a 1970s Berlin leather bar, an impression heightened by the sounds of Lou Reed and Janis Joplin instead of Peer Raben's melancholy score, hauntingly played through the rest of the film. And there, peering at the scenes of sadomasochistic carnage, half hidden behind a door, is Fassbinder himself, in dark glasses and a leather jacket. The idea, no doubt, was to bring the movie up to date, to show that political decadence and sexual violence were no less relevant in the 1970s than in the 1920s. The effect, however, is to make these scenes look oddly dated, not timeless but rather typical of the underground theater scene from which Fassbinder emerged in the 1960s.

Perhaps he went over the top in this hallucinatory epilogue, but if so, he went bravely, gloriously over the top, with all guns blazing. Some of Fassbinder's visual inventions are brilliant elaborations on Döblin's own imagination. The religious imagery, for example, al-

ready heavily present in the novel, which is, after all, a kind of passion play, is filtered through Fassbinder's peculiar perspective in the last part of the movie: Biberkopf nailed to a cross, watched by the women he has killed or abandoned; Reinhold wearing a crown of thorns; and one especially striking scene of Frau Bast as the Virgin Mary cradling a puppet of Biberkopf with a Nazi armband. A hint, perhaps, that Biberkopf, once he recovered his sanity, would become a perfectly normal little man, and thus, in Fassbinder's words, "no doubt become a Nazi."

Döblin could not have known quite what would be in store for Germany just a few years after he published his novel. But the specter of Hitlerism is already hovering over the work. Biberkopf and his gang show a total contempt for politics, especially the politics of the Social Democrats, who were hanging on to the last threads of the Weimar Republic. The political meetings, described in the novel, of anarchists and Communists are pregnant with latent violence. Fassbinder did know what happened, of course, and hints at the future by having brown-shirted storm troopers march through the last scenes of Biberkopf's delirium. We also hear the sounds of the "Horst Wessel Song" clashing with the Socialist "Internationale." It is fitting that he should end his movie on this note. The novel, in Fassbinder's words,

offered a precise characterization of the twenties; for anyone who knows what came of all that, it's fairly easy to recognize the reasons that made the average German capable of embracing his National Socialism.

Fassbinder ends his essay, written in 1980, with the hope that more people will read Döblin's great book—"For the sake of the readers. And for the sake of life." I share that hope. Those who are

not blessed with the good fortune to be able to read the novel in German can still enjoy Fassbinder's great film. But it is high time for the book to find a new translator brilliant and inventive enough to do justice to the text in English. Of course it is untranslatable, but that is no reason not to try.[5]

5. Michael Hofmann is translating the book for New York Review Classics.

5

THE DESTRUCTION OF GERMANY

FROM THE COCKPIT of an RAF Lancaster bomber, the approach to a major German city at night in 1943 must have been a bit like entering a brightly lit room stark naked—a moment of total vulnerability. Trapped in the blinding web of searchlights, tossed about by flak explosions, terrified of fighter planes attacking from above, freezing in temperatures well below zero, exhausted through lack of sleep and constant tension, limbs aching from having to sit in the same cramped position for many hours, ears tormented by the screaming engines of a plane fighting for its life, the pilot knew he might be blown to bits at any time. And that is indeed what happened to the more than 55,000 airmen in Bomber Command who lost their lives somewhere over Germany.

If they were lucky enough to make it through the flak, the bomber crew would have seen something of the inferno they helped to set off. Billows of smoke and flame would reach heights of six thousand meters. Essen, an industrial city in the Ruhr, was described by one bomber pilot as a huge cooking pot on the boil, glowing, even at a distance of more than two hundred kilometers, like a red sunset.

Another pilot recalls: "This is what Hell must be like as we Christians imagine it. In that night I became a pacifist."[1]

Now imagine what it must have been like to be stuck in a dark cellar in Hamburg or Bremen, gasping on carbon monoxide and other gases. Gradually the fires outside turn the cellar into an oven, so those who have not already been asphyxiated have to face the firestorms raging with the force of typhoons outside. Firestorms suck the oxygen out of the air, so you cannot breathe or, if you can, the heat will scorch your lungs, or you might die in melting asphalt or drown in a cooking river. By the end of the war, in the spring of 1945, up to 600,000 people had burned, or choked, or boiled to death in these man-made storms.

Then consider the aftermath, when concentration camp inmates were forced to dig out the charred remains of people in the air raid shelters, whose floors were slippery with finger-size maggots. One of the rare German writers to describe such scenes, Hans Erich Nossack, wrote:

Rats and flies ruled the city. The rats, bold and fat, frolicked in the streets, but even more disgusting were the flies, huge and iridescent green, flies such as had never been seen before. They swarmed in great clusters on the roads, settled in heaps to copulate on ruined walls, and basked, weary and satiated, on the splinters of windowpanes. When they could no longer fly they crawled after us through the tiniest of cracks, and their buzzing and whirring was the first thing we heard on waking.[2]

1. "So muss die Hölle aussehen," *Der Spiegel*, January 6, 2003, p. 39.
2. Quoted in W.G. Sebald, *On the Natural History of Destruction* (Modern Library, 2004), p. 35. An English translation by Joel Agee of Nossack's *The End* will be published in December 2014 by the University of Chicago Press, with a foreword by David Rieff.

Same events, different perspectives.

Were all these victims—the bomber pilot blown up in the sky, the civilian baked to death in a cellar, and the prisoner who had to gather corpses with his bare hands—equal in their suffering? Does death flatten all distinctions? In fact, the story gets more complicated. Wolf Biermann, the singer and poet, was six when the bombs rained on Hammerbrook, a Hamburg working-class district where he lived with his mother, Emma. To escape the flames Emma dragged her boy into the Elbkanal and swam to safety with him clinging to her back. He remembers three men burning "like Heil-Hitler torches," and seeing a factory roof "fly through the sky like a comet." But Biermann also knows that in that same year his father was murdered in Auschwitz. As he puts it in his song "The Ballad of Jan Gat": "I was born in Germany under the yellow star [of David], so we accepted the English bombs as gifts from Heaven."

Later in 1943, in an attempt to "Hamburgerize" Berlin, Air Chief Marshal Sir Arthur Harris, also known as "Bomber" or "Butcher" Harris, decided to unleash the full might of Bomber Command on the capital. My father, a Dutch university student who had refused to sign a loyalty oath to the German occupation authorities, had been deported from Holland and forced to work in a factory in east Berlin. The first wave of RAF bombers arrived over his head on a cold November night. A shallow ditch is all the foreign workers had to protect them. Some were killed during that first raid, when the factory received a direct hit. Nonetheless, the next morning my father and his friends were disappointed that the RAF did not follow up immediately with another huge raid to exploit the general disorder.

As it happens, it took almost two years of daily destruction—the British by night, the Americans by day, and the Soviets firing off their large guns called Stalin Organs—to flatten much of Berlin. "Hamburgerization" (the phrase was Harris's) was a failure, for this largely

nineteenth-century city of sturdy brick buildings and wide boulevards would not burn as easily as older cities with narrow medieval quarters whose wood-beamed houses caught fire instantly. And so the bombing went on and on, leaving my father and millions of others in a state of permanent exhaustion and exposure to the cold and the rats.

Thomas Mann, exiled in Southern California, declared that the Germans were reaping what they had sowed. This, by and large, has been the prevalent attitude in the Allied countries, both during and after World War II. After all, it was the Germans who started the destruction of Europe. German bombers had demolished much of Warsaw, Rotterdam, and Coventry before the RAF unleashed "strategic bombing" on German civilians. Strategic bombing was also known as "area bombing," aiming to destroy whole cities rather than specific targets, or "morale bombing," aiming to break the morale of the civilian population. Already in 1940, three years before Hamburg, Hitler was fantasizing about reducing London to ashes. He told Albert Speer:

> Göring will start fires all over London, fires everywhere, with countless incendiary bombs of an entirely new type....We can destroy London completely. What will their firemen be able to do once it's really burning?[3]

That the Germans had it coming to them is still good enough reason for English soccer fans to taunt German supporters in football stadiums by stretching their arms en masse in imitation of the bombers that laid waste to their country. And until recently most Germans showed no sign of protest. In his now famous lecture in Zurich, later

3. Quoted in *On the Natural History of Destruction*, pp. 103–104.

published in *On the Natural History of Destruction*, W. G. Sebald took German writers to task for ignoring the destruction of Germany as a subject. This literary silence echoed a more general silence. "The quasi-natural reflex," Sebald writes, "engendered by feelings of shame and a wish to defy the victors, was to keep quiet and look the other way." He mentions how in 1946 Stig Dagerman, a Swedish reporter, passed by train through mile after mile of rubble and wilderness that was once a dense part of Hamburg. The train was packed, like all trains in Germany, "but no one looked out of the windows, and he was identified as a foreigner himself *because* he looked out." "Later," says Sebald,

> our vague feelings of shared guilt prevented anyone, including the writers whose task it was to keep the nation's collective memory alive, from being permitted to remind us of such hu-miliating images as the incident in the Altmarkt in Dresden, where 6,865 corpses were burned on pyres in February 1945 by an SS detachment which had gained its experience at Treblinka.

This unarticulated sense of guilt may have played a part, even though the guilty German conscience about the Holocaust only emerged slowly and partially about twenty years after the war. The reason German liberals, scholars as well as artists, have shied away from German victimhood is also political. The bombing of Dresden, for example, has long been a favorite topic of German revanchists and guilt-deniers on the extreme right. A common rhetorical trick in far-right websites and such publications as the *National-Zeitung* is to turn the language used about Nazi crimes against the Allies. Thus, there is talk of the Allied "*Bombenholocaust*," and the annihilation of German civilians, "just because they were Germans." The figure "six million" is bandied about, as though that were the number of

German civilians killed by Allied bombs. "There was also a Holocaust against the Germans," concludes the *National-Zeitung*. "Yet in contrast to the denial of Nazi crimes, the denial of this Holocaust against the Germans is not threatened with punishment." This is not the kind of thing most Germans would wish to be associated with.

And if Dresden, which even Winston Churchill (rather hypocritically) condemned in hindsight, was easily harnessed to a malign cause, this was all the more true of such horrors as the ethnic cleansing of Germans in Silesia and Sudetenland at the end of the war. And so the very idea of Germans as victims acquired, as Sebald puts it, "an aura of the forbidden," but not so much, as he argues, because of guilty "voyeurism" as because of the rancid stink of nasty politics. Extremes, of course, provoke other extremes. To counter neo-Nazi demonstrations against the "Allied Holocaust," the "Anti-fascist Action" group in Berlin gathered in front of the British embassy for a "Thank You England" party, while chanting: "New York, London, or Paris—all love Bomber Harris!"[4]

Perhaps the author and former student leader Peter Schneider was right to contest Sebald's claim by stating that it "was too much to expect [of the postwar generation] that they should break the stubborn silence of the Nazi generation at the same time as they considered the fate of German civilians and refugees."[5] But Sebald was surely right to think that paying such attention was long overdue. It was time to take the subject of German suffering out of the hands of the *National-Zeitung* and its bitter sympathizers.

4. "So muss die Hölle aussehen," p. 42.
5. From *Ein Volk von Opfern?* (A People of Victims?), edited by Lothar Kettenacker (Berlin: Rowohlt, 2003), p. 163.

The silence was broken with a bang with the publication of *The Fire*, by Jörg Friedrich.[6] This exhaustive and harrowing account, city by city, month by month, of Germany's destruction became a best seller in Germany and provoked an endless round of TV discussions, polemics in magazines and newspapers, radio debates, and books, taking one position or another. It was as if Germans, having been mute for so long, needed to talk and talk and talk.

Friedrich is anything but a revanchist or a Holocaust denier. Quite the opposite: he is a bearded member of Peter Schneider's 1968 generation who spent much of his journalistic career exposing crimes of the Third Reich and detecting signs of neo-Nazism in the Federal Republic of Germany. Perhaps he felt that his work on the Nazis was done, and it was now time to look at the other side. In any case, his study of Allied "morale bombing" is every bit as passionate and filled with righteous indignation as his earlier contributions to such works as the *Encyclopedia of the Holocaust*. As a kind of visual companion to *The Fire*, Friedrich has also published *Brandstätten* (Sites of Fire), a book of photographs of ruined cities, burned corpses, and other images of what it was like to be at the receiving end of area bombing.[7]

Friedrich has been accused by some British commentators, who may or may not have actually read *The Fire*, of calling Churchill a war criminal and excusing German war crimes by indicting the Allies. In fact, he neither calls Churchill a war criminal nor excuses German crimes. He mentions, albeit in passing, the fact that the Germans were the first to firebomb great cities, namely Warsaw and Rotterdam. He also observes that Göring's Luftwaffe killed 30,000 British civilians in 1941. And he makes sure the reader knows that "Germany's ruin

6. *The Fire: The Bombing of Germany, 1940–1945* (Columbia University Press, 2006).
7. *Brandstätten: Der Anblick des Bombenkriegs* (Berlin: Propyläen, 2003).

was the result of Hitler." Of course, this leaves the responsibility of other Germans out of the picture. But that is not the subject at hand.

Friedrich does, however, draw a sharp distinction between bombing cities as a tactic to assist military operations on the ground and bombing as a strategic doctrine to win the war through terror and wholesale destruction. The Germans, he claims, always stuck to the former, while the Allies opted for the latter. Whether this distinction is quite as clear as he claims is open to doubt. The Luftwaffe surely aimed at working-class areas of London during the Blitz as a strategy of terror and not just as a battlefield tactic. But the Allies took this doctrine to its limit, culminating in the atom bombings of Hiroshima and Nagasaki in 1945.

Bombing civilians was not in itself a new phenomenon. Friedrich mentions the German Zeppelin raids on Britain in 1915. Five years later Churchill, as air and war minister, decided to put down an uprising in Mesopotamia with bombs. In 1928 Air Marshal Hugh Trenchard, who had taken part in those raids against Arabs and Kurds, proposed that the best way to destroy the enemy in future wars was not to attack his military forces directly but to destroy the factories; the water, fuel, and electricity supplies; and the transportation lines that kept those military forces going. This is what the RAF tried to do in the first half of 1941. But its Wellington bombers had little chance of hitting factories or shipyards. It was hard to spot any target except by day or on bright moonlit nights, and even then it was almost impossible to drop bombs with precision. The price of trying was also very costly. More than half the bomber crews lost their lives. Only one bomb in five landed within a five-mile radius of the target. Indiscriminate bombing of city areas was an easier option.

Already in 1940, when Germany appeared to be invincible, Churchill believed that there was only one sure path to winning the

war and that was "an absolutely devastating, exterminating attack by very heavy bombers from this country upon the Nazi homeland."[8] One reason men of Churchill's generation thought of such desperate measures, apart from their desperate situation, was the traumatic legacy of World War I. The idea of another war of attrition with armies butchering one another for years was intolerable. Better to get it over with fast.

However, the RAF had the wherewithal to attempt this only three years later, by which time the strategy had been fully developed out of a sense of impotence and failure. The main thinker behind it was Air Marshal Charles Portal, who had already had experience of bombing unruly tribesmen in Aden, where he was posted in 1934. Harris, his successor as head of Bomber Command, and another veteran of the bombing in Mesopotamia, was the man who carried it out. What had changed since the idea was first introduced by Trenchard was that war had expanded to all industries, including the workforce itself. Civilians, so it was hoped, would turn against their leaders if they were bombed out of their homes and had no means of survival. Hit them hard enough and their morale would crack. Londoners had already demonstrated that the opposite was true by their show of defiance under German bombing, but Portal dismissed this by claiming that the Germans, unlike the plucky Cockneys, were prone to panic and hysteria.

In fact, of course, the Germans did not turn against their leaders at all. Instead, as my father observed in Berlin, they pulled together pretty much as the Londoners did. It is impossible to know for sure, but there is little evidence that morale bombing, at least in Germany,

8. Quoted in Richard B. Frank, *Downfall: The End of the Imperial Japanese Empire* (Penguin, 1999).

made the war any shorter. Lord Zuckerman, himself a proponent during the war of hitting transportation lines and thus a fierce critic of strategic bombing, has argued that the war might even have ended sooner if his tactic had been adopted.[9] If so, this was certainly not obvious in 1943, when Albert Speer told Hitler that six more bombings on the scale of Hamburg would bring Germany to its knees.

Zuckerman's transportation bombing might sound more humane than Harris's terror, but to judge from Friedrich's account, raids on transportation centers and other forms of tactical bombing were not necessarily less costly in human lives. Railway stations were usually located in the center of cities. The bombing raids on transportation lines in France and Belgium, in preparation for D-Day, killed 12,000 French and Belgian citizens, double the number of Bomber Command's victims in Germany in 1942. Yet all these attacks had a clear military purpose.

It is hard to see, however, what purpose was served by bombing German cities and towns long after much of Germany had already been reduced to rubble. As late as 1945 huge US and British air fleets still went on dropping bombs on destroyed cities, as though they wanted to kill every rat and fly that remained in the ruins. The RAF dropped more than half its bombs during the last nine months of the war. From July 1944 until the end of the war 13,500 civilians were killed every month. And this at a time when the Allied air forces refused to bomb the railway lines to Auschwitz because that was not a military priority. Why? Why did Würzburg, a town of baroque churches and medieval cloisters, a place without any military importance whatsoever, have to be obliterated in seventeen minutes on March 16, 1945, less than one month before the German surrender?

9. "The Doctrine of Destruction," *The New York Review of Books*, March 29, 1990.

And why, for that matter, did Freiburg, or Pforzheim, or Dresden have to go?

Zuckerman believed that "Bomber" Harris liked destruction for its own sake. Possibly that was it. There were also those, in Washington and London, who believed that Germans had to be taught a lesson once and for all. General Frederick Anderson of the US Air Force was convinced that Germany's wholesale destruction would be passed on from father to son, and then on to the grandchildren, which would suffice to stop Germans from ever going to war again. That, too, may have been part of it. No doubt there were feelings of revenge and sheer bloody-mindedness as well.

But a more mundane explanation might be a combination of bureaucratic infighting and inertia. Once a strategy is set in motion, it becomes hard to stop or change. Zuckerman drew attention to the struggles before D-Day between Harris and USAF General Carl Spaatz on one side and, on the other, proponents of transportation bombing, such as Air Chief Marshal Sir Trafford Leigh-Mallory. He wrote:

> Harris and Spaatz soon joined forces in trying to prevent what they regarded as the subjugation of their "strategic" aims to the "tactical" needs of Overlord. Spaatz had an additional worry. The proposed "transportation plan" threatened his independence, and would place him under the command of Leigh-Mallory.

Such petty quarrels have consequences. And Friedrich has surely done us all a service to chronicle just how severe they were.

Something can be true even if it is believed by the wrong people. The fact that Friedrich's book was hailed in some very unpleasant quarters, such as the already mentioned far-right *National-Zeitung*, is not proof that he is wrong. Nor is the fact that Martin Walser, the controversial novelist who believes that the Germans have repented enough, endorsed *The Fire* by comparing it to Homer's description of the Trojan War. In both cases, Walser says, the narrative is above distinctions between killers and victims. This kind of statement should be treated with care. There is still a difference between a state bent on conquering the world—and exterminating a given people on ideological grounds—and a state fighting to stop that. And although most German citizens may have been innocent of atrocities, there is a difference between concentration camp victims and a people that followed a leader bent on mass murder.

Again, Friedrich cannot be accused of nostalgia for the Third Reich or excusing its crimes. But he has done little to distance himself from the wrong supporters either. First of all, he chose the right-wing, mass-market tabloid *Bild-Zeitung* to serialize parts of *The Fire*. It is as though he deliberately aimed his message at the crudest readership—not neo-Nazi, to be sure, but relatively ill-informed, mostly illiberal, and prone to sensationalism. More serious is Friedrich's odd terminology, which comes uncomfortably close to the rhetorical tricks of the *National-Zeitung*. Cellars are described as *Krematorien*, an RAF bomber group as an *Einsatzgruppe*, and the destruction of libraries as *Bücherverbrennung*, or book burning. It is impossible to believe that these words were chosen innocently.

The question is why a former leftist Holocaust researcher and neo-Nazi hunter would do this. There are, of course, examples of people switching from one form of radicalism to another. One of the most odious books written on the alleged amnesia about German suffering is by Klaus Rainer Röhl, an ex-Communist who turned to the far

right.[10] Röhl blames the Americans, Jewish "emigrants," and German '68ers for brainwashing the German people into feeling guilty about the Jewish Holocaust, while denying the destruction of Germans in death marches, terror bombing, and "death camps." Here speaks the fury of a disillusioned radical, swapping a leftist utopia for the sour resentment of the self-pitying right.

Friedrich, however, appears to have fallen prey to a different kind of rage. The last chapter of *The Fire* and his book of photographs provide an indication. *The Fire* ends with a long lament for the destruction of German books kept in libraries and archives. The lament is justified, but its placement at the end of a 592-page book is curious, as though the loss of books, in the end, is even worse than the loss of people—which, from a particular long-term perspective, may actually be true, but that does not make it morally attractive. The choice and especially the editing of the pictures in *Brandstätten* leave a similar impression. There are horrifying pictures of corpses being scooped up in buckets, and other images of frightful human suffering. (The fact that these corpses are being handled by concentration camp inmates is mentioned without further comment.) But the real calamity, as it is presented in Friedrich's book, is the destruction of beautiful old cities, of ancient churches, rococo palaces, baroque town halls, and medieval streets. The first thirty-eight pages of the book are given to photographs of Germany before Bomber Harris did his worst.

It is right to feel sad about the loss of all this historic beauty. For Friedrich this is something akin to losing the German soul. "Those who lose their lives," he writes, "leave the places they created and which created them. The ruined place is the emptiness of the survivors." The Germans, he believes, have been disinherited and lost their

10. *Verbotene Trauer: Ende der deutschen Tabus* (Forbidden Mourning: The End of a German Taboo) (Munich: Universitas, 2002).

"central historical perspective." The last photographs of the book contrast the beauty of old German streets with the ugliness of what came after.

Again perspectives count. Friedrich's anger about feeling disinherited is directed not just at the Anglo-American morale bombers but also at the postwar Germans who refused to recognize the damage. Out of the catastrophic destruction came a zealous need to construct a new, modern postwar Germany, stripped of history, which had been so badly stained by Hitler's legacy. Hans Magnus Enzensberger once observed that one cannot understand "the mysterious energy of the Germans" if one refuses "to realize that they have made a virtue of their deficiencies. Insensibility was the condition of their success."

It is this insensibility that angers Friedrich, this lack of feeling for the "needlessly sacrificed old cities," the collective turning away from German history and culture. Perhaps he puts too high a premium on material rather than human damage. Friedrich might have mentioned that by far the bigger blow to German *Kultur* was the murder and expulsion of many of the best and most intelligent people of an entire generation. The loss to Germany of the cultivated German-Jewish bourgeoisie is impossible to calculate. Wrapped inside Friedrich's highly conservative lament, however, is a leftist rage against Americanization and West German capitalism. This is where the old '68er meets the chronicler of German victimhood. His aim seems to be not only to wrest the history of German suffering from the clutch of the far right but to rescue the glories of German history from the twelve years of Hitler's thousand-year Reich. And this, despite the pitfalls that Friedrich has not always been able to dodge, seems a perfectly respectable thing to do.

6

THERE'S NO PLACE LIKE HEIMAT

EAST BERLIN, OCTOBER 1990: Hans-Jürgen Syberberg, the grand master of cinematic kitsch, walked into the old conference room where the German Communists founded their state. He had just seen part of his film *Hitler—a Film from Germany* for the first time in years. "My God," he said to a gathering of people that included Susan Sontag, the actress Edith Clever, and various East German cultural worthies who smiled a lot and drank vodka. "My God, I was really provocative! If only my enemies had realized.... I am surprised I'm still alive!" Whereupon the artist stroked his beautiful tie, smoothed his superbly coiffed head, and looked around the table like the cat who had just eaten the canary.

Two days later, we met once again in the former government building, now the Academy of Arts, to hear Syberberg, Sontag, Clever, and other members of a distinguished panel discuss his works, in particular the Hitler film and his recently published book of essays, which has caused a big fuss in German literary circles.[1] Syberberg began the proceedings by saying that only here, in the former Communist

1. *Vom Glück und Unglück der Kunst in Deutschland nach dem Letzten Kriege* (Berlin: Matthes & Seitz, 1990).

capital, could he openly express his views, unlike in West Berlin, where the academy was controlled by his left-wing enemies.

Syberberg's delivery was remarkable: an almost silky tone of voice alternating with what can only be described as a theatrical tirade: a tirade against the filth, the shamelessness, the soulless greed, and the vacuous idiocy of contemporary (West) German culture, corrupted by America, by rootless "Jewish leftists," by democracy. Syberberg also believes that the pernicious legacy of Auschwitz has crippled the German identity that was rooted in the German soil, in Wagner's music, in the poetry of Hölderlin and the literature of Kleist, in the folk songs of Thuringia and the noble history of Prussian kings—a *Kultur*, in short, transmitted from generation to generation, through the unbroken bloodlines of the German people, so cruelly divided for forty years as punishment for the Holocaust.

Well, said some of Syberberg's champions on the panel, shifting uneasily in their seats, these opinions may be absurd, even offensive, but he's still a great artist. Then an elderly man got up in the audience. He had seen the Hitler film, he said, his voice trembling with quiet rage, and he thought it was dreadful. He was left with the impression that Syberberg actually liked Hitler. And although he was a Polish Jew who had lost most of his family in the death camps, he could almost be tempted to become a Nazi himself after seeing that film: "All those speeches, all that beautiful music."

Then followed a remark that stayed in my mind, as I tried to make sense of Syberberg and of the literary debates raging in Germany, in the wake of November 1989: "Why is it," the Polish Jew said, "that when a forest burns, German intellectuals spend all their time discussing the deeper meaning of fire, instead of helping to put the damned thing out?"

I thought of Günter Grass, who, with the lugubrious look of a wounded walrus, complained night after night on television that no-

body would listen to him anymore. His constant invocation of "Auschwitz" as a kind of talisman to ward off a reunited Germany had the air of desperation, the desperation of a man who had lost his vision of Eden. His Eden was not the former GDR, to be sure, but at least the GDR carried, for Grass, the promise of a better Germany, a truly socialist Germany, a Germany without greed, Hollywood, and ever-lurking fascism.

I thought of Syberberg, who gloomily predicted that the awesome spectacle of a newly unified German *Volk*, his vision of Eden, would soon be replaced by the rancid democracy of party politics. And I thought of Christa Wolf, who had made a speech in East Berlin exactly a year before. The revolution, she said, had also liberated language. One of the liberated words is "dream": "Let us dream that this is socialism, and let us stay where we are."

Syberberg, Grass, and Wolf: they would seem to have little in common, apart from being earnest German intellectuals who loathe "Hollywood." But they all bring to mind something the wise old utopian Ernst Bloch once wrote:

> If an object [of political belief] appears as an ideal one, then salvation from its demanding and sometimes demandingly enchanted spell is only possible through a catastrophe, but even that does not always come true. Idolatry of love is a misfortune that continues to cast a spell on us even when the object is understood. Sometimes even illusionary political ideals continue to have an effect after an empirical catastrophe, as if they were—genuine.[2]

2. *The Utopian Function of Art and Literature: Selected Essays*, translated by Jack Zipes and Frank Mecklenburg (MIT Press, 1989), p. 128.

In her famous essay on Syberberg's *Hitler—a Film from Germany*, Sontag makes much of the multiplicity of voices and views expressed in his work: "One can find almost anything in Syberberg's passionately voluble film (short of a Marxist analysis or a shred of feminist awareness)."[3] It is not that she ignores those aspects of Syberberg that upset many German critics—the Wagnerian intoxication with deep Germanness, for example—but she sees them as single strands in a rich combination of ideas, images, and reflections. They are not to be dismissed, she thinks, but they also should not be allowed to obscure the genius of his work, which cannot be reduced to certain vulgar opinions, to the quirks one almost expects of a great and eccentric artist.

It is a respectable view, which is, however, not shared by the artist himself. As he made clear in his essays, as well as on stage at the East Berlin Academy of Arts, Syberberg does not separate his political, social, and aesthetic opinions from his art. Indeed, they are at the core of his creative work.

His ideas, expressed in films, theater, and essays, are certainly consistent. In the collage of images and sounds that make up his Hitler film, which, as Sontag rightly observes, is a kind of theater of the mind, there is never any doubt in whose mind the action takes place. It is not Hitler's mind, even though Syberberg salutes the dictator as a demonic colleague, a man who saw his destruction of Europe as an endless, epic newsreel. Hitler, in Syberberg's opinion, was "a genius, who acted as the medium of the *Weltgeist*." But it is Syberberg's mind, not to mention his *Geist*, that has shaped everything in the

3. "Syberberg's Hitler," *Under the Sign of Saturn* (Farrar, Straus and Giroux, 1980).

spectacle; and the fascinating thing is that Syberberg's philosophy, if that is what it is, is articulated most clearly by a ventriloquist's dummy in the shape of Hitler.

This monologue, in which Hitler, as a melancholy puppet, talks about his legacy to the world, comes at the end of the third part of the four-part film:

> Friends, let us praise. Praise the progress of the world from the other world of death. Praise from Adolf Hitler on this world after me.... No one before me has changed the West as thoroughly as we have. We have brought the Russians all the way to the Elbe and we got the Jews their state. And, after a fashion, a new colony for the USA—just ask Hollywood about its export markets. I know the tricks better than any of you, I know what to say and do for the masses. I am the school of the successful democrat. Just look around, they are in a fair way to take over our legacy....
>
> People like me want to change the world. And the Germany of the Third Reich was merely the Faustian prelude in the theater. You are the heirs. Worldwide.
>
> On November 10, 1975, the United Nations resolved by a two-thirds majority, quite openly, that Zionism is a form of racism....
>
> And in the United States? Nothing about gas at Auschwitz on American TV. It would damage the American oil industry and everything having to do with oil. You see, we did win, in bizarre ways. In America....
>
> Long live mediocrity, freedom, and equality for the international average. Among third-class people interested only in the annual profit increase or a higher salary, destroying themselves,

relentlessly, ruthlessly, moving toward their end and what
an end.[4]

It is disturbing to hear condemnations of Zionism, let alone sneers
about "third-class people," through the mouth of Hitler, even if he
is just an effigy, a dummy transmitting Syberberg's voice. But the
message is not new. The rantings about America being the heir to
Hitler's projects would hardly surprise if they came from the pen
of, say, Allen Ginsberg in full flight (Christa Wolf I shall leave
until later). And the offensive trick of defusing German guilt by
equating Hitler with Zionism also has a familiar ring. As for blaming
democracy, Hitler's first victim, for its own demise (as Syberberg
puts it in one of his essays: "Electoral democracy logically leads to
Hitler"), that is a favorite ploy of antidemocrats everywhere. But
Syberberg's disgust with the third-class postwar world goes further
than that; it has turned his misty mind toward a dark and exalted
vision of German *Kultur*, which makes many of his countrymen
squirm.

Syberberg believes in Germany as a *Naturgemeinschaft*, an or-
ganic community whose art grows from the native soil. Art, he
writes, was once "the balsam on the wounds of the 'I,' which was
identical with the native land," whereas now art has lost its meaning,
for the postwar Germans have lost their identity as Germans, have
severed their umbilical cord with the soil that nurtured them. Post-
war German art is "filthy and sick." It is "in praise of cowardice and
treason, of criminals, whores, of hate, ugliness, of lies and crimes

4. The full script was published by Farrar, Straus and Giroux in 1982, entitled *Hitler: A
Film from Germany*, translated by Joachim Neugroschel.

and all that is unnatural."[5] It is, in other words, rootless and degenerate. German art can only be elevated from this stinking swamp by dedicating itself once again to beauty, the beauty of nature and the *Volk*. Like many attempts to make a cult of beauty, Syberberg's art often plummets from its exalted heights into kitsch: Wagner booming away on the soundtrack as a tearful Viennese aesthete reads Syberberg's poetic vision of impending doom.

A German journalist once did the obvious thing: he showed Syberberg a tract on degenerate art written in the 1930s by the Nazi propagandist Alfred Rosenberg and compared it to Syberberg's words. Syberberg admitted there were similarities, but argued that just because Rosenberg said the same thing, this didn't mean it was wrong. Thank God, he said, he hadn't thought of Rosenberg, for then he might not have stated his honest opinion, for such is the terrible taboo left by the Nazi past on German aesthetic traditions.

But who has imposed this taboo? And why has German art and society "degenerated" to such a low point? In Syberberg's new book of essays we get to the nub of the matter:

> The Jewish interpretation of the world followed upon the Christian, just as the Christian one followed Roman and Greek culture. So now Jewish analyses, images, definitions of art, science, sociology, literature, politics, the information media, dominate. Marx and Freud are the pillars that mark the road from East to West. Neither are imaginable without Jewishness. Their systems are defined by it. The axis USA-Israel guarantees the parameters. That is the way people think now, the way they

5. These quotations are from *Vom Glück und Unglück der Kunst in Deutschland nach dem Letzten Kriege*.

feel, act and disseminate information. We live in the Jewish epoch of European cultural history. And we can only wait, at the pinnacle of our technological power, for our last judgment at the edge of the apocalypse.... So that's the way it looks, for all of us, suffocating in unprecedented technological prosperity, without spirit, without meaning.

The indictment continues in Syberberg's strange, ungrammatical, baroque style: "Those who want to have good careers go along with Jews and leftists," and "the race of superior men [*Rasse der Herren-menschen*] has been seduced, the land of poets and thinkers has become the fat booty of corruption, of business, of lazy comfort." Over and over, the message is banged home: the real winners of the last war are the Jews, who have regained their motherland, their ancient *Heimat*, the very thing the Germans have lost. And the Jews had their revenge for Auschwitz by dropping the atom bomb and atomizing the *Kultur* of Europe through their barren, rationalist, rootless philosophy.

The old man who stood up in the East Berlin Academy was wrong, of course: Syberberg does not like Hitler. Like Ernst Jünger, an author he often quotes, he sees Hitler as a megalomaniac, who vulgarized and distorted ideals that should have been kept pure, beautiful, in the custodianship either of rough and simple peasants, the purest representatives of the old *Volk*, or of aristocratic *Feingeister*, such as Jünger and Syberberg, the true heirs of Hölderlin, Kleist, and Wagner. Hitler's greatest crime was not to kill six million Jews—an act of which Syberberg does not approve—but to destroy the *Herrenvolk*, or rather, the culture of the *Herrenvolk*, by tainting it with his name, by making, as Syberberg often puts it, Blood and Soil a taboo.

Syberberg is not so much a crypto- or neo-Nazi as a reactionary dandy, of the type found before the war in the Action Française or in

certain British aristocratic circles. Like T.S. Eliot, Ernst Jünger, Charles Maurras, and Curzio Malaparte, he is a self-appointed savior of European *Kultur* from the corrupt forces of alien, often Semitic barbarism. And culture, in his mind, is associated with an ideal community, always in the past, before the expulsion from Eden, a *Gemeinschaft*, where the *Volk* was united, rooted, organic, hierarchic. "German unity, Silesia, beauty, feeling, enthusiasm. Perhaps we should rethink Hitler. Perhaps we should rethink ourselves."

As the examples of Malaparte and even Jünger show, this is not a matter of being left or right: it can be both. It is certainly antidemocratic, for the institutionalized conflict of interests, without which democracy cannot exist, is deeply offensive to those who dream of organic communities. In Syberberg's case, his politics are in fact as Green as they are tinged with Brown. He worships nature in a way that only a man who holds people, as opposed to the People, in contempt can. His ideal view of the *Naturgemeinschaft Deutschland* comprises "plants, animals, and people," in that order.

Yet for this most dandified of aesthetes, it is not so much nature itself as the idea of nature that appeals, the antiurban ideal of a natural order. His work in theater and cinema is anything but natural, or organic, or raw, but, on the contrary, highly artificial. If Syberberg had a sense of humor his art would be camp. When Edith Clever ends her monologue in the recent Berlin stage production of Kleist's *The Marquise of O* (directed by Syberberg), she turns around, and in a gesture that is supposed to denote deep melancholy, stretches her arm and releases a dead oak leaf, which flutters slowly, like an arid butterfly, to the ground. She just, but only just, gets away with it because she is a great actress. In lesser hands this moment of supreme "beauty" would be more like something out of Charles Ludlam's Theater of the Ridiculous.

It is not for his aesthetics, however, that Syberberg has been

attacked but for his politics. The strongest criticism of his book was published in *Der Spiegel*, the liberal weekly magazine.[6] Syberberg's views, wrote the critic, were precisely those that led to the book burning in 1933 and prepared the way for the Final Solution of 1942. In fact, he went on, they are worse, for "now we know that they are caked with blood....They are not just abstruse nonsense, they are criminal." The *Spiegel* critic compared Syberberg to the young Hitler, the failed art student in Vienna, who rationalized his failure by blaming it on a conspiracy of left-wing Jews. Syberberg feels he is an unappreciated genius, and he too blames it on the same forces.

Frank Schirrmacher, the young literary editor of the *Frankfurter Allgemeine Zeitung*, and the scourge of woolly thinkers of all political persuasions, is equally opposed to Syberberg and draws similar parallels with the 1920s and 1930s. And like the critic in *Der Spiegel*, he singles out for special censure an interview with *Die Zeit* in which Syberberg claimed that he "could understand" the feeling of the SS man on the railway ramp of Auschwitz, who, in Himmler's words, "made himself hard" for the sake of fulfilling his mission to the end. He did not admire this feeling, but he could understand it. Just as he could understand its opposite, the rejection of principles to act humanely.

No doubt Syberberg, who genuinely does not regard himself as a Nazi sympathizer, sees such attacks as further proof of his claim that a taboo is blocking an honest appraisal of German history. As soon as one talks about anything that smacks of mystical ties with the German soil, or anything that suggests identification with certain aspects or people of the Nazi period, out pops the Nazi bogeyman, and one is immediately called a fascist or a Nazi. There are, of course, some good reasons for this.

6. The review was by Hellmuth Karasek.

Nonetheless, Syberberg, despite his self-aggrandizing paranoia as a persecuted genius, has a point. It is true that it is difficult to be an admirer of German Romanticism these days without being reminded of its perversions. To talk seriously about the ties of Blood and Soil in Germany is impossible without thinking of the consequences of such ideas in the past. It is also true, however, that antifascism has become reified, to use the phrase invented by the great Jewish leftist himself, Karl Marx. It was not something you could argue about. Antifascism was the state religion and historical alibi of the ancien régime in the eastern half of Germany, and it gave the leftist intellectuals of the Federal Republic a kind of moral stick with which to beat off all challenges from the right.

One can easily understand why antifascism should have become an obsessive concern of the liberal German intelligentsia, and why the more prominent "antifa" spokesmen have cloaked themselves in the moral mantles of a higher priesthood. It has to do with collective guilt, with the fact that many collaborators with Nazism continued to occupy important positions in the West German judiciary, in business, even at the universities. It is also because until the 1960s Nazism was a guilty national secret in the Federal Republic, something one didn't discuss in polite circles. Those who did were often precisely the people Syberberg accused of robbing the Germans of their precious identity: returned refugees from Hitler, such as Theodor Adorno and Ernst Bloch.

A reaction was bound to come and it emerged in the 1980s, when historical revisionism and neoconservatism became popular everywhere, from Chicago to Frankfurt to Tokyo. Some of the reaction, not only in Germany, came in the form of a neoromantic critique of rationalism and liberalism. Syberberg's publisher, Matthes & Seitz, played a part in this. One of its authors, Gerd Börgfleth, launched an attack on "the cynical Enlightenment." Like Syberberg he blamed

the "returned Jewish left-wing intelligentsia" for "wishing to remodel Germany according to their own cosmopolitan standards. In this they have succeeded so well that for two decades there has been no independent German spirit at all."[7]

At the same time in *The Salisbury Review* several British writers began to celebrate a mystical reverence for the English spirit, and historians cast doubt on left-liberal interpretations of recent history. As anti-anticommunism went out of fashion, anti-antifascism gained respectability. But it was one thing for, say, Roger Scruton to celebrate the spirit of England; it was quite another for Germans and Japanese to behave in a similar way; they could not respectably get around the war. Anti-Semitism, an old tradition in European nationalism everywhere, cannot possibly be separated from German *Blut und Boden*. Hence the acrimonious tone of the "Historians' Debate" in Germany, hence the bitter controversy around Syberberg. And hence the strong emotions unleashed by the chauvinistic aspects of the 1989 revolt and the process of unification that followed.

Earlier this year a radical right-wing journal published a tract by Börgfleth entitled "Deutsches Manifest." Like Syberberg's essays, it was inspired by the 1989 revolt in East Germany:

> The people's movement in the GDR was the *real* Germany, which the West Germans have betrayed—betrayed to a capitalist-liberal economic epidemic, which devoured the body of the *Volk*, betrayed to the cult of technology, which is destroying the land, and to cosmopolitan lies, which are intended to complete the destruction of the German national character.[8]

7. *Konkret*, October 10, 1990.
8. *Konkret*, October 10, 1990.

This is more or less identical to Syberberg's view, but what is more remarkable is its similarity to some of the opinions held by such "antifa" prophets of the left as Günter Grass or the East German playwright Heiner Müller. They, too, have a horrific vision of the destruction of the *Volk* by D-Marks and technology. They also believe that the People have been betrayed by the West. It is indeed an old conceit of both right-wing and left-wing Romantics to believe that the soul of the people was preserved in a purer and more innocent state under the old Communist regime. Which brings me to Christa Wolf.

Like Grass and Syberberg, Christa Wolf grew up in a part of the old Reich that is now Poland. Like them, she lost her *Heimat* and has been haunted by that loss ever since. She was born in Landsberg, now Gorzow, in 1929, in time to be a member of the BDM, the girls' equivalent of the Hitler Youth. In her most interesting book, *Patterns of Childhood*,[9] she tries to deal with her sense of guilt about having been a participant, albeit a rather passive and innocent one, in the Nazi state:

> Don't ask your contemporaries certain questions. Because it is unbearable to think the tiny word "I" in connection with the word "Auschwitz." "I" in the past conditional: I would have. I might have. I could have. Done it. Obeyed orders.

The "I," as in many of her novels, has a slippery identity. *Patterns of Childhood* is written in the form of an interior monologue inspired

9. Translated by Ursule Molinaro and Hedwig Rappolt (Farrar, Straus and Giroux, 1984).

by a short visit to her native town. The adult narrator is referred to as "you": "Don't ask your contemporaries." The narrator's childhood self, the one that took part in rallies cheering on the Nazis, is called Nelly. It is not entirely clear when Nelly becomes "I," but it is presumably around the time that she rejects her Nazi childhood and embraces its ostensible opposite, the Communist state.

A major component of Wolf's ambivalent sense of guilt is the idea of being a passive observer, a reporter, a writer, while others suffer. The only way to overcome this problem is to take an active part in building a better world, to help create, however flawed in its execution, an ideal community, a political utopia. As she put it in an interview given in 1979: "For me, only writing can still offer us a chance of bringing in the utopian dimension."[10] And her idea of utopia is linked to the two most traumatic experiences of her life: her complicity in and subsequent repudiation of Nazism, and her expulsion from her *Heimat*:

January 29, 1945: a girl, Nelly, stuffed and stiff in double and triple layers of clothes (stuffed with history, if these words mean anything), is dragged up on the truck, in order to leave her "childhood abode," so deeply anchored in German poetry and the German soul.

To have admitted complicity in the Nazi movement (Wolf never passes herself, or more accurately her literary persona, off as a resister; on the contrary, she was a true, if very youthful, believer) was in fact an unorthodox thing to have done as a writer in the GDR. The correct party line was that Communists had been Hitler's main vic-

10. The quotations from Wolf's interviews are all from *The Fourth Dimension: Interviews with Christa Wolf*, translated by Hilary Pilkington (Verso, 1989).

tims, and resisters to the last man, woman, and child. And since the GDR was a socialist state, run by the former victims and resisters, it was the better half of Germany, the antifascist Germany, where collective guilt could not be an issue. The Nazis lived in the West. The East German, as Peter Schneider put it in a recent essay, was "the German with the good conscience." So for the country's most prominent novelist to say quite openly that she had believed in Nazism, or worse, that nobody in her hometown had resisted it, was not what her comrades, who ran the show, wished to hear.

As could be expected, she was attacked by Marxist critics in her own country for being "subjective," for breaking away from class analysis. But for the same reason she was hailed by many in the Western world as a brave dissident. She had her share of problems with the GDR censors, and her work was widely published in the West. But she was not a dissident, for however subjective and ambivalent her writing may be, she never doubted the moral superiority of the Communist state. This is made quite clear in *Patterns of Childhood*, where the echoes of the Nazi state are never to be heard in the GDR, or the Soviet Union, but in Chile and the US. To quote just one aside:

> No mention ever [by the Nazis] of the uprising of the Jews in the Warsaw ghetto, which must have been at its height at the time Nelly was kneeling at her Christian altar. (And what if the blacks in their ghettos rise up someday, you ask a white American. He says regretfully: They haven't got a chance. Because of the very fact that they're black. They're sitting ducks. Every single one of them would be gunned down.)

This kind of remark was appreciated in New York and Berkeley, as well as in the *Volkskammer* of Berlin, capital of the GDR. Which

partly explains Wolf's huge success in East and West. She played to many galleries at once. I am not suggesting she did this cynically, as a smart career move. There is no evidence that she was disingenuous about this. She honestly believed that America was rotten, and that the Nazi legacy was a Western, capitalist problem. As she said in an interview in 1975 (these dates are important): "The 'better history' is on our side, the others are unlucky, they have the old Nazis." Or: "I do think it would be impossible for it to happen again here. As we can see, the world as a whole is incredibly threatened by fascist and fascistic tendencies. The reasons why it cannot happen here, though, are, I think, first and foremost historical. I don't want to set myself up as some kind of prophet, but the necessary conditions do not exist here."

The dates of these quotations are important, because Wolf now says that she realized as early as 1968 that, as she put it in an interview given this year on British television, the government of the GDR was creating something fundamentally different from what she had hoped for. The word "fundamentally" is a surprise. She was a candidate for the Communist Party's Central Committee from 1963 until 1967, and she only resigned from the Party in 1989. It is true, however, that she was always critical of the stupidity and stuffiness of bureaucrats and pedagogues in the GDR, and their absurd penchant for parades, flags, community singing, in short, of the general conformity demanded in the name of the socialist ideal:

The fact that authors identify with the basic principles of this society does not temper, but in fact brings out more sharply, the conflicts that have been caused by certain distortions in the GDR, and these have indeed provoked fundamental debate within our literature.

Christa T., Wolf's most famous literary character, is an individualist who cannot cope with the pressures to conform. And Wolf's account, in *No Place on Earth*,[11] of an imaginary meeting between Heinrich von Kleist and the Romantic poet Karoline von Günderrode is about the difficulty of reconciling the desire for spiritual freedom with the demands of a highly structured society. Christa T. dies young, of a fatal illness. Kleist and von Günderrode both commit suicide. Naturally, this sense of things never sat well with the gray and frightened men who ruled the GDR, for they wanted upbeat heroes who could serve as models to the People. And just as naturally, it provided great comfort to many readers in the GDR, who struggled with precisely such predicaments.

But this did not make Wolf a dissident. One of her main subjects was how to compromise for the sake of a higher ideal. As a young woman put it to me recently in East Berlin: "Living here was like being a Catholic; it wasn't a matter of staying Catholic or not, but how you managed your relations with the Church—a question, really, of personal morality."

Wolf's struggles with her personal morality struck a tremendous chord with a people force-fed with propagandistic pap. Yet she never wavered in her political commitment. This made her the ideal writer for a Communist regime, for she made it easier for people to live in a quasi-totalitarian state. Indeed, she made the personal sacrifices, the spiritual hardship seem virtuous. And this made those who chose to move to the capitalist West appear weak, even cowardly. Her first novel, *A Divided Heaven*, is about a man who decides to go west, leaving behind his fiancée, who wants to stick to the task of building a better Germany. There is no doubt which character we are supposed

11. Translated by Jan van Heurck (Farrar, Straus, and Giroux, 1982).

to admire. Wolf made the point again in many speeches, some delivered as late as November 1989.

Even state censorship, in her view, was not something to get overly upset about, for it, too, was spiritually bracing. After all, she said in 1975, "Goethe couldn't have his *Tasso* performed for decades. But did he sulk?" Of course not. It is easy to give up, but "much more difficult to remain productive and just." Not revolt, but a stiff upper lip; that was Wolf's prescription for the long-suffering citizens of the GDR. Nietzsche is supposed to have said that "dancing in chains is the highest art." And now that the chains have been severed? Hans Joachim Schädlich, a novelist who was forced to leave the GDR in 1977, put it this way: "They never liked the great authoritarian father, but now that he's gone, they don't know how to live without him."

Wolf, like all her colleagues in the GDR, had developed a fine antenna for censorial sensitivities and knew pretty much how far she could push her luck. But the East Germans had an advantage over writers in other Communist countries in that they could have their work published in West Germany. Some of Wolf's novels, *Cassandra* for example, actually appeared in two versions: a censored one in the East and an unexpurgated one in the West.[12]

The not uncommon belief that censorship fosters creativity is nonsense. But masterpieces have been produced in very difficult circumstances. Dancing in chains is not an absolute impossibility. Wolf is an interesting, if humorless, writer, whose books may not merit the Nobel Prize, which she was close to getting, but then nor do those of many authors so honored. She has expressed the inner life of an idealist, who was neither a conformist nor a dissident. The quest for her

12. *Cassandra: A Novel and Four Plays*, translated by Jan van Heurck (Farrar, Straus and Giroux, 1984).

own identity is her main subject. In *The Quest for Christa T.*[13] and *Patterns of Childhood* she turned autobiography into a fictional art. And in *No Place on Earth* and *Cassandra* she deftly removes the borders between the essay and fiction. *Cassandra* is a feminist reinterpretation of the Greek tragedy. Wolf identifies so closely with her heroine that Cassandra often sounds more like the author than the prophet of Troy. Although all these books are stylistically inventive, her best, in my view, is *Patterns of Childhood*.

This has much to do with the period in which the novel is set. For it is a story of disillusion with a faith once firmly held. She catches the duplicity of the Nazi state in all its ghastly nuances, because she can recognize it exactly for what it was. And she can do this without losing a certain human sympathy for the people who shared her beliefs.

Her novels set in the GDR are different. Instead of disenchantment, there is an almost perverse will to believe, to hold on to the faith, to catch that glimmer of utopia. This matters less in an allegorical story, such as *No Place on Earth*. And even in her contemporary novels she never describes the GDR as a workers' paradise. What animates all her novels is not her belief that the contemporary Communist state is wonderful but her tenacious wish to believe that one day it will be. So whereas *Patterns of Childhood* is a novel of disenchantment, her subsequent books are those of a believer, who realizes at the same time that reality falls far short of her ideal.

It might be argued that just as the Roman Church gives Graham Greene's work a piquancy it might not otherwise have had, Wolf's art derives its strength from her faith in communism. In fact, however, I think neither writer has benefited from getting religion. There is something perverse, even willfully blind about both of them. Wolf's oblique criticism of the Communist state is superficial and whatever

13. Translated by Christopher Middleton (Farrar, Straus and Giroux, 1979).

piquancy it may contain, this hardly compensates for her tiresome preaching about the evils of bourgeois politics, America, capitalism, and so forth. But whereas Greene is also a cynical Englishman, aware of his own perversity, Wolf has allowed faith to cloud her vision of reality.

This may explain her latest novel, *Was bleibt*, written in 1979, "reworked" in 1989, and published this year.[14] It is a slight work, little more than a novella, really, about a writer's horror at finding out one morning that she is being watched by two young men posted outside her door. They are clearly Stasi agents, even though that notorious institution is never mentioned in the text. Considering what else the Stasi was up to—torturing people, for example—watching a famous, well-connected writer's window may seem a minor affair. But not to Wolf (for the narrator is obviously she); it brings her usual soul-searching ambivalence to a crisis point: "I was possessed by a raging pain, which had settled itself inside me and made me a different person." She is panic-stricken by the ghastly Kafkaesque atmosphere of her city, where everybody speaks conspiratorially or with a forked tongue, where old friends suddenly shun you in the street— why? Is it me? Is it them? Is it just in the imagination?

The crisis comes to a head:

I, myself, I could not get over those two words. Who was I? Which part of the multiple being, from which I constructed myself? That part which wished to know? Or that which wished to be spared? Or was it that third self, which still wanted to dance to the same tune as those men, outside my door?...That's what I needed: to be able to believe that one day I could get rid

14. Munich: Luchterhand, 1990; *What Remains and Other Stories*, translated by Heike Schwarzbauer and Rick Takvorian (Farrar, Straus and Giroux, 1993).

of that third self; to believe that that was what I really wanted; and that, in the long run, I'd rather suffer those men outside than that third self in me.

Then the climactic scene: the writer is invited to give a lecture. She notes a distinct nervousness in the cultural worthies who have organized the evening, but she doesn't grasp what it is until much later, when she discovers that she has been talking, honestly, she believes, or at any rate as honestly as she could, under the circumstances, to a select audience of officially trusted people. Her other audience, the young people who found solace in her books, were not allowed in; they were beaten up by the police. Order had to be maintained in the better Germany.

As Wolf describes the incident, in her anxious inner voice, we suddenly see Nelly emerge again, the innocent girl who joined the Hitler Youth organization. She knew, yet she didn't know. She was an accomplice, yet she was innocent. She was innocent, but…well, perhaps, "I would have. I might have. I could have. Done it. Obeyed orders."

This time, however, she couldn't get away with it. She was not a young girl but a middle-aged writer, blessed with many privileges. This time, she wasn't able to duck responsibility for a state she had supported. Analyzing her private fears, in that solipsistic way that has become her inimitable style, as though those fears were more important than their actual cause, was too much like discussing the meaning of fire while the forest burned. And so the book was violently attacked as soon as it appeared last spring.

For one thing, as many critics pointed out, the book simply came too late. If she had published it ten, or five, or even two years earlier, it would have caused a sensation. She would have been acknowledging the reality of a system whose terrors and failures were still being

glossed over by many in the West. But to have done so now that the Stasi, the Wall, and all the other tawdry tools of oppression had been broken made her look opportunistic, self-pitying, and ridiculous. It was, as Ulrich Greiner wrote in *Die Zeit*, "as embarrassing as her resignation from the Party at a time when there was no more risk in doing so." To bring out the book now, he went on, "didn't betray a lack of courage, since there were no more dangers, but of sincerity toward herself, and her own history, a lack of sensitivity toward those whose lives have been destroyed by the Communist state."

Embarrassing and insensitive, certainly; dishonest, perhaps. But can Wolf be accused of being a "collaborator," a *Mitläufer*, as they say in German? Was she simply a vulgar careerist, after all? Should she have spoken out more forcefully against the GDR regime? Does the fact that she did not discredit her as a writer? Does it detract from her work? These questions are being asked, sometimes by people who didn't have to face the dilemmas of a Communist state. To demand courage in another person is always a tricky business when one is not exposed to the same dangers oneself. There is an element of hypocrisy involved here too, since many Western intellectuals applauded writers like Wolf, as well as the leftist, anti-American causes she stood for. If she is to be crucified for her opinions, so should many much more comfortably placed people in the West. And if it's a matter of feeling betrayed by a writer who was thought to have been a dissident, she certainly never pretended to be one.

And yet, the positions of writers in quasi-totalitarian states must be taken into account in an assessment of their work. Hermann Broch once remarked that "truthfulness is the only criterion for autonomous art." But could art produced in a state like the GDR ever be called autonomous? The officially sanctioned writers were, in the words of Günter Kunert, a novelist who went west, supposed to be ideological mediators between the powers that be and the people.

Some conformed more to this model, others less. At what point is the work of an artist fatally compromised by the political pressures he or she cannot or will not resist? Kunert was privileged, like Wolf. But "he couldn't stand it anymore to walk around happy and free in the midst of prisoners. The privilege to be able to travel became an oppressive burden. And one was always aware that this privilege depended to a great extent on one's good behavior."[15] Good behavior, naturally, extended to what appeared in print.

Since much of the present debate in Germany about writing in the former GDR is between those who stayed and those who left, there are echoes of the late 1940s. A similar battle took place then between the exiles, many of whom returned to the socialist half of Germany, and the writers who had made their pact with Hitler. The most famous exile was Thomas Mann. This was his assessment of the years of his absence:

> In my eyes, the books that could be published at all in Germany between 1933 and 1945 are less than worthless. I hardly wish to touch them. They reek of blood and shame. It was not allowed, indeed it was impossible to create "culture" in Germany, while we knew what was going on all around us. What was done instead was to gloss over decay and decorate the hideous crime. One of the agonies we suffered was to watch how the German spirit and German art were being used as the shield of something absolutely monstrous.[16]

The GDR was not the Third Reich, nor was everything published there until 1990 worthless. But *Kultur*, including the German spirit

15. *Frankfurter Allgemeine Zeitung*, June 30, 1990.
16. *Thomas Mann: Briefe II, 1937–1947* (Frankfurt: Fischer Taschenbuchverlag, 1979).

alluded to by Mann, was pressed into service by the state to further its political ends. And just as the writers who stayed in Nazi Germany sneered at the "unpatriotic" exiles, those who stuck with the Communist state, such as Stefan Heym, still express contempt for those who left. The point of finding out why writers like Heym and Wolf allowed themselves to be compromised by a corrupt and oppressive regime, all in the name of a distant ideal, is not to morally condemn them, or to suggest that their work can be reduced to a mere exercise in propaganda. Wolf's books are certainly better than that. But without questioning their politics, it is impossible to understand the nature of their art. For in the melancholy context of modern history, especially in Germany, art and politics cannot be cleanly separated without doing damage to the very thing Wolf considers the central theme of her work: our memory.

It is interesting that both Syberberg and Wolf share a fascination for Kleist and the German Romantics. Could it be that in their respective quests for utopia—in Syberberg's case a kind of kitsch, de-Nazified vision of Blood and Soil, in Wolf's an ideal socialist state without Stalin—that they have something deeper in common than a loathing for America and messy liberal democracy? Do they miss, perhaps, the heady sense of idealism of their youth, which they have tried to recreate, in their different ways, ever since? This makes them rather anomalous in a nation that is distinctly lacking in idealistic fervor these days, but it is precisely why Wolf still admonished the masses to "dream" and why Syberberg uses every opportunity to vent his misanthropic disgust with the modern world and the people who live in it. They are intellectuals forever in search of the ideal community.

In an interview given in 1982, Wolf says something very self-revealing about the German Romantics of the nineteenth century: "They perceived with some sensitivity that they were outsiders, that they were not needed in a society which was in the process of becoming industrial society, of intensifying the division of labour, of turning people into appendages of machines."

This is the common enemy of many intellectuals, in East and West, of left and right: the industrial society of machines, contracts, of contending political parties, where the imagination is not in power, where intellectuals and artists are outsiders, tolerated, often well paid, even lionized, but nonetheless on their own. Nazism and socialism promised solidarity, a family state, unity of the *Volk*. There was a role to play for idealists; they could be prophets of the new order. Wolf was a prophet in the GDR, the antifascist *Heimat* that was in so many ways the mirror image of her first, Nazified home: "We were living as socialists in the GDR because we wanted to be involved in that country, make our contribution there. When individuals are thrown back on literature alone, they are plunged into crisis, an existential crisis."

It is this crisis that leads to the kind of fear displayed by Syberberg, and even Grass, the fear of being ignored, of preaching to deaf ears, of losing the prophet's mantle. The *Heimat* is also a childish fantasy, a fantasy of order, security, and power, the ideal conditions of infancy. Syberberg lost his *Heimat* twice; he was expelled from Pomerania at the end of the war and left the GDR in 1953. And he has been pining for the *Volk* ever since, for the banners of solidarity, the smell of the native soil, the sacred poetry of the German bards, the ruined castles of the ancient kings, and so on. Because this ideal community is an imaginary one, he must invent it through the fairy tales of his childhood: Hitler's speeches, Karl May's adventure stories, and

echoes from Bayreuth. Which may be why his film sets look like gigantic toy stores, with Syberberg, as a monstrous child, rummaging through the props of his imagination.

Wolf, whose fantasy was never as baroque as Syberberg's, invented her imaginary community in the Communist state. Her communism, as is so often true, was always reactionary, the road back to something that was lost, long ago. Something she would never forget, just as Cassandra couldn't forget Troy:

> All this, the Troy of my childhood, no longer exists except inside my head. I will rebuild it there while I still have time, I will not forget a single stone, a single incidence of light. It shall be kept faithfully inside me, however short the time may be. Now I have learned to see what is not, how hard the lesson was.

7

THE AFTERLIFE OF ANNE FRANK

ANNE FRANK WAS an ambitious young woman, and most of her wishes came true. She wanted to be a famous writer and "to go on living even after my death!"[1] Few writers are as famous as she. *The Diary of Anne Frank* continues to be read by millions of people in dozens of languages. The movie version was a global success. The "award-winning" play, based on the diary, was a smash hit on Broadway, as well as pretty much everywhere else, and its current revival is playing to full houses.[2] As is usually the case with fame of this scale, the quality of the original work does not fully explain the legendary status of its author.

Anne Frank has become more than a writer, and more than a victim of the Holocaust whose eloquent voice happens to have reached us across the stinking pits of Bergen-Belsen. She has become an almost sacred figure, a Jewish Saint Ursula, a Dutch Joan of Arc, a female Christ. I grope for Christian examples, since Jews don't canonize their martyrs as saints. Nor do Jewish saints offer universal

1. *The Diary of Anne Frank: The Critical Edition*, edited by David Barnouw and Gerrold van der Stroom (Doubleday, 1989), p. 587.
2. Frances Goodrich and Albert Hackett, *The Diary of Anne Frank*, adapted by Wendy Kesselman, directed by James Lapine, at the Music Box Theater, New York City, 1997.

redemption. Anne's most famous words—"In spite of everything, I still believe that people are really good at heart"—have been notoriously wrenched out of context to promise just that. And gratefully they were received, too, especially in Germany.

Anne's death, premature and brutal, also lent itself easily to a common thirst, not just for absolution but for a kind of sentimental aestheticism. Her smile has become as famous as Mona Lisa's. It pops up everywhere, from Santa Barbara, where it was recently on display to promote "tolerance," to the English city of York, where the smile was projected onto a medieval tower where Jews were massacred during the twelfth century. Anne's diary has been set to music. There are cartoon versions, one of them Japanese. Anne has been a character in at least one famous novel. About the only thing we haven't seen so far is Anne Frank on Ice.

A beautiful and talented girl dying so young was always destined, in the minds of many, to live on forever. She had wished it, but I doubt that the result was quite what she had in mind. Many letters arrive every day at the Anne Frank Foundation, located a few steps away from the "secret annexe," at Prinsengracht 263, in Amsterdam. They come from all over the world. Some are from people who think they have "seen" Anne somewhere, in Argentina, or Belgium, or Japan. Many more come from people who think they *are* Anne Frank.

The curse of fame is that it attracts cranks, mostly harmless, sometimes not. Cranks latch on to redeemers. And not just cranks. The actor who played Anne's father in the original Broadway production said the play gave him a "sacred feeling." He wasn't the only one. But Anne's diary, sold as a message of universal redemption, was actually something much better than that. For she was too intelligent to have written a simple message, redemptive or otherwise. What lifts the diary above the level of a mere witness account is the author's capacity to grapple with problems to which there are no easy

answers. These include the problems of sexuality, growing up, and relations between parents and children, but also of being Jewish, of national belonging, religious faith, fate and personal freedom, the meaning of life, and of being denied the right to live.

Since it contains so much, readers get different things from the diary, just as they would from any complex work. Adolescent girls identify with Anne's adolescence. People who want their hearts warmed by a story about a humorous girl rising above terrible circumstances will be satisfied. Jews probing for meaning in collective suffering will find it inspiring as well. Anne is a ready-made icon for those who have turned the Holocaust into a kind of secular religion. It was Anne, after all, who said that "if we bear all this suffering, and if there are still Jews left, when it is over, then Jews, instead of being doomed, will be held up as an example." Yet at other times, Anne said she wanted people to "overlook Jew or non-Jew, and just see the young girl in me." She believed in God, but cared little for the ritual forms of Jewish faith. She said Jews "can never become just Netherlanders or just English or any nation for that matter," but she also said that her "first wish after the war is that I may become Dutch!"

About the hard questions in life, then, Anne felt ambivalent. That was a mark of her intelligence. But since the question of what it is to be a Jew happens to be a most contentious one, her ambivalence on that score has caused great bitterness among Jews who seek Anne's spiritual patronage. Reading about Meyer Levin's feuds with Anne's father, Otto Frank, over the right to produce different versions of the diary on stage, you get the feeling that the vexed question about Jewish "identity" is being fought over Anne's soul.

Everyone wants his own Anne: Otto Frank wanted his daughter to teach a universal lesson of tolerance; and Meyer Levin wanted her to teach Jews how to be good Jews. Both have their defenders. Barbara Epstein, who coedited *The New York Review of Books*, was the first

American editor of the diary, and close to Otto. The two books by Lawrence Graver and Ralph Melnick offer different views: Graver is neutral, but Melnick is one of Levin's chief advocates.[3] Now that the play is being revived on Broadway, in Wendy Kesselman's rewritten version, Levin's defenders, including, most stridently, Cynthia Ozick, seem to be winning the day. In an age of "identity politics," where universalism has acquired a bad odor, this is hardly surprising.

Ozick, following Levin, accuses Otto of falsifying his daughter's diary, and blames it on his "deracinated temperament."[4] Accusing Jews of rootlessness is an old anti-Semitic ploy. I suppose what Ozick means by this repellent phrase is that Otto's "temperament" should have been more Jewish. I am not sure what a Jewish "temperament" is, but Otto's roots were German, and it was the Nazis who cut them off.

Otto Frank was born in Frankfurt-am-Main, in a family of cultivated, liberal German Jews, the kind of people who listened to Beethoven and Brahms, read Goethe and Schiller, attended the Gymnasium, and felt patriotic about Germany. During World War I, Otto was made a lieutenant in the German army. He was not a religious man. If that means he was "deracinated," then so be it. But there is no reason to believe he was ashamed of his Jewish ancestry. He claimed never to have experienced anti-Semitism before the Nazis, even in the army, which may be true. His privileged background, shared by many other Jews in France or Hungary or Holland, meant that being persecuted in his own country as a member of an "inferior race" was a particularly sickening blow. A detail about his arrest by the Nazi police in 1944 shows the complexity of his position. When

3. Graver, *An Obsession with Anne Frank: Meyer Levin and the Diary* (University of California Press, 1997); Melnick, *The Stolen Legacy of Anne Frank: Meyer Levin, Lillian Hellman, and the Staging of the Diary* (Yale University Press, 1997).
4. "Who Owns Anne Frank?," *The New Yorker*, October 6, 1997, p. 82.

the Austrian policeman who broke into the annex spotted a trunk with Otto's military rank written on the lid, the wretched man's attitude changed instantly. "Inwardly," Otto later recalled, "this police sergeant has snapped to attention."[5] This tragicomic scene was not used in any theatrical version of the diary.

Otto admitted that the Holocaust made him more conscious of being a Jew—how could it not have? But any form of Jewish essentialism, any attempt by Jews or Gentiles to once again single him out and put him in a unique category, would have been abhorrent. This attitude was not uncommon among survivors. Most French Jews were happy to be defined by General de Gaulle as French citizens, nothing more, nothing less, who had suffered under the Nazis, like all French patriots. This was a distortion of history, to be sure, but perhaps not a distortion of identity: after all, in many cases, they always had felt more French than anything else and were pleased to be welcomed back to the fold. It was left to their children to redress the historical balance.

So when Otto returned to Amsterdam, as the lone survivor of his family, and was handed his daughter's diary by Miep Gies, the Dutch woman who had helped to hide the Franks during the war, he was not inclined to view it as a "Jewish" document. First of all, it was his daughter's document. Reading it, knowing what had happened to her, must have been unutterably painful. The idea that she had died for nothing, as just another grisly statistic, would have sharpened his pain. But in the end, there were her words, and she had intended them to be published. Only they would give meaning to her death. The question was precisely what meaning they should convey. How to be a good Jew, keep to the ancestral faith, and bear witness to Jewish

5. Quoted in Ernst Schnabel, *Anne Frank: A Portrait in Courage* (Harcourt Brace, 1958), p. 136.

suffering? That is certainly one way of reading them. Jews "will be held up as an example," she wrote. She also said, "Who knows, it might even be our religion from which the world and all peoples learn good." She even struck a Darwinist note: "Right through the ages there have been Jews, through all the ages they have had to suffer, but it has made them strong too; the weak fall but the strong will remain and never go under!"

Otto, however, chose to read his daughter's words in a different, more universal light. If the world and all peoples are to learn good, he thought, then all forms of discrimination must be tackled at once. When an Israeli journalist asked him whether he intended to continue his struggle against anti-Semitism, Otto answered, "No, not against anti-Semitism, but against discrimination, against lack of human understanding, and prejudice. Anti-Semitism is the primary example of these three. To fight anti-Semitism one has to touch the root of the evil."[6]

The reasoning is impeccable. But the problem with using a historical example for such a universal aim is that the specific is too easily overlooked. The Nazi attempt to exterminate all Jews was not simply an unusually extreme form of human prejudice; nothing quite like it had ever been attempted before. When the movie version of Anne's diary, or, more accurately, the movie version of the staged version of the diary, first came out, the critic for *The Hollywood Reporter* hailed it as an expression of "Anne's final philosophy." And this was "that other peoples have also suffered persecution but always there have been some people...who have taken a stand for decency. This proved to her that the world is fundamentally and enduringly good."[7] In fact, Anne didn't have a "final philosophy,"

6. *The Stolen Legacy of Anne Frank*, p. 177.
7. *The Stolen Legacy of Anne Frank*, p. 178.

*108*

and what she wrote was less comforting. But *The Hollywood Reporter* accurately reflected Otto's idealism, as well as the simple, uplifting message that Broadway and Hollywood producers liked to sell.

Otto's universal message against prejudice certainly left its mark in Anne's adopted land, where the Anne Frank Foundation, set up by Otto himself, has done a great deal to spread the good word. Newsletters are sent out. A traveling Anne Frank education program goes around the schools. Videos and comic books are distributed about black teenagers being excluded from discos or children of Turkish immigrants being bullied in the schoolyard. None of this is bad, but this type of education is taking place in an atmosphere where symbols of collective suffering are becoming the primary source of national or ethnic or religious identification. A common lack of historical perspective, or even knowledge, might help to explain this.

When I went to elementary school in Holland in the 1950s, history was national history, which meant learning about national heroes: William the Silent beating the Spaniards, Admiral de Ruyter beating the English, and the Dutch resistance...well, not quite beating but fighting heroically against the Germans. For some time I was under the happy illusion that the Princess Irene Brigade had single-handedly taken the beaches at Normandy. Heroism has gone out of fashion in history education now. Indeed, education in pre-twentieth-century history has gone out of style altogether. And so, of course, has religious education, except in a few pockets of die-hard Protestantism. Instead, children learn about the evils of sexual, racial, and gender discrimination. Victims have become more familiar than heroes or saints. Anne Frank is the saintly victim every Dutch schoolchild knows. So even in this respect, Anne's wish has come true. The Dutch have taken her to their collective bosom as the most famous Dutch victim in history.

It was a tragic misfortune that Otto Frank's first and most fervent American promoter should have been a man whose take on Anne's diary was utterly at odds with Otto's own. Meyer Levin was born in Chicago, the son of immigrants from Lithuanian shtetls. His father had a shop called Joe the Tailor. Meyer was a gifted child, and his parents worked hard to give him a good education. Religion was not part of it. Levin, like Otto Frank, was not bar mitzvahed. But he was called "kike" and "sheeny" by the Italian kids, and he felt ashamed of his parents' lower-middle-class *Yiddishkeit*. According to Graver, he once told an interviewer how much he hated the "shame and inferiority in my elders; they considered themselves as nothing, greenhorns, Jews."

However, after years of fretting about it, Levin found a focus for his uneasy Jewish "identity." It came from the shock of seeing German concentration camps, as a reporter, in 1945. In a dispatch from Buchenwald, he wrote: "My mind has become in the faintest way like their minds; I am beginning to understand how they feel." This vicarious identification would grow stronger in time. Levin felt he had to "pay for being alive," by bearing witness, by writing about the Jewish experience, by creating, in his books, a Jewish voice or, as Cynthia Ozick might prefer, by voicing the Jewish "temperament." But this was before Saul Bellow or Philip Roth (or Woody Allen) made Jewish voices familiar to a wide audience. Levin's novel about his Jewish self-discovery, entitled *In Search*, was rejected by American publishers, and he had the manuscript printed in Paris at his own expense.

While feeling rejected and dejected, his Jewish voice cast beyond the pale, Levin once again had a revelation. He came upon Anne Frank, in French, as a kindred soul. Her diary, he said, years later,

when he was fighting her father in the Supreme Court of the State of New York, "had a passion similar to mine in setting down truly the lives of these people." He believed he understood her in a way few others, certainly no Gentiles, ever could. So he got in touch with Otto, and offered to promote the publication of the diary in America. He also thought the book would make a good play, and suggested that he would be the best man to write it. Impressed by Levin's enthusiasm, Otto agreed.

The rest of the sad story can be briefly told. The US edition of the diary, published by Doubleday, was boosted by Levin's glowing review on the front page of *The New York Times Book Review*. He also wrote the play. It was rejected by various producers as unsuitable for the commercial stage. Otto was persuaded to drop Levin in favor of two established Hollywood scriptwriters, both Gentiles, who were recommended by Lillian Hellman. The husband-and-wife team, Frances Goodrich and Albert Hackett, known for their work with Frank Capra, produced a heartwarming, uplifting work, full of laughter and tears, about a perky teenager who happens to be Jewish but could just as well not be. The Nazis manage to snuff out her life but not her message of tolerance and goodwill. The rest is showbiz history.

To Levin this was not just a career setback; it was a conspiracy of Stalinists, Broadway hucksters, and self-hating Jews to stifle his authentic Jewish voice. The main Stalinist, in his opinion, was Hellman. Through her manipulations, Anne had been robbed of her Jewish identity and became an unwitting propagandist for progressive internationalism, which crushed every national sentiment, and Zionism in particular. The Broadway huckster was Garson Kanin, the director, who smothered Anne in all-American schmaltz. And the self-hating Jew was of course Otto himself, who masked his (and his daughter's) true identity in vacuous universalism.

And Levin? More and more, he began to see himself as Anne's alter ego, or even as Anne herself. He compared the Broadway producers who championed Goodrich and Hackett's play to Nazis who took away business from Jews. His own play, Levin said, had been "killed by the same arbitrary disregard that brought an end to Anne and six million others. There is, among the survivors, a compulsion to visit on others something of the evil that was visited on them." This particularly low blow was aimed at Otto, of course. And for good measure: "Oh how your daughter would weep for the evil use to which you have allowed her work to be put." But Levin would wage a "Warsaw ghetto resistance" against the Broadway production. He sued Otto for breach of contract, unsuccessfully. He then asked Simon Wiesenthal to look into Otto's behavior at Auschwitz. But Wiesenthal had better things to do.

It was all desperately sad and unedifying. The difference between the two accounts of Levin's tribulations is that Graver writes as a historian and Melnick as a passionate advocate of his hero's conspiracy theories. Graver is not unsympathetic to Levin. He thinks Levin's version was indeed closer to the spirit—and words—of Anne's diary. But he demolishes the Broadway-Stalinist-self-hating-Jewish conspiracy theory. Instead, he blames the "Zeitgeist" of the 1950s, which combined the popular demand for universal uplift, the Broadway producers' interest in providing it, the "assimilationist mood" among many American Jews, the postwar pressure to be friendly to Germany, and the anti-anticommunism of the left. The Zeitgeist, as well as Levin's "self-defeating behavior," was responsible, in Graver's view, for obscuring Levin's play and "his efforts to deepen public understanding of the significance of what was done to the Jews of Europe." This is being very fair to Levin.

Melnick is less fair toward Levin's critics. Hellman is Melnick's and Levin's most heinous bête noire. In their view, she led the conspirato-

rial pack. Melnick's tactic is guilt by association. Stalin's Soviet Union was anti-Semitic, Hellman defended Stalin's Soviet Union and was "a thoroughly self-hating Jew," so it stands to reason that Hellman was Stalin's agent on Broadway. After reminding us of Stalin's persecution of Jewish writers, Melnick states: "This silencing of the Jewish artistic voice found its parallel in Hellman's treatment of Meyer and the *Diary* at the very time when Stalin's most notorious and potentially dangerous anti-Semitic attack was beginning to unfold, in the guise of what came to be know as the Doctors' Plot of 1953."

Now, Hellman had indeed been a Communist; she had no time for Zionism, could be mean and vindictive, and had a cavalier attitude toward the truth. But according to most accounts, including Graver's, her involvement with the Anne Frank play was not very significant. She was asked to write the play herself but declined, saying, "I think [the diary] is a great historical work which will probably live forever, but I couldn't be more wrong as the adaptor. If *I* did this it would run one night because it would be deeply depressing. You need someone who has a much lighter touch."[8] This suggests showbiz wisdom, rather than self-hatred or Stalinism. She was friendly with Goodrich and Hackett and gave them advice when they asked for it. According to them, her most useful tips were structural.

The Soviets denied the uniqueness of the Holocaust, to be sure. Goodrich and Hackett's play skates lightly around it. It is made clear that the victims were Jewish, and the death camps their final destination. But Anne is given the line: "We're not the only people that have had to suffer." Levin saw this as Hellman's smoking gun, for didn't she voice the same opinion, using the same phrase, in her memoir *Pentimento*? Melnick picks up on this too, in high dudgeon. The

8. Quoted in *Frances and Albert*, an unpublished manuscript book about Frances Goodrich and Albert Hackett, by David Goodrich.

same words are indeed spoken in *Pentimento*, not by Hellman, however, but by Julia, the fictionalized resistance heroine Hellman claimed to have performed brave deeds with. "Julia" tells "Lillian" (in the late 1930s, so before the Holocaust) that she will use her money to save victims of the Nazis. "Jews?" asks Hellman. And Julia says, "About half. And political people. Socialists, Communists, plain old Catholic dissenters. Jews aren't the only people who have suffered here." In that context, Julia was of course right.

In fact, if anyone was chiefly to blame for the "revisionism" of the 1950s play, it was the director Garson Kanin, another Jew swabbed by Levin with the self-hating, Stalinist brush. He insisted on taking out Peter van Daan's line about having to suffer "Because we're Jews! Because we're Jews!" He told the Goodrich and Hackett to substitute the jaunty "Oh, Hanukah!" song for the more sober and dignified "Ma'oz Tzur." And Kanin argued that Anne's statement about Jews having had to suffer through the ages was an "embarrassing piece of special pleading. Right down the ages, people have suffered because of being English, French, German, Italian, Ethiopian, Mohammedan, Negro, and so on." This is missing the mark so widely, you wonder whether he ever had it in his sight.

Levin's play has hardly ever been performed, since Otto owned the rights to the diary. This is a shame, for now we shall never know whether his version would indeed have been more effective in deepening public understanding of the Holocaust. I think the Broadway producers and Otto were right to assume that Goodrich and Hackett's version would reach a wider audience, which is not to say it was the better play. But popular entertainment can sometimes deepen people's understanding. Depth is a relative concept. Showbiz can be remarkably effective, for better or worse. The Goodrich and Hackett play stunned audiences in Germany, just as the American TV soap opera *Holocaust* would a generation later. People are moved pre-

cisely because they identify with the victims as characters—though not of course with their fate. Hollywood's international appeal always has been its stress on character instead of milieu. Cultural and historical accuracy suffers. But making German audiences identify with Jewish victims is better, it seems to me, than teaching them lessons on how to be a good Jew. Such identification can result in sentimental self-pity, but it is more likely to give people at least some idea of the evil that was done.

I am in any case not sure that Levin's play was less of a distortion of the diary than Goodrich and Hackett's version. I have only read a late, much revised version of Levin's script. It is clumsy and hopelessly didactic. It isn't easy to recreate the atmosphere of the secret annex in Amsterdam, where eight terrified people argued about all manner of things, including the Jewish Question, in a mixture of German, Dutch, and broken Dutch (mimicked by Anne in the diary). But I find the following dialogue between Otto and his wife, Edith, somewhat implausible:

Mrs. Frank: We haven't taught our children, Otto. We ourselves know so little, and they know less. Perhaps God wants to wipe out our people because we have failed him.

Mr. Frank: We taught our children to believe in God. In our day that is already something. We never believed the forms were so important, Edith.

Mrs. Frank: We haven't loved our God, Otto. And since being here, it is strange, but I feel more and more His love for us.

This is what Levin wanted his characters to say. And Mrs. Frank, in a liberal way, was more religious than her husband. But it sounds

more like an interior dialogue in Levin's own head. He "got" religion late in life. When Otto visited New York, Levin took him to his synagogue, hoping that Otto would share in his discovery of Judaism. Then there is Mr. van Daan, a solid German businessman, who alternates in Levin's version between sounding like a friendly rabbi and a character in a Yiddish soap opera. When his son, Peter, asks him why only religion should help us to tell right from wrong, he preaches: "That is the way it came to us. The Jewish way. Everybody in the world, Peter, has the right to be what they are, and we have the right to be Jews." Again, this sounds like Levin being pious more than the van Daan we know from the diary.

If Goodrich and Hackett's sin was to take the Jewishness out of the Franks and van Daans, Levin's sin is to put too much of it in. These were people, after all, who celebrated Saint Nicholas (which has no religious significance in Holland) with greater gusto than Hanukah. Otto actually wanted to give Anne a copy of the New Testament on Hanukah, for her education. Mr. van Daan's pork sausages were the highlight on the annex menu. Levin was right to insist on the uniqueness of the Holocaust, but making the characters appear more Jewish than they did in real life was the wrong way to make the point. For one of the horrors of Nazi anti-Semitism was that it didn't matter how Jewish or un-Jewish you were, appeared, or wanted to be, they would get you anyway. And here, I think, we have arrived at the center of Levin's antagonism. Levin resented Otto, and his kind, for not being willing, in Levin's eyes, to be good enough Jews. He condemned Otto for his assimilationism. The ferocity of Levin's battles with Otto, which are still being fought by his defenders, has less to do with the diary itself than with class and "identity" politics.

Melnick sets the tone of his book by stating in the preface that Stalinist propaganda was only one reason for cutting out Anne's "Jewish avowal" in the play. There were other "equally egregious

reasons for this decision, both commercial and assimilationist." Having established that Stalinism and assimilationism are equally egregious, Melnick quotes Levin's view that assimilationists suffer from "psychic cancers, ugly secret growths that our people have so long buried in their souls."

The Jews most associated with assimilationism, not just in the US, are of course, the prosperous German Jews. Ill feeling against them is deep and goes back a long way. German Jews tended to disassociate themselves from the poor, religious immigrants and refugees from the east. The *Ostjuden* were regarded as riffraff who gave respectable Jews a bad name. Later on, too many assimilated Jews, lucky enough to be in Britain or the US, looked the other way when Hitler went about annihilating their less fortunate brethren. Walter Lippmann's refusal to write even one column forthrightly denouncing the persecution of Jews is a well-known and indeed shameful example. So a degree of resentment is understandable. But when resentment about German-Jewish snootiness slips into paranoia, as it does in some of the recent comments on the case, including Melnick's, reasonable argument is cut short.

It has become fashionable to assert one's minority status, especially in the US. And this can be a positive thing. Diversity is good. Jews who wish to live according to the customs and religious beliefs of their ancestors contribute to it. But this is no reason to feel such contempt for those who choose not to do so. Wanting to be assimilated does not necessarily imply self-hatred. The person who had felt ashamed of his parents' Jewishness was Levin, not Otto Frank. The fact that people such as the Franks were not able to live out their lives as ordinary Germans was not their fault, but Hitler's. To think that they were punished by God for not being good Jews is to say that God is a Nazi. If Mrs. Frank really said such a thing, she was deluded. If Levin invented it, he was being grotesque.

Of the three theatrical versions of Anne Frank's diary, Kesselman's rewrite of Goodrich and Hackett's play strikes the fewest false notes. It provides a sharper historical perspective. And Anne's famous lines of redemption—"In spite of everything..."—are given a dark twist of irony, for they are spoken moments before the Nazis arrive to claim their victims. Critics have praised the current production for its tough-mindedness: "A Darker Anne Frank," as one headline put it. This is right. But before condemning the "Fifties Zeitgeist" too smugly for its sentimentalism, we should reflect on our own variety. In an interview with Charlie Rose, Linda Lavin, who plays Mrs. van Daan, describes how people come back "into our dressing rooms, sobbing at the end of the evening—sobbing. And I'm holding friends—strangers, people who've come to say—what—to show us what they have just been through. We know what they've been through because we've presented it and they're afraid for us."

What they went through was a theatrical performance. Reviewing the play in *Time* magazine, Richard Zoglin called Anne Frank's diary a "communal rite of grief." That was indeed the mood of the audience with whom I "shared" the experience of watching the play in December. The more I see people expressing their "identities" in communal rites of grief, the more I am inclined to admire Otto Frank's dignity, and his perhaps naive, but nonetheless admirable, wish to put his own grief to a more universal purpose.

8

OCCUPIED PARIS:

THE SWEET AND THE CRUEL

HÉLÈNE BERR, TWENTY-ONE, student of English literature at the Sorbonne:

> This is the first day I feel I'm really on holiday. The weather is glorious, yesterday's storm has brought fresher air. The birds are twittering, it's a morning as in Paul Valéry. It's also the first day I'm going to wear the yellow star. Those are the two sides of how life is now: youth, beauty, and freshness, all contained in this limpid morning; barbarity and evil, represented by this yellow star.[1]

Philippe Jullian, twenty-three, artist and aspiring man of letters:

> Read *The Poor Folk*, and felt like a character out of Dostoevsky, just as I felt extremely Proustian three years ago. I always see myself through the colored windows of my admiration. I'm afraid of having no more great works to immerse myself in.

1. *The Journal of Hélène Berr*, translated by David Bellos (Weinstein, 2008).

After Balzac, Proust, Dostoevsky and the English, what is left for me?...

How ugly they are, those poor Jews, who wear, stuck to their clothes, that mean yellow star.[2]

Same date, June 8, 1942; same place, Paris; two different journals. Although both were solidly bourgeois, Berr's background was grander than Jullian's. She was Parisian; he came from provincial Bordeaux. Her father, Raymond Berr, was a famous scientist who ran a major chemical company. His was an impoverished war veteran named Simounet, of whom Philippe felt so ashamed that he took the name of his maternal grandfather, Camille Jullian, a noted historian of the Gauls. Philippe was a socially ambitious homosexual whose diary proudly dwells on dinners in the company of Jean Cocteau and his circle.[3] Hélène's idea of a perfect evening was listening to a Beethoven trio or discussing the poetry of Keats with her friends from the Sorbonne. But the main difference between them was one imposed by the German occupiers: she was Jewish, and he was not.

This was not an identity that Hélène had sought. Quite to the contrary, the Berrs were secular, assimilated, and felt more French than Jewish. In a journal entry on December 31, 1943, she notes:

When I write the word *Jew*, I am not saying exactly what I mean, because for me that distinction does not exist: I do not feel different from other people, I will never think of myself as a member of a separate human group, and perhaps that is why I suffer so much, because I don't understand it at all.

2. *Journal, 1940–1950* (Paris: Grasset, 2009).
3. A lifelong Anglophile, Jullian went on to write a well-received biography of Oscar Wilde (1967).

The suffering that she refers to, the daily humiliations, the terror of deportation, torture, and probable death, the experience of seeing her father dragged off to a concentration camp (for just having pinned, not sewn, the yellow star onto his suit), mothers being torn from their children, relatives and friends disappearing without a trace, none of this figures in Jullian's diaries. Not that he has any sympathy for the Nazis. But his attention is elsewhere. Thus he writes, in December 1943:

> Monday, in Paris, return of [my friends] Clerisse and Grédy, beautifully dressed. Lunch at Madame Grédy, perfectly "natural.". . . I go and find the Rilke poems with my prints, which, taken as a whole, disappoint me. However, their fine presentation makes me cry with joy.

From Jullian's journals the reader might get the impression that life in wartime Paris was almost normal. Germans are barely mentioned. Food was short, to be sure, but something could always be rustled up at dinner parties attended by a young aesthete with the right connections.

Of course, Jullian was not exactly representative of the French population. But the impression that life went on, and that the horrors that afflicted the Berrs, and many others, could be safely ignored by those who were not marked with yellow stars, is not totally false. Paris, unlike other European capitals under Nazi occupation, was meant to look normal. Nominally, it was under French (Vichy) rule, and German policy was to encourage cultural life there as long as it was not unfriendly to the German cause. Francophile administrators, such as the German "ambassador," Otto Abetz, were sent to Paris expressly to cultivate French writers and artists.

Herbert von Karajan conducted the German State Opera in Paris.

Cocteau's plays were performed all through the war. Jean-Paul Sartre published his books, as did Simone de Beauvoir, and German officers were among those who came to see Sartre's plays. Albert Camus was patronized by the German chief of literary propaganda, Gerhard Heller. Film studios thrived under German supervision. And Sartre and Camus wrote for the resistance too. Things were even easier for French collaborators. For them, as Robert Paxton observes in *Collaboration and Resistance*, "life in occupied Paris was sweet."[4]

A tiny number of people resisted the Germans from the beginning. Some were religious, others were dedicated followers of Charles de Gaulle or committed leftists, and some just couldn't bear to remain passive.[5] The art historian Agnès Humbert was not religious, but she fit the other categories. She started the first resistance group in France with colleagues from the Musée de l'Homme, including the poet Jean Cassou. Her gripping wartime memoir, a kind of reconstructed journal written just after the war, was first published in English in 2008.[6]

Recalling a conversation with Cassou in August 1940, she writes:

> Suddenly I blurt out why I have come to see him, telling him that I feel I will go mad, literally, if I don't do something, if I don't react somehow. Cassou confides that he feels the same, that he shares my fears. The only remedy is for us to act together, to form a group of ten like-minded comrades, no more.... I don't harbour many illusions about the practical effects of our actions, but simply keeping our sanity will be success of a kind.

4. *Collaboration and Resistance: French Literary Life Under the Occupation*, edited by Olivier Corpet, Claire Paulhan, and Robert O. Paxton (Five Ties. 2010).

5. Communists were the best-organized resisters, but they mainly became active beginning in 1941, after the Soviet Union was attacked.

6. *Résistance: Memoirs of Occupied France*, translated by Barbara Mellor (Bloomsbury).

Humbert was arrested, along with most of the group, in 1941, and barely survived prison and slave labor in Germany. She was immensely brave and driven by a strong sense of left-wing idealism. At a time when there was no prospect at all of a German defeat, her actions would have seemed quixotic to most people in France, who tried to carry on as best they could. Since the Germans made this easier in Paris (as long as you weren't Jewish) than in Warsaw, say, or Minsk, passivity was perhaps not the most honorable option, but at least it was a perfectly understandable one.

When General de Gaulle returned as a French hero in 1944 and told his compatriots that there was only one "eternal France," and that all French patriots had stood up to the Nazi invaders, this myth was gratefully received. The more complicated reality was slow to emerge. It took an American historian, Robert Paxton, to start the flood of literature on Vichy France. But even though the murkier picture of collaboration and compromise, as well as heroic resistance, is now generally accepted in France, a confrontation with the superficial normality of wartime Paris can still come as a shock.

The French photographer André Zucca was not a Nazi. But he felt no particular hostility toward Germany either. And as the historian Jean-Pierre Azéma remarks in his preface to the riveting book of Zucca's photographs, *Les Parisiens sous l'Occupation*,[7] he "was not a shining example of philosemitism." Zucca simply wanted to continue his pre-war life, publishing pictures in the best magazines. And the one with the glossiest pictures, in fine German Agfacolor, happened to be *Signal*, the German propaganda magazine. When a cache of these pictures was exhibited at the Bibliothèque Historique de la Ville de Paris last year, the press reacted with dismay. How could this

7. Jean Baronnet, *Les Parisiens sous l'Occupation: Photographies en couleurs d'André Zucca* (Paris: Gallimard, 2000).

"celebration of the victor," "underlining the sweetness of life in an occupied country," take place "without any explanation"?

Perhaps there should have been more explanation, but the pictures are only tendentious in what they do not show. You don't see people being rounded up. There is only one blurred image of an old woman walking along the rue de Rivoli wearing a yellow star. There are no photographs of endless queues in front of half-empty food stores. There are no pictures of Drancy, where Jews were held in appalling conditions before being transported east in cattle trains. But what Zucca's pictures do show, always in fine Agfacolor weather, is still revealing. They are disturbing to the modern viewer precisely because of their peculiar air of normality, the sense of life going on while atrocities were happening, as it were, around the corner.

We see nice old ladies doing their knitting in the gardens of the Palais-Royal. We see a café on the Champs-Élysées packed with well-dressed Parisians enjoying their aperitifs. We see young people bathing in the Seine. We see fashionable ladies in elaborate hats at the races in Longchamp (this, in August 1943, when mass deportations were in full swing). The streets, to be sure, are weirdly empty of cars, and there are German men and women in uniform popping up here and there, drinking coffee, entering the Métro, playing in brass bands, paying their respects to the Unknown Soldier at the Arc de Triomphe. Still, the overall impression is one of a people engaged in what the French call *se débrouiller*, coping as best they can.

For some French men and women—perhaps more than we would like to know—the occupation was actually a source of new opportunities. That life was sweet for the "collabos" is clear. But a remarkable new book on the sexual aspects of foreign ocupation, *1940–1945*

Années érotiques, the second in a two-volume set by Patrick Buisson, shows that the presence of large numbers of German soldiers meant liberation of a kind for large numbers of French women: young women rebelling against the authoritarian strictures of bourgeois life, middle-aged spinsters yearning for romance, widows, women alone, women in bad marriages, and so on.[8] Buisson does not ask us to admire these tens of thousands of women engaging in "horizontal collaboration," but to comprehend the complexity of their motives.

He is scornful of the movie stars, fashion folks, and social climbers who did better than most, thanks to their German contacts or lovers: Arletty, Coco Chanel, Suzy Solidor, et al. But he is just as hard on the men who took their revenge after the war on the army of unknown women who had strayed into German arms. Such women were stripped naked and paraded through the streets, shorn of their hair, their bodies daubed with swastikas, jeered at by the mob. Buisson writes:

> When the Germans were defeated, or about to be defeated, the "Boche's girl" served as a substitute to prolong a battle that no longer held any dangers and affirmed a manliness that had not always been employed in other circumstances.

In hindsight, especially if one was not alive in those days, it is easy to moralize about the behavior of people under occupation. It is a humbling experience to see the letters, documents, books, and photographs from wartime France, such as the ones displayed at the New York Public Library in the spring of 2009. Since they were not always easy to read in the gloomy light, it is our good fortune that we have *Collaboration and Resistance* to consult. Though not quite a catalog

8. *1940–1945 Années érotiques: De la Grande Prostitution à la revanche des mâles* (Paris: Albin Michel, 2008).

of the exhibition, it shows much of the same material. There we find enough evidence of bravery, as well as cowardice and shabby compromises, to help us appreciate how hard it was to live under the Nazis, especially in a city where compromise was encouraged and a façade of normality imposed.

People have to live, writers want to be published, artists wish to continue painting. In other countries under Nazi rule there was little room between collaborating and going underground. Precisely because there was more leeway in France, the moral choices were harder, or at least more complicated. As Paxton says:

> We need to avoid easy assumptions that the responses of French writers, editors, and publishers to these crises fall neatly into boxes we have constructed retroactively, labeled "collaboration" and "resistance."

Cocteau, for example. Like Zucca, the photographer, he liked to think of himself as "apolitical," and considered Germanophobia, the default French mode at least since the late nineteenth century, as a form of bigotry. Yet he was loathed by the French fascists as a decadent homosexual and corrupter of French morals. Notorious collaborators, such as Pierre Drieu La Rochelle and Robert Brasillach, called him *enjuivé*, "Jewified." Cocteau, for his part, despised the Vichy regime as a band of "criminal boy scouts."[9]

Cocteau did, on the other hand, frequent German literary salons; dine at Maxim's with cultivated German officers, such as the writer Ernst Jünger; and praise the marble celebrations to Aryan manhood by Hitler's favorite sculptor, Arno Breker. Artistic friendships, he

9. See p. 574 of Claude Arnaud's superb biography, *Jean Cocteau* (Paris: Gallimard, 2003), which deserves an English translation.

claimed, were more precious to him than vulgar shows of patriotism. Praising Breker, whom he had known before the war, was Cocteau's way of rebelling against what he saw as narrow-minded chauvinism. And besides, Cocteau was never one to turn down an invitation to a good party. And parties at the German Institute, on the rue de Lille, were lavish, even if the company was louche.

On the other hand again, Cocteau, who was not anti-Semitic, did everything in his power to get his friend Max Jacob, the poet, released from Drancy, alas without success; Jacob died in capitivity in 1944. And there were reasons for cultivating the likes of Jünger, Breker, or Karl Epting, the director of the German Institute. Their patronage kept the far more ferocious French Nazis off his back. Cocteau's biographer Claude Arnaud writes: "When the extremist press launched its attacks on Cocteau in the spring of 1941, Breker 'spontaneously' offered him a way of getting in touch 'by special line to Berlin in case something bad should happen.'"

Like Philippe Jullian, the young aesthete, Cocteau was hardly typical of most French people under Nazi occupation. But like the majority of his compatriots, he was a *débrouillard*, a survivor, who was neither heroic nor utterly abject, but who adapted to difficult circumstances. To keep going, as a writer, a filmmaker, and a poet, might even, with some indulgence, be seen as a form of defiance. In his finely considered account of the period, Arnaud describes this as the most common—if perhaps self-serving—attitude among French artists and entertainers after the German troops arrived in Paris:

Theaters and nightclubs had to be reopened, just to show the Germans the persistence, if not the superiority, of the French way of life; poetry readings, theatrical tragedies, loud laughter to show them that nothing was over yet; to love, to write, to dance, to keep on performing, just to drown out the noise of

marching boots, and affirm the forces of life over the troops of death.

If this attitude was not shared by all French artists, it surely was by Cocteau. Yet no matter how much he attempted to lead a normal artistic life in abnormal times, some aspects of wartime bohemia must have been pretty strange even by his standards. One of his favorite haunts during the war was a brothel named L'Étoile de Kléber on the rue Villejust. The madame was a colorful figure named Madame Billy. Edith Piaf lived under her roof for some time. Michel Simon, the movie actor, was a frequent guest, as were Maurice Chevalier and Mistinguett, with her entourage of gigolos. The food, acquired on the black market, was superb, and the conversation brilliant. Piaf could be relied upon to sing for her supper. For Cocteau it was a refuge in hard times.

But not just for him and his friends from the beau monde. German officers, always in impeccable civilian clothes, were loyal clients of the brothel, as were agents of the Gestapo, whose torture chambers on the rue Lauriston were conveniently nearby. If this mélange was not strange enough, Mme Billy's establishment was frequented by members of the French resistance too. Only once in a while did unpleasantness intrude, such as when the German police decided that Jews might be among the company, and all the French guests were required to pull down their trousers. According to the writer Roger Peyrefitte, all the men protested vehemently except for Cocteau, who rather took pleasure in the exercise.

Far from the mainstream, these scenes at L'Étoile de Kléber, but like Zucca's photos they were revealing of a certain aspect of wartime Paris that would be difficult to imagine in any other Nazi-occupied European city. One might argue that simply by publishing their books, putting on their plays, and making their movies, artists like

Sartre and Cocteau were not really defying anyone but collaborating in a way: they helped the Germans hold up the façade of normality. But there were many gray areas, described by Paxton and others, where personal loyalties trumped political principles, and compromises were mixed with acts of resistance. Camus, for example, was published by Gallimard, which was run by collaborators, but he also edited *Combat*, the clandestine journal of resistance.

For Hélène Berr, there could be no gray areas. She may not have felt apart, as a Jew, from other people, but that made no difference to her enemies. For her too, until it became utterly impossible, striving to lead a normal life was a matter of pride. Barred by Vichy laws in 1942 from studying for her *agrégation*, the civil service degree, she kept working on her doctoral thesis on Keats's Hellenism. And most fatefully, she refused to leave her beloved native city of Paris. When an offer was made to release her father from Drancy if the family agreed to emigrate, she noted in her diary on July 2, 1942, that leaving would mean "giving up a sense of dignity." Escaping was a form of defeat. She also despised "Zionist movements" for that reason, as they "unwittingly play into the Germans' hands." Resistance was the only honorable course. Running away would mean "giving up the feeling of equality in resistance, if I agree to stand apart from the struggle of other Frenchmen."

Well-meaning people urged the Berr family to flee, but in Hélène's view they "fail to grasp that for us it is just as much of an uprooting as it would be for them, because they do not put themselves in our shoes and consider us as naturally destined for exile." Of all humiliations, this was perhaps the one she most keenly felt, that even French compatriots who wished her no harm still talked as if her ancestry set

her apart. Being compelled to suffer for being a Jew created a barrier that she regarded as not only cruel but absurd. Giving in to this absurdity, for her, would be an act of cowardice.

At the same time, enforced suffering created a different kind of solidarity too. The order to wear the yellow star in 1942 struck her as barbaric, and her first instinct was to refuse. Then, on June 4, 1942, she had another thought: "I now think it is cowardly not to wear it, vis-à-vis people who will." She continued: "Only, if I do wear it, I want to stay very elegant and dignified so that people can see what that means. I want to do whatever is most courageous. This evening I believe that means wearing the star."

Hélène was in fact among the few brave people who resisted very early on. In 1941, she joined a clandestine network to save Jewish children from deportation. Apart from the increasing hardships faced by her own family, she quickly became aware of the depths of human cruelty: a woman hauled off to a concentration camp because her six-year-old child wasn't wearing a yellow star; 15,000 Jews trapped in the Paris velodrome for five days in July 1942, without water, electricity, lavatories, or food, before being sent to the death camps.[10] This notorious event goes unrecorded (or at least unpublished) in Jullian's journal.

Always fearing for the lives of her own family and friends, as well as the children under her clandestine care, Hélène longed from moments of normality, however fleeting. September 7, 1942, a visit to the university library:

> It seemed to me that I was emerging from a different world. Saw André Boutelleau, Eileen Griffin, Jenny. We left together to go to

10. Not that it makes any substantive difference, but there was in fact one toilet for more than ten thousand people, many of them old, very young, or sick.

rue de l'Odéon, then to Klincksieck's bookshop, then to Budé's bookshop; and when we came back here, we had tea with Denise listening to Schumann's concerto and the Mozart symphony.

Such echoes of her old life became increasingly rare. By 1943, the gulf between the persecuted and those who remained unmarked, as it were, had become unbridgeable. But it was not the difference between collaborators and resisters that preyed on her mind. What disturbed Hélène more than anything was the indifference, obliviousness, and condescending pity of the decent folks around her. What shocked her most was the human capacity for looking the other way. Which is why she decided to keep a diary. October 10, 1943:

> Every hour of every day there is another painful realization that *other folk* do not know, do not even imagine, the suffering of other men, the evil that some of them inflict. And I am still trying to make the painful effort to *tell the story*. Because it is a duty, it is maybe the only one I can fulfill.

A week later, Hélène walks to the Métro with an old student friend, a Gentile, who "lives in a different world from ours!" The friend, named Breynaert, is just back from a holiday on Lake Annecy. Hélène refuses to be envious of such friends or make them aware of their insensitivity, because she doesn't want their pity. But, she writes, "it is painful to see how distant from us they are. On pont Mirabeau, he said: 'So, don't you miss being able to go out in the evening?' Good God! He thinks that's all we're up against!"

Reading this diary is not just upsetting because we know what happened to the writer but because she knew what was likely to happen to her even as she was writing it. On October 27, 1943, Hélène quotes (in English) the famous poem by Keats:

This living hand, now warm and capable
Of earnest grasping, would, if it were cold,
And in the icy silence of the tomb,
So haunt thy days and chill thy dreaming nights
That thou would wish thine own heart dry of blood....

She does not want her hand to go cold. No one can really imagine her own death. Hélène still hoped that she would survive to see again her beloved fiancé, a philosophy student named Jean Morawiecki, who had fled to Spain to join the Free French forces in North Africa. He was the designated custodian of her diaries in case of her deportation. Morawiecki received them after the war from the Berrs' cook, Andrée Bardiau.

On March 8, 1944, at 7 AM, Hélène and her parents were finally arrested. On the 27th, Hélène's twenty-third birthday, they were loaded into cattle cars to Auschwitz. Her mother was gassed in April. Her father was killed in September. People remembered Hélène for trying to keep up the morale of fellow inmates by singing bits from the Brandenburg Concertos and César Franck's Violin and Piano Sonata.

On March 22, Jullian wrote in his diary:

> The twenty days I spent in the country were quite pleasant, and I take no pleasure in returning to Paris. One is awfully tired of feeling irritated all the time. The atmosphere is tense with raids, the fear of departures to Germany. An uncertain period, cowardly for those who aren't heroes.

Paris is liberated on August 25, 1944. Jullian is happy that the German occupation is over. But on October 2, he writes:

Paris may be freer, but uncomfortable too. On the rue de Wagram there are more maids in their Sunday best attached to the Americans than there were in the arms of the Germans. Vulgarity, sad lubricity in the Métro of Étoile; stupid meetings, lost times and lives.

Hélène was still in Auschwitz then. In November, she was transported to Bergen-Belsen. On April 10, 1945, five days before British and Canadian troops liberated the camp, Hélène, ravaged by typhus, no longer had enough strength to rise from her bunk. She was then beaten to death by one of the guards.

Millions and millions of lives were lost in the war, many of them under terrible circumstances. And millions have been lost since then. But it is the destruction of one precious life, of an extraordinary young woman whom we have come to know through her most intimate thoughts, that brings out the full horror of this ghastly waste. Of all the entries in her journal, one sticks in my mind more than any other. It was written on October 25, 1943. Hélène is gripped by anxiety at the thought that she might not be there when her fiancé returns:

> But it is not fear as such, because I am not afraid of what might happen to me; I think I would accept it, for I have accepted many hard things, and I'm not one to back away from a challenge. But I fear that my beautiful dream may never be brought to fruition, may never be realized. I'm not afraid for myself but for something beautiful that might have been.

9

THE TWISTED ART OF DOCUMENTARY

The function of propaganda is…not to make an objective study of the truth, in so far as it favors the enemy, and then set it before the masses with academic fairness; its task is to serve our own right, always and unflinchingly.

—ADOLF HITLER, *Mein Kampf*

ALL GOVERNMENTS MAKE propaganda. The difference between totalitarian government propaganda and the democratic kind is that the former has a monopoly on truth; its version of reality cannot be challenged. Past, present, and future are what the rulers say they are. Which is why, from the official point of view, there is no stigma attached to the word "propaganda" in totalitarian societies. Nazi Germany had a Ministry of Volk Enlightenment and Propaganda, and the Soviet Union a Department for Agitation and Propaganda.

The idea that rulers should impose their own realities exists, at least as an aspiration, in democracies too. It was nicely summed up by a US government official (probably Karl Rove) who stated that

"we [the Bush administration] create our own reality."[1] But democratic governments and parties are not supposed to dictate the truth. We expect partisanship from our politicians; they can try to make their case. But the word "propaganda" has a negative connotation. It smacks of coercion or official lying. And so propaganda cannot be called that, but must be disguised as "news," or "information," or "entertainment" (*Casablanca, Mrs. Miniver*). The propaganda department of the US government during World War II was called the Office of War Information, and on several occasions during the last Iraq war heroic myths were presented as news stories.

This is not an argument for moral equivalence. One can be arrested for exposing official lies in democracies, but the chances of that happening are slimmer than under dictatorships, where the fate of whistle-blowers and naysayers is often far worse than jail.[2] Nor is it an argument against governments trying to propagate a message. This can be necessary to mobilize people behind a difficult but essential enterprise (fighting Nazi Germany, say). Perhaps the masking of propaganda is an inevitable bit of hypocrisy in a democratic society, even though slipping fictions into news stories as facts cannot be condoned under any circumstances.

Some propaganda is not only made for a good cause but can be factually true. But if so, can we still call it propaganda? And if it is for a good cause, should we still mind that it is propaganda? If it is also good art (pictures commissioned by churches or kings or the Cuban Communist Party, for example), should we care about the cause? Some of these questions, and more, are raised by two fascinating documentaries, one the reconstruction of a US government film

1. An aide to George W. Bush, quoted by Ron Suskind, "Faith, Certainty and the Presidency of George W. Bush," *The New York Times Magazine*, October 17, 2004.
2. This was written before Julian Assange or Edward Snowden became household names.

made in 1948 to justify the Nuremberg war crimes trials, and one about a perverse and vicious Nazi propaganda film, made in 1942, that was never completed or shown. Neither the Nuremberg nor the Nazi movie could be classified as great art, even though *A Film Unfinished*, the documentary about the Nazi movie, is certainly an extraordinary accomplishment.

The idea for *Nuremberg: Its Lesson for Today* was born in a special film unit of the Office of Strategic Services led by John Ford, the famous director. His associates were the navy lieutenant Budd Schulberg (who went on to write *On the Waterfront*, among other things) and Budd's brother Stuart, a Marine Corps sergeant. The original idea was to compile visual evidence about the Third Reich to help Justice Robert H. Jackson, the US prosecutor at Nuremberg. The material was culled from Nazi propaganda films, newsreels, private movies, and indeed anything the fimmakers could lay their hands on that hadn't been destroyed by the Germans at the end of the war.

This actually resulted in three films. Two were shown in the courtoom, entitled *The Nazi Plan* and *Nazi Concentration Camps*. These were not released to the general public. A third film, *Nuremberg: Its Lesson for Today*, produced by Pare Lorentz, who had written documentaries during the New Deal, was directed by Stuart Schulberg. Now brilliantly restored by his daughter Sandra and Josh Waletzky, it was shown only to German audiences at the time. It combined material from the films shown at the trial with new footage shot of the trial proceedings by cameramen from the Army Signal Corps. The movie begins with part of Jackson's opening statement about the trial being a way to make "peace more secure" and serve as a "warning against all those who plan to wage an aggressive war."

Much of the film will be quite familiar to anyone who has an interest in Nazi history: the rallies, the speeches, the blitzkrieg, the ghastly scenes of corpses being dumped into the mass graves of Belsen. The most unusual footage is the only scene not screened in the courtroom at Nuremberg, of a car pumping carbon monoxide into a sealed room. This improvised gas chamber was filmed by an SS commander who used such methods to kill Jews as well as mental patients.

The reconstruction of the 1948 documentary, which had only survived with a German soundtrack, is a remarkable feat: testimonies in the trial had to be transferred from wax recordings and synchronized with images on the screen; the score was recreated by the composer John Califra from musical cues jotted down by the original composer, Hans-Otto Borgmann, who, curiously, had had a previous career writing music for such Nazi propaganda movies as *Hitlerjunge Quex* (1933).

Although no doubt useful as a historical document for future generations who will be less familiar with images of the Third Reich, Schulberg's film is especially interesting for what it tells us about the time when it was made: that short period between the Nazi war crimes trials, undertaken in the hope of building a better, more just world, and the beginning of the cold war, when harder-nosed policies prevailed. *Nuremberg: Its Lesson for Today* was a propaganda film, but the exact nature of the propaganda was contested from the beginning. This contest reflected bureaucratic battles within the US government, as well as political differences about priorities in the new postwar order.

Robert A. McClure, the director of the US military government's Information Control Division, saw the film as a tool to teach the Germans a lesson. It was to be part of the denazification programs set up by the Allied occupation governments, the cinematic counter-

part, as it were, of forcing German citizens to tour the concentration camps and see what their country had done. The producer, Pare Lorentz, however, had a wider, more idealistic vision, shared by Justice Jackson and the War Department in Washington, D.C. The lesson for today had to be a lesson to us all. The trial, with its newly created laws, was meant to be a moral exercise, a beacon of justice to light the way to a better future, and the film, as Schulberg and Lorentz conceived it, was supposed to justify that goal.

In the short run, the War Department won this battle over messages. Despite various attempts by McClure and the military government in Germany to produce alternative scripts and make a different movie, one less tied to the trial itself and more to Nazi crimes in general, the Lorentz/Schulberg version eventually got made. By dividing the film into sections following the main indictments at Nuremberg—war crimes, crimes against humanity, and crimes against peace—the documentary makes the case for the prosecution, without considering the legal problems of victors judging the vanquished according to laws that did not exist when the crimes were committed.[3] Scenes of Hermann Göring running rings around Jackson in his cross-examination are not shown. Nor is any attention paid to Allied war crimes, such as the terror bombing of civilian populations, or to the fact that Stalin's Soviet judges were hardly in a position to represent impartial justice or to prosecute crimes against humanity. The main Soviet judge, Iona Nikitchenko, had presided over some of Stalin's worst show trials during the purges in the 1930s. He told his colleagues in Nuremberg that impartiality was just a waste of time. But challenging the Nuremberg trial in any way was the precise opposite of what the film was intended to do.

3. Even though war crimes were already a recognized category, crimes against peace, including conspiracy to wage aggressive war, and crimes against humanity were not.

Since this movie was supposed to have a universal message, it was slated to go into general release in the US and elsewhere. Even though the message of the film accorded perfectly with Jackson's views, he was worried about the use of Nazi propaganda material. Wouldn't it look too convincing to the uninformed viewer? "Unless," he said, "the audience is informed as to the falsity of the claims made in the propaganda films, the films really are what they were intended to be—good propaganda for Hitler."[4] It is difficult to see his point from our better-informed perspective today, but Jackson made sure that the films were carefully tailored to avoid giving Americans the wrong impression.

In the end, Americans were never shown the movie at all. It was good enough for the Germans, who flocked to see it in 1948 and 1949. But as the cold war began, Berlin was blockaded by the Soviets, the Marshall Plan gathered speed, and priorities changed. A new Communist enemy had to be faced. It was not expedient to stir up further American hostility against the Germans by paying too much attention to Nazi atrocities. Enthusiasm for war crimes trials began to wane in official quarters. And so, in the medium term, the line taken by the military government, that the lessons of Nuremberg should be confined to the Germans, won the day after all.

But now, after the cold war, the original purpose of the film has come back into its own, with an added twist of history. When it was made, and the trials were still going on, the persecution and genocide of the Jews were an important part of the Nazi story but not yet the crux of it. This was before the publication of Anne Frank's diary, before the Eichmann trial, before the Holocaust came to define evil in modern history or was even used as a common term at all. The

4. These quotes are in Sandra Schulberg's companion book with the DVD, *The Celluloid Noose* (2010), which contains the recollections of Budd Schulberg as well.

main purpose of the film was to warn the world against waging aggressive war. Now that the Holocaust is the most familiar and in many cases just about the only thing many Americans know about World War II, *Nuremberg: Its Lesson for Today* will largely be seen as a warning against racism. This is not necessarily a bad thing. It just shows how history lessons change with the times, regardless of the intentions of the people who originally conceived them.

———

One of the things Budd Schulberg turned up in the fall of 1948, from an archive in Soviet-occupied Babelsberg, site of the famous UFA movie studios, was a two-reel film shot by German cameramen in the Warsaw ghetto. Presumably this was from the same cache that was uncovered by East Germans less than ten years later, part of an unfinished Nazi movie made in 1942, entitled *Das Ghetto*. The ghetto occupied less than 3 percent of the city land. Some 450,000 Jews were squeezed into filthy tenements, often without water, heat, or sanitation. By the time the ghetto was liquidated in April 1943, 100,000 had died of hunger and disease. That the movie had been made for propaganda is clear. One of the surviving German cameramen, named Willy Wist, admitted as much during an investigation in the 1960s into the deeds of a former SS commandant of the "Jewish residential district." He said, "Of course we knew it had a propagandistic purpose." But he claimed not to have known what that purpose was. Since the film was never completed, we still don't know for sure.

The discovery, in the late 1990s, of outtakes from *Das Ghetto* revealed that many scenes in this "documentary" were actually staged. Over and over, neatly dressed Jews are made to walk past emaciated figures dying in the streets. Crowds are shown being violently dispersed by Jewish ghetto police wielding clubs. A plump

young woman posing as a waitress in a luxurious restaurant—filled with other carefully selected Jewish extras dancing and eating lavish meals—is filmed standing outside, ignoring a skeletal person begging for a scrap of food. Sleek gentlemen in fur coats are lined up next to people in rags. Men and women, casting terrified looks at the camera, are made to jump up and down naked in a ritual bath.[5] The diaries of Adam Czerniaków, head of the Jewish Council, describe how the Nazi film crew staged scenes in his own apartment, with someone impersonating him having meetings with men dressed up as Orthodox Jews.

The footage also contains horrifying scenes that we now know were part of daily life in the ghetto: whimpering children being forced by policemen to shake out a few bits of food from their ragged clothes, emaciated corpses being piled into mass graves. We almost never see any Germans, but it is enough to glimpse the faces of people passing the camera, full of terror and loathing, to know that they are there. As soon as the filming, which took thirty days, was over, Czerniaków was ordered to draw up lists of people to be deported to the camps. Almost none of them survived, including Czerniaków himself, who knew what awaited the victims and took a cyanide pill.

The question remains why this propaganda film was made, and why it was never finished. Turning one's own crimes into propaganda is, after all, an eccentric thing to do, even for the Nazis. Perhaps the Germans wanted to convince people that the terrible conditions in "Jewish residential areas" were the fault of the Jews themselves, of their rich and callous leaders, and of their brutal ghetto police. If even the Jews treated their own people like *Untermenschen*, then the

5. A book by Barbara Engelking and Jacek Leociak, *The Warsaw Ghetto: A Guide to the Perished City* (Yale University Press, 2009), reveals that the humiliation was carried even further: the petrified men and women were also forced to have sex.

Nazis had the perfect right to remove this blight from the world. Most probably it was something along those lines. But why did they feel the need to make this case? Why did they even wish to show the horrors of the ghetto in the first place?

It may have been part of the systematic humiliation of their victims, before rushing in for the kill. Such humiliation is often the prelude to mass murder: think of the Serbian rape camps in Bosnia, or the horrors visited by Hindus and Muslims upon one another in 1947, or the massacres in China, Cambodia, and Rwanda, among many other places. The desire to degrade people before killing them probably speaks against any notions of inherent "exterminationist" mentalities.[6] Rather, it suggests that people have to overcome certain barriers before they can exterminate fellow human beings willingly. First they must destroy their victims' dignity and reduce them to groveling wrecks, no longer quite human. The film may have been made with that purpose in mind. We know that the Germans treated the Warsaw ghetto as a type of zoo, with special tours laid on for curious visitors, who were permitted to lash out at the wretched victims with whips for their amusement.[7] Jews in the Warsaw ghetto came from all classes and nations. Some had been German citizens. The more the victim resembles the murderer, in culture and background, the greater the need for degradation, hence, possibly, the peculiar cruelty of civil wars.

One of the great merits of Yael Hersonski's *A Film Unfinished* is that she doesn't press any answers onto the viewer. She doesn't pretend to know precisely what the Nazis were thinking when they commissioned or made this awful film. Her aim is not to make a

6. The phrase was coined by Daniel Goldhagen in his book *Hitler's Willing Executioners: Ordinary Germans and the Holocaust* (Knopf, 1996).
7. See Engelking and Leociak, *The Warsaw Ghetto.*

particular political or moral statement, even though politics may have inspired a certain line of cinematic inquiry. Hersonski, an Israeli in her thirties, is after something else, which has to do with the nature of cinema, with being a witness, with recording reality, and how it affects filmmakers as well as the audience. In her own words:

> What I'm fascinated by is how [the Germans] documented their own evil. That's fascinating to me because there is this cliché, a truthful one, about filmmaking as an act of observing, like a peeping tom. It's not voyeurism, but standing there and staring.[8]

Having grown up with films and photographs of the Holocaust, she fears that we have become numb to the images of horror. She says, "I mean, we see it as far away, black and white images of history, as dry illustrations, as objective documentation—as allegedly objective documentation—like it got done by itself." What she demonstrates with great finesse is how subjective our perceptions actually are. She shows the same footage from utterly different points of view: that of the cameraman, Wist, whose recorded testimony is read by an actor (Wist died in 1999), and that of several survivors of the ghetto who are now living in Israel. We watch the survivors watching the film, sometimes covering their eyes when the pictures (or the memories) become too painful. Their comments are mixed with readings from ghetto diaries, including Czerniaków's.

The cameraman, an owlish-looking figure in glasses, whose own image suddenly appears in one of the outtakes of the ghetto streets, as though by accident, does not come across as a deliberate liar but as a man who lived his life in shocked denial. He was, in his own

8. See her interview, "How Yael Hersonski Finished 'A Film Unfinished,'" *The Clyde Fitch Report*, September 6, 2010.

word, "shattered" by the experience, and tried to distance himself from it as much as he could afterward. Aware of the "terrible conditions" in the ghetto, he claims that he never had any inkling of the ultimate fate awaiting the Jews. They themselves had no idea, he recalls with great conviction, even though his contacts with the Jews can hardly have been intimate. When it comes to Wist's own complicity in acts of sadism, such as the filming of naked people forced to humiliate themselves and others in the ritual bath, he hides behind technicalities, talking about the difficulty of filming in low light.

The survivors, filmed by Hersonski, mostly stare at the images in numbed silence, afraid, as one of them says, of recognizing her own mother in the crowd. One of the women can't bear to look at the piles of corpses being dropped into a great hole in the ground, like rubbish in a garbage dump. She explains that when she lived in the ghetto, as a young girl, she grew so used to such things that it hardly affected her anymore, except once, when she tripped over a corpse and found herself with her face pressed against the face of a dead man. The memory of her mother comforting her with the extraordinary luxury of a crust of bread and a speck of jam still brings tears to her eyes. And she cries now when she watches the film. "Today," she says, "I am human. Today I can cry again. I am so glad that I can cry and I am human."

And what about us, the viewers who were neither victims nor complicit in the crimes? In some ways, this is the most painful question raised by Hersonski's film, because there is an element of voyeurism in watching atrocities, whether we like it or not, and yet it is important to be reminded of man's capacity for inhumanity and not to forget what happened in the past. I can remember a debate in the German press almost twenty years ago, when an exhibition about the Holocaust was held at a villa in Wannsee, outside Berlin, the very spot where the logistics of genocide had been planned on a cold

morning in January 1942 by brandy-drinking Nazi officials. Photographs were displayed on the villa's walls of cowering women, stripped of their clothes, lined up in front of freshly dug pits in Poland and Lithuania moments before being shot. The pictures were taken by German killers, as mementos, one last humiliation before the murder of their victims.

Should we be watching this now? Should these women be humiliated once again by our gaze? Weren't we all being turned into peeping toms too? It was decided by the organizers of the exhibition that the importance of showing historical evidence, of making sure people didn't forget, was greater than the dangers of prurience. Hersonski, by making her film, clearly thinks so too. But implicitly, she takes the dilemmas of witnessing horrors further. Seeing what the Nazis did is one thing, but what about watching images of atrocities taking place in our own time? Mass murder and torture can now be seen in photography exhibitions, magazines, and movies, on the Internet, and even on the evening news.

Talking about her film, Hersonski made this link with the present quite clear: "What is my ethical position when I'm sitting very comfortably in my living room and seeing whatever is happening a few kilometers from my city in the occupied territories?" Her point is not that Gaza is like the Warsaw ghetto and she does not suggest that Israeli behavior can be compared to Nazi mass murder. The question is how we respond to images of human suffering, especially if we can be held in some way responsible:

Then what do you do as a witness? It's a terrible question—it's a haunting, torturing question. It's our essential question. I think that it was also a major reason why I made this film—because the Holocaust not only confronted humanity with an in-

conceivable horror but it also did mark the very beginning of the systematic implementation on film of that horror.

Hersonski believes that the bombardment of photographic images has numbed us. Others have thought this, and then changed their minds.[9] It was not a problem that occurred to the makers of *Nuremberg: Its Lesson for Today*. Filmed atrocities were still too fresh, too shocking. Perhaps this also explains why the Nazis refused to finish *Das Ghetto*. German audiences might have been so horrified by the images of Jewish suffering that the propaganda message, whatever it was, would have gotten lost. One hopes that this would have been the case. The impact of *A Film Unfinished* is surely sufficient proof that, even in our media-saturated age, filmed images can still move our feelings, if not necessarily create a better world.

9. See Susan Sontag's *On Photography* (Farrar, Straus and Giroux, 1977) and *Regarding the Pain of Others* (Farrar, Straus and Giroux, 2003).

10

ECSTATIC ABOUT PEARL HARBOR

YAMADA FUTARO (1922–2001) was a novelist, known in Japan chiefly for his mystery stories. He studied medicine before the war and was a voracious reader of European, mainly French, literature. Donald Keene, the éminence grise of Japanese scholarship in the US, was born in the same year as Yamada and shared his taste in French literature, though "Yamada probably read more of Balzac than I did." Even as Tokyo was being obliterated around him by B-29 bombers in early 1945, Yamada was reading Maeterlinck's *Pelléas et Mélisande*. Keene was in Okinawa then, and carried *Phèdre* in his knapsack.

And so, "in some ways," Keene observes, "we were alike." Which makes the diary entries of this bookish Japanese intellectual with cosmopolitan tastes all the more surprising. March 10, 1945:

> It won't be enough to drag down into hell an American for each Japanese who dies. We will kill three of them for each one of us. We will kill seven for two, thirteen for three. We can survive this war if every Japanese becomes a demon of vengeance.

Keene, who never hated the Japanese, even though he certainly looked forward to their wartime defeat, tries to find a charitable explanation for Yamada's bloodlust, and his own lack of it:

> Probably my lack of hatred was due, in part at least, to the fact that the Japanese had not destroyed the city where I lived, nor did I fear that they might occupy my country.

He adds that "the dropping of the atomic bombs profoundly shocked me."

Fair enough. Like more than 70 million other Japanese in March 1945, Yamada was facing the almost total destruction of his country. But there was more to it: he was convinced, long before the catastrophic end of the war, that without a passionate belief in *Yamato damashii*, "the spirit of Japan," his country was doomed. He had an exulted, heroic, quasi-religious view of national destiny, shared by many Japanese writers at the time (not only Japanese writers, of course, but they are the subject at hand). Keene, in his superb little book *So Lovely a Country Will Never Perish*, tries to figure out why.[1]

Why were so many writers and intellectuals in Japan ecstatic about the news of Japan's successful raid on Pearl Harbor? And they were not all right-wing fanatics either. Keene mentions a distinguished scholar of English and French literature, Yoshida Ken'ichi, son of the postwar prime minister Yoshida Shigeru. Ken'ichi (1912–1977) had studied at King's College, Cambridge, before the war, lived in Paris and London, and translated Poe, Baudelaire, and Shakespeare. Here he is, just after Pearl Harbor:

1. *So Lovely a Country Will Never Perish: Wartime Diaries of Japanese Writers* (Columbia University Press, 2010).

But even as we bask in this glory, what can we do apart from revitalizing our resolve? It is a vital resolve whose meaning we should ponder moment by moment....We need not fear even air attacks. The sky of our thought has been cleared of England and America.

This image of clearing skies, of clouds being lifted, is common in poems and diaries written at the time of Pearl Harbor. One reason is that the skies had been far from clear in the low decade of bloody campaigns in China that preceded it. The feeling was common that on December 8, 1941, Japan was at last fighting the real enemy. Whereas the war in China, officially designated in 1937 as the "China Incident," felt ignoble and deeply hypocritical, with all the propaganda of liberating Asia barely concealing mass murder, taking on the "Anglo-American beasts" felt like a noble, even glorious enterprise.

There was a racial element in this, born of a sense of cultural humiliation, experienced more strongly, perhaps, by intellectuals, especially Westernized intellectuals, than by most other Japanese. The greatest Japanese writer of the early twentieth century, Natsume Soseki (1867–1916), had warned his countrymen in 1914 that the speed and intensity of modernization along Western lines would lead to a collective nervous breakdown. In 1941, the breakdown appears to have been complete. Ito Sei (1905–1969), a poet and novelist who translated *Lady Chatterley's Lover* after the war, wrote on December 9, 1941:

This war is not an extension of politics or another face of politics. It is a war we had to fight at some stage in order for us to believe firmly, from the depths of our hearts, that the Yamato race is the most superior on the globe....We are the so-called

"yellow race." We are fighting to determine the superiority of a race that has been discriminated against. Our war is not the same as Germany's. Their war is a struggle among similar countries for advantage. Our war is a struggle for a predestined confidence.

And Ito, as Keene remarks, did not consider himself to be a fanatic (nor, clearly, was he very well informed about Nazi Germany). What his words reveal, of course, is a crippling lack of confidence, a feeling of humiliation that had turned lethal. In most cases, this wasn't lasting—at least not the lethal aspect. Yamada's overwrought cries for revenge, as late as 1946, were rare. Ito, as well as Yoshida, became a friend of Keene and spent a year at Columbia University on his recommendation.

Keene first came across wartime diaries, by Japanese soldiers, as a US Navy translator. These were often far from fanatical, or even particularly ideological. In Keene's words:

Reading the moving descriptions of the hardships suffered by men who probably died on some atoll in the South Pacific soon after writing the last entry made me feel a closeness to the Japanese greater than any book I had read, whether scholarly or popular.

Why, then, did he decide to concentrate on the accounts left behind by well-known literary figures? Keene's main reason is that they were simply better written than most. "The surviving diaries by 'unknown' Japanese," he writes, "tend to be repetitious because the writers usually lacked the literary skill to make their experiences distinctive." Besides, as he also explains, one can't read all the diaries of the time. So one might as well stick to real writers.

This raises questions upon which Keene does not choose to dwell: How representative were writers and intellectuals? Did they simply express popular feeling with greater skill? Or were their views and emotions perhaps too distinctive to illuminate what was in the thoughts and feelings of most "unknown" Japanese? There are no watertight answers to these questions, of course. For it is impossible to know what most people really thought at a time when expressing the unorthodox, even in diaries, could have dire consequences. The Thought Police, as well as one's neighbors and other busybodies, were constantly prowling around for subversive or defeatist elements.

Keene makes the important point that ultranationalism was not necessarily the result of provincialism or ignorance about the outside world. On the contrary, it was often precisely the people who had been most exposed to foreign experience who became the most rabid promoters of bellicose propaganda. In some cases this might be ascribed to disillusion: the idealistic worshiper of Western literature being offended in Europe or the US by social slights or mere indifference. The same phenomenon sometimes occurs in reverse, so to speak: the ardent Japanophile who blames Japan for not fulfilling unrealistic expectations.

Offense taken could explain the case, mentioned by Keene, of the poet and sculptor Takamura Kotaro (1883–1956). He adored the works of Rodin and studied in Paris, New York, and London, where he made friends with the potter Bernard Leach. He wrote disparaging poems about his fellow Japanese, which can only be described as racist: "Small-minded, self-satisfied / Monkey-like, foxlike, squirrel-like, gudgeon-like, minnow-like, potsherd-like, gargoyle-faced Japanese!" This was published in 1911. Here are some lines from another poem, written in 1914, inspired by Leach: "My friend of the Anglo-Saxon race I respect and love! / My friend of the race / That produced Shakespeare and Blake...." And this: "I became an adult in Paris. / In Paris

too I first touched the opposite sex, / And in Paris first found a liberation of my soul...."[2]

And yet, even then, the exultation was mixed with darker feelings. Takamura wrote in a letter (unsent) that "even amid the shouts of joy of Paris," he suffered every day "an anguish that is bone-deep." He couldn't understand "the white race." And the racial, as is so often the case, became sexual:

Even while I am embracing a white woman I cannot help wondering if I am not embracing a stone, hugging a corpse. I have often longed to drive a knife deep into a pure-white, waxen breast.

So Takamura's reaction to Pearl Harbor does not come as a complete surprise:

Remember December eighth!
On this day the history of the world was changed.
The Anglo-Saxon powers
On this day were driven back on East Asian land and sea,
It was their Japan that drove them back,
A tiny country in the Eastern Sea,
Nippon, the Land of the Gods
Ruled over by a living god.

The point here is not the particular quasi-religious mania that is being espoused in this poem. What is interesting—and not limited to Japan—is the deep longing among certain writers and intellectuals to

2. From Keene's *Dawn to the West: Japanese Literature in the Modern Era* (Holt, Rinehart and Winston, 1984), pp. 295, 301, and 302.

identify with a people, a cause, or a faith. This longing was especially acute in the early twentieth century among Japanese writers who came back to Japan from Western sojourns terrified of being marginalized, or even cast out, for being deracinated, for having lost the purity of their Japaneseness. They needed to rid themselves of the taint of cosmopolitanism. This lends an edge of hysteria to the writings of such figures as Takamura or Noguchi Yone (father of the Japanese-American sculptor Isamu Noguchi), which might not have been quite so prevalent among more ordinary Japanese.

One should always be wary of comparisons that sweep too broadly across different cultures and times, but it might not be too far-fetched to detect a comparable psychology at work in highly educated American intellectuals who express a deep admiration for Sarah Palin. Posing as the voice of the "real" people (as Palin might put it) is comforting, and often a bid for power. Thinking for oneself can be a lonely business. In wartime Japan it was also very dangerous.

For Japanese, born in a relatively isolated country at a time when the cultural inferiority of Asians was widely assumed, even among many Asians themselves, the hunger for identification with the nation, or "race," and for proof of their superiority was especially sharp. Such feelings are not unique or even hard to understand. What is more difficult to fathom is how intelligent, educated people could justify intellectually their sudden switches from worldly cosmopolitanism to chauvinistic mania, and then, just as suddenly, back to liberalism after Japan's defeat in 1945.

Some writers never joined this roller-coaster ride, to be sure. Keene quotes extensively from the justly celebrated diaries of the great short-story writer Nagai Kafu (1879–1959). Kafu (Japanese commonly refer to him by his first name, as a sobriquet) despised the militarists in the 1930s and had nothing good to say about nationalist propaganda during the war: "This is a case of inept sentiments in

inept language." Kafu, like Noguchi and Takamura, had lived abroad, in the US and France,[3] and was an expert in French literature and a lover of French wines and Scotch whiskey, the supplies of which, to his great annoyance, ran out during the war. He lost his house and all its contents in a bombing raid. But he never blamed the foreign enemies for the destruction of his country. December 31, 1944: "It's entirely the doing of the [Japanese] military. Their crimes must be recorded for all time to come."

One reason Kafu retained his cool was his utter disinterest in being a joiner. Although he came from a well-off family, had early literary success, and taught French literature at a first-rate university, Kafu had already turned his back on the academic and literary worlds before the 1920s. He was happiest in the company of strippers, prostitutes, and geisha. His reputation as a distinguished eccentric settled, Kafu could afford an attitude of sardonic detachment.

There were a few others, quoted by Keene, who shared Kafu's disdain for militarist posturing from the beginning. Watanabe Kazuo (1901–1975), a professor of French at Tokyo Imperial University, was one. He cursed "those who have swelled our people's pride. This is the source of all our unhappiness." Kiyosawa Kiyoshi, a journalist who had been partly educated and had worked in the US, was another.[4] The most interesting diaries, however, are by writers who expressed doubts, while still going along with the prevailing mood. Their risky introspection exposes the tension between the natural skepticism of a thinking person and the desire to escape from isolation and join the crowd.

Takami Jun (1907–1965) was such a man. Like Kafu, Takami

3. His *American Stories*, translated by Mitsuko Iriye (Columbia University Press, 2000), are well worth reading.
4. His diary has been published in English: *A Diary of Darkness*, edited by Eugene Soviak, translated by Eugene Soviak and Kamiyama Tamie (Princeton University Press, 1999).

found inspiration for his pre-war writings in the raffish milieu of Tokyo's plebeian pleasure districts. If Kafu's lyrical descriptions expressed a nostalgia for fading or already long-faded brothel areas, Takami's stories celebrated the lives of common people in contemporary Tokyo. It is as though, in his imagination at least, he wished to be one of them. In 1933, he had been tortured by the police as a suspected Communist. During the war, Takami traveled to China and Southeast Asia as an army correspondent. Not a fanatical nationalist like Ito or Noguchi, he identified with the suffering and fortitude of ordinary people, though not so much, it must be said, of ordinary Chinese or Southeast Asians.

When the war ended, an event that Kafu celebrated by drinking into the night with friends, Takami wrote:

I was not one who wished for the defeat of Japan. I am not happy about the defeat. I wanted Japan to win somehow, and to this end exerted my meager strength in my own way. Now my heart is filled with great sorrow. It is filled with love of Japan and the Japanese.

At the same time, Takami was happy that writers could express themselves more freely again. Despite his patriotism, he had always loathed the censorship and other restrictions of militarist authoritarianism. As soon as the war was over, he analyzed the reasons why he had failed to resist it. It is one of the clearest and most honest testimonies to the anguish of being a skeptic living under dictatorship that I have read:

I would not say now that my work up to the present has been a total lie, but I can say that under the restrictions, which grew worse by the day, I wrote nothing that was not a product of

self-deception, a soothing of my conscience, a forcing of myself to go forward in a direction not in my heart, an endurance with clenched teeth.

And yet his very sense of relief, even joy, about freedom regained made him feel ashamed, as though he were betraying his long-suffering compatriots. "During the war," he wrote,

> things were so terrible, what with the indiscriminate pressure against freedom of speech, the despotism of some Japanese... that I often thought that if we won the war it would be terrible.... But now that I am confronted with the reality of defeat, I cannot but be ashamed of those feelings of mine.

The reality of defeat, especially among male Japanese, provoked all the old feelings of humiliation that blended the sexual with the racial: the sight of Japanese women, by no means all prostitutes, flinging themselves at tall, well-fed, smartly dressed American soldiers for a pack of Lucky Strikes or a pair of silk stockings; the swaggering GIs taking up all the seats on overcrowded trains; and so on. Kafu, as usual, took all this in his stride, and expressed his characteristic interest in the going rates for sex in the new pleasure districts catering to foreign troops. Observing some American officers trying to speak a little Japanese to a bar girl at a Tokyo hotel, he contrasted their courtesy to the thuggish behavior of Japanese officers in China.

Takami, too, wrote about the way local women took to the alien occupiers. Less detached (or indeed prurient) than Kafu, he was shocked at first when he saw a Japanese woman carrying on with her American lover at a railway station, publicly, loudly, without any embarrassment. A seemingly ordinary woman, she looked "proud to

behave shockingly with an American soldier even when surrounded by watching eyes. Such sights might, unexpectedly soon, cease to seem unusual." But then Takami thinks again: "It would actually be a good thing if that happened very soon. Best of all would be a deluge of such sights. It would be good training for the Japanese!"

This, as Keene points out, was not a common reaction. As he says:

> For most Japanese men (including Takami a short while earlier), the sight of a Japanese woman behaving immodestly with an American soldier was the least welcome feature of the Occupation.

This was no doubt true, but most Japanese took to the freedoms installed by the unexpectedly benign Allied occupation with gusto: suffrage for women, the relatively free press (relative because criticism of the Allied occupiers, or even the US itself, was banned), democratic education, scenes of kissing in the movies, jazz music, independent labor unions, land reform, and much more. In fact, the speed with which the Japanese turned from emperor-worshiping chauvinism to Yankee-style *demokurashii* shocked some intellectuals and was another source of shame. Why did it take a horrendous military defeat and a foreign occupation to liberate the Japanese? Why couldn't they have done it themselves? Was the very alacrity of change not a sign that freedom in Japan was just skin-deep?

Here is Takami:

> When I think back to the fact that freedom, which naturally should have been given by the people's own government, could not be given, and instead has been bestowed for the first time by the military forces of a foreign country occupying their own, I cannot escape feelings of shame.

Yamada Futaro, the same man who called for vengeance after the defeat, watched the transformation of his country with a degree of skepticism, precisely because he himself had allowed irrational passions to cloud his better judgment during the war:

> I suppose that the new tone in the newspapers will soon completely change the Japanese view of the war and their view of the world. The more fervently a man embraced supralogical thought up to now, the more he will be engulfed in the new wave, and he will lose himself in it because it stems from emotionally the same temperament.—The same human being who thought of enemy soldiers as demons and who ran about frantically killing them, before a year has passed will look on himself as a world criminal and begin to feel blind faith in "peace" or "culture."

One sees what he means. And Yamada was not entirely wrong. But this cannot be entirely right either. The "temperament" that embraces personal and political freedoms is not quite the same as the collective hysteria of a people at war, who would be cruelly punished for any sign of nonconformism. The comforts, such as they are, of conformity in a dictatorship don't stem from quite the same source as the more testing challenges of freedom.

It is also a little too flattering to the American occupiers to view the transformation of postwar Japan as a kind of religious conversion. Many Japanese had been fighting for almost a century for more democratic institutions, freedom of expression, and social equality. For much of the 1920s, the Japanese government, though far from being perfectly democratic, was more liberal than any other government in Asia, almost all of which was ruled by colonial regimes. What embarrassed Takami, Yamada, and other writers was probably

not just that intellectuals had been unable, or unwilling, to stop their country from sliding into militarism (and indeed were quite willing to promote it) but the added humiliation that they played a less important part in the democratic restoration than they might have wished.

For it was not just "the military forces of a foreign country" that liberated the Japanese. Much of the credit for this must also go to Japanese politicians, activists, bureaucrats, schoolteachers, and labor union leaders. One of the lessons of the postwar changes in Japan, and West Germany, is that "democratization" cannot work without the active participation of able local elites and the consent of the majority of "unknown" people. Writers, artists, scholars, and journalists can make a difference. Watanabe Kazuo, the professor of French, was not wrong to castigate his fellow intellectuals in 1945 for their lack of moral backbone under militarism. He was right to say that "intellectuals should be strong and courageous in order to protect the freedom to think and the integrity of thought."

But it is a common feature of intellectuals everywhere to overrate their own political importance. More depressing, however, is the fact that writers and scholars, regardless of their superior literary skill or knowledge, are no less prone to following fashions and promoting their rulers' vain and destructive campaigns for national or military glory than other people. As Keene has demonstrated in his admirable book, this was certainly true of Japanese intellectuals in the dark years of the last century. But it is a lesson from which intellectuals in other countries, often operating under far less difficult circumstances, can derive equal profit.

11

SUICIDE FOR THE EMPIRE

IMAGINE WHAT IT must have been like to be squeezed into a human torpedo loaded with three thousand pounds of TNT, or into the cockpit of a flying bomb, and crash into a ship at six hundred miles per hour, if one is lucky, or suffocate slowly inside a tight steel coffin if the target has been missed. As a military tactic adopted by the Japanese at the end of 1944, suicide bombing did considerable damage to the US Navy. Ships were sunk; many Americans lost their lives. And the attacks left a terrible mess. A witness recalls:

> After the sailors had thrown overboard the hunks of metal that remained from the attacking planes, they began hosing down the decks, and soon the water was red with blood. Here and there they found shreds of flesh and other remains from the bodies of the Japanese pilots—tongues, tufts of black hair, a brain, some arms, a leg. One sailor triumphantly hacked off a finger and removed a ring. Before long the decks were clear.[1]

1. Quoted in Ivan Morris, *The Nobility of Failure: Tragic Heroes in the History of Japan* (Holt, Rinehart and Winston, 1975), p. 294.

But suicide bombing, horrible as it was, did nothing to stave off Japanese defeat. Perhaps it wasn't really meant to. It was more like a deadly theatrical gesture, a horrendous face-saving device, aimed at the Japanese themselves more than their enemies. Vice Admiral Onishi Takijiro, who introduced this practice, admitted as much to the first kamikaze unit in 1944. He said, "Even if we are defeated, the noble spirit of the kamikaze attack corps will keep our homeland from ruin. Without this spirit, ruin would certainly follow defeat."[2] Onishi committed suicide the day after Japan surrendered. But his message resonates even now at kamikaze memorial museums in Japan, where schoolchildren are still told that the young suicide pilots sacrificed their lives for the peace and prosperity of future generations.

Who were these young men who volunteered, sometimes but not always under considerable duress, to die in this ghastly manner? On the surface, the kamikazes, or Special Attack Forces (Tokkotai), bore a certain resemblance to suicide bombers today, even though they never targeted civilians—a considerable difference. Their public declarations about purity, noble sacrifice, and the conviction of a heroic afterlife suggest a similar kind of religious zeal. And they were dying for a country that was fighting a war against the West, not only for economic or political reasons but, according to Japanese propaganda, for spiritual and cultural reasons too.

In fact, however, a closer look at the Tokkotai turns some currently received views of suicide tactics upside down. Suicide bombing, in Palestine, Israel, or New York, is often seen as an act of desperation, bred from oppression (by Israel, US imperialism, corporate globalization, or whatnot), but also from ignorance and the humiliating failure of Muslim societies to adapt to modern civilization, that is,

2. Quoted in *The Nobility of Failure*, p. 284.

scientific, secular, universalist, post-Enlightenment civilization, usually described as Western. The implication of this view is that suicide bombing is an atavistic act typical of a premodern society.

The kamikaze pilots may have been at war with the West, but despite their frequent references to ancient Japanese traditions, the samurai spirit, and all that, they were in fact typical products of modern civilization, and as steeped in European and American culture as educated Westerners of their class and age, perhaps even more so. Some of them were Christians. Not just that, but the nation they chose to die for had been, for at least half a century, a model of modern development, much of it diligently copied from the West.

It is of course possible that the Western-style modernity of twentieth-century Japan and its brightest young men was just a veneer, a phony piece of mimicry with no authenticity or substance. Perhaps a fanatical samurai, in thrall to ancient codes and fierce ancestral gods, was always ready to jump out from under the polished surface of every graduate of Tokyo Imperial University. But I rather doubt that things were so simple. Consider Sasaki Hachiro, one of the student suicide pilots featured in Emiko Ohnuki-Tierney's book *Kamikaze, Cherry Blossoms, and Nationalisms*.[3] Like many Tokkotai volunteers he was a student at one of Japan's top two universities: Tokyo Imperial University (the other was Kyoto Imperial University). It was also typical that he was a humanities student. Engineers and the like were deemed to be less expendable in a country at war and thus not asked to volunteer for an early death.

Sasaki was a keen reader of, among others, Engels, Marx, Schopenhauer, Bentham, Mill, Rousseau, Plato, Fichte, Carlyle, Tolstoy, Romain Rolland, Erich Maria Remarque, Weber, Chekhov, Wilde,

3. *Kamikaze, Cherry Blossoms, and Nationalisms: The Militarization of Aesthetics in Japanese History* (University of Chicago Press, 2002).

Mann, Goethe, Shakespeare, Tanizaki, Kawabata, and Natsume Soseki. This short list was not unusual for a Tokkotai. Ohnuki-Tierney mentions a suicide pilot who read not only as widely but in English, French, German, Italian, and Sanskrit too. Others wrote their wills in French and German. Certain authors—Heidegger, Fichte, Hesse—come up in most of the young pilots' reading lists, which reveal a common taste for German idealism. Death, for obvious reasons, is a much-quoted subject in Tokkotai diaries and letters, hence the interest in Kierkegaard and Socrates. And Goethe's *Faust*, too, was much read.

Far from being a fanatical militarist, Sasaki had been against the war from the beginning and deplored the vulgar gloating over Japanese victories in China. Nor was he taken in by emperor worship, which official propaganda had whipped into a frenzied national cult. But he *was* an idealist and a patriot. What makes his and other cases analyzed by Ohnuki-Tierney so fascinating is that the romantic patriotism of these Japanese warriors in the last ditch was filtered through and often expressed in the language of Western thinkers.

Sasaki, like some other Tokkotai, considered himself a Marxist. Although he was appalled by the Japanese war in China, he thought the war against the US and Britain was justified, because they were the homelands of evil capitalism. Japan, too, of course, had been infected by the capitalist poison. He wrote:

> If the power of old capitalism is something we cannot get rid of easily but if it can be crushed by defeat in war, we are turning the disaster into a fortunate event. We are now searching for something like a phoenix which rises out of ashes.

Sacrificing his life, then, was a way to save his country, a show of spiritual purity that would usher in a better, more equitable world.

Such a spiritual task could not be left to ignorant soldiers. It had to be done by the best students. Ohnuki-Tierney shows how common this kind of thinking was among the Tokkotai. She argues that military authorities had deliberately exploited the youthful idealism of these elite students. This is no doubt true, but the speech by Vice Admiral Onishi in 1944 suggests that at least some of the military officers shared their idealism. Marx is unlikely to have been the vice admiral's bedside reading, but his view that only a show of sacrificial spirit would save Japan from ruin was no different from Sasaki's. And right-wing nationalists were as anticapitalist as the Marxist intellectuals, which is why some Marxists found a niche in the Japanese empire, especially in Manchukuo, the puppet state in northeastern China.

The symbolism surrounding the Tokkotai was not all European, of course. The short-lived beauty of the cherry blossom is an ancient symbol of evanescence, though not, as Ohnuki-Tierney rightly observes, of military self-sacrifice. So the suicide planes were called *oka*, or cherry blossoms. And the suicide pilots had cherry blossoms pinned onto their uniforms. Before their final sorties, Tokkotai would often sing a song set to an eighth-century poem, which went:

In the sea, water-logged corpses,
In the mountains those corpses with grasses growing on them
But my desire to die next to our emperor unflinching.
I shall not look back.

The idealization of early death and self-sacrifice is present in many, perhaps in most cultures. In the history of Islam, it belongs to a rebellious tradition, of assassins and purist sects. This is true, to some extent, in Japan as well. Suicidal last stands are associated with reactionary lost causes and sincere rebels. The much-cited hero of

many Tokkotai was a fourteenth-century samurai named Kusunoki Masashige, who committed suicide after losing a battle for the old imperial dynasty against a new, more vigorous regime. Another heroic model was Saigo Takamori, the champion of samurai values in a rapidly Westernizing society, who led a hopeless rebellion in 1877 against the Meiji government, and then killed himself. His followers—samurai who had lost their old privileges in the modern state—marched to their deaths singing the following words (translated by Donald Keene):

> *We've reached a point we can take no more*
> *We warriors can only do our utmost*
> *To save tens of thousands of people,*
> *Today our last, on the road to the other world.*

What all these heroic last stands have in common is a romantic ideal of recovering ancient purity from modern corruption. In the same song, quoted above, Saigo's samurai reviled the traitors who "sold our country to the dirty foreigners." This is not a uniquely Japanese idea. In line with a number of fashionable modern theorists, whose words she is much too fond of quoting (with such fascinating material at hand, why drag in Pierre Bourdieu at every opportunity?), Ohnuki-Tierney points out, over and over, how the Tokkotai symbols, the cherry blossom, the hero worship, the cult of self-sacrifice, the beauty of violent death, and so on, are all modern constructs and distortions. True enough. But that is in the nature of all culture, modern or not. To think otherwise is to assume the existence of some untouched source of purity. For a modern construct to be convincing, there has to be something in the history of a culture to exploit.

The culture that produced Sasaki and his fellow Tokkotai was a

fusion of Japanese, Chinese, and Western ideas and aesthetics. One cannot usefully disentangle them to identify the purely native, even though nativists still claim that they can. Nor can we take Tokkotai references to Japanese traditions at face value, for such references were often compulsory. The wills of many Japanese were couched in heroic cherry-blossom phrases. But as one Tokkotai, quoted by Ohnuki-Tierney, put it in a letter home: "Of course, we could not say what we really thought and felt. So we had to lie. It was taboo to express our true thoughts."

Who knows whether Marx or Socrates were bigger influences on Tokkotai than Saigo, but the extraordinary fusion of East and West, which shaped the culture of modern Japan, produced one of the most sophisticated, economically successful, artistically rich countries in the modern world. The question is how all this creative energy turned into such an orgy of self-destruction. Possible answers must lie somewhere in the story of Japan's effort to adopt the "civilization and enlightenment" of the modern West, the story of the Meiji Emperor's Japan.

The Meiji Emperor, known to foreigners as Emperor Mutsuhito, was only fifteen when he was suddenly plucked, in 1868, from the cloistered world of the imperial court in Kyoto to become the central figure of the new Japanese state. This is what he looked like then, in the description of an English interpreter, quoted in Donald Keene's book about the emperor:

> He was dressed in a white coat with long padded trousers of crimson silk trailing like a lady's court-train. . . . His eyebrows

were shaved off and painted in high up on the forehead; his cheeks were rouged and his lips painted red and gold. His teeth were blackened.[4]

But in 1871, a mere three years later, he was shaking hands with foreign dignitaries at Western banquets in Tokyo. Soon after that he had an elaborate Western-style uniform designed for him. He even remembered to adopt that peculiar foreign custom of smiling in public—with foreigners, of course, never with Japanese.

Keene does a heroic job of painting a personal picture of the Meiji Emperor, which is an impossible task. Even after seven hundred–odd pages, we don't really know what he was like, apart from the fact that he drank too much, liked the company of concubines, was a stickler for detail, and, like Neville Chamberlain, disliked meeting foreigners but was unfailingly polite to them. Keene depends a great deal on a multivolume court chronicle, the *Meiji tenno ki*, which is a dubious source of veracity. No doubt, as Keene points out, Japanese men cried a lot more in those days, but the number of times the nobility of the emperor's character reduces courtiers and politicians to tears must surely be an exaggeration.

Keene's book, however, is also about Meiji's world, and specifically about the astonishing band of provincial samurai, later known as the oligarchs, who engineered the Meiji Restoration of 1868, and built the modern Japanese state. Such men as Ito Hirobumi, Yamagata Aritomo, and Matsukata Masayoshi, all of whom served as prime minister, were the architects of Japan's new central government, the constitution, the modern armed forces, the education system, and much else that went with *bunmei kaika* (civilization and enlightenment). The other slogan of the time was *fukoku kyohei* (rich

4. *Emperor of Japan: Meiji and His World, 1852–1912* (Columbia University Press, 2002).

country, strong army). The two slogans were, of course, conceptually linked.

One of the interesting aspects of Keene's book, which is stronger on description than on original ideas (and those descriptions of court protocol can be tedious), is the emperor's personal involvement in political affairs. The privy council, which Ito presided over for some time, was one of the most powerful ruling institutions. Like his grandson, Hirohito, the emperor dutifully attended its meetings and was directly involved in the appointment of his government ministers.

But his main significance was still symbolic, as a constitutional monarch and a sacred figure, half kaiser and half pope with bloodlines that supposedly went back to the Sun Goddess. The imperial institution was the national church, as it were, which gave religious sanction to the political arrangements of his time. The emperor personified the nature of the modern Japanese state: hence his interest in military matters, the quasi-traditional Shintoist mystique, and the speedy costume change from ancient Japanese court dress to a Western-style uniform. His Western style was meant to convey to the world the progressive, modern nature of the Japanese state. The Japanese tradition, tailored for this purpose, was meant to give the Japanese a sense of reverence and continuity in a world of lightning change.

Ohnuki-Tierney calls the Meiji oligarchs "intellectual cosmopolitans" who built the Japanese state as a fortress against Western colonialism. This is a fair way of putting it. Ito Hirobumi and his colleagues, including the very conservative Yamagata Aritomo, were passionately interested in Western ideas. They traveled to Europe and the United States, shopping around for models of the ideal modern state. The Meiji Constitution was modeled after the Prussian one, though an article was added about the "sacred and inviolable" nature of the emperor. The armed forces followed French and British examples. Education was organized along French lines. And from

elementary schools to the top universities, the doors had been opened wide to all manner of European and American influences.

Keene describes a visit of the emperor to a rural elementary school in 1876. The emperor, whose education included a close reading of Samuel Smiles's *Self-Help*, was nonetheless taken aback when he heard Japanese schoolchildren recite Andrew Jackson's speech to the Senate and Cicero's attack on Cataline. In just the same way, many conservatives were annoyed when the Japanese elite held fancy dress balls for foreign guests. The idea of Ito dancing polkas and waltzes dressed up as a Venetian was not universally approved of, even if, like the adoption by educated Meiji men of Western clothes, it was meant to show foreigners that Japan was a serious modern country, worthy of their respect.

Alas, however, for the more liberal and pacific-minded Japanese, the quickest way to gain respect for a modern nation in the late nineteenth century and to stave off Western colonialism was to win wars and build an empire of its own. Here, too, Meiji Japan was amazingly successful. In 1895, the Japanese army, though vastly outnumbered, managed to humiliate China and acquired Taiwan as its first colonial spoil. Even more astonishingly, in 1905, Japan became the first modern Asian state to win a war against a European power, imperial Russia.

The Sino-Japanese War in particular was seen by most Japanese, even the liberals, as a blow for progress against a backward, decadent nation. Popular woodblock prints of the war show the Japanese as long-legged, pale-skinned heroes, and the Chinese as pigtailed little yellow men. Keene quotes Uchimura Kanzo, a free-thinking Christian, who later became a pacifist and bravely defied the excesses of Japanese emperor worship: "Japan is the champion of Progress in the East, and who, except her deadly foe, China—the incorrigible hater of Progress—wishes not victory for Japan!" The racist con-

tempt for Chinese and other Asians, later to explode in such atrocities as the Nanking Massacre, began at this time, in the name of progress, civilization, and enlightenment.

It was not entirely by chance that Japan's victory over Russia should have coincided with the British agreement to finally end its extraterritorial privileges in Japan. The "plucky Japanese" were enormously admired for their military prowess, not only in Britain but in the US. President Theodore Roosevelt said he was absolutely "pro-Japanese," because Japan was fighting for civilization. Victory in 1905 prepared the way for Japan's gradual colonization of Korea. This, too, was done in the spirit of progress. It was Japan's duty, after all, as the most advanced Asian nation, to benefit its backward neighbors with the firm smack of discipline.

At home, in Emperor Meiji's Japan, progress was more open to question. Even though Japanese authorities (following the Chinese example) had done their best since the mid-nineteenth century to reserve "Western learning" for purely practical matters, such as building guns and battleships, and to preserve Sino-Japanese thought for ethics, morality, and social order, this didn't really work. With Western ideas came demands for more democracy and civil rights. Exposure to European literature and philosophy encouraged individualism and a different perspective on sex and romantic love. Industrialization brought millions of rural people to the cities and changed social relations in the countryside. Political parties were formed. Critical journalism started to appear. And a national movement for civil rights began to spread fast.

By 1890 the forms of parliamentary democracy had been adopted as another badge of modern progress, like colonialism abroad. But all this made the Meiji oligarchs nervous. Their worry was how to control the forces they had unleashed, how to create a modern nation without being hindered by the "selfish" interests of party politicians

or the subversive influence of socialists and other dissenters. Even Ito Hirobumi, a relative liberal among his peers, was dismayed by what he saw as the unruliness of American and British politics. French republicanism was hardly a suitable example either. The newly unified German state, held together by a strong monarchy, authoritarian government, military discipline, and mystical ethnic nationalism, was by far the most congenial model.

Ito rather fancied himself as the Japanese Bismarck, and was impressed by such Prussian jurists as Rudolf von Gneist and Lorenz von Stein. What emerged was a German-Japanese concoction in which Stein and others had a hand. The following words by Ito, quoted by Ohnuki-Tierney, go to the heart of the matter:

> Under the great teachers, Gneist and Stein, I have come to understand how to conceptualize the basic structure of the nation. The cardinal point is to strengthen the imperial foundation and safeguard his sovereignty as indissoluble. There is a tendency now [in Japan] to regard the writings of radical liberals in England, the United States and France as the golden threads, but they will lead our country to decline.

It was Stein who advised the Japanese to make Shinto into a national religion, which would supply the reverential ceremonies of the imperial court and hold the nation together. Where such ceremonies didn't exist, they were invented. This was not so different from Victorian England. But the mixture of Teutonic legalism and Japanese nativism laid the foundation for an authoritarian, militarist state, whose highest authorities became almost impossible to challenge because their decisions were wrapped in the priestly mantle of divine kingship.

Keene mentions, rather summarily, the two imperial rescripts, or

decrees, that had a particularly disastrous effect on Japanese politics until the very end of World War II. First, in 1882, came the Imperial Rescript to Soldiers, drawn up by the architect of the modern armed forces, Yamagata Aritomo. The idea was to remove soldiers from politics. Their loyalty was not to the civilian government but to the emperor, their "supreme Commander-in-Chief." They were his "limbs" and he was their "head." It went on:

Do not be beguiled by popular opinions, do not get involved in political activities, but singularly devote yourself to your most important obligation of loyalty to the emperor, and realize that the obligation is heavier than the mountains but death is lighter than a feather.

This was one of the pillars of the Meiji state, which took the traditional loyalty of samurai to their feudal lords and focused it on the emperor alone. The rescript made the duty to sacrifice one's life for the emperor official. Designed to take the military out of political affairs, it actually introduced a dangerous political element. For if a soldier's loyalty was solely to his commander in chief, then it was legitimate to rebel against civilian politicians who were seen as a threat to his divine authority. This would lend justification to all kinds of attempted coups d'état and assassinations by military fanatics, especially in the turbulent 1930s.

While the unofficial coups, led by middle-ranking army hotheads, were crushed by the authorities, top military officials also used imperial propaganda first to undermine and then to destroy the authority of civilian politicians. By 1932, political parties were excluded from the cabinet, and military decisions were taken by a Supreme War Council, made up entirely of military figures. By the late 1930s, the Japanese Imperial Army was ready to carry out its version of the

emperor's will and gather China and eventually the rest of Asia under one imperial roof.

The second Imperial Rescript, on education, was handed down by the emperor in 1890. Much discussion among the oligarchs and their advisers had preceded it. All were united in the worry that Westernization had gone too far, or at least had to be countered by an official dose of traditional morality. Some stressed the importance of Shinto, others, including the emperor himself, of Confucianism. The rescript begins with a solemn statement about the founding of the empire by "Our Imperial Ancestors," and goes on to say that loyalty and filial piety of the emperor's subjects are the unique characteristics of his empire. In the neo-Confucian tradition, people are taught to obey their fathers and social superiors. The Meiji Emperor's subjects were told to "offer [themselves] courageously to the State; and thus guard and maintain the prosperity of Our Imperial throne coeval with Heaven and Earth."

Nationalism, then, based on neo-Confucian notions of obedience and Shintoist ideas of ancestral purity, was the basis of modern Japanese education. All Japanese were expected to bow to copies of the rescript, which was treated, quite literally, as holy writ. Again, there were elements of this kind of thing in European monarchies too, but Meiji nationalism was designed to destroy the substance of democratic politics with cultural propaganda. Instead of the legitimate contest among different political interests, the Japanese political space was filled with exhortations to be loyal, united, and obedient, and, above all, to worship the emperor.

If the emperor had actually been an absolute monarch or a military dictator, the system would at least have been coherent, but the Meiji Constitution was vague about political authority. The emperor was invested with absolute sovereignty without clearly defined government powers. The famous political theorist Maruyama Masao

later characterized the Japanese emperor as a sacred shrine carried on the shoulders of the men who ruled in his name. This worked quite well under the Meiji oligarchs, because they at least knew where they were heading and had the authority to keep the turf battles of court, parliament, and the armed forces under control. After they passed from the scene, no one inherited their authority, and these institutions were at each other's throats most of the time. Once the imperial shrine had been hijacked by military leaders in the 1930s, it ran amok without anyone being able to stop it.

Keene concludes his mammoth study by stating: "Emperor Meiji definitely left behind the footprints of a great monarch." Well yes, perhaps. But he also left behind an important lesson for developing societies. Contemporary China springs to mind. It is dangerous to modernize economic and military institutions without political reforms that lead to genuine popular sovereignty. Westernization without guarantees of political freedom makes no sense.

The great Meiji novelist Natsume Soseki warned his countrymen that the combination of nationalism and slavish imitation of the West would lead to a national nervous breakdown. He was not far wrong. The effect of Japan's particularly virulent brand of authoritarian modernism was especially hard on the educated young. Their heads filled with Marx, Kierkegaard, and imperial propaganda, they were confused about their proper role in a quasi-totalitarian society. Where was a bright idealistic graduate of Tokyo Imperial University to turn when his country took on the world in the 1940s? He could become an extreme nationalist, a Communist martyr, or he could go down in flames as a human bomb, hoping his spirit would save the nation. So we should pity the poor Tokkotai. Their likes will not be seen again. For they were the last representatives of the very best of Meiji culture, and the modern empire's final sacrificial victims.

12

EASTWOOD'S WAR

A COMMON FACTOR in conventional war movies, whether they are made by Americans, Europeans, or Asians, is the lack of visible enemies. They are there, in the way Indians were there in old westerns, as fodder for the guns on our side, screaming *Banzai!* or *Achtung!* or *Come on!* before falling to the ground in heaps. What is missing, with rare exceptions, is any sense of individual difference, of character, of humanity in the enemy. And even the exceptions tend to fall into familiar types: the bumbling or sinister German, hissing about ways to make you talk; the loud, crass American; the snarling Japanese.

Colonel Saito, the camp commander in *The Bridge on the River Kwai* (1957), played by Sessue Hayakawa, shows some personal qualities, but they still fall within the well-trodden domain of the stoic samurai, growling his way to the inevitable ritual suicide. Then there are the epic battle films, such as *Tora! Tora! Tora!* (1970), about the attack on Pearl Harbor, jointly directed by an American (Richard Fleischer) and two Japanese (Fukasaku Kinji and Masuda Toshio). We see historic figures barking orders on the bridges of aircraft carriers and the odd Japanese pilot baring his teeth as he approaches the USS *Arizona*, but there is no time in the midst of all the gunfire for intimacy.

There are reasons for this lack of enemy characters, both practical and propagandistic. It was hard in Hollywood, until recently, to find enough competent actors to play Japanese roles (or Vietnamese for that matter). Japanese soldiers were usually played by an assortment of Asian-Americans who shouted a few words in barely comprehensible Japanese. Hollywood could have done better but too few people cared. If finding convincing foreign actors was not easy in California, it was even harder in Japan. American soldiers in wartime Japanese propaganda films were often played by White Russians who hardly spoke English. Sometimes Japanese actors with wax noses and blond wigs had to do. And the stock GI in postwar Japanese movies, raping local girls and stomping across the tatami floors in his boots, is usually played by any available white male in need of some easy cash. The same principle holds for Chinese movies, by the way, where most "Japanese devils" speak in heavy Chinese accents and Americans in every accent known to Caucasian man.

The propagandistic reason is perhaps more important than the practical one. Most war movies have been about heroes, our heroes, and individual differences among the enemies were irrelevant because their villainy could be taken for granted. In fact, showing individual character, or indeed any recognizable human qualities, would be a hindrance, since it would inject the murderousness of our heroes with a moral ambiguity that we would not wish to see. The whole point of feel-good propaganda is that the enemy has no personality; he is monolithic and thus inhuman.

Like the classic western, the war movie as patriotic myth has been challenged more and more since the heroic days of John Wayne and Robert Mitchum. Think of *Catch-22* or *Platoon* or Kubrick's *Full Metal Jacket*. And even before World War II, such films as *All Quiet on the Western Front* and *La Grande Illusion* treated the enemy as human beings. But Clint Eastwood is the first director, to my knowl-

edge, who has made two films of the same battle, showing both sides from the perspective of individual soldiers with fully developed characters. Deftly, without polemics or heavy-handed messages, he has broken all the rules of the traditional patriotic war movie genre and created two superb films, one in English, the other in Japanese: *Flags of Our Fathers* and *Letters from Iwo Jima*. The latter, in my view, is especially fine.

The choice of Iwo Jima, where the first US landing on Japanese soil took place in February 1945, makes perfect sense. Almost 7,000 Americans and 22,000 Japanese died in thirty-six days of fighting on that small volcanic island 650 miles from Tokyo. The famous photograph by Joe Rosenthal of six GIs hoisting the American flag on top of Mount Suribachi made the battle into an instant myth, heralding victory over Japan, just as enthusiasm and money for the war were running out in the US. This image, reproduced in every newspaper, on postage stamps, in sculptures, trinkets, posters, magazines, banners, monuments, and not long after the war in a movie starring John Wayne, was sold to the public as the epitome of American heroism and triumph. To raise morale and sell war bonds, three of the original six flag-raisers who survived, John "Doc" Bradley, Rene Gagnon, and Ira Hayes, were paraded around America like movie stars, mounting a papier-mâché Suribachi in a Chicago baseball stadium, being feted in Times Square, dining with senators and congressmen, meeting the president and finally, after the fighting was over, John Wayne himself.[1]

The gap between the real horror of Iwo Jima and the razzmatazz back home proved to be too much for Hayes, a Pima Indian, who took to drink, and whose wretched life, beginning on an impoverished

1. Bradley, Gagnon, and Hayes actually played themselves, alongside Wayne, in the 1949 movie *Sands of Iwo Jima*.

reservation and ending facedown in a freezing ditch in Arizona, had its own mythical qualities, lamented in a ballad sung by Bob Dylan. Gagnon, too, although a willing huckster to begin with, died young as an alcoholic. And Bradley, whose story, written up in a best-selling book by his son James, holds *Flags of Our Fathers* together, had nightmares for the rest of his life.

But there is another reason, apart from patriotic mythology, why Iwo Jima was a good choice, for there, trapped in the black volcanic sand, the Americans really did fight a faceless enemy. Led by Lieutenant General Kuribayashi Tadamichi, the Japanese had dug themselves into a vast warren of caves, tunnels, and pillboxes. Unsupported by any sea or air power, they were under orders to fight to the death, hoping against hope that this would deter an invasion of Japan. Lethal but invisible, they spent days and nights in sauna-like conditions, with food and water supplies running out fast, killing as many enemies as they could before, in many cases, blowing themselves up. No wonder the marines thought of their enemies as rats who had to be burned out of their holes with flamethrowers. Many Americans on Iwo Jima had the words "Rodent Exterminator" stenciled on their helmets.[2]

You realize that Eastwood has made a highly unusual war movie right from the beginning of *Flags of Our Fathers*, when the US Navy steams toward Iwo Jima in full force. Not yet realizing quite what's in store for them, the young soldiers still have time to cheer the bombers streaking overhead, as though they are at a football game— just as the audience is invited to do in more conventional pictures. One man, in his excitement, falls overboard. The good-natured laughter of his buddies suddenly freezes when they realize that no

2. John W. Dower, *War Without Mercy: Race and Power in the Pacific War* (Pantheon, 1986), p. 92.

ship is going to stop for one individual marine thrashing about in the ocean. The war machine rolls on. "So much for leaving no man behind," mutters Doc (Ryan Phillippe) under his breath.

Much is made in the film of the fact that these soldiers did not think of themselves as heroes. They were ordinary young men sent into a hellish place, from which all bright color has been drained in the film, as though the sulfurous landscape itself is dead. All you could do, in the words of Hayes, was to "try and stop getting shot." Although the story is centered around Doc, the most interesting character in the film is Hayes, beautifully acted by Adam Beach, who grew up on an Indian reservation himself. Of the three, Hayes was the most dedicated soldier. Military service offered an escape from poverty and degradation. The US Marine Corps was the first and only American institution where he felt accepted. Nicknamed Chief Falling Cloud, he was popular with his fellow soldiers, and he repaid them with his loyalty.

This is shown in the movie in various ways. Hayes never wanted to leave his unit to join the promotional hoopla in the US. He is the one who cracks up at an official function when he meets the mother of Sergeant Strank (Barry Pepper), one of the flag-raisers who was killed soon afterward. "Mike, Mike," he sobs, "he was a hero. Best marine I ever met." That Hayes survived, only to be paraded around football stadiums and reception halls in order to sell war bonds, fills him with shame.

There are moments in the film when the phoniness triggers horrifying visions for the survivors. Firecrackers and roaring crowds sound like mortars and gunfire, and memories come flooding back of buddies left behind screaming. At an official banquet, where "the heroes" are served a dessert in the shape of Mount Suribachi with the flag raised on top, the hovering waiter whispers "Chocolate or strawberry?" before covering the sugary scene with blood-red sauce. That

some bars still refuse to serve Hayes, as an Indian, adds to his sense of displacement and humiliation. Drunk and brawling, he is called a "disgrace to his uniform" by one of the military promoters, and finally he gets sent back to the battle front, the only place he felt respected, and in some way, perhaps, at home.

Despite his sympathetic depiction of Hayes, Eastwood has been accused of racism for not including black soldiers in *Flags of Our Fathers*.[3] There were, in fact, more than nine hundred African-Americans among the 110,000 men on Iwo Jima. If Eastwood had followed the conventions of postwar war pictures, he might have included at least one by dividing the heroes among various ethnic types: the doughty WASP, the slow-talking southerner, the wise guy from Brooklyn, the tough black from Chicago. But Eastwood is not dealing in types. He shows how a few men, who actually existed, tried to cope with a terrible experience.

The problem with any film trying to make us feel the horror of war is that it is an impossible enterprise. Watching combat on a screen, no matter how skillful the camerawork, acting, soundtrack, or digital simulation, can never make us feel what it was really like on Iwo Jima. The harder a film tries to reconstruct reality, the more one is aware of the futility. Steven Spielberg, Eastwood's co-producer, was a technical wizard in *Saving Private Ryan* and *Schindler's List*, but mercifully, the real experience of Normandy and especially Auschwitz still remains wholly beyond our grasp. But Eastwood does manage to provide a hint (and a hint is all that is feasible) of the way war affects an ordinary soldier: the terror, the cruelty, but also the moments of selflessness, even grace.

He gives us glimpses of some of the cruelty: the casual murder of two Japanese POWs by GIs who are too bored to guard them; the

3. See, for example, Earl Ofari Hutchinson in *The Huffington Post*, October 24, 2006.

tearing apart of an American soldier dragged into a cave by a group of half-crazed Japanese; the remains of Japanese soldiers splattered on the rocks after they detonate hand grenades against their own bodies. But although Eastwood is very good at showing the gap between the sickening reality of war and the stories we make up afterward, he does not deny the possibility of heroic acts. We see how Doc risks his life in lethal crossfire by crawling out of his hole to help a wounded soldier. It is an act that has nothing to do with patriotism, "fighting for freedom," or anything of the kind, and everything to do with simple decency, which is rare enough to be called heroic.

Bradley evidently never talked to his children about his wartime experiences, and when the press called him on anniversaries, he told his son to say he was away on a fishing trip. But in the film, near the end of his life, gasping for breath in a hospital bed, he tells his son of one memory of Iwo Jima. It is the last, haunting image of the movie. Men like Bradley, in his son's words, "fought for their country, but died for their friends," and we "should remember them the way they were, the way my dad remembered them." We then see Doc and his friends strip to their underpants and run into the sea, splashing about and yelling in youthful exuberance at the sheer pleasure of still being alive, at least for a few more hours, or perhaps days. In that simple scene, where not a shot is being fired, you feel something of the horror of the wanton destruction of human beings whose adult lives had barely begun.

Empathy is harder to muster for enemy soldiers, especially soldiers from strange countries, whose languages we don't speak. One might be appalled by the mass murder of Japanese in Hiroshima or Nagasaki, just as one deplores the deaths of Bangladeshis in a terrible

flood, or villagers in Darfur. But as long as they have no recognizable faces, their suffering remains almost abstract, a question of numbers. To make a convincing film about people in an unfamiliar culture is difficult. European directors in the US often have a hard time catching the spirit of the place. For a foreign director to make a Japanese film without any false notes or cultural slip-ups, a film in which the characters, who speak in subtitled Japanese, are wholly convincing and thoroughly alive, is an extraordinary feat. Several filmmakers, from the pre-war Nazi propagandist Arnold Fanck to the great Josef von Sternberg, have tried. To my mind, Eastwood is the first to have pulled it off.

Letters from Iwo Jima opens and closes with scenes of Japanese researchers digging in the caves for anything left behind by the soldiers who died there. They find a sack full of unposted letters from soldiers to their families. The narrative of the movie is based on some of these letters, as well as the remarkable letters written and illustrated by General Kuribayashi, published several years ago in Japan.[4] Some of the letters to his family were actually written in the 1920s and 1930s, when he lived and traveled in North America as a military attaché. They are used as a device to flash back to the earlier, more peaceful life of a humane aristocrat who liked and understood America well enough to realize the folly of going to war against it. Perhaps for this reason, he was sidelined for much of the war by more militant officers, and given the thankless task at the end of fighting a suicidal battle.

Watanabe Ken plays the part of Kuribayashi with just the right degree of noblesse oblige toward his men and contempt for the less imaginative and sometimes brutal officers who regard him as a soft America-lover. It was Kuribayashi's idea, carried out against a great

4. "*Gyokusai Soshireikan*" *no Etegami* (Tokyo: Shogakukan, 2002).

deal of obstruction, that the Japanese should dig themselves in rather than stage futile banzai charges on the beaches. Although he was quite aware of the ultimate fate of his army, he saw no merit in wanton self-destruction. Unusually for a senior Japanese officer in World War II, the general intervenes when he sees a sergeant abusing men in his platoon. Common soldiers were used to being treated brutally. But there is nothing sentimental about the portrayal of Kuribayashi. He is not a closet pacifist but a professional Japanese soldier, who wrote to his wife:

> I may not return alive from this assignment, but let me assure you that I shall fight to the best of my ability, so that no disgrace will be brought upon our family. I will fight as a son of Kuribayashi, the Samurai, and will behave in such a manner as to deserve the name of Kuribayashi. May ancestors guide me.[5]

The only other character in the story with any personal knowledge of the enemy is Baron Nishi Takeichi (Ihara Tsuyoshi), a dashing equestrian who won an Olympic medal in Los Angeles in 1932 and entertained Mary Pickford and Douglas Fairbanks at his house in Tokyo. Instead of hacking a wounded GI to pieces, as some of his men might have done, he reminisces in English about the good old days, telling the dying American of his Hollywood connections. "No kidding," says the GI, shortly before he expires. Nishi has the hearty manners of a sporting Englishman. He is rather like the Erich von Stroheim character in Jean Renoir's *La Grande Illusion*, a member of the international aristocracy, at home in any place where wine, horses, and women have an acceptable pedigree.

5. Quoted in Thomas J. Morgan, "Former Marines Remember the Most Dangerous Spot on the Planet," *The Providence Journal*, June 28, 1999.

The ordinary Japanese soldier, trained to jump up at the mere mention of the emperor, to think of foreigners as devils, and to exalt violent death as the highest honor, is harder for a modern audience to comprehend. He seems faceless, because Japanese military policy was to stamp out all signs of individual character, more than was the case even with US Marines. Even under normal conditions the tendency in Japan is to "knock in the nail that sticks out." During the war this tendency became extreme. Any sign of unusual behavior was liable to be punished by the thuggish Kempeitai (Military Police Corps) or Tokkotai (Special Higher Police). In one of the few scenes in *Letters from Iwo Jima* that takes place in Japan, we see a Kempeitai officer ordering a young recruit to shoot someone's pet dog, as a test of his toughness. When the recruit tries to spare the dog, he is dismissed and sent to die on Iwo Jima.

This recruit, named Shimizu (Kase Ryo), is one of the soldiers in Eastwood's film whose mask of blind obedience and suicidal fanaticism fails to hide a more reflective, even compassionate nature. When another young soldier, Saigo (Ninomiya Kazunari), refuses to kill himself with a hand grenade after the others in his platoon have all committed suicide, Shimizu threatens to shoot him for his treachery. But in fact he, too, feels that he is too young to blow his brains out in a doomed war, and they decide to save their own lives by surrendering to the Americans. Shimizu goes first, but is killed by his American guard. Saigo fails to move, which saves him.

The hesitant voicing of growing doubts, the dangerous signs of humanity, are expressed in dialogues between the young soldiers that could easily have slipped into mawkishness, but in fact are intensely moving. Kuribayashi, the compassionate general, may have doubted the wisdom of going to war, but war is still his métier; he never doubts his duty to carry on until death. Saigo, acted by a teenage pop idol, is a baker in civilian life, with a pregnant wife waiting at home.

He was dragged into the conflict without wanting to be part of it. When the neighborhood committee comes around to his house with his draft card, congratulating him on the honor of being ordered to die for his country, Saigo cannot disguise his anguish. Ninomiya, the teen star, is absolutely convincing in this part, for you realize how very young many of these men were, and how ill-suited to be turned into killing machines.

Saigo, indeed, is very different from Hayes, who found a home and a purpose in the marines. Like Shimizu, the aspiring Kempeitai officer who couldn't bring himself to kill a child's pet dog, Saigo is out of place, used as fodder in a war that doesn't make sense to him. Others around him have internalized the fanaticism of the Japanese militarized state. Lieutenant Ito, for example, played with a little too much histrionic effect by the young Kabuki actor Nakamura Shido, is obsessed with driving his men to suicide. Others, like soldiers everywhere, use war as an opportunity for licensed sadism. Saigo and Shimizu are interesting because they continue to think for themselves, despite every attempt to stop them from doing so. Unlike Baron Nishi or Kuribayashi, they have no knowledge of the world outside Japan. But their personal integrity remains intact in what is otherwise a depiction of Hell.

In the real Battle of Iwo Jima, of the 22,000 Japanese left to defend the island only about a thousand survived. Some surrendered, others were caught before they could kill themselves. In the movie, Saigo is the only one of his unit to live on. We don't know how the real General Kuribayashi died. There are stories that he died a samurai's death by his sword. Possibly he was torched or blown up in his cave. In Eastwood's film, he leads a suicidal charge into the American camp, which almost certainly did not happen. Saigo is with him, but is knocked down by the marines who capture him. In the final shot of *Letters from Iwo Jima*, we see him on the ground in a long

line of wounded American soldiers, his face turned toward the camera. Lying under his army blanket, waiting to be taken off the island of death, Saigo is no different from the Americans lined up beside him, and yet it is unmistakably him; and that is the point of Eastwood's remarkable movie.

13

ROBBED OF DREAMS

THE ANNOUNCEMENT APPEARED on a Japanese website: the first sushi restaurant had just been opened in Ramallah. I thought of the Palestinian prime minister, Salam Fayyad, and his policy for the West Bank. With the peace talks going nowhere, why not create the modern trappings of a real country that one day could become a real state? New roads, banks, "five-star" hotels, office towers, condominiums. He calls it "ending the occupation, despite the occupation."

A visitor to Ramallah is immediately struck by the cranes and scaffolding of fresh construction. That and the Palestinian gendarmerie in red or green berets patrolling the streets, young men trained and equipped largely with American money, and overseen first by US Lieutenant General Keith Dayton and since October 2010 by Lieutenant General Michael Moeller.

This is the new Palestine, collaborating with Israel and the US to smarten up the West Bank and keep down Hamas, even though Prime Minister Fayyad was never elected, and Hamas won the last Palestinian elections in 2006. Under President Mahmoud Abbas, and his prime minister, the West Bank is supposed to outdo Islamist Gaza in prosperity and security. The Soho Sushi and Seafood Restaurant had to be linked to this enterprise.

Located inside the Caesar Hotel, a modern building in a plush Ramallah suburb, the restaurant was empty when we arrived for lunch. Like the mausoleum of Yasser Arafat, erected in polished Jerusalem stone on the ruins of his old headquarters—shot to pieces by the Israeli army during the last years of his life—everything looked shiny, still unused. Phil Collins was singing softly in the background. A friendly waitress with long curly dark hair and black pants took our orders for sushi rolls. Her name was Amira; she was a Christian Palestinian from Bethlehem.

Amira explained that the seven Palestinian sushi chefs employed by the hotel had been trained by a Japanese lady from Tel Aviv. They had had to learn how to make sushi in two months. The result, so far, was mixed. Business was picking up, Amira said. But there was a slight drawback. The Jordanian man who sold the land to the Palestinian owners of the Caesar Hotel had stipulated that alcohol may not be served on the premises.

Although she had never been to the US, Amira carried an American passport, as well as Palestinian identity papers. Her parents had become US citizens before returning to Palestine, where her father taught Arab literature in Bethlehem. Palestine was her home, Amira said, in perfect English. She explained that she had been trained in restaurant management in Spain, in the Basque country. The Spanish, she found, were confounded by her, since they expected all Arab women to wear a veil. When she went to parties, she said, it was always the same story:

A Spanish guy would ask where I was from. When I said I was from Palestine, he would give me a long lecture about how horrible the Israelis were. Then he'd turn round and leave me stuck on my own. You see, they think we're all terrorists. It's very sad.

She repeated this phrase a lot, Amira. It was very sad, for example, that it could take three, four, even five hours to get to Bethlehem from Ramallah, depending on the Israeli checkpoints. Normally the trip would only take thirty minutes via Jerusalem. But Ramallah is surrounded now by Israeli settlements. And these are connected by a network of roads only Israelis are allowed to use. Ramallah is also cut off by the high concrete wall that divides Israel from Palestine. Israelis are not permitted to visit Ramallah or Bethlehem. Some Palestinians have permits to go to Jerusalem. Some live there. But it can take them three, four, or five hours to get there, even though the trip can be made in fifteen minutes by car.

Amira also told me how hard it was for young Palestinians to find jobs on the West Bank, despite the new polish given to Ramallah, and how difficult it was to make ends meet, even if they did manage to be employed. A great deal of money keeps pouring into Palestine, from the US, the European Union, the Gulf states, and other Arab countries, to build hospitals, roads, hotels, and so on, but the territory's relative isolation behind the wall is bad for business. It would help if Israelis could go there to spend money, but they can't.

To get back to Jerusalem, I shuffled through the checkpoint with several hundred Palestinians. We were required to move slowly through a narrow tunnel of steel mesh, as though we were prisoners entering a high-security jail. There was an air of resignation. People didn't talk much. When they did, the conversation was muted. Mothers tried to keep their children calm. Young men tapped nervously on their cell phones. Some people laughed at an anxious joke. You cannot allow tempers to fray when you are crushed together in a cage.

The odd thing was that Israeli soldiers were nowhere to be seen. No jeeps, no watchtowers or patrols. Once every ten, fifteen, sometimes twenty minutes, a green light would briefly start blinking, a

gate would open with a loud clunk, and a few people at a time could proceed to the next gate. I was lucky. It only took an hour and a half this time. After the last gate shut behind me, I finally saw two Israeli soldiers through the tiny window of a small, airless office, young women in their early twenties, giggling and chatting as they pressed the button that opened the gates, casually, with all the time in the world. A boring job, no doubt. They barely saw the Palestinians, whose documents they scrutinized before at last allowing them to emerge into the open air.

———

Every Friday afternoon, without fail, several hundred people, sometimes more, never less, gather on a dusty corner of East Jerusalem, a few minutes' walk from the famous American Colony Hotel. They are there to protest against the evictions of Palestinian families from their homes. The Palestinians are thrown out, and Jewish settlers move in, dressed in the dark suits and black hats of their ultra-Orthodox faith. This is Sheikh Jarrah, a mostly Arab neighborhood. After the 1948 war, Palestinian refugees were resettled there, on what was then Jordanian territory, and were allowed to stay after the area was reclaimed by Israel in 1967.

This arrangement changed some years ago, when various Jewish organizations, religious and secular, decided to lay claim to homes that had belonged to Jews before 1948. The grounds for this are not always straightforward, sometimes relying on documents dating back to the Ottoman Empire whose provenance is often contested. In some areas, though not necessarily Sheikh Jarrah, Palestinians pretend that they are being evicted after selling their properties to Jews, a serious crime in Palestine. In any case, Palestinians do not have the same right to repossess their lost properties in West Jerusalem. It is

all part of a wider Israeli strategy to gradually reclaim the whole of Jerusalem, including many surrounding villages, by moving Palestinians out, often forcefully, and Jews in. As Prime Minister Benjamin Netanyahu once put it: "Jerusalem is not a settlement, it is the capital of Israel."

The Israeli protest against these practices was started by Hebrew University students. They are joined every Friday by well-known academic and literary figures, such as David Grossman, Zeev Sternhell, Avishai Margalit, David Shulman, and even a former attorney general, who was born in the area, named Michael Ben-Yair. Some people shout slogans, sing songs, or carry placards saying "Stop the Occupation!" or "Stop Ethnic Cleansing!" But most just turn up, every week, in a show of solidarity.

Apart from the young Arab boys who come to sell freshly squeezed orange juice to the protesters, there are not many Palestinians on the scene. This is less true of demonstrations outside Jerusalem. But here, the worst that can happen to a Jew is to be beaten up and spend a day in a police lockup. If a Palestinian is caught, he might lose his permit to live in Jerusalem, and thereby his home, his job, his livelihood.

The protests are lawful. Even so, at first the demonstrators were badly roughed up by the police who block off the road to the new Israeli settlements. Some people got clubbed, there was tear gas, elderly protesters were kicked to the ground. Broadcast on the television news, these scenes caused considerable dismay, and the police were ordered to show more restraint. This is still Jerusalem, after all. Restraint is not deemed quite so urgent in the occupied territories. And so the weekly protests continue, even as more Arabs are evicted and new settlers move in, if not here, then in other Arab neighborhoods: Silwan, Ras al-Amud, Abu Tor, Jabel Mukaber.

Protesters cannot do very much about this state of affairs. But even symbolic gestures count in a country where most people seem to

have become hardened to the humiliation and ill-treatment of a minority living in their midst. The protests show that there is still a sense of decency in a nation coarsened by daily brutalities. In a way, the Sheikh Jarrah Solidarity Movement is the most noble form of patriotism.

I usually went to the weekly protest with an old friend called Amira, like the Palestinian waitress. But my friend is Jewish, and Israeli. The evictions, dumping families into the streets, the behavior of the settlers, the general attitude of Israelis toward the Palestinians, trigger a rage in her that lasts well beyond the weekly protests. It is always there, smoldering, often expressed in a kind of loathing of her own country. She is disgusted by the sight of Israelis having a good time in bars, restaurants, and coffee shops while the Arabs continue to be humiliated. Some might interpret this as neurotic, a form of self-hatred. But I don't think so.

"You must understand," her husband, who is British, explained to me one Friday afternoon.

Amira is really very patriotic. She grew up full of Zionist idealism. She was taught to believe that Israel was a great experiment in building a new, more humane society. Disillusion began in her late high school years. Amira, and others, especially of an older generation, are furious because they have seen those ideals collapse. They can't recognize their own country anymore. It's as if they've been robbed of their dreams.

———

It was pouring rain in Sheikh Jarrah, but still the Israeli protesters gathered, and the young Palestinian boys squeezed oranges under an improvised tent whose roof periodically released floods of rainwater.

And there, as always, was Ezra Nawi, perhaps the most remarkable figure among the Israeli activists, pressing the flesh with the energetic bonhomie of a born politician.

In fact, Nawi, a stocky man with thick eyebrows and a bronze complexion, is not a politician at all but a plumber, a gay Jewish plumber, from an Iraqi Jewish family. He became an activist in an Arab-Jewish human rights group in the 1980s after becoming intimately acquainted with the hardships of Arab life in Israel through his Palestinian lover.

Nawi's activism is more practical than overtly political. He goes wherever Palestinians are in trouble, being chased off their land by the Israeli army, or assaulted by armed Israeli settlers. His main area of operation is south Hebron, where Bedouins try to survive as best they can in the desert or in slums. When they refuse to move from their land, their animals are poisoned, their wells blocked, and their plots of land destroyed or simply confiscated. Israeli settlements surround the squalid towns where Arab shepherds, deprived of their traditional livelihoods, are often forced to live.

This is a lawless place, where young armed men in black hats make their own rules. And when they need more force against the natives, they can call in the army. These men and women came to this land from all over the world, from the US, Europe, South Africa, Russia, and Israel too.

I set off one Saturday, with Nawi and a number of other activists, including David Shulman, the eminent Iowa-born Israeli scholar of Indian civilization. Not far from a large Israeli settlement, we stood at the edge of a small brown field, watching a Palestinian farmer sow seeds with a flick of the wrist, rather like a fisherman casting with his rod, while another man drove an old tractor up and down. On the other side of the field stood a group of Israeli soldiers, guns slung across their shoulders, not aggressive exactly, but watchful. We were

there, Shulman explained to me, to make sure settlers didn't come to prevent the Palestinians from planting their seeds. Often the soldiers, at the behest of the settlers, would chase the activists away or even arrest them. This is not legal. But as I said, the law does not usually stretch to these ancient lands.

This time they kept their distance, and the seeds were sown. Meanwhile, Nawi had already gone ahead to another trouble spot. Settlers had erected fences around a field that had belonged to a Palestinian family for generations, until it was taken away from them a decade ago. The reasons for these confiscations are variable; in this case the army had claimed it was necessary for military exercises, which didn't prevent Israelis from building their settlements there.

While surveying the majestic rocky landscape, stretching all the way to the Negev desert, Shulman remarked that these wild places tend to attract crazy people. This was once the land where prophets and other holy men roamed. As he spoke, I heard a raucous voice yelling something in German. On the other side of the new fence stood a wiry man in a black cowboy hat and black jeans. He spoke with the fury of a fanatic. His name was Yohanan. He was shouting at a middle-aged Palestinian, telling him to shut up (*Maul halten!*).

The Palestinian explained in Arabic that this land had belonged to his family for generations. Yohanan, a Jewish convert, born in Germany as the son of a Catholic priest, said there was no proof of this. He did not invoke the Bible, however, to bolster his own claim to this bit of what he called Judea and Samaria. He talked like a pre-war German nature worshiper. He spoke fervently about his special relationship with the land, his understanding of the plants that grew there. In Germany, he pointed out, if a plot of land is not taken care of by its owner, it falls to the person who works it instead. He was the tiller of this soil, he said, and so the land was his.

Yohanan is an oddball, a loner, disliked by other Israeli settlers.

His house, a kind of improvised caravan, stood in isolation on a nearby hill. He had some dark tales of Israeli brutality, of vengeance and festering feuds. It is tempting to see the violence in places like south Hebron as deriving from ancient tensions, fed by religious or racial hatred, going back perhaps even to biblical times. In fact, however, the Bedouins are not religious fanatics, nor do they lay sacred claims to their property. And not all the Jewish settlers are fired by religious zeal either. What you see there, on these arid frontiers, is not an Old World story but a New World one, of settlers and natives, of cowboys and Indians, of eccentric gunmen and outlaws. It is how the West was won.

———

During my stay, the Israeli papers seemed obsessed by sex scandals. Two in particular dominated the news: the conviction of Moshe Katsav, the former president of Israel, of rape, sexual harassment, and "committing indecent acts"; and the accusation made against Police Major General Uri Bar-Lev of "using force in an attempt to have an intimate encounter" with a woman, a social worker identified as "O."

"O," as well as another figure in the lurid tales of the general's love life, named "M," a cosmetician, were not paid party girls, à la Berlusconi. Bar-Lev met "O" at a conference, and she had known "M" for a long time. A third woman, "S," had allegedly introduced "M" to Bar-Lev, after he had requested a threesome. The ex-president Katsav, too, knew his accusers well. He even told one that he was in love with her. They were women working in his office, one in the Tourism Ministry when Katsav was minister of tourism, the other two in the President's Residence.

Remarkably, a recent academic survey by Dr. Avigail Moor revealed that six out of ten Israeli men, and four out of ten women, did

not consider "forced sex with an acquaintance" to be rape.[1] The case
of Bar-Lev seems to have had something to do with office politics. He
was a contender to become the new police chief. Not everyone wishes
him well. And Katsav's deeds point to office politics of a more brutal
kind. The tone in Israeli papers, censorious and lip-smacking at the
same time, reminded me of the British tabloids—in the words of a
Haaretz columnist, "that well-known combination of pornography
and self-righteousness."[2]

Public scandals were not the only items in the papers to do with
sex, however. There was also the open letter from thirty-odd wives of
prominent rabbis, belonging to an organization aimed at "saving the
daughters of Israel." The letter called on Jewish girls not to date Arab
boys. "They seek your company," the letter warned, "try to get you
to like them, and give you all the attention in the world." And then
you are trapped. One rabbi, named Shmuel Eliyahu, notorious for
telling people in his town of Safed not to rent or sell apartments to
Arabs, expressed a similar sentiment. He said that he was happy to
be civil to Arabs, but, he added, "I don't want the Arabs to say hello
to our daughters."

Rabbi Eliyahu, it should be said, is reviled by the liberal Israeli
press and does not enjoy wide support in the country. And yet, to
dismiss him as a complete maverick would be a mistake. A survey
conducted jointly by Israelis and Palestinians found that 44 percent
of Jewish Israelis support the call to stop renting apartments to Arabs
in Safed. One can only guess what the figure would be if the question
involved sexual relations between Jews and Arabs, but it would prob-
ably be considerably higher.

1. See Harriet Sherwood, "Sex Survey Shows 'Tolerant Attitude' to Rape by Acquain-
tance," *The Guardian*, January 21, 2011.
2. Ari Shavit, "Between Galant and Bar-Lev," *Haaretz*, November 25, 2010.

About a mile separates Al-Quds University from the Old City of Jerusalem. Catering to more than ten thousand undergraduates and postgraduates, Al-Quds is the only Arab university in the Jerusalem area. You could walk there in about twenty minutes from the Old City. But you cannot do so anymore, since the wall separating Israelis from Palestinians cuts the university off from the city. The original plan in 2003 was to run the wall right through the campus, destroying two playing fields, a car park, and a garden. Protests from faculty and students, backed by the US government, stopped this from happening. But the place still feels isolated. To get there from Jerusalem, you have to breach the wall and pass through several checkpoints. The twenty-minute walk is now a forty-minute drive, but only if you have the right permits and if the soldiers manning the checkpoints don't wish to detain you. Israelis are not supposed to go there at all.

Despite being cut off, Al-Quds, whose president is Sari Nusseibeh, one of the great liberal minds in Palestine, feels like a lively institution. Muslim students in head scarves mingle with secular students and Christians. There are Jewish professors too. And most Palestinians who teach there have degrees from European or American universities.

I visited Al-Quds on the last day of my stay in Jerusalem. The reason, apart from my curiosity to visit a Palestinian campus, was that Al-Quds has a partnership with Bard College, where I teach in the US. I was invited to a class on urban studies. The students presented papers on a remarkable plan to build a completely new Palestinian city, named Rawabi, just north of Ramallah. Construction work has already begun, even though the Israeli government has not yet given permission to build an access road, without which Rawabi would be stuck on a rocky mountaintop, with views of Tel Aviv but no road to Ramallah.

One of the students, a young woman in a head scarf, explained what Rawabi would look like, with office towers, American-style suburban homes, and all the comforts so often lacking in Palestinian towns today: electricity, running water, Internet connections, and sources for green energy. It would have cinemas, a hospital, cafés, a conference center, underground garages, and a large park. Rawabi, in short, is the stuff of Prime Minister Fayyad's dreams, the smart new Palestine, financed in this case mostly by the government of Qatar. And Israeli Prime Minister Netanyahu is said to be in favor too, for this would spell a kind of "normalization" without the need for Israeli concessions.

This alone would be enough to raise Palestinian suspicions. Would such a project not be an abject form of collaboration? Is it not a way of acquiescing to the status quo? The students of Al-Quds could not make up their minds. They were excited about the plans for a new, modern, urban Palestine but could not shake off a sense of deep ambivalence.

For there are other problems, besides Netanyahu's alleged enthusiasm. Fayyad is not popular among many Palestinians. Hamas may not be much loved on the West Bank, but the news, revealed on an Al Jazeera website, that Fayyad is cooperating with the Israeli army to suppress fellow Palestinians was not generally well received. Nor was the fact—also revealed on Al Jazeera— that the Palestinian Authority was prepared to concede parts of East Jerusalem to Israeli control. Aware of his vulnerability, Fayyad, almost as soon as the crowds revolted in Egypt, dissolved his cabinet and promised elections in September.

The Al-Quds students did not dwell on these political issues, but they did mention that Israeli firms have been contracted to take part in the construction of Rawabi. Even worse, in some Palestinian eyes, the developer, Bashar Masri, has accepted a donation from the Jew-

ish National Fund of three thousand tree saplings, as a "green contri-
bution." One blogger denounced these as "damned Zionist trees."

But it gets even more complicated. If Palestinians have doubts, so
do Israeli settlers, who have staged demonstrations against the proj-
ect and tried to disrupt its construction. Rawabi is a "threat to secu-
rity," they claim. Rawabi is a step toward building a Palestinian
state. Rawabi, they say, will cause pollution, traffic jams, and much
else. What the settlers really can't stand is that Rawabi will be tower-
ing over them. Before Rawabi, Israeli settlements, illegal according to
international law, always towered over the Palestinians.

The students of Al-Quds argued back and forth, the women more
vociferously than the men. In the end, they remained ambivalent.
There was no absolutely right answer, no solution that would suit
everyone. That they were clearly aware of this, and continued argu-
ing, left me with a sliver of hope amid the melancholy of a country
slowly being torn apart by people whose claims are never anything
but absolute.

14

THE CATTY CHRONICLER:
HARRY KESSLER

ON JULY 23, 1914, Count Harry Clément Ulrich Kessler, Anglo-German aesthete, publisher, art collector, world traveler, writer, part-time diplomat, and socialite, hosted a lunch at the Savoy Hotel in London for, among others, Lady Cunard, Roger Fry, and Lady Randolph Churchill, Winston's mother. In the afternoon, he attended a garden party at the residence of the prime minister, H.H. Asquith. Then he viewed some paintings at Grosvenor House with Lady Ottoline Morrell, a patroness of the Bloomsbury group. In the evening he met Sergei Diaghilev at the theater, where he had a seat in the private box of one of the Guinnesses. This was a busy but not uncommon day for Kessler.

One would never know from his diary account of this day that World War I would start a mere five days later. But that is not the most surprising thing. Kessler, the consummate cosmopolitan, the dandy who spoke at least three European languages equally fluently, who knew everyone from Bismarck to Stravinsky, who was as much at home in an aristocratic Parisian salon or English country house as in a Prussian officer's club, this same man would be cheering on the war as a fire-breathing German chauvinist. You would have expected him to be closer, in temperament and point of view, to someone like

Lytton Strachey, who distanced himself from the European catastrophe as a conscientious objector. Instead, in his wartime diaries, Kessler sounds more like Ernst Jünger, the soldier-writer who glorified the "storm of steel" of such bloody battles as Langemarck (1914), as though mass slaughter were a morally uplifting, spiritually cleansing experience.

Here is Kessler on the Battle of Langemarck, where, according to German nationalist legend, thousands of student volunteers were cut down by machine-gun fire while singing "Deutschland über Alles":

Along with all that is deepest in the German soul, music too breaks out in this deadly struggle of our people....What other people sings in battle, goes to its death singing?

Well, in reality, those poor German boy-soldiers did no such thing either. There was no time for much singing as they rushed to their deaths. Kessler, who, unlike Jünger, wasn't there, could be excused for swallowing the legend. It is the tone of celebration that surprises.

What possessed Kessler to be such a macabre cheerleader only a few months after having tea with Lady Cunard? A possible explanation is that he was simply a man of his time. Many people, in England and France no less than in Germany, were drunk with patriotism and seduced by the idea that war would provide the brisk invigorating spirit needed at a time of national decadence. My British grandfather, not yet eighteen when the war began, could not wait to be sent to the deadly trenches of Flanders, but then he was the son of German-Jewish immigrants and felt that his patriotism needed to be proven. Kessler was not Jewish—"*au contraire,*" as the very Irish Samuel Beckett is supposed to have said when someone inquired whether he was English. But perhaps there was an element of anxiety in Kessler too, a slight worry that he might not be seen as quite German enough.

What is certain is that the heroic spirit in Germany, for Kessler's generation, had been much boosted by the ideas of Friedrich Nietzsche: the idea of renewal through struggle, of the will to power, of men taking upon themselves God's tasks of destruction and creation. In 1895, Kessler wrote in his diary: "There is probably no twenty-to-thirty-year-old tolerably educated man in Germany today who does not owe to Nietzsche a part of his worldview." Kessler was clearly influenced by Nietzsche's idea that great art comes from a state of intoxication. The danger begins when this state is applied to national politics.

But if Kessler was nothing more than a mirror of his time, we might not be reading his diaries anymore with so much pleasure. What makes him such an appealing figure is his struggle with the received ideas of his age. He was too cosmopolitan, by birth, education, and inclination, to be an unambivalent nationalist. With certain ideas of his time, however, Kessler might not have struggled quite hard enough.

His diaries fascinate on various levels, first of all as an observant, witty, frequently catty chronicle of European culture and high society between the fin de siècle and the Great War, and following that, between 1918 and the Nazi regime. The second part of the diaries, covering the Weimar period, was widely known and published in English in 1971.[1] The first part, ending in 1918, was not found until fifty years after Kessler hid them in a safe when he fled from the Nazis to the island of Mallorca in 1933.[2] Both the pre–Great War and

1. *Berlin in Lights: The Diaries of Count Harry Kessler, 1918–1937*, edited and translated by Charles Kessler (London: Weidenfeld and Nicholson, 1971). The introduction I wrote for the US edition (Grove, 2000) appeared in somewhat different form as "Dancing on a Wobbly Deck," *The New York Review of Books*, April 27, 2000.
2. *Journey to the Abyss: The Diaries of Count Harry Kessler, 1880–1918*, edited and translated by Laird M. Easton (Knopf, 2011).

Weimar-period diaries have the heady atmosphere of dancing on the deck of the *Titanic*, the sense of looming calamity, which he saw coming with a sense of foreboding in the 1920s and with a degree of aristocratic insouciance in the early 1900s. When Hitler came to power, Kessler was a broken, disillusioned, frightened man. In 1914, he still saw war as a romantic adventure.

One of the eeriest entries in his World War I diary was written on the Polish–Austrian border. It is January 16, 1915. He is having supper with some military comrades in a small, barren railway station waiting room. He writes: "There is little in the mood that speaks of a great adventure and yet we are on one of the most adventuresome journeys in world history." The name of the station is Oswiecim, better know to later generations as Auschwitz.

———

Who was Harry Kessler? He was born in 1868 in Paris to a beautiful Anglo-Irish mother, Alice Blosse-Lynch, and a banker from Hamburg named Adolf Kessler. The family lived in Paris, where Alice performed little plays in her private theater with Sarah Bernhardt, Eleonora Duse, and Henrik Ibsen, among other guests. Holidays were taken in German spas, such as Bad Ems, where the elderly German emperor Wilhelm I took such a shine to Alice that Harry was sometimes rumored to be his bastard son. In fact, as Laird Easton points out in the helpful introduction to his translation of the diaries, Alice only met the emperor two years after Harry was born. Adolf was ennobled in 1879 for his services to the German community in Paris.

Kessler's early school days were spent in England, at a boarding school in Ascot. As a delicate German youth, he was probably bullied. And yet, he looked back wistfully to his English school days in

a way not unrelated to his homoerotic inclinations. It was at Ascot, and Potsdam, where he later trained as an army cadet, "that I suffered perhaps the most violent and intimate sorrows. But I would sacrifice all of the untroubled and even blissful hours of my life just to taste once more this mixture of pain and joy." Revisiting the scenes of his youth, he goes for a walk around Windsor in 1902: "In Eton, looking at the lightly clad, nimble youths, still something of the same feeling."

The diaries begin in 1880, while Kessler was still at Ascot. Written in perfect English, they express the kind of opinions one would expect of a snooty upper-class schoolboy. On the rowdy demonstrations in London against unemployment, which led to the famous Riot Act in 1886, he has this to say: "Why on earth were not the horse guards commanded to charge and disperse the mob if need be with their swords; really when it comes to saving the richest part of London from all the horrors of a pillage nothing is too severe."

Then, in 1891, the diary suddenly switches from English to German. Kessler was of course as much a master of his native tongue as he was of English. Alas, the translation leaves a different impression. The grammar is often mangled, the sentences creak as though written in a thick German accent, and the mistakes are legion. A *Kaserne* is a military barracks, not a "casern." *Genial* is not genial but brilliant, literally "of genius." *Schallplatten*, or records, is not normally rendered in English as "gramophone platters." To translate *schleppen* as to schlepp, as in they "schlepped along little children," sounds Yiddish, which I'm sure was not intended by the author. Hotel Emperorhof instead of Kaiserhof is eccentric. And the grasp, in translation, of this great cosmopolitan's European geography seems deficient. It is The Hague, not the Haag, and Antwerp, not Anvers, at least not in an English text.

But even though Kessler decided that his principal loyalty was to

Germany, he was not a narrow-minded nationalist. As an aspiring diplomat, art collector, and publisher of fine books, he still spent much time in Paris, where he struck up friendships with the sculptors Auguste Rodin and Aristide Maillol, as well as with Paul Verlaine, who expressed an odd fondness for Bismarck's speeches. In England, Kessler knew most people of consequence in politics and the arts. And he was a regular at such seasonal fixtures as the races, always attended with an eye for curious details. At Derby he observed one of the chief entertainments, which was "tossing a pin at a live Negro. He sticks his head through a hole and for a penny anyone who wishes can throw a ball at his skull; who hits the target gets a prize."

In 1892, Kessler embarked on a world tour, first taking in the United States, where he much preferred the women in New York society to the men, who were "businessmen, the older ones often vulgar, the younger for the most part boring, loud, and suffering from ulcers." He liked Japan, where "the perfect and natural manners of even the most common man, make of the average Japanese a being who is infinitely more remote from barbarism than the crude, sensation-hungry European." He didn't much care for the British imperial trappings in India, but found the view of Benares from the Ganges "wordlessly beautiful and colorful and moving." On to Egypt, and then back to Europe by way of Sicily, where he was so happy to see "familiar places and cities after all the fantastic and strange sights" of the Orient that he "even rejoiced at the sight of the old baroque church in Taormina, converted into a theater."

Kessler would not become a pacifist, let alone a social democrat, until the Weimar period, when he became known as "the Red Count." And even then, when democracy needed every defender it could get, he was too much of a social snob to feel much affinity with the common man's elected representatives. Yet drawn as he was to

high society in various European capitals, he saw through its affectations with an acid eye. Here he passes an evening in Paris with the Baroness van Zuylen and her lesbian lover, Mme Riccoï:

They collect, as they told me, perfumes and everything connected to perfumes. This completely pretentious society has altogether about as much taste as a healthy farm girl: the Zuylen woman...advertises, as something especially original, "that she is mad about the Gothic." Boni de Castellane, who came later, said of Riccoï "that she only likes what she can lick; she is only concerned with what is good to lick."

He adds that the Baroness van Zuylen was née Rothschild, but "does not look very Jewish." Whether this was something to be said in her favor is not quite clear.

One advantage of the homosexual life is that it often cuts across class barriers. Kessler's lovers were not usually from his own social milieu. There was the "little sailor cadet Maurice Rossion" and "the little Colin," a French bicycle racer. True, Kessler took a rather exclusively aesthetic view of these boys, as if they were specimens of the kind he liked watching in Whitechapel boxing rings: "A few magnificently slender and thoroughbred young fellows among them. Not completely full-blooded like the Greeks but beautiful, slender half-bloods." But relations were not only physical; he liked to ply the little sailor and the little Colin with important literary works: Balzac, etc.

Kessler's most intimate friendships were with gifted men who felt like outsiders. Despite his fashionable disdain for Jews in general, one of his closest friends was the statesman and industrialist Walther Rathenau, who was Jewish, although not entirely happy to be so. Kessler's anti-Semitism is worth looking at a little more closely, for it

helps us understand his wider views of society and politics, and perhaps even why he would become one of the champions of a devastating war.

Disobliging remarks about Jews that speckle Kessler's diaries are often made by others. Degas, for example, in 1907, on a Belgian Jew, who became a French citizen: "Such people do not belong to the same humanity as us." Or Richard Wagner's widow, Cosima, on "the Jewish question": "She thinks the Jews are a danger because they are *different* from the Germans.... By cohabiting with us, therefore, matters of morality, of honesty, etc. have been *thrown into question* which *should not be subject to reflection* on the part of reason." Kessler records these statements, the latter in 1901, without comment.

The views of Kessler's great friend Rathenau are cited at some length. Rathenau believed that Jewish intellect, honed over two thousand years of Talmudic disputation, was "completely sterile in itself." The Germans, however, were a different matter: "The more he [Rathenau] gets to know the Germans, the more his respect and admiration for them increases." This was in 1906. Sixteen years later, after having saved the German war industry during World War I, the great German Jewish patriot was murdered by two ultranationalists in Berlin, following up on the popular beer hall song of the time: "Knallt ab den Walther Rathenau, die Gottverdammte Judensau!" (Bump off that Walther Rathenau, the Goddamned Jewish pig).

Some of Kessler's own observations often concern physical appearance, as in his entry on a friend's Jewish wife, named Isi: "Isi has something physically repellent for me, as if she belonged to another species." This was in 1899. Two years later, on the same person: "A brown, demonic, at times almost beautiful appearance, but physically repulsive." The repulsion may owe something to the fact of Isi being a woman. But these remarks are rather typical of a man whose social, political, as well as artistic judgments are above all aesthetic.

This made him vulnerable to ideas that would turn out to be very toxic indeed. In 1896, Kessler speculates about the nature of modern society. The feudal state, he argues, with its feudal codes of loyalty and honor, was replaced by the dynastic state, based on the interests of the ruling families, and this in turn was replaced by "the racial state within which the links are nationalism and language." Although Kessler has little sympathy for the (anti-German) chauvinism of the French, particularly the reactionary Roman Catholic kind, which he dismisses as the "sickness of nationalism," he can see a certain beauty in the racial state. One of the more disturbing diary entries, of June 20, 1904, reads:

> I would like to see someone who would settle down somewhere and make it his life's task to pursue the beautification of the body (the race) through games, hygiene, nutritional supplements for the poor up to sixteen years, perhaps even arranged marriages.

Post-Holocaust, such notions are of course abhorrent, even though in some far-flung places such as Singapore they still enjoy some credence. However, 1904 is not 1935. There is no hint of violence in Kessler's views. What he tries to do is to bridge the gap between his social and his artistic views with a utopian vision of beauty. The model for Kessler is not some Wagnerian fantasy of medieval Germany, or other forms of Teutonic Gothickry, which he considered vulgar. His ideal is ancient Greece. It is at once an erotic and a political ideal. He writes, in 1908: "Is it possible that our culture can find its way, without making a break with the past (Christianity), to a standpoint from which it can say yes, with a good conscience, to lust, to the naked, to all of life, as did the Greeks?"

He wrote this in Olympia, traveling around Greece with Maillol

and Hugo von Hofmannsthal, the Viennese playwright. Maillol, always eager to please his patron, says all the right things about Greece. He shares with Kessler a fondness for buttocks, brought to mind by "ship boys" diving for gold coins in the Bay of Naples, but also, less obviously, by the columns of the Parthenon, which Maillol declares to be "like the buttocks of a woman." Later, in Paris, he declares his enthusiasm for Nijinsky: "He's absolutely Eros. Before you wondered where the Greeks got this? Now you see—it was young people like him."

Hofmannsthal is less taken by the worship of everything Greek, which almost destroys his friendship with Kessler. Relations are strained even further when Hofmannsthal confesses to having gone through Kessler's luggage at the hotel. "Somewhere," writes Kessler, "there is clearly a difference between us regarding tact, perhaps a racial difference." Perhaps he was referring to Hofmannsthal's Jewish great-grandfather.

And yet, Kessler refuses to sink to the depths of Wagnerian anti-Semitism. It is, in fact, Rathenau who mentions, approvingly it seems, the poisonous racialism of Arthur de Gobineau, in an argument about—what else?—Greece. Kessler paraphrases his friend's argument thus: the Greeks lost their essence and became vain in the fifth century "when the good, strong, blond blood had been pushed aside by the black blood of a lower race, which happened approximately from the Persian wars on." Kessler objects to his Jewish friend "that the racial question was much too complicated and still much too unclear to derive such general, apodictic principles from it."

Kessler was not the only one to project visions of ancient Greece onto his own place and time. Think of the many Greco-Roman colonnades adorning the British Empire. But his was an erotic vision that he pinned to his hopes of a sexual utopia in Germany, one where men could be free to dance naked in the northern sun. In 1907, returning

to Paris from Germany, he comments that all Germans seem to be talking about is pederasty and zeppelins. He hopes this will lead to

a kind of sexual revolution through which Germany will very quickly, in broad daylight, overtake the lead that France and England have had up to now in these things. Around 1920 we will hold the record *"in Paederasticis,"* like Sparta in Greece, which is *not* the case today.

Perhaps not. But a month later, back in Berlin, he talks about the new generation in Germany:

Everywhere an awakening of sensuality, often merely an obscure thirst for beauty. As an early example it occurred to me how the Garde du Corps officers during my days as a junior officer would make Pfeil, back then still a cadet and a boy as pretty as a picture—drunk and take off his clothes.

The countermodel to Kessler's ideal of Greece is Rome, whose "magnificent parvenu style" still impresses the world, "as much and even more so than the diamonds of a Jewish banker's wife or the racing yacht of the most recent Chicago millionaire." This is what offended Kessler's sense of beauty: the prospect of "Americanization," the "economically unified state" that threatened to replace the "racial state." Americanization was cheap, grasping, shallow, vulgar, unnatural, impure. The symbol of the Americanized parvenu is the Jewish banker's wife.

Kessler's Germany, confounded with an erotic, aesthetic fantasy of Greece, was a place in his imagination. He knew it, too. Returning from Paris to Cologne in December 1908, he wrote how much he loved "the isolation of being abroad" but could not give up on Weimar

and Berlin: "They are the background of my life, a sort of mythical background, approximately like 'heaven' for Christians." And this, he believed, was worth fighting for in the Great War against the Western powers.

Kessler's descriptions of the war are extraordinary for their vividness and their typically Kesslerian romanticism. On the Russian campaign in 1915, he revels in the soldierly camaraderie, with cheerful young men wandering

> along this last border of life with light feet....The air one breathes is like champagne, the light that one can still enjoy with young eyes. The Greek god of death, the beautiful, softly swinging youth prevails here, not the pathetic ugly skeleton.

He reads an essay on the "inner transformation of Germany" and muses: "The 'new man' as the result of the transformation of Germany during the war. This mystical goal inspires me as well." Contrast that to the "Jews, who sit in every village as numerous as lice."

Despite the champagne-like air, Kessler can still see the terror of war clearly. On the Russian front:

> The battle here must have been especially bitter. Many of the dead have half their skulls torn away, the face caved in; a lot of tall, good-looking lads from the Semenoff Guards Regiment.

But he wants to believe in a German victory until the end, even speculating that in the face of American money, Germany has "the cunning of our Jews which I have deployed, plus our efficiency."

Imminent defeat leaves Kessler in a state of despair. But at least this allows him to take a more realistic view of the world. He writes that "the war has done more to uproot the old morality than a thousand

Nietzsches." He worries that "the entire European world has begun the ferment, all the anger from the trenches is rolling backward." Viewing an exhibition in Zurich of paintings and woodcuts (Gaugain, Seurat, Kirchner), he can no longer see a way to bridge the gap between his aesthetic and his political ideals, which is expressed in one of the most revealing entries in his diary, on March 27, 1918:

> A huge gap yawns between this [artistic] order and the political-military one. I stand on both sides of the abyss, into which one gazes vertiginously. In the past there were bridges: religious, mystical, priestly-political. Today they have collapsed.

The only way for a better world to emerge from the wreckage is "out of a new ideology that commands a general consent." This new ideology would soon come in Germany, with devastating consequences, an ideology that owed much to ideas Kessler himself had championed, of race, youth, purity. The new age, leading up to the next world war, would be a grotesque version of Kessler's dream of the vigorous, masculine, racial society. Kessler was utterly opposed to the Nazi ethos. But by then it was far too late.

Kessler's diaries should be read not only for the pleasure of the author's always stimulating and often amusing company but because they contain a chilling lesson. Here was one of the most cultivated, cosmopolitan men of his time, an intellectual committed to European civilization who nonetheless endorsed ideas that contained the seeds of its near destruction. What does this tell us about our own age, when new notions are floating around about defending Western civilization against a foreign faith, notions that could turn out to be just as toxic? Cultural sophistication, alas, is no prophylactic against the allure of terrible ideas.

15

THE BELIEVER

NEAR THE END of his book *Hitch-22*, which is neither strictly a memoir nor quite a political essay but something in between, Christopher Hitchens informs the reader that he has, at long last, learned how to "think for oneself," implying that he had failed to do so before reaching the riper side of middle age. This may not be the most dramatic way to conclude a life story. Still, thinking for oneself is always a good thing. And, he writes, "the ways in which the conclusion is arrived at may be interesting...just as it is always *how* people think that counts for much more than *what* they think."

Like many people who count "Hitch" among their friends, I have watched with a certain degree of dismay how this lifelong champion of left-wing, anti-imperialist causes, this scourge of armed American hubris, this erstwhile booster of Vietcong and Sandinistas, this ex-Trot who delighted in calling his friends and allies "comrades," ended up as a loud drummer boy for President George W. Bush's war in Iraq, a tub-thumper for neoconservatism, and a strident American patriot. Paul Wolfowitz, one of the prime movers behind the Iraq War, became his new comrade. Michael Chertoff, head of the Homeland

Security Department under Bush, presided over his citizenship ceremony at the Jefferson Memorial in Washington, D.C.[1]

Ah, some will say, with a tolerant chuckle, how typical of Hitch the maverick, Hitch the contrarian: another day, another prank. It is indeed not always easy to take this consummate entertainer entirely seriously, but in this case I think one should. In fact, Hitch's turn is not the move of a maverick. If eccentricity were all there was to it, his book would still have offered some of the amusement for which he is justly celebrated, but it would have no more relevance than that. Far from being a lone contrarian, however, Hitchens is a follower of a contemporary fashion of sorts. Quite a few former leftists, in Europe as well as the US, have joined the neo- and not so neo-conservatives in the belief that we are engaged in a war of civilizations, that September 11, 2001, is comparable to 1939, that "Islamofascism" is the Nazi threat of our time, and that our shared hour of peril will sort out the heroes from the cowards, the resisters from the collaborators.

There was nothing inherently reprehensible about supporting the violent overthrow of Saddam Hussein, who was after all one of the world's most monstrous dictators. In this respect, Hitchens had some good company: Adam Michnik, Václav Havel, Michael Ignatieff, to name but a few. It is in the denunciation of those who failed to share his enthusiasm for armed force that Hitchens sounds a little unhinged. He believes that the US State Department was guilty of "disloyalty." For what? For warning about the consequences of not planning for the aftermath of war? He also claims that the US was subject to a "fantastic, gigantic international campaign of defamation and slander." He mentions the movie director Oliver Stone, the late Reverend Jerry Falwell, and Gore Vidal. International campaign?

1. *Hitch-22: A Memoir* (Twelve, 2010).

Still, as Hitchens says, it is the "how" that should concern us, not only the "what." And this is where the memoir is indeed of interest. George Orwell once wrote that he was born in the "lower-upper-middle class," not grand by any means, better off and better educated than tradesmen, to be sure, but without the social cachet of people who might mix with ease in high metropolitan society. This is the class into which Hitchens was born too, but only just. His father, Commander Hitchens, was a disgruntled naval officer who'd had "a good war" but was retired against his will and reduced to making a modest living as an accountant at a rural school for boys. "The Commander" was a quiet drinker but by no means a bon viveur—quite the contrary, it seems. His conservatism was resentful, about the end of empire, the end of naval glory, the end of any glory. "We won the war—or *did* we?" was a staple of his conversation with fellow *alte Kämpfer* in the less fashionable pubs and golf courses of the English home counties.

Hitchens professes to have much admired the Commander and his wartime exploits, such as sinking the German warship *Scharnhorst* in 1943: "Sending a Nazi convoy raider to the bottom is a better day's work than any I have ever done." Perhaps the young Hitch really did think like that. It certainly informs his current enthusiasm for heroic gestures in the Middle East. But his greatest love was not expended on the Commander but on his mother, Yvonne, who would have wished to have been a bon viveur in metropolitan society but was stuck instead in small-town gentility with her peevish husband.

She adored her son, and he clearly adored her. The chapter on his mother is, to my mind, by far the best in the book, because his feelings for her are expressed simply, without sentimentality, and above all without the need to make a point or clinch an argument. Watching a production of *The Cherry Orchard* one night in Oxford, Hitchens

felt a pang of vicarious identification with the women who would never quite make it to the bright lights of the big city, and who couldn't even count on the survival of their provincial idyll, either. Oh Yvonne, if there was any justice you should have had the opportunity to enjoy at least one of these, if not both.

If Hitch had one mission in life it was to not be like one of those women.

Yvonne's end owed more to Strindberg than to Chekhov. She broke away from the Commander and took up with an ex-vicar of the Church of England, who had renounced his faith and replaced it with devotion, shared by Yvonne, to the Maharishi Yogi. Together they left for Greece, without saying goodbye to anyone, and were found dead sometime later in a seedy hotel in Athens. Perhaps because they felt that life had failed them, they had decided to die together. Hitchens was devastated. The account of his trip to Athens, at the grisly height of the military junta, is simple, poignant, personal, and sounds right.

This, however, is not the end of Yvonne's story. Years later, in 1987, Hitchens's grandmother revealed that her daughter had harbored a secret. She, grandmother Hickman, also known as "Dodo," was Jewish. Perhaps Yvonne was afraid that this information might not have gone down well at the Commander's golf clubs. Her son, however, was rather pleased by the news. Hitchens's great friend Martin Amis declared: "Hitch, I find that I am a little envious of you." Quite why having a Jewish grandmother should provoke envy is not made entirely clear. But Hitchens, following strict rabbinical rules, feels that he qualifies as "a member of the tribe." He then revives the old-fashioned notion that Jews have special "characteristics," which interestingly coincide with ones he accords to himself:

222

cosmopolitanism of the rootless kind, sensitivity to the suffering of others, devotion to secularism, even a penchant for Marxism. I'm not sure who is being flattered more: Hitch or the Jews. Long before he was aware of having inherited Jewish characteristics, politics entered his life. Hitchens was educated at a respectable private institution, named the Leys School, in Cambridge. Politics at this establishment for the lower-upper and upper-middle classes were suitably Tory. Hitchens quite enjoyed his school days and gives an amusing, even appreciative account of them. It was then, however, in the mid-1960s, that the "exotic name" of Vietnam began to dominate the evening news. He was shocked by what he heard about this war, and when the British government refused to withhold support for "the amazingly coarse and thuggish-looking president who was prosecuting it," he, Christopher Hitchens, began "to experience a furious disillusionment with 'conventional' politics." He continues: "A bit young to be so cynical and so superior, you may think. My reply is that you should fucking well have been there, and felt it for yourself."

To which one might well reply: Been where? Cambridge? And why the sudden hectoring tone? Clearly, even then, doubt would never get a look in once a cause was adopted. With his brother, Peter, who is now a rather ferocious conservative journalist of some note in England, Hitchens went off to demonstrate against the war in Trafalgar Square, donning "the universal symbol of peace" on his lapel with "its broken cross or imploring-outstretched-arm logo." Here, too, a pattern was set. I did not know Hitchens in those days, but ever since I met him in London in the 1980s, I've never seen him without a badge in his lapel for one cause or another.

Protesting against the Vietnam War was not a bad thing to do, of course. But still sticking to the business of how rather than what Hitchens thinks, the peculiar tone of self-righteousness, combined

with a parochial point of view, even when the causes concern far-away, even exotic countries, is distinctive. After leaving the Leys School, he enrolled as an undergraduate at Balliol College, Oxford. Introduced to the ideas of Leon Trotsky by Peter, Hitchens joined a tiny group of revolutionaries named the International Socialists, or IS. Peter, by all accounts, was the hard man, the enforcer of the right ideological line. Hitchens was too much of a hedonist to be a truly convincing hard man. He was prone to flirtation with, among other gentlemen, a college warden with an eye for pretty boys, who would invite him to the more exclusive Oxford high tables.[2]

IS had about one hundred members but, Hitchens writes, had "an influence well beyond our size." The reason for this, it seems, was that "we were the only ones to see 1968 coming: I mean *really* coming." Again the self-referential choice of words is remarkable. Not the students in Prague, Paris, Mexico City, or Tokyo, not even the Red Guards in Beijing—no, it was the members of the International Socialists at Oxford who *really* read the times.

A more charming (though for some readers perhaps rather cloying) by-product of this concentration on small bands of loyal comrades is Hitchens's near adulation of his friends, all famous in their own right. Martin Amis, James Fenton, and Salman Rushdie merit chapters of their own. So does Edward Said, but he fell out of favor after September 11, as did Gore Vidal, whose gushing blurb on the back cover of the book has been crossed out. I'm not sure whether the fondly recalled examples of Amis's linguistic brilliance do his best friend any favors. Calling the men at a grand black-tie ball "Tuxed

2. These flirtations elicit the odd remark that he has a special sympathy for women, because he knows "what it's like to be the recipient of unwanted or even coercive approaches." This, I feel, underrates the seductive appeal of the habitual charmer.

fucks" is mildly amusing, but a sign of "genius at this sort of thing" it surely is not. In any case, these tributes are clearly heartfelt.

Perhaps a tendency toward adulation and loathing comes naturally with the weakness for great causes. Politicians and people Hitchens disapproves of are never simply mentioned by name; it is always the "habitual and professional liar Clinton," "the pious born-again creep Jimmy Carter," Nixon's "indescribably loathsome deputy Henry Kissinger," the "subhuman character" Jorge Videla,[3] and so on. What this suggests is that to Hitchens politics is essentially a matter of character. Politicians do bad things, because they are bad men. The idea that good men can do terrible things (even for good reasons), and bad men good things, does not enter into this particular moral universe.

By the same token, people Hitchens admires are "moral titans," such as the Trinidadian writer C.L.R. James. Not only was James a moral titan but he was blessed with a "wonderfully sonorous voice." He also had "legendary success with women (all of it gallant and consensual, unlike that of some other masters of the platform)." This is a dig at President Clinton, whom Hitchens habitually calls a "rapist." Why he should know how James, or indeed Clinton, behaved in the sack isn't explained. But bad sexual habits are clearly a sign of bad politics. For many years Gore Vidal was a "comrade," worshiped by Hitchens as much as Rushdie et al. But now that he has taken the wrong line on Iraq and September 11, we have to be told that Vidal "always liked to boast that he has never knowingly or intentionally gratified any of his partners." Well, that puts paid to him. Hitchens reassures us four pages later that whatever followed from his own

3. Not that the Argentine junta leader was not guilty of horrendous crimes, but even criminals, alas, are human.

meeting with Amis, it "was the most *hetero*sexual relationship that one young man could conceivably have with another." Good for Hitchens and Amis.

Another typical word in Hitchens's lexicon is "intoxication." This can literally mean drunk. But that is not what Hitchens means. Writing about his early political awakening, when he shared with his fellow International Socialists a "consciousness of rectitude," he claims:

> If you have never yourself had the experience of feeling that you are yoked to the great steam engine of history, then allow me to inform you that the conviction is a very intoxicating one.

This must be true. When Hitchens became a journalist for the *New Statesman*, after graduating from Oxford, he adopted a pleasing kind of double life, part reporter, part revolutionary activist, imagining how he might help an IRA terrorist hide from the law. He found this double life "more than just figuratively intoxicating." One can only assume that intoxication again played a part when he took the view that yoking himself to George W. Bush's war was to hitch a ride on the great steam engine of history.

The trouble with intoxication, figurative or not, is that it stands in the way of reason. It simplifies things too much, as does seeing the world in terms of heroes and villains. Or, indeed, the dogmatic notion that all religion is bad, and secularism is always on the right side of history. One of the weaknesses of the chapter on Hitchens's journalistic exploits in Poland, Portugal, Argentina, and other places is that he never seems to be anywhere for very long or meet anyone who is not either a hero, someone very famous, or a villain. One longs to hear the voice of an ordinary Pole, Argentinian, Kurd, or Iraqi. Instead we get Adam Michnik, Jorge Luis Borges, Ahmed Chalabi, all

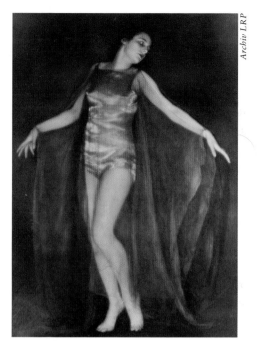

Leni Riefenstahl performing her dance *Dream Blossom*
at the Deutsches Theater, Berlin, 1923

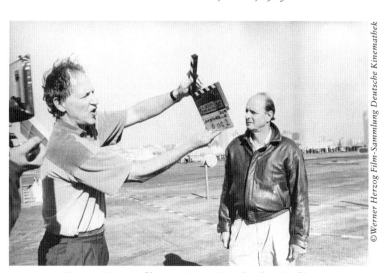

Werner Herzog filming Dieter Dengler for the film
Little Dieter Needs to Fly, 1997

Members of the 72nd Shinbu Squadron at the Bansei Air Base, Japan,
May 26, 1945, the day before they committed suicide in kamikaze attacks

US soldiers advancing through the streets of Zweibrücken, Germany,
March 1945

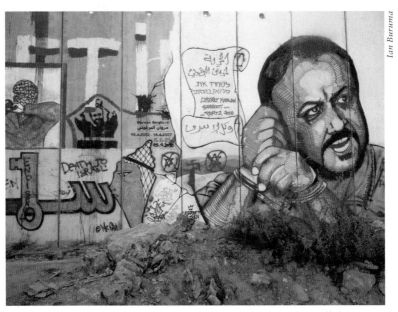

Israel's separation wall at the Qaladia checkpoint, near Ramallah, 2010

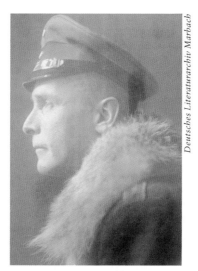

Count Harry Kessler, 1917

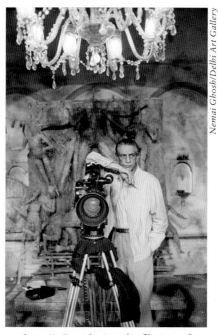

Satyajit Ray during the filming of
Ghanashatru (Enemy of the People), 1989

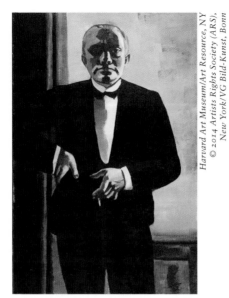

Max Beckmann: *Self-Portrait in Tuxedo*, 1927

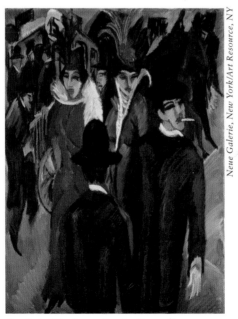

Ernst Ludwig Kirchner: *Berlin Street Scene*, 1913–1914

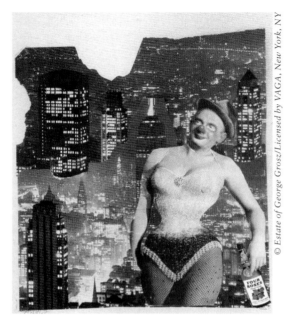

George Grosz: *Grosz as Clown and Variety Girl*, 1958

A wedding couple at the Window of the World theme park, Shenzhen, China, 2008

Drawing by R. Crumb, 1977

Mishima Yukio posing as Saint Sebastian, 1966

interesting people but rather exceptional ones. One misses all areas of gray, all sense and variety of how life is lived by most people.

In some countries, most people are religious. A consequence of the constant sneering about religion, of any kind, is that it obscures political analysis. What should we think, for example, of the persecution of religious parties in Middle Eastern police states? Must we stand with secular dictatorships in Egypt and Syria just because they are opposed by the Muslim Brotherhood? Was a military coup in Algeria justified only because Islamists won democratic elections in 1991? There is no simple answer to any of these questions. But atheistic sloganeering does not help.

Hitchens seems to be perfectly well aware of this. He writes in his concluding chapter:

> The usual duty of the "intellectual" is to argue for complexity and to insist that phenomena in the world of ideas should not be sloganized or reduced to easily repeated formulae. But there is another responsibility, to say that some things are simple and ought not to be obfuscated.[4]

He is right. Standing up to Nazism or Stalinism was the only decent thing to do in the last century. There are turning points in history when there can be no ambiguity: 1939 was such a year, and for Communists perhaps 1956. The question is how Hitchens came to the conviction that 2001 was such a time. The mass murder perpetrated in lower Manhattan, Virginia, and Pennsylvania by Osama bin Laden and his terrorist gang must be strongly condemned. Nor do I have a quarrel with the claim that Saddam Hussein's "state machine

4. This dilemma explains the title of the book, *Hitch-22*.

was modeled on the precedents of both National Socialism and Stalinism, to say nothing of Al Capone." But the idea that September 11 was anything like 1939, when Hitler's armies were about to sweep across Europe, is fanciful.

For Hitchens, however, it seems to have brought back the specter of the Commander. He quotes Auden's poem "September 1, 1939," when "Defenseless under the night / Our world in stupor lies." He recalls Orwell's essay, entitled "My Country Right or Left," written in 1940, when Hitler was at his most menacing. And he thunders: "I don't know so much about 'defenseless.' Some of us will vow to defend it, or help the defenders." He decides that the US is "*My country after all*" (his italics). He realizes that "a whole new terrain of struggle had just opened up in front of me." Acquiring US citizenship at the Jefferson Memorial may not be quite on the same order as sinking the *Scharnhorst*, but it was one way to contribute to the War on Terror, I guess.

In fact, as Hitchens writes, his break with the old left on the question of US military interventions came earlier, in the Balkans. In Bosnia, he writes, "I was brought to the abrupt admission that, if the majority of my former friends got their way about nonintervention, there would be another genocide on European soil." I, for one, agreed with that sentiment then and still do. Still, Iraq in 2003 was not Bosnia in the early 1990s. Saddam had certainly been guilty of mass murder in the past, and would have had no scruples to be a killer again, but the Iraq War was not launched to stop genocide. It was sold to the public as a necessary defense against a tyrant's acquisitions of nuclear weapons and a strike against the men who, as was quite falsely alleged, helped to bring the Twin Towers down. Liberal hawks and neocons, as well as some hopeful (or desperate) Iraqi liberals, were more sold on the idea of liberation and democracy, but officially that was an afterthought. If a democracy cannot make up

its mind precisely why it needs to start a war, it is surely better not to start one in the first place.

Weapons of mass destruction did not clinch the argument for Hitchens. For even if it could have been proved that Saddam had none, he writes, "I would have argued—did in fact argue—that this made it the perfect time to hit him ruthlessly and conclusively." Since 2001, in the mind of Hitchens, was like 1939, he skates over any distinction between Saddam and bin Laden, and talks blithely about "the Saddamist–Al Qaeda alliance." So keen was he to be among the liberators, and so attracted to the heroic gesture, that both his moral compass and his journalistic instincts began to seriously let him down.

In an earlier phase of his career, Hitchens tells us, "I resolved to try and resist in my own life the jaded reaction that makes one coarsened to the ugly habits of power." Quite right too. He was also commendably staunch about the use of torture by the British in Northern Ireland. A Labour minister who defended torture as a necessary measure is called "a bullying dwarf." Hitchens writes: "Everybody knows the creepy excuses that are always involved here: 'terrorism' must be stopped, lives are at stake, the 'ticking bomb' must be intercepted." What on earth was this same Hitchens thinking, then, when he adopted Donald Rumsfeld's deputy, Paul Wolfowitz, as his new good friend?

Hitchens was so smitten with George W. Bush's Pentagon, despite its connivance at torture, that he appears to have believed everything he was told: "In all my discussions with Wolfowitz and his people at the Pentagon, I never heard anything alarmist on the WMD issue." To be sure, Wolfowitz has since admitted that oil was a major reason for going to war, and the threat of WMDs was just a convenient "bureaucratic" excuse. But his Pentagon boss certainly was alarmist about the nuclear threat, as were the president and the vice-president.

In claiming that there was no alarmism at the Pentagon, Hitchens is either disingenuous or a lousy reporter.

He appears to want it both ways, however. On the one hand, WMDs didn't matter, and on the other he wants us to believe that they were indeed a threat, and what is more, that he, Hitchens, found proof of this. UN inspectors under Hans Blix looked at five hundred sites in Iraq without coming up with any evidence of WMDs before they were recalled. But Hitchens dismisses these as "very feeble 'inspections.'" Blix must have been very feeble indeed, for Hitchens, on one trip to Baghdad, in the company of Wolfowitz, was shown components of a gas centrifuge dug up from the back garden of Saddam's chief physicist. And he was told by the US Defense Department that "some of the ingredients of a chemical weapon" had been found under a mosque.

That is not all. Before the war a band of comrades, including Ahmed Chalabi—a slippery political operator with strong links to Iran—was taken up by Hitchens, this time with the rather grandiose name the Committee for the Liberation of Iraq. It was "the combination of influences" of this group "by which political Washington was eventually persuaded that Iraq should be helped into a post-Saddam era, if necessary by force." And this group of heroes, according to Hitchens, was subjected to a "near-unbelievable deluge of abusive and calumnious *dreck*." This unbelievable deluge was dropped, no doubt, by the kind of "Western liberals" whose "sick relativism . . . permitted them to regard 'honor' killings and genital mutilation as expressions of cultural diversity."[5] Not to mention liberals like "Norman Mailer, John Updike, and even Susan Sontag," who all "appeared to be petrified of being caught on the same side as a Republican president."

5. If you look for them carefully, especially in universities, you might still find some people who think like that, but I would hesitate to call them liberals.

THE BELIEVER

Again, the narcissism, the narrow scale of characters, and the parochial perspective are startling: "We were the only ones to see 1968 coming." It is as if the central focus of the Iraq War was about scores to be settled between Hitchens and Noam Chomsky or Edward Said. It is odd that in all his lengthy accounts of the war, the name of Dick Cheney is mentioned only once (because he happened to share the same dentist with Hitchens). What is utterly missing is a sense of perspective, and of the two qualities Hitchens claims to prize above all: skepticism and irony. A skeptic would not answer the question whether he blamed his former leftist friends for criticizing the war with: "Yes, absolutely. I was right, and they were wrong, that's pretty much it in a nutshell." Asked about his literary influences, Hitchens mentioned Arthur Koestler. He was right on the mark. Koestler, too, lurched from cause to cause, always with the same unshakable conviction.[6]

How, then, does Hitchens think? Several times in the book he expresses his loathing of fanaticism, especially religious fanaticism, which in his account is a tautology. As a typical example he cites the Japanese suicide pilots at the end of World War II. In fact, many were not so much fanatical as in despair about a corrupt society going under in a catastrophic war. But if modern Japanese history must serve as a guide to our own times, Hitchens might have mentioned a different category of misguided figures: the often Marxist or formerly Marxist intellectuals who sincerely believed that Japan was duty-bound to go to war to liberate Asia from wicked Western capitalism and imperialism. They saw 1941 as their finest hour, the moment when men were separated from boys, when principle had to be defended, when those who didn't share their militancy were disloyal

6. Perhaps "liberating Iraq," the caption to a photograph of Hitchens smoking a cigarette with delighted Iraqis, is meant to be ironical. Somehow, I doubt it.

231

weaklings. These journalists, academics, politicians, and writers were not all emperor-worshipers or Shintoists, but they were believers nonetheless. The man who emerges from this memoir is a bit like them: clearly intelligent, often principled, and often deeply wrongheaded, but above all, a man of faith.

16

THE LAST BENGALI RENAISSANCE MAN

ON A VISIT to Calcutta I was told a story about Louis Malle. The French director had spent some time in the city to film part of his famous—and in India notorious—documentary on India. One day he was shooting a riot scene, quite common in Calcutta. This infuriated a Bengali policeman who ran up to Malle threatening to smash the camera. Malle objected. "Who do you think you are?" shouted the Bengali. "Louis Malle," replied the director. "Ah," said the Bengali with a sweet smile, "*Zazie dans le métro.*"

It is no doubt an apocryphal tale, but one hears many such stories in Calcutta. It tells you something about the atmosphere of the place, an extraordinary combination of squalor and high culture, violence and civility.

I was told this anecdote by an urbane newspaper editor called Aveek Sarkar. We met in his office, housed in an old building in the center of a commercial district where beggars and rickshaw wallahs dodged in and out of the hopeless traffic jams, while entire families, the children naked, the adults in flimsy clothes, washed themselves by burst waterpipes. Aveek was dressed in a dhoti and smoked Montecristo cigars. He offered me a fine Scotch whiskey and talked about

Bengali poetry. Every Bengali is a poet, he said. There are at least five hundred poetry magazines in the state of West Bengal and when Calcutta celebrates the birthday of its greatest poet, Rabindranath Tagore, poetry bulletins are published by the day, sometimes even by the hour. "We don't look to the rest of India, which is intellectually inferior," he mused. "Our literature is related to French literature, not Hindi. I don't even read Hindi. Calcutta is like Paris."

Aveek kindly introduced me to Satyajit Ray, the film director, graphic designer, composer of music, and author of children's stories. He lives in a grand old apartment building in an elegantly crumbling area known as South of Park Street. His working room is stacked with books—anything from Bengali literature to fifteenth-century Italian art to modern British theater design. There are inkstands, pens and paintbrushes, and an old-fashioned gramophone. And in the midst of this sits Ray, a tall, handsome man, dressed in a dhoti, drinking tea. He speaks English with a refined baritone drawl, rather like a donnish Oxford aesthete. Without having seen Calcutta—or, indeed, his films—one might mistake him for a brown sahib, a genteel colonial relic. He is something far more complex than that, however, for he represents a style historically and socially rooted where most of his films take place, in the decaying grandeur of his native city.

Ray had been very ill. He still appeared weary. "It's a frightful bore making films in India these days," he said. The Bengali film industry was in a sad state. Cut off from a large potential audience in Bangladesh by a government ban there on Indian films, there are not enough Bengalis to sustain the industry anymore. Compared to the average movie produced in Calcutta today, Ray said he would rather see a splashy Bombay musical: "At least there's plenty of action and pretty girls."

His last film was completed from his hospital bed, by issuing instructions to his son. It is possible that some of Ray's genius will be

carried on to the next generation, but not likely. Genius, of course, cannot be taught. Besides that, India has changed too much. It is almost impossible now to make the kind of understated, humanist movies that Ray did. The style is not fashionable, but then it never really was. One of the most remarkable things about Ray's films is that they ever got made at all.

In an essay about the Japanese cinema, Ray commented on Kurosawa's masterpiece, *Rashomon*: "It was the kind of film that immediately suggests a culmination, a fruition, rather than a beginning. You could not—as a film making nation, have a *Rashomon* and nothing to show before it."[1] It is hard to disagree, but this makes Ray's achievement all the more baffling. For what, in the Indian cinema, laid a foundation for *Pather Panchali*, Ray's first film, made in 1955? It had the maturity of a culmination of something, while in fact it was only the beginning. As early influences Ray cites the humanism of Jean Renoir, the technical economy and realism of Rossellini and De Sica, but he had no Indian masters to follow or challenge. Yet unlike so many "arty" Asian films, Ray's work was never a reflection of half-understood Western styles. From the very beginning, his films were unmistakably Indian. How did he do it? What, if not Indian cinema, was his artistic source?

"The raw material of the cinema is life itself. It is incredible that a country which has inspired so much painting and music and poetry should fail to move the film maker. He has only to keep his eyes open, and his ears. Let him do so."[2] Ray wrote this in 1948, seven years before his first film was shown. It offers at least a vague and general answer to the question above. There is more to Ray, though, than a sensitive pair of eyes and ears. To find clues to his particular vision

1. Satyajit Ray, *Our Films, Their Films* (Calcutta: Orient Longman Ltd., 1976), p. 155.
2. *Our Films, Their Films*, p. 24.

one must, I think, go back much further than Renoir or Rossellini, back to the Bengali renaissance of the 1820s and 1830s.

The Bengali renaissance was the product of a small number of families, often divided among themselves in cliques. These families—the Tagores, the Debs, the Rays, the Ghoses, the Mallicks— were mostly high-caste Hindus and were collectively known as the *bhadralok,* literally, gentlemen of substance. The British called them the "educated natives." While the Bengali elite had consisted of large landowners, the *bhadralok* attained social prominence in the late eighteenth and early nineteenth centuries by acting as middlemen for the East India Company and private British traders. They were the clerks, the fixers, the contractors, the translators, the minor civil servants, and the tax collectors who made fortunes by fleecing the old landlords, who often ended up in penury (the theme of one of Ray's best films, *The Music Room,* 1958). Their main enthusiasm was modern education, for which they had an almost unquenchable thirst: science, English literature, European philosophy, and politics. They organized reading societies, established English-language schools, stocked libraries, started printing presses, and published newspapers. The *bhadralok,* in other words, were the first modern Indian bourgeoisie: men who sought a spiritual answer to modernization in a fusion of European liberalism and enlightened Hinduism. Anxious to be cosmopolitan, they were still steeped in their own past.

This was the source of some ambivalence. Since they were colonial middlemen their interests lay with the British Empire, which their political ideals would ultimately lead them to oppose. Their sons and grandsons, frustrated by the lack of political power on the one hand and the inertia of Indian traditions on the other, often turned to Marxist radicalism. The reformist zeal of the *bhadralok* left a legacy in Bengal of Marxist government and occasional terrorism. The cultural sophistication, the fruit of the Bengali renaissance, gave us thou-

sands of garrulous coffee-shop philosophers, millions of poets, and the occasional genius, such as Rabindranath Tagore and Satyajit Ray. Tagore's grandfather, Dwarkanath, was a typical example of the pioneering *bhadralok*. He started off as the chief native officer of the East India Company's opium and salt department, but in true *bhadralok* style later owned several English-language newspapers. A British friend described him as "a Hindoo with an enlarged mind and a truly British spirit." He might have said the same about Satyajit Ray's grandfather, Upendrakisore Ray, an accomplished musician of Western classical music, graphic artist, composer of songs, and writer of children's stories. Upendrakisore launched a children's monthly magazine called *Gandesh*, which Satyajit revived in 1961 and in which most of the short stories in *The Unicorn Expedition* first appeared.[3] Few renaissance men maintain the same level of excellence in everything they put their hands to. Although Ray's stories, written for teenagers, never quite scale the heights of his films, they are suffused with the same spirit.

His characters reflect the gentle patrician humanism, so typically *bhadralok* and so typical of Ray's work. There is Shonku, the scientist-inventor, whom Ray calls "a mild-mannered version of Professor Challenger," one of Arthur Conan Doyle's creations. Professor Shonku travels around the world showing off his strange inventions— a computer the size of a football that knows the answers to a million questions, or Corvus, the crow genius. Like Ray, Shonku is cosmopolitan, at home in most capital cities, thirsty for new knowledge, but at the same time very Indian in his fascination with the metaphysical. His adventures take him to Zen gardens in Kyoto and Tibetan monasteries where he learns how to fly off to an imaginary

3. Satyajit Ray, *The Unicorn Expedition and Other Fantastic Tales of India* (Dutton, 1987).

land filled with unicorns. The Shonku stories, in the manner of Jules Verne and H. G. Wells, humanize science. The author's attitude, his humanism, and his faith in science remind one of a more self-confident age in the West, when people still believed in progress, an age before Auschwitz and the invention of the atom bomb. Indians (and most Asians, for that matter) often like to make the neat distinction between scientific Western civilization and spiritual Eastern civilization. Professor Shonku, again a bit like his creator, quite successfully manages to straddle both.

The sad appeal of *bhadralok* culture is that it flowered so briefly. Ever since the British shifted the capital of the Raj to New Delhi in 1912, Calcutta has been a city in decline. Its European elegance had always been somewhat anomalous in the humid heat of Bengal. But Calcutta somehow managed to wear its decadence with a certain amount of grace; the high culture in the midst of squalor strikes one almost as a kind of dandyism. It is a common theme in Ray's work, and a common trait in many of his characters. In his book there is the story of a middle-aged man who used to be a successful amateur actor and earned a decent living. Now reduced to genteel poverty, he is suddenly asked to fill in as an extra in some tawdry local film. His only line is "Oh!" as he is knocked down in the street by the star of the production. He rehearses the scene endlessly on his own, trying to recapture his old élan. He does the scene perfectly:

> But all the labour and imagination he had put into this one shot—were these people able to appreciate that? He doubted it. They just got hold of some people, got them to go through certain motions, paid them for their labours and forgot all about it. Paid them, yes, but how much? Ten, fifteen, twenty rupees? But what was twenty rupees when measured against the intense satisfaction of a small job done with perfection and dedication?

He walks away without waiting for his pay. He is too good for such a sordid business. Just as Apu's father in *Pather Panchali*, Ray's first film, is too cultured for his surroundings. He is a poor literary Brahmin dreaming of writing a masterpiece, while his family almost starves in a village of illiterate peasants. And just as the landlord in *The Music Room* ignores his debts and pawns his possessions so he can still pretend to live in aristocratic style. Ray is never sentimental about these dreamers. "It is true," he says about *The Music Room*, "I am interested in all dying traditions. This man who believes in his future is for me a pathetic figure. But I sympathise with him. He might be absurd, but he is fascinating."[4]

The sad nobility of being out of step with one's surroundings or time can go much deeper than the simple contrast between poverty and dreams. In a way, the entire *bhadralok* culture, its refinement, its liberalism, its sophisticated attempt to bridge East and West, was out of step—just as Calcutta, the old colonial capital, has been out of step for a long time with the way India developed in the twentieth century. Although Ray himself, like Tagore, at whose school he studied art, believes in the enlightened values of the liberal *bhadralok*, he gently mocks the proponents. Not only are some of the Bengali intellectuals in his films a little absurd but they wreak havoc upon the emotions of innocent people by being carried away by their ideas to the exclusion of all else. This is particularly true of films based on Tagore's stories. Bhupati, the pipe-smoking journalist husband in *Charulata* (1964), is one example. His head, usually buried in books, is so full of new ideas that he loses sight of the people around him. His young and beautiful wife, Charu, is bored and frustrated, endlessly

4. *Satyajit Ray: An Anthology of Statements on Ray and by Ray* (New Delhi: Directorate of Film Festivals, 1981), p. 34.

peering through her binoculars at life outside the claustrophobic women's quarters. Bhupati, the modernist, is still a traditional Indian husband who takes his wife for granted. He encourages his young cousin, Amal, a literary youth, to keep her company. The inevitable happens. Charu falls in love. Amal runs away to escape his guilt. Bhupati learns his lesson.

In the first scene of *The Home and the World* (1984), based on another Tagore story, we see Nikhil reading Milton in English to his young bride, Bimal, who doesn't understand a word. The story takes place in the first decade of the twentieth century, when Bengal was partitioned by Lord Curzon, dividing Hindus and Muslims. Nikhil is a large landowner. His grand mansion reflects his culture: part of the house, particularly the women's quarters, is wholly traditional, while the drawing room, with its crystal chandeliers, chintz-covered sofas, flowered wallpaper, oil paintings, grand piano, and cut-glass ornaments is Victorian English. Nikhil sees it as his mission to get his wife out of the women's quarters ("Purdah never was a Hindu custom") and into the Victorian drawing room. To please her husband, she takes singing lessons from an English lady and learns to recite English poetry. He finally gets her to break the taboo of purdah: she opens the door of the women's rooms and walks through the hall to the drawing room, where she is introduced for the first time to a man who is not a relative. His name is Sandip. The home, as it were, is suddenly opened to the world.

Sandip, the revolutionary demagogue, seduces women the way he seduces the masses. He dazzles them with his ruthless charm. This supreme egotist, justifying his actions by a kind of Nietzschean nihilism, writes in his diary that "whatever I can grab is mine.... Every man has a natural right to possess, and therefore greed is natural. What my mind covets my surroundings must supply." He covets Bimal and she falls for him, stealing her husband's money for Sandip's

cause (to Sandip sex and his cause come down to much the same thing). Sandip's present cause is boycotting British goods. He forces the poor Muslim traders, who cannot survive by selling expensive and inferior Indian goods, to burn their British products. Those who refuse are robbed and sometimes killed. Sandip exploits communal tensions between Hindus and Muslims, leaving them to slaughter one another in riots. All for the cause.

Nikhil, the gentle humanist who believes in the freedom of choice, does not dare to intervene for fear of losing his wife. He allows his friend to stay in his house, for otherwise "Bimal would regret it. She would not stay with me out of her own choice. That would be unbearable." When Bimal finally sees through her lover's deception, Sandip escapes the chaos he has caused. Nikhil tries to stop the killing and is shot dead. Barbarism has proved to be a stronger force than Nikhil's enlightened ideals.

Nikhil and Sandip, the humanist and the radical, the two faces of modern Bengali culture. "We both decided to have nothing to do with irrational conventions," says Nikhil at one point in the film. "He was just more radical than I." Besides Ray, the other Bengali filmmakers of importance, Ritwik Ghatak and Mrinal Sen, were both Marxists. Ghatak, who was four years younger than Ray, was a Communist sympathizer until his death in 1976. People who champion Sen's films often accuse Ray of being sentimental, lacking in class analysis, or even of being "feudal." It is certainly true that Ray is less interested in analyzing the human predicament politically than in showing how people behave, how they react to love and death. With Sen—though oddly enough less than with the more radical Ghatak—one sometimes feels that he is more interested in ideas than in people.

Unfortunately, the weakness of *The Home and the World*, compared, say, to *The Music Room*, *Charulata*, or the Apu trilogy, is

precisely that the characters represent ideas, preventing them from wholly coming to life. This accounts, perhaps, for the unusual—for Ray's films, that is—wordiness of the movie. Ray's best scenes are often silent: the death of Durga, Apu's sister, in *Pather Panchali*, or the look on the face of the starving husband at the end of *Distant Thunder* (1973), set during the great famine in 1943, when his wife tells him she is pregnant. Words could never express the emotional intensity of those silent moments. Words, at least to one who cannot understand Bengali, appear to detract from the realism in *The Home and the World*; they express literary and political ideas rather than feelings.

Ray suffered a heart attack while making *The Home and the World*. But I think the relative weakness of the film (it is still very good compared to most movies in India, or anywhere else) cannot be explained by Ray's ill health alone. The flaws are also in Tagore's original story.[5] Tagore's biographer, Krishna Kripalani, wrote that Nikhil, "who is compounded of the Maharshi's [Rabindranath's father] religious insight, of Gandhi's political idealism and of Tagore's own tolerance and humanism, is too shadowy to be real." Sandip, however, "the Machiavellian patriot, the unscrupulous politician, the splendid wind-bag and shameless seducer is, on the other hand, very real."[6] In Ray's film it seems more the other way around. Nikhil, played by Victor Banerjee, still reveals a brooding complexity, while Sandip, played by Soumitra Chatterjee, appears as more of a caricature.

The most convincing character is the woman in the middle, superbly acted by Swatilekha Chatterjee. As is the case with many Jap-

5. *The Home and the World* (London: Penguin, 1985).
6. *Rabindranath Tagore: A Biography* (Grove Press, 1962; revised edition, Calcutta: Visva-Bharati, 1980), p. 264.

anese heroines, Bimal's shy and submissive exterior hides a character that is stronger and more passionate than those of the men who appear to dominate her. One is reminded of the women in Mizoguchi Kenji's films such as *Sansho Daiyu* (Sansho the Bailiff). Both Ray and Mizoguchi managed to get great performances out of their leading men (think of Soumitra Chatterjee as the grown-up Apu, or Shindo Eitaro as the wicked bailiff in *Sansho Daiyu*), but the most powerful roles are usually for women. (Strangely, women hardly figure at all in Ray's short stories.)

Japanese critics like to call Mizoguchi a "feminist" (they use the English word). And many of Ray's films, such as his latest one, deal with the emancipation of women. But neither filmmaker—least of all Mizoguchi, a traditionalist to the core—is a feminist in the political sense of the word. Ray once said in an interview: "A woman's beauty, I think, also lies in her patience and endurance in a world where men are generally more vulnerable and in need of guidance."[7] This is precisely what Mizoguchi would have said. It is what the Japanese critics meant by his feminism. The transition from Asian tradition to Western-influenced modernity, a constant theme in both Ray's and Mizoguchi's work, often focuses on women. Still the bedrock of tradition, they offer solace. But it is also those same traditional women whose emotions are most affected by modernization.

There may be a religious element in this brand of feminism. Japan and India, particularly Bengal, share strong matriarchal traditions of worshiping mother goddesses. This, by the way, is a thread running through Ritwik Ghatak's films, where women sacrifice everything for their men. Ghatak, a keen student of Jung as well as Marx, tends to mix religious and political metaphors: his suffering heroines stand for the downtrodden peasants, for sacrificing goddesses, and even for

7. *Satyajit Ray: An Anthology of Statements on Ray and by Ray*, p. 67.

his motherland, raped by the British imperialists and their Indian capitalist collaborators.

We speak of Western civilization because of shared religious, philosophical, and political traditions. Do such widely different countries as India and Japan have enough in common to allow us to talk of a distinct Eastern civilization? Tagore, as his statements in China and Japan made clear, believed so. In his fascinating essay about Japanese cinema, Ray, though a little more tentatively than Tagore, reaches the same conclusion. He quotes his old professor at Tagore's academy as saying: "Consider the Fujiyama.... Fire within and calm without. There is the symbol of the true Oriental artist."[8] Mizoguchi and Ozu Yasujiro, Ray says, "both suggest enormous reserves of power and feeling which never spill over into emotional displays." Well, this depends on what one means by emotional displays. But I think I know what Ray means. The feelings under the surface, the long spells of apparent calm, suddenly interrupted by an emotional climax: a look of terrible grief, a stifled scream, a burst of silent tears. The image of the woman betrayed by weaker men, biting her sari or kimono in anguish: this marks the style of Ray's films, as it does of Mizoguchi's. Perhaps this offers a hint of what makes Ray's films seem, for lack of a better word, Asian.

Ray's films, like those of Mizoguchi, are often accused of being slow. To those for whom only perpetual action can stave off boredom this may be true. But the lingering over everyday details, the moments of complete calm—compared by Ray to the slow movements in music—are necessary to express the intensity of the emotional highlights. The slow realism of the classic Asian cinema is a bit like the Japanese Noh theater or the English game of cricket: the slowness—which, to me, is never boring—draws you into the world ex-

8. *Our Films, Their Films*, p. 157.

pressed on the screen, the stage, or the playing field. This process is more than entertainment—it is not always entertaining. Nor is it a matter of slowing down life to the pace of real life—that really would be boring. Rather, it slows down moments in life sufficiently to, as it were, catch reality.

This form of realism has almost died out in the Japanese and Indian cinema. Commercial pressures, especially acute in a place like Bengal, with only a small educated audience, are partly to blame. With the advent of television, video discs, and other new entertainments, the film industries have opted for safe formulas: song and dance in India, soapy melodrama in Japan. But I do not believe this is the only reason for the coarsening of Japanese and Indian cinema. Ray made the following point about the great Japanese directors:

> I am not saying that these masters did not learn from the West. All artists imbibe, consciously or unconsciously, the lessons of past masters. But when a film maker's roots are strong, and when tradition is a living reality, outside influences are bound to dwindle and disappear and a true indigenous style evolve.

This was certainly true of Ray, Mizoguchi, Ozu, even Kurosawa. They all imbibed the work of such different directors as John Ford, Frank Capra, and Jean Renoir. But they were settled in their own traditions, which was the very condition that made their art universal. This is what has changed. Few young Japanese filmmakers are at home in Japanese painting, as Mizoguchi was; few Indian filmmakers could compose a score of Indian music, as Ray does. What is left, in this world of instant communications, is a constant exposure to Western fashions, which, without a strong traditional culture to absorb them, become meaningless ornaments. These ornaments are merged with the showy conventions of local pop culture. The result

is often profitable, sometimes entertaining, but only rarely extraordinary. There are still serious films being made in India, but they tend to be melodramas containing political messages. Both in style and content they are parochial in a way that Ray's films never are. One rather fears it will be a long time before another Satyajit Ray appears in India. He is one of the last true cosmopolitans and perhaps the very last Bengali renaissance man.

17

THE WAY THEY LIVE NOW: MIKE LEIGH

THERE WAS A time, about twenty-five years ago, when spontaneity was the rage. This was encouraged in daily life, as well as in the theater. Indeed, the cult of spontaneity demanded that the barriers between the two should be removed: theater was life, life was theater. "Happenings" turned the world into a stage. Inhibitions were an enemy, to be kicked over in public. Audiences had to "participate." And the participants in theater workshops were provoked into revealing their "true" selves in so-called encounter sessions. People would howl and cry and laugh hysterically, while others would sit around, watching this mental stripping with embarrassed fascination. Orchestrating these spectacles was the leader, or director, or whatever he (almost always a he) was called, who looked at what he had wrought with the smug demeanor of a guru.

Much of this was more group therapy than theater. Happenings could be fun, even creative, but the cult of spontaneity produced little of lasting value. For most theater workshops and happenings were too narcissistic, too unformed, too raw to be meaningful to anyone besides the participants. Letting it all hang out does not create a work of art. Transforming one's feelings into something else can do so, but that takes talent and discipline. The former is always in short

supply, and the latter is hard to reconcile with pure spontaneity. And yet the experimentation of the 1960s was not a wasted effort. For some remarkable things emerged from the dross. Peter Brook's work in the theater, for example, and the movies of John Cassavetes owed much to improvisation. And then there is Mike Leigh. His latest film, *Naked*, won him the best director's prize at the 1993 Cannes Film Festival.

Leigh was born in the north of England in 1943. He was trained in the theater at the Royal Academy of Dramatic Art and in film at the London Film School. When he arrived in London in the early 1960s, he was excited by Cassavetes's movies, and by Brook's work at the Royal Shakespeare Company. "Improvisation," as he put it, "was around." But he distanced himself from its psychodramatic excesses. Happenings didn't interest him. Acting, writing, and directing did. He no longer acts. But so far he has written and directed twenty-four theater plays, twelve TV plays, four movies, one radio play, and several short sequences for television. He describes himself as a storyteller. His stories are made up during many months of rehearsal. "There is nothing extraordinary about our technique," Leigh told me in his London office. In fact, I think there is. What is extraordinary is the combination of improvisation and discipline, spontaneity and precision.

The notes for his published plays mention that they have "evolved from scratch entirely by rehearsal through improvisation." This is true of the movies as well. To make *Naked*, a story about a drifter in London who is so terrified of domesticity that he abuses every woman who falls for his manic charm, Leigh put his actors through four months of rehearsal before shooting a frame. There was no script to begin with. Leigh's actors literally have to find their characters, through improvisation and research into the ways people in specific communities speak and behave. The setting for Leigh's stories can be

in Northern Ireland (*Four Days in July*), or in a modern South London slum (*Meantime*), but wherever it is, Leigh and his cast immerse themselves in the local life before creating the story. Then, gradually, as Leigh works with each of his actors individually, speech patterns, facial expressions, body movements, accents are developed until characters emerge, as it were, naturally. But still there are no lines. The rehearsal, Leigh says, "is to prepare ourselves, so we can make up the film."

Leigh starts with a rough idea for a story. Sometimes it is no more than a mood, or a sense of place. He showed me the first shooting script for *Naked*. It contained no lines and no instructions, just a bare outline: Scene One. London. Day. Johnny and Sophie. And so on. Each scene is then rehearsed on location, while Leigh writes the script. By the time he is ready to shoot, everything has to be precise. There is no more improvisation in front of the camera. "To get everything right for that one moment on film, that's what interests me. You want the spontaneity of the theater to happen at that white-hot moment when the camera is rolling." These decisive moments in Leigh's work are theatrical, often hilarious, and yet for the most part absolutely believable. There is usually a climactic scene in every story, a horrible family row, a chaotic explosion of repressed emotion, sometimes relieved by an instance of tenderness. These scenes are theater, but with the dangerous edge of reality.

In the radio play *Too Much of a Good Thing* (1979), the plot, as with most of Leigh's plays, is deceptively simple. Nothing much happens, yet everything happens. Pamela falls in love with Graham, her driving instructor. Pamela lives with her father, a ratcatcher. Graham is Pamela's first love. Graham likes Pamela, but after he has successfully coaxed her into bed one Friday night, he soon loses interest. Pamela realizes it is all over. She returns home to her father. Her father carries a dead rat through the house to burn in the garden.

Pamela is upset. Thinking it's the dead rat that has distressed her, her father tells her to cheer up. "It might never 'ave 'appened," he says.

The BBC refused to broadcast *Too Much of a Good Thing* until 1992. The official line was that the play was "too banal." But the ban probably had more to do with an explicit sex scene between Graham and Pamela. The fact that you cannot see but only hear them making love—the clothes slipping off, the sighs of anticipation, the yelps of excitement—makes the scene more suggestive and, therefore, perhaps, more shocking to a BBC controller than it would have been on film. To say that the play was "banal" was, in any case, to utterly miss the point. Of course the words were banal, as banal as the letters most people write, or the conversations one overhears in public places. Leigh's drama, like Harold Pinter's, is created by what lies beneath those banal conversations. His characters hide their feelings in a number of ways: by talking in clichés lifted from the mass media or in an endless stream of puns or jokes, or by saying nothing much at all. Some are hopelessly inarticulate. Others, like Johnny, the drifter in *Naked*, keep up a constant brilliant, ironic patter to ward off intimacy.

There is a lot of cruelty in Leigh's plays. People test one another's nerves, not always intentionally, until they cannot take it anymore, and the tension is released in verbal or physical violence, like a thunderstorm following days of sultry weather. Aggression is sometimes the only way people can communicate their feelings. Singing is another. What you will not get is the fine writing of mainstream drama. The people in Leigh's plays and films may sound grotesque at times, but only rarely do they sound like actors or actresses.

Leigh is often described as a satirist of English manners. And to some extent he is. He is a master of the nuances of British class divisions: a particular kind of wallpaper, a pair of spectacles, a turn

of phrase can be enough to place a character in terms of class, region, and upbringing. Again, it is his precision that is striking. Art direction and stage design (usually by Alison Chitty) are of vital importance.

Take, for example, his stage directions for *Goose-Pimples*, a wonderful play produced in London in 1981, but alas never recorded on film. The play takes place in the flat of Vernon, a car salesman in a tacky North London suburb. His flatmate, Jackie, who works as a croupier in a gambling club, brings a rich Arab client home for a drink. The Arab hardly speaks English and thinks he is being taken to a brothel. Jackie and Muhammed are joined by Vernon and Irving, another car salesman, and his wife, Frankie, who is having an affair with Vernon. Muhammed thinks Vernon is the barman, and Vernon calls Muhammed Sambo. The play shows what might happen when a confused Arab businessman is suddenly trapped in the company of ignorant, drunken, lower-middle-class English people. It is a slow but relentless descent into hell. Here are Leigh's instructions for Vernon's apartment:

> The flat is on the second floor of a block of flats...built around 1935. The lounge and dining areas are in a double room, which was designed originally as two rooms with folding doors between them, but the doors have been removed. In the lounge area are a black leather sofa and swivel armchair, a side table, a bar with bar-stools, a music center with cassettes and records underneath, a television and an imitation leopard-skin rug... The walls are papered with tiger-skin wallpaper (or something similar). There are no pictures, but several mirrors and veteran car motifs. The doors to the two areas are close to each other, and have frosted-glass panes.

There is nothing impressionistic about this. Leigh describes with the meticulousness of a social anthropologist. The same is true of accents, which makes his plays very hard to perform outside Britain. These are Leigh's notes for *Ecstasy*, performed in London in 1979:

> Jean and Dawn are natives of Birmingham. Mick is from County Cork, Len is from rural Lincolnshire and Roy and Val are from inner North London, where the play is set. The dialogue, language and usage in *Ecstasy* are extremely precise, and in the author's view the play should only be performed in the correct accents.

Note the "inner North London." The play is set in Kilburn, only a few subway stops away from the suburbs of outer London. But Kilburn, with its run-down streets and mixed population, is another world from the chintzy, tawdry gentility of the outer suburbs that are the setting of many other Leigh dramas, such as *Life Is Sweet*.

Leigh himself—a slight, stooped figure, whose bulging eyes appear to be popping out of his skull, like those of a child staring at the grown-ups, not wanting to miss a thing—is perfectly placed to be a chronicler of the British scene. He grew up in a middle-class Jewish household in a working-class district of Manchester, where his father practiced medicine. Leigh's father was known as the "whistling doctor," since he was always whistling as he went on his rounds. Leigh went to a local state school and he would watch his father's National Health Service patients coming to the house to be treated. To be surrounded by people who are familiar, yet different, is to grow up with watchful eyes. Leigh's way of looking at people, with their heightened oddities, is rather like the way children observe their teachers at school. Every quirk is mercilessly noted.

Leigh often displays a kind of horrified delight in the tawdriest aspects of English life: tiger-skin-patterned wallpaper, dolls of Spanish dancers on bedside tables, male hands groping large bottoms wrapped in pink chiffon. His England, populated by grasping used-car dealers, nosy social workers, randy postmen, frustrated housewives, office clerks, and croupiers, could not be further removed from the thatched-cottage or countryhouse image of England promoted in *New Yorker* ads or Merchant Ivory films. Leigh's loving reconstruction of seediness sometimes reminds one of Diane Arbus's photographs. Like Arbus he has been accused of patronizing his subjects. This is because, like Arbus and her admirers, Leigh and his audience are, on the whole, not of the same class as the people portrayed. And there is, of course, a certain voyeuristic pleasure to be got from Leigh's work. But unlike many of Arbus's subjects, Leigh's characters are not freaks. For the world he has created, with some but not very much exaggeration, is entirely normal. Much of England really is like that. And because he is so unsentimental in his depiction of the working class, or the striving lower-middle class, his characters are rarely caricatures.

Leigh's method of improvisation has much to do with this. For if his actors and actresses simply acted out the tics and mannerisms of class stereotypes, his work would be no more than social satire. What makes Leigh's theater so much more than that is the way his actors develop their characters. The mannerisms, the accents, the walks form just one layer of the complex personalities built up over time. It is as though Leigh's method speeds up the natural formation of personality: the process of a lifetime compressed into the space of months. This does not always work, especially with minor characters. There may not always be time enough. Some of the weaker performances in Leigh's films—the yuppie couple in *High Hopes*, for

example—look unfinished, for they are stuck in their mannerisms; their characters remain unformed. Usually, however, his characters come splendidly alive.

In his latest stage play, *It's a Great Big Shame!*, performed this autumn in London, Leigh tries to undermine the sentimental, music-hall image of nineteenth-century London's East End by showing the cold, rough reality behind its chirpy Cockney ditties. The play is in two parts. The first part is a long sketch of squalid Victorian street life and a disastrous marriage between a simpleton and a shrew. The second half is about lower-middle-class black people, living in the same place today. Leigh has as little patience with the conventional images of calypso and racial solidarity as he has with the mawkishness of the Victorian music hall. Like the white Cockneys a century before, the black Cockneys are sad, angry, bickering human beings who drive each other to violence. The violence, brought on by the usual Leigh mismatch of weak husbands, frustrated wives, and selfish, disapproving siblings, leads to murder in both instances. Faith, the black sister in this play (Marianne Jean-Baptiste), clucking with disdain and parroting the language of advertising brochures, was the perfect example of a developed Leigh character. You can see exactly where she comes from, so to speak, but she is also a unique person.

Leigh's characters only turn into caricatures when he uses them purely to make points. This almost never happens with his working-class roles. It rarely happens with his nouveaux riches. The ghastly, giggling Valerie in *High Hopes*, slipping into a frothy bath with a champagne bottle stuck in her mouth, is an exception. But it often happens with his yuppies, such as the absurd sadist Jeremy in *Naked*, who drives around alone in his black Porsche, looking out for women to abuse. Members of the upper end of the middle class in Leigh's work are never the nice sons of Jewish doctors, or the educated urban audience of his plays. They are what is known in Britain as Hooray

Henrys, braying cads in striped shirts who are brutal to everyone beneath them—that is, when they are not sitting around in Kensington drinking champagne or pelting each other with bread rolls. Many of Leigh's films and plays show how the different strands of British society connect—or fail to connect. The topography of big British cities, especially London, helps him, for London's geography is full of tragicomic possibilities. It has been the strategy of postwar local governments to mix up, where possible, privately owned houses with so-called council houses, homes bought by municipal authorities to provide public housing. And the steady gentrification of the poorer parts of London and other cities has added to this social mosaic. The street I live in is fairly typical: our neighbors on one side are unemployed working-class white people; on the other is a family from Bangladesh and a cleaning lady from Jamaica. Next to them lives a stockbroker.

This sort of mixture sets the scene in much of Leigh's work. The opening sequence of *Grown Ups*, a film made for the BBC in 1980, shows a row of modern semidetached houses in Canterbury. Dick and Mandy ("Mand") have just moved in. Dick works in a hospital canteen, and Mandy as a cashier in a department store. They are visited by Mandy's monstrously intrusive sister, Gloria ("Glore"). Gloria: "Tell you what Mand, I reckon you've really come up trumps 'ere." Mandy: "It's private next door." Gloria: "I know, I've seen." Mandy (proudly): "It's private all the way up." Dick (sourly): "Yeah, but it's council all the way down, innit?"

The gap between council and private is also one of the ingredients of *Abigail's Party*, one of Leigh's funniest, most harrowing, and successful plays, first performed in the theater, then on television. It is set in North London in a patchwork of new housing developments and nineteenth-century terraced houses. Abigail's mother is an upper-middle-class divorcée, called Sue, who owns her house. She is invited

over for a drink by her distinctly down-market neighbors, Beverly and Laurence. Beverly, beautifully acted by Alison Steadman, is a gross, overdressed, restless housewife with a taste for Mediterranean crooners. Laurence is an anxious estate agent with high cultural aspirations (Beethoven's Ninth on the stereo). Laurence is being slowly destroyed by the endless humiliations meted out by his wife. They are joined by an ex–football player, whom Beverly tries to seduce, and his wife, Angela (Ange), a garrulous nurse. Genteel, buttoned-down Sue is almost as much out of place in this company as the Saudi businessman is with Vernon's friends in *Goose-Pimples*.

But Leigh's most perfectly realized battle in the simmering British class war—perhaps the best thing he has done—is a BBC film called *Nuts in May* (1976). The action here does not take place in row houses but in tents. Keith and Candice Marie (Alison Steadman) are an earnest middle-class couple on a camping holiday in Dorset. They eat health food, listen to birdcalls, and play folk music on the banjo. Keith likes to lecture his wife on nature, health, and local history. Candice Marie has a hot-water bottle in the shape of a cat called Prudence. Keith ritually kisses Prudence good night before turning in. Ray, a burly college student from Wales, turns up on the camping site. Ray likes beer, football, and pop music played at high volume. Tension begins to build, especially when Candice Marie appears to like Ray. Then Finger, a plasterer, and his girlfriend, Honky, arrive on a motorbike. Finger and Honky are loud, lusty working-class people who like to fry sausages and beans when they are not making love or farting in their tent. Candice Marie eggs Keith on to do something about the noise. Keith has to prove his manhood. And the tension explodes in a scene of comic violence when Keith loses his temper and runs amok.

Much of the comedy in *Nuts in May*, as in all Leigh's work, lies in the minutely observed mannerisms of British class. But to say that his

films are *about* class is like saying that Buñuel's films are about the Catholic Church. In fact, *Nuts in May*, like Leigh's other plays and films, is as much about the sex wars as the class wars: the two are subtly interwoven. Keith's weediness is constantly shown up by virile local farmers, as well as by Ray and Finger. That is why Candice Marie, mousy as she may seem, goads him into action. In the contemporary half of *It's a Great Big Shame!*, it's the strong presence of Barrington, the muscle-bound friend of the pipsqueak Randall, that finally drives Randall's wife, Joy, to murder her husband. Likewise, the key to Leigh's latest film, *Naked*, is not, as the critic of *Le Monde* thought, a critique of "Thatcherism" or the homeless problem; it is sex.

In *Naked*, Johnny, played brilliantly by David Thewlis, needs sex but is terrified of domesticity. Homelessness, far from being his problem, is Johnny's chosen path to self-destruction. He wants women to love him, but backs off when they do. He is a disturbing character to watch, especially in the current state of gender politics, because he is a charming misogynist. Which is not to say that the film is misogynistic. As in other Leigh movies—*Life Is Sweet*, for example—the strongest, most sympathetic character is a woman. Compared to the others, Johnny's ex-girlfriend Louise is a rock of stability who is trying to throw him a lifeline.

Leigh's dark vision of London's wet, neon-streaked streets, where young drifters huddle around fires under Victorian railway arches or holler madly in the night, gives *Naked* the air of a French film noir. The movie looks different from anything he has done before. But *Naked* is not as much of a new departure for Leigh as some critics have suggested. For Johnny is trapped in the same dilemma that runs through all of Leigh's work: Hell is the others, but the others are also our only salvation. The lifelines of family and marriage are potential prisons too.

Louise almost manages to turn Johnny around from being a manic destroyer of himself and others in his orbit. There is a scene of great tenderness, after Johnny has been beaten up in the street by thugs. Louise washes his wounds, and they revive their former intimacy. Together they sing an old song from their native Manchester—a typical Leigh touch. And at last Johnny looks at peace with himself. Louise decides to give up her job in London and they plan to go back to Manchester together. The Mancunian tune is like a Siren song, full of promise of a better, more settled life. But like a cardboard-city Ulysses, Johnny resists it, and when Louise goes off to hand in her notice at work, he lopes off into the grubby streets as fast as his wounded legs can take him.

We are not supposed to admire Johnny. He is too perverse, too destructive for that. But we can recognize, nonetheless, that his predicament is a common human problem, for which Leigh offers no solution. He just stares at it, picks at it, ponders it, and shows it in every film and play he has done. Family lives, particularly relations between husbands and wives, are almost always disastrous in Leigh's work. Yet some of the strongest scenes in his films are of reconciliation.

In *Meantime*, Mark and Colin, his slow-witted younger sibling, live in the domestic hell of a cheap housing estate. Colin is a humiliated, cowering figure, whose only gesture of defiance against his bleak existence is to shave his head to look like the local skinheads. Mark has taken out his own frustrations on Colin throughout the film. But now he strokes his brother's bald head, in a gesture of solidarity. "Kojak," he says. And for the first time in the movie, we see Colin smile. In *Grown Ups*, family life is a mixture of mayhem and smoldering rows, yet Dick and Mandy decide to have a baby. In *High Hopes*, the elderly mother is mistreated by her coarse and selfish daughter, and family relations are catastrophic, but still her son,

Cyril, a working-class romantic who worships at Karl Marx's tomb, and his girlfriend, Shirley, want to start a family of their own. And so it goes on. People persist in getting married, in having families, even though the chances are that it will all end in misery. But there is one thing sadder than connecting badly with other people, and that is not connecting at all. Leigh's first feature film, *Bleak Moments*, made in 1971, offers an interesting parallel to his most recent one. Both films are about failing to connect. In *Naked* the sex is loveless and brutal, in *Bleak Moments* the sex is suppressed. Both films show how people use language without being able to communicate feeling, except in song (hence, perhaps, the British fondness for community singing).

The main characters in *Bleak Moments* are a typical Leigh cast. Sylvia and Pat work as secretaries at an accountant's office. Hilda is Sylvia's mentally retarded sister. Norman is a hippie from Scunthorpe, and Peter a schoolteacher. Pat is unattractive, but disguises her unhappiness behind a veil of hysterical good cheer. Sylvia is attractive but repressed. Norman is so shy, he can only express his feelings by singing folk songs atrociously. Hilda is emotional but cannot talk at all. And Peter, who fancies Sylvia, is as tight as the white collar around his neck. It is as though middle-class English life has made all these people, except Hilda, emotionally constipated.

In one marvelous scene, they are all gathered for a cup of tea in Sylvia's house. None of them knows what to say to the others. They are all too embarrassed to talk. Like an English Bergman or Dreyer (there is something Scandinavian about the English affinity for unhappiness), Leigh trains his camera on their faces, one by one: Peter, anxious, disapproving, jaws working, lips pursed; Sylvia, unsure, unhappy, eyes darting about the room; Pat, embarrassed, sucking a chocolate; Norman, catatonic, fidgeting; Hilda, close to tears.

That same evening, after an excrutiating meal in a local Chinese restaurant, Peter and Sylvia return to her house. Desperate for some connection, physical, mental, or preferably both, Sylvia forces Peter to drink sherry with her. After a great deal of embarrassment, they kiss. Sylvia breaks away and asks Peter whether he would like a cup of coffee. "That would be very nice," he says. End of love scene.

Peter had spoken before about the problems of language. He tells Sylvia how difficult it is for him to communicate with Hilda. "I never know what to say to her," he says. Sylvia tells him to say anything he likes. Yes, he says, but "I mean that the usual conversational gambits don't seem to be any use." Sylvia looks at him and says, "I'm not sure conversational gambits are ever of any use. They seem to me to be an evasion of what is going on."

This is the key to all Leigh's work: conversation as a form of evasion. One could say it is the key to English manners too. It is hard to get on a London bus or listen to the people at the next table in a cafeteria without thinking of Leigh. Like other wholly original artists, he has staked out his own territory. Leigh's London is as distinctive as Fellini's Rome or Ozu's Tokyo. These are of course products of the imagination, cities reinvented for the movies. Leigh's England is personal as well as a local product. And yet it is universal too. For Vernon and Graham and Candice Marie, and the many others, are not just Leigh's people, not even just British people; by creating them, he has shown us a glimpse of ourselves.

18

THE GREAT ART OF EMBARRASSMENT

SYDNEY AND LINDA are characters in a play by Alan Bennett, entitled *Kafka's Dick*.[1] Sydney, like Kafka, is an insurance man. He is interested in books, or, more precisely, in the people who write them. He likes biographies: "I'd rather read about writers than read what they write." Linda, his wife, does not share her husband's literary interests. But she has picked up one or two tidbits; she knows that Auden wore no underpants, and that "Mr. Right for E.M. Forster was an Egyptian tramdriver." Some day, she says, she'll read and "learn the bits in between." Sydney, exasperated by his wife's obtuseness, explains why she has missed the point: "This is England. In England facts like that pass for culture. Gossip is the acceptable face of intellect."

Two years ago the book at the top of the British best-selling lists was Alan Clark's *Diaries*, a banquet of social and political gossip. The best-selling book last year was *Writing Home*, a collection of Alan Bennett's diaries, articles, and notes.[2] This was also the pundits' first choice in the annual lists of best books of the year. The second choice was a new biography of Evelyn Waugh. Sydney was

1. Published in *Two Kafka Plays* (Faber and Faber, 1987).
2. Faber and Faber, 2005.

right: the thirst of the British public for gossip is unslakable. The popular press thrives on sensational tittle-tattle about the private lives of public figures. The more upmarket papers publish ever more "profiles." And British publishers produce an endless flow of letters, diaries, biographies, and autobiographies. There is no life in this nation of rather diffident and private people that is not worth prying into.

What makes Bennett's stylish and witty diaries so remarkable is that this ostentatiously diffident and private playwright has turned himself into a public act. Alan Bennett is having a fantastic success playing Alan Bennett. His act is studied but also intimate. As a man who, in his own words, "can scarcely remove his tie without first having a police cordon thrown round the building," he tours the country, from bookshop to bookshop, reading, quite beautifully, his private thoughts to a huge audience. He has created a person, in his diaries, his television appearances, and his readings, who is both real and entirely theatrical. As well as being a playwright, Bennett is a fine actor, who started his career in 1960, as a member of the comedy revue *Beyond the Fringe*. His public rendering of his private thoughts is far from being an exercise in "letting it all hang out." With Bennett, self-deprecation is a form of self-control.

Bennett's public role happens to be one the British adore: the most successful playwright of his time as a nebbish with bicycle clips. Public envy, so easy to ignite, is undercut by his self-presentation as a socially crippled eccentric in tweeds and owlish glasses. Here he is, remembering his early days in *Beyond the Fringe* (you must imagine a pair of doleful eyes and a plaintive delivery, the demeanor of a man always stuck in the back of any queue):

20 August. Watching Barry Humphries on TV the other night I noticed the band was laughing. It reminded me how when I used to do comedy I never used to make the band laugh. Dudley

[Moore] did and Peter [Cook], but not me. And somehow it was another version of not being good at games.

Here he is, in Hollywood, attending the screening of a film he wrote:

Mark [the producer] is introduced first, the spotlight locates him, and there is scattered applause; then Malcolm [the director] similarly. When my turn comes I stand up, but since I am sitting further back than the others the spotlight doesn't locate me. "What's this guy playing at?" says someone behind. "Sit down, you jerk." So I do. The film begins.

If the modesty seems contrived, well, as Kafka says in *Kafka's Dick*: "All modesty is false, otherwise it's not modesty." And if it isn't actually modesty so much as an envious disposition, always thinking others are ahead, that is a tendency with which many British people can identify. So much about Bennett is quietly reassuring: his soft Yorkshire accent, his humble yet respectable background as the son of a butcher in Leeds, and his taste for saucy music-hall jokes. Even the edge of confirmed bachelorhood is softened by confessions of love for his (female) housekeeper, comfortably installed in a cozy country cottage.[3]

In *Kafka's Dick*, Kafka rises from the dead, to turn up in Sydney and Linda's house. His biographer Max Brod is there too. Only Kafka is not aware of his fame, for he still thinks Brod burned all his manuscripts. In Brod's words: "He knows he's Kafka. He doesn't know he's *Kafka*." Which reminds me of the girl who finally got to sleep with *Mick Jagger*. When she was asked the next morning what he had been like, she said, "Great, but he was no Mick Jagger." Bennett knows

3. He has since "come out" and is sharing his life with a man.

he's *Bennett*. What makes his private/public diaries so clever is that he not only performs himself but comments on his own performance.

He admits that he sometimes takes his background "down the social scale a peg or two," claiming for example that he hardly ever read a serious book until he was in his thirties. This, he writes, "conveniently forgets the armfuls of books I used to take out of Headingly Public Library—Shaw, Anouilh, Toynbee, Christopher Fry."

Bennett's finest performances as *Bennett* have been on television. He wrote and presented two superb documentaries in which he appears as a kind of social spy, wandering through an art gallery in Leeds and skulking around the corridors of a hotel in Harrogate. He eavesdrops on conversations in the lobby or the tearoom, he observes local worthies at official luncheons, he overhears people's comments as they shuffle past the paintings, and as he discreetly snoops from room to room, gallery to gallery, he tells us the story of his own life, and especially the panoply of "embarrassments," "awkwardnesses," and "discomforts" he has suffered. He remembers how his father always had trouble tipping the room boy, and how his mother struggled all her life not to appear "common." As a coda to his stay at the hotel in Harrogate, he recounts an embarrassment, experienced on the train back to London. He had paid a special weekend fare. The ticket collector took one look at his ticket and told him to move to the compartment for weekend travelers. "You don't belong in here," he said. "This is for the proper first-class people. Out."

It is a class act. But Bennett is more than a cuddly performance artist. In his plays, he has turned his private embarrassments into the core of his art. Self-consciousness, the gap between our private selves and our public roles, between the way we are and the way we want to be seen, this is the running theme of Bennett's drama. Nowhere is this more explicitly so than in *The Madness of King George*, the play and now the movie directed by Nicholas Hytner.

At the beginning of the film, we see the king being dressed for his public performance, at the opening of Parliament: the robes, the crown, and Handel's music blaring away in the background. Then we see the court of George III, in all its stuffy formality. And we see the king, rushing about, hither and thither, as "Farmer George" patting the rump of a pig to the delight of one of his farmers; as the caustic sovereign signing documents for William Pitt, the prime minister; as the disapproving father of the foppish Prince of Wales; and as the fond husband ("Mr. King") to his dowdy Queen Charlotte ("Mrs. King"). He is bluff and hearty, an eccentric autocrat. Yet he is never wholly at ease. He is in fact a shy man playing a boisterous public role, ending his sentences with a "hey, hey," or a "what, what."

Nigel Hawthorne plays the part to perfection, both on stage and in the film. Helen Mirren is also good as the solicitous queen. Rupert Everett is a less happy choice as George, the Prince of Wales. He does not look right, for a start. For George is "Fat George," the glutinous idler, scheming to gain a public role for himself. Everett is thin. Lolling about, with his stomach padding slipping almost down to his knees, he looks like a cake that has not risen. On the whole, however, the casting is inspired, with Julian Wadham as the buttoned-up Pitt, and Ian Holm as Dr. Willis, who breaks the king's will through the force of his own. The smaller parts are splendid too: the doctors, looking like grotesques in a Hogarth print, the smirking courtiers, the greedy politicians—hard-drinking Whigs around the prince, and slippery Tories hanging on to the king's ermine.

My main complaint about the movie is that Bennett's script seems flatter and less subtle than his original play. Many of the funniest lines have been cut. The film is nice to look at and the message comes across, but there are fewer laughs. Not that the film is solemn, but it's as if facial contortions, in the manner of Everett's Prinny, have to make up for the pruning of the text. Perhaps the play is too literary

to translate well into film. Perhaps Hytner's inexperience as a film director is the problem. Other screenplays by Bennett, such as *Prick Up Your Ears*, directed by Stephen Frears, and *An Englishman Abroad*, superbly directed by John Schlesinger, have worked very well.

King George's mania nonetheless remains an affecting spectacle. His problem may have been caused by a disease called porphyria, which produces chemical changes in the nervous system. It is suggested in the Bennett version that the madness was made worse by the king's incompetent and querulous doctors, who tortured him with various painful cures. But the heart of the story is that very Bennettian preoccupation, embarrassment, or rather the lack of it. As a result of his dementia, the king loses his self-consciousness. In the words of Baker, one of the king's physicians, "His tongue runs away with him. Thoughts that a well man keeps under he just babbles forth." Gone are the hail and hearty manner, the what, whats and the hey, heys. Instead, the king talks dirty, and assaults the queen's mistress of the robes, whom he had always eyed but never touched, for the king was unusually monogamous. Now, he keeps nothing under. He has lost control of himself. The question is, Who is "himself"?

Bennett, the man who cannot take off his tie without a police cordon, has always been fascinated by people who lose control of themselves. His diary entries include trips to New York, where he stays with a friend in a SoHo apartment. A mad, eighty-two-year-old woman called Rose shouts obscenities up the stairs day and night. Bennett remarks: "In England, where eccentricity is more narrowly circumscribed, Rose would have been long ago in hospital herself; but here in New York, where everyone is mad, she is tolerated." To keep control is to enjoy the dignity of one's public role; to lose it is to risk embarrassment, or worse. Old people in Bennett's plays live in

terror of being "taken away" to special homes, where they will be patronized by social workers and lose their dignity. Yet to court embarrassment, by flouting conventions, can seem admirable, especially to a playwright who feels unable to do so himself (or so he says). *Writing Home* includes a gem, entitled "The Lady in the Van." It is an extraordinary account of Bennett's relationship with Miss Shepherd, a bag lady on the far side of eccentricity who lived in a van, which she parked in front of Bennett's house in London. Bennett describes Miss Shepherd in detail. He also examines himself, his way of life ("timid"), his motives for getting involved with the lady, his attitudes, and even his politics. He is not easy on himself. He admits to a combination of liberal guilt, fear of confrontation, and inertia. And there is the usual fine nose for the nuances of embarrassment:

> *May 1976.* I have had some manure delivered for the garden and, since the manure heap is not far from the van, Miss S. is concerned that people passing might think the smell is coming from there. She wants me to put a notice on the gate to the effect that the smell is the manure, not her. I say no, without adding, as I could, that the manure actually smells much nicer.

But there is a tender fascination too. He admires the lady's boldness. He is a kindly voyeur. He has looked and held out a hand where others would look away.

This same tenderness, for a man who defies the conventions of his role, even if this defiance is the result of a sickness, makes *The Madness of King George* such a moving story. The scenes of the ranting king, sitting half naked in his own excrement, at the mercy of his ghastly doctors, are the best in the film. The king, like the bag lady, is living in squalor. The filter of decorum no longer operates. His dignity as the king is destroyed. It is not a pretty sight: reduced to his

raw instincts, no man ever is. It is a relief to see him cured. And yet...
the man who cures him, Willis, the former clergyman, is depicted by
Bennett as a mixture of a male nanny and rather sinister social
worker. The mad king is a kind of rebel, and the sane king, however
eccentric in his habits, is a conformist; he has been tamed.

The king is not unlike another famous English character Bennett
adapted for the stage: Toad, in Kenneth Grahame's children's story
The Wind in the Willows. Toad is the lord of Toad Hall, located in a
place called River Bank. Its denizens include Badger, and Mole, and
Rat. Toad, wearing a loud tweed suit and huge round glasses, is a
braggart, an idler, a spendthrift, and mad about cars, which he drives
recklessly and very badly. The "poop, poop" of his horn is usually
the prelude to an accident. Toad, in other words, sounds like a
Wildean fantasy of the eccentric aristocrat to whom the rules of so-
cial convention don't apply. He does what he likes: "I live wholly for
pleasure; pleasure is the only thing one should live for."

Bennett has a more unusual take on Toad.[4] He speculates that
Grahame had meant Toad to be Jewish. As he writes: "[Grahame]
had endowed him with all the faults that genteel Edwardian anti-
Semitism attributed to *nouveaux riches* Jews." He is, in any case, not
an unsympathetic character. Grahame, like Bennett, or should I say
Bennett, was an example of the timid English writer who felt ex-
cluded by his own inhibitions from life's pleasures, and so invented
characters, like Toad, who could let their hair down. The love of bad
jokes and nursery naughtiness, shared by Bennett, runs like a con-
stant stream through English life and letters. So does the love of
dressing up, of playing charades, of a kind of innocent campery.
Only in Victorian or Edwardian England is it possible to imagine a

4. *The Wind in the Willows* (Faber and Faber, 1991).

senior army officer (the Chief Scout, Baden-Powell, say) getting up in front of his troops to dance in drag—without a thought of homosexuality crossing his mind.

The world of Toad, Badger, Rat, and Mole is like that: they are all confirmed bachelors; they don't much like women; they—or at least Toad—camp it up like mad; and it was all written for children. Bennett is of course not an Edwardian, and his jokes are not those of an innocent. Near the end of the play, Toad is kissed by the young girl whose clothes he wore to escape from jail: "It's rather becoming, don't you think?" Toad then kisses Rat:

RAT: No, no. Please.
(RAT *is most reluctant and is covered in embarrassment but the* GAOLER'S DAUGHTER *kisses him nevertheless and with unintended consequences.*)
Oh. I say. That's not unpleasant. I think my friend Mole might like that. Moley. Try this.
(*So* MOLE *gets a kiss too and perhaps his kiss is longer and more lingering.*)
What do you think?
MOLE: Mmmm. Yes.
RAT: Yes. I think one could get quite used to that.
(*Life, one may imagine, is never going to be quite the same again—at least for* RAT *and* MOLE.)

Whether the "one" who might imagine includes many children is open to doubt. Bennett explains why the play (produced quite beautifully, by the way, by Nicholas Hytner) caught his imagination: "Keeping it under is partly what *The Wind in the Willows* is about. There is a Toad in all of us or certainly in all men, our social acceptability

dependent on how much of our Toad we can keep hidden." Perhaps part of Bennett's intemperate dislike of Mrs. Thatcher is to do with her tendency to keep our Toads down too forcefully.

Finally, inevitably, since every fairy tale must end, Toad is tamed, like King George, though not as violently. After his escape from prison, he learns how to tone down his act, to behave modestly. Toad Hall will become a more genteel place. Chairman Badger suggests it might be converted to a nice mix of executive apartments, offices, and a marina to attract the tourists. Something vital will be lost:

> BADGER: I wouldn't have believed it if I'd not seen it. But it's true: Look at him. He's an altered toad.
> MOLE: And he is better? I mean... *improved.*
> RAT: Well of course he's better. He's learned how to behave himself. No more crazes. No more showing off. He's one of us.
> MOLE: Yes.
> BADGER: What is it, little Mole?
> MOLE: I just thought... I just thought that now he's more like everybody else, it's got a bit dull.

King George's reversion to normality is equally dramatic. In the film, the scenes of his madness are shot in cold rooms or in a wintry fog. The final cure takes place in a sunny garden. The king is reading *King Lear,* with Thurlow, the cynical lord chancellor (John Wood), playing Cordelia. The king, much moved by the play, orders Thurlow to kiss his cheek. Thurlow does so with acute embarrassment, but observes that the king suddenly seems more himself. The king: "Do I? Yes, I do. I have always been myself even when I was ill. Only now I seem myself. That's the important thing. I have remembered how to seem. What, what?"

This is all beautifully done, but Bennett seems to have had trouble with the ending. This is perhaps because his attitude is never preachy, or strident, but usually ambivalent. Ambivalence does not make for conclusive endings. The play ends with the dismissal of Dr. Willis on the steps of St. Paul's Cathedral: "Be off, sir. Back to your sheep and pigs. The King is himself again. God Save the King." In his preface to the play, reprinted in *Writing Home*, Bennett gives us an alternative ending, which he discarded, but it is very funny. The king and queen, sitting on the cathedral steps, draw lessons from the king's treatment of doctors. They conclude that kings and rich men fall victim to too many conflicting interests. The fortunes of too many doctors, too many politicians, too many courtiers rise and fall with the king:

KING: ... I tell you, dear people, if you're poorly it's safer to be poor and ordinary.
QUEEN: But not too poor, Mr King.
KING: Oh no. Not too poor. What? What?

The film ends—in my view less successfully—with a comment on the modern monarchy. Waving regally at the adoring crowds, the king talks to his bored and disillusioned son about the royal family being a model family, of a model country: "Let them see that we are happy. That is what we're here for."

Model family, model country, Britain as a homogenized theme park, like Toad Hall, with its offices and its marinas. Bennett has been there before, in different plays. A rather maligned play, entitled *Enjoy*,[5] is about an elderly couple living in genteel poverty in a

5. *Forty Years On and Other Plays* (Faber and Faber, 1991).

northern English town. Connie Craven, or Mam, knows the neighborhood has taken a bit of a dive: "It used to be one of the better streets, this." Wilfred Craven, or Dad, has a steel plate in his head, as a result of an accident. He recalls that he was somebody during the war: "I had six men under me." Their daughter, Linda, is a prostitute. Mam and Dad insist she is a personal secretary.

The Cravens, desperate to keep up appearances, have been left behind. Their street is to be demolished. They no longer know their neighbors. Their old way of life is obsolete. And they are to be taken away by social workers, who call them by their first names (Mam and Dad are obsolete too). But they are to be taken to a very special home, a theme-park home, which tourists will pay to visit. Their old way of life will be preserved, as a living museum, a place where neighbors still stop and pass the time of day, coal fires burn cozily—during opening hours only—and "on certain appointed days soot will fall like rain, exactly as it used to."

Bennett clearly does not like what happened to Toad Hall, and Mam and Dad's street. He has written warmly about the Leeds of his youth, with its fine Victorian buildings (many of them demolished in the 1960s) and its civic pride. Yet to call him nostalgic would be to misread him. Nostalgia is part of the problem with contemporary England, where culture has come to mean Heritage, and tradition is equated with theme parks. However much he plays up his north country roots, in his work and his public performances, he does not wish to go back. He writes in *Writing Home*: "I do not long for the world as it was when I was a child. I do not long for the person I was in that world. I do not want to be the person I am now in that world then. None of the forms nostalgia can take fits. I found childhood boring. I was glad it was over."

And yet, like the late John Osborne, a very different playwright, Bennett is a romantic about England, a merrier England that once

THE GREAT ART OF EMBARRASSMENT

might have been. In a review of Osborne's autobiography, Bennett writes how much he (Bennett) enjoyed the "frozen embarrassment" of the National Theatre audience that greeted one of Osborne's new plays. He writes: "I often disagree with his plays, but I invariably find his tone of voice, however hectoring, much more sympathetic than the rage or the patronizing 'Oh dear, he's at it again' he still manages to provoke in an audience." One difference between Bennett and Osborne is that Bennett never provokes rage. I'm not sure Bennett would take this as a compliment.

Osborne adored the cheekiness of pre-war music-hall acts; above all he loved the Cheeky Chappie himself, Max Miller, the comic in the flashy suits who cracked blue jokes with a wink and wicked leer. Very much of a Toad, Miller's humor was a blow against everything that was mean and pinched and boringly respectable. Yet Miller was also, in Osborne's words, "traditional, predictable and parochial." It is a combination Bennett would appreciate as well. Osborne's hatred of Britain's modern decline into shoddy, standardized Americana expressed itself in a yearning for eccentric aristocracy. He became a bit of an Evelyn Waugh figure, a country squire, firing off slightly mad articles to *The Spectator*. It was part of his act: one way to protect yourself from a gossip-hungry public is to turn yourself into a character.

Bennett has no time for *The Spectator* and is hardly an Evelyn Waugh figure. His politics are of the decent, liberal-minded left. Yet his attitude toward England is close to Osborne's. It is, as always, an ambivalent attitude, reflected in some of his most successful characters. Bennett's portrayal of Guy Burgess, the spy, in *An Englishman Abroad*, is brilliant because there was something of the music hall in Burgess. His services to the Soviet Union are hard to excuse. He spied for Stalin but, as people said at the time, with bags of charm. He was a Cheeky Chappie, a Toad—"he was fond of luxury and

display, of suites at Claridges and fast cars which he drove abominably."[6]

Bennett's screenplay[7] is based on the true story of Coral Browne, the actress, meeting Burgess in Moscow in 1958, during her tour with the Old Vic theater company. Browne, already ill with cancer, plays her younger self in the film. Bennett, the director John Schlesinger, and the actor Alan Bates get the frayed charm of Burgess in Moscow just right. Without condoning what he did, they show some sympathy for the old queen playing his Jack Buchanan record, trading on yesterday's gossip, and ordering Old Etonian ties from London. In the movie, and no doubt in life, Burgess in Moscow comes across as a shipwrecked Englishman from a vanished age. He had done his best to undermine the British government, yet he loved England with a passion. It is hard to imagine Bennett, or Osborne, as Soviet spies, but their work is fueled by a similar brew of love and subversion.

Bennett's first play in the West End was entitled *Forty Years On*. It is a play within a play. The setting is a boarding school called Albion House. The headmaster (John Gielgud in the original production) is about to retire. The school is no longer rich, except in memories. The headmaster points out: "We don't set much store by cleverness at Albion House so we don't run away with all the prizes. We used to do, of course, in the old days."

The play, put on by the boys, is entitled *Speak for England, Arthur* (a reference to Arthur Greenwood, the Labour Party leader who was asked to speak out against Chamberlain on the eve of World War II). Its humor is something between *Beyond the Fringe* and Max Miller: a sequence of music-hall jokes, puns, and parodies of English mem-

6. Cyril Connolly's description of Burgess in *The Missing Diplomats* (London: The Queen Anne Press, 1952).

7. Also performed as a play, on a double bill entitled *Single Spies*, together with *A Question of Attribution*, a play about Anthony Blunt (Faber and Faber, 1989).

THE GREAT ART OF EMBARRASSMENT

oirs (suggested by, among other things, Harold Nicolson's diaries). The play—and the play within the play—pokes fun at such English institutions as the empire, the monarchy, and war heroes: "I met one of them tonight, down at the House. A very gallant young man. Everything that a hero should be. Handsome, laughing, careless of his life. Rather a bore, and at heart, I suppose, a bit of a Fascist."

The headmaster is a marvelous creation, one of the best of Bennett's many shipwrecked Englishmen, stranded in the past, befuddled by and disapproving of the modern world. As part of the play within the play, he quotes Baden-Powell and makes speeches about Lawrence of Arabia, without quite realizing their satirical intent: "Speaking fluent Sanskrit he and his Arab body servant, an unmade Bedouin of great beauty, had wreaked havoc among the Turkish levies." But he knows "there's an element of mockery here I don't like."

Boarding schools, headmasters, war heroes, these were of course precisely the targets of satirists, cartoonists, filmmakers, and novelists in the 1960s. In *Beyond the Fringe*, Bennett was celebrated for his parodies of vicars and Battle of Britain pilots. He is still proud of his turn as Douglas Bader, the RAF ace who lost his legs when he was shot down. But as in all parodies, mockery was mixed with affection. The fashion in Swinging London for nineteenth-century army uniforms was an expression of irony, but perhaps also of nostalgia for a grander, more dramatic age. It is not so surprising, then, to find the headmaster of Albion House making a speech at the end of the play that echoes Bennett's own feelings about his country:

Country is park and shore is marina, spare time is leisure and more, year by year. We have become a battery people, a people of under-privileged hearts fed on pap in darkness, bred out of all taste and season to savour the shoddy splendours of the new civility.

The school matron then laments the fate of old people tidied up into tall flats. But the headmaster has not finished:

Once we had a romantic and old-fashioned conception of honour, of patriotism, chivalry and duty. But it was a duty which didn't have much to do with justice, with social justice anyway. And in default of that justice and in pursuit of it, that was how the great words came to be cancelled out. The crowd has found the door into the secret garden. Now they will tear up the flowers by the roots, strip the borders and strew them with paper and broken bottles.

Osborne could have written this in one of his diaries for *The Spectator*. There is some disdain in these words for hoi polloi, the TV-watching masses in their ghastly leisure clothes, for what Harold Nicolson called the "Woolworth's world." The play is also a lament for a world that Bennett himself, among others of his generation, lampooned. As usual it is Bennett who best explains his own feelings. His heart, he writes in his diary, "is very much in Gielgud's final speech in which he bids farewell to Albion House and this old England. And yet the world we have lost wasn't one in which I would have been happy, though I look back on it and read about it with affection."

This feeling of ambivalence, romantic and skeptical at the same time, is "what the play is trying to resolve." Of course it didn't succeed. It couldn't have. It never will be resolved, it never has been. But it has inspired the English theater since Shakespeare. What is *Henry V*, if not an expression of ambivalence, toward the king, toward England?

Burgess's treachery, at least in Bennett's interpretation, falls into the same category. Burgess tells Coral Browne: "I can say I love Lon-

don. I can say I love England. I can't say I love my country, because I don't know what that means." Bennett writes that this is "a fair statement of my own, and I imagine many people's, position." Perhaps it is. Bennett also believes that betrayal is an extension of skepticism and irony. Possibly so. But Burgess says something else, something closer to the bone. When Browne asks him why he became a spy, he answers: Solitude. Keeping secrets offers solitude. Was Burgess's double-act, like King George's "what, what," like Osborne's country squire, like *Bennett*, a façade behind which a shy man could hide from a nation of snoops?

It's impossible to be sure. But Burgess pulled off a remarkable act, for he was so brazen, so openly outrageous, so Toad-like that he seemed not to have been acting at all. I have never met Bennett (or Burgess, for that matter), but I suspect he is as different from Burgess as Toad is from Mole. Yet one line in *An Englishman Abroad* sticks in my mind. Burgess: "I never pretended. If I wore a mask it was to be exactly as I seemed." Is this the spy speaking, or is it the author? What, what?

19

THE INVENTION OF DAVID BOWIE

Every time I thought I'd got it made
It seemed the taste was not so sweet
So I turned myself to face me
But I've never caught a glimpse
Of how the others must see the faker
I'm much too fast to take that test

Ch-ch-ch-ch-Changes…
— DAVID BOWIE, "Changes," *Hunky Dory*, 1971

DAVID BOWIE: "My trousers changed the world." *A fashionable man in dark glasses*: "I think it was more the shoes." *Bowie*: "It was the shoes."[1] He laughs. It is a joke. Up to a point.

There is no question that Bowie changed the way many people looked in the 1970s, 1980s, even 1990s. He set styles. Fashion designers—Alexander McQueen, Yamamoto Kansai, Dries Van Noten, Jean Paul Gaultier, et al.—were inspired by him. Bowie's extraordinary

1. From the documentary *The Story of David Bowie* (BBC, 2002).

stage costumes, from Kabuki-like bodysuits to Weimar-era drag, are legendary. Young people all over the world tried to dress like him, look like him, move like him—alas, with rather variable results. So it is entirely fitting that the Victoria and Albert Museum should stage a huge exhibition of Bowie's stage clothes, as well as music videos, handwritten song lyrics, film clips, artworks, scripts, storyboards, and other Bowieana from his personal archive.[2] Apart from everything else, Bowie's art is about style, high and low, and style is serious business for a museum of art and design.

One of the characteristics of rock music is that so much of it involves posing, or "role-playing," as they say in the sex manuals. Rock is above all a theatrical form. English rockers have been particularly good at this, partly because many of them, including Bowie himself, have drawn inspiration from the rich tradition of music-hall theater. If Chuck Berry was a godfather of British rock, so was the vaudevillian Max Miller, the Cheeky Chappie, in his daisy-patterned suits. But there is another reason: rock and roll being American in origin, English musicians often started off mimicking Americans. More than that, in the 1960s especially, white English boys imitated black Americans. Then there was the matter of class: working-class English kids posing as aristocratic fops, and solidly middle-class young men affecting Cockney accents. And the gender-bending: Mick Jagger wriggling his hips like Tina Turner, Ray Davies of the Kinks camping it up like a pantomime dame, Bowie dressing like Marlene Dietrich and shrieking like Little Richard. And none of them was gay, at least not most of the time. Rock, English rock especially, has often seemed like a huge, anarchic dressing-up party.

2. "David Bowie Is," an exhibition at the Victoria and Albert Museum, London, March 23–August 11, 2013. Catalog of the exhibition edited by Victoria Broackes and Geoffrey Marsh, with contributions by Camille Paglia, Jon Savage, and others (London: V&A Publishing, 2013).

No one took this further, with more imagination and daring, than Bowie. At a time when American groups would often dress down—affluent suburban kids disguised as Appalachian farmers or Canadian lumberjacks—Bowie quite deliberately dressed *up*. In his words: "I can't stand the premise of going out [on stage] in jeans...and looking as real as you can in front of 18,000 people. I mean, it's not normal!" Also in his words: "My whole professional life is an act...I slip from one guise to another very easily."

The costumes of Bowie's rock theater are all on display at the V&A. And many are outrageously beautiful. The red-and-blue quilted suit and red plastic boots designed by Freddie Burretti for Bowie's Ziggy Stardust character in 1972. Yamamoto Kansai's kimono-like cape splashed with Bowie's name in Chinese characters for *Aladdin Sane* in 1973. Natasha Korniloff's surrealistic cobweb bodysuit with false black-nail-polished hands tickling the nipples for the 1980 Floor Show. Ola Hudson's black pants and waistcoat for Bowie's incarnation as the Thin White Duke in 1976, which look as though they were designed for a male impersonator. And Alexander McQueen's exquisitely "distressed" Union Jack frock coat from 1997. Then there is the perverse nautical gear, and the "Tokyo pop" black vinyl bodysuit, the matador cape, the blue turquoise boots, and on and on.

Bowie's image was as carefully contrived for album covers as for the actual musical performances: Sukita Masayoshi's black-and-white photograph of Bowie posing like a mannequin doll on the cover of *"Heroes"* (1977), or Bowie stretched out on a blue velvet sofa like a Pre-Raphaelite pinup in a long satin dress designed by Mr Fish for *The Man Who Sold the World* (1971), or Guy Peellaert's lurid drawing of Bowie as a 1920s carnival freak for *Diamond Dogs* (1974).

All these images were created by Bowie in collaboration with other artists. He drew his inspiration from anything that happened

to catch his fancy: Christopher Isherwood's Berlin of the 1930s, Hollywood divas of the 1940s, Kabuki theater, William Burroughs, English mummers, Jean Cocteau, Andy Warhol, French chansons, Buñuel's surrealism, and Stanley Kubrick's movies, especially *A Clockwork Orange*, whose mixture of high culture, science fiction, and lurking menace suited Bowie to the ground. Artists and filmmakers have often created interesting results by refining popular culture into high art. Bowie did the opposite: he would, as he once explained in an interview, plunder high art and take it down to the street; that was his brand of rock-and-roll theater.

What has been truly unusual about Bowie, in comparison to other rock acts, is the lightning speed of his costume changes. His musical changes reflected this, from the throbbing rhythm of the early Velvet Underground to the harsh dissonances of Kurt Weill to the disco beat of 1970s Philadelphia. The range of his singing voice, aching in some songs, full of bravura in others, but always haunted by a sense of danger, helped him straddle many genres. To get the excitement of Bowie's best live performances, one would have had to be there, but the artful videos, made by Bowie with various talented filmmakers, some of which are displayed to great effect at the V&A show, still give a flavor of his theatrical appeal.

Two of the most famous videos are *Ashes to Ashes* (1980) and *Boys Keep Swinging* (1979), both directed by David Mallet. Bowie plays three roles in *Ashes to Ashes*: an astronaut, a man curled up in a padded cell, and a tragic Pierrot tormented by his mother. In *Boys Keep Swinging*, Bowie appears as a late-1950s rock and roller, and plays all three backup singers in Hollywood diva drag: two end up whipping their wigs off in a kind of fury; one turns into a menacing maternal figure. A common feature in Bowie's videos, as well as his stage shows, is an obsession with masks and mirrors, sometimes several mirrors at the same time: his characters watch themselves being

watched. In his earlier interviews, Bowie spoke often about schizo-phrenia. Stage roles would spill out into his personal life. As he put it: "I couldn't decide whether I was writing characters or whether the characters were writing me."

So who is David Bowie? He was born in 1947 as David Jones in Brix-ton, South London, but grew up mostly in Bromley, a relatively genteel and deeply dreary suburb. Many rockers, including Mick Jagger and Keith Richards, grew up in such places, which the novelist J. G. Bal-lard, who lived for most of his adult life in Twickenham, described as

> far more sinister places than most city dwellers imagine. Their very blandness forces the imagination into new areas. I mean, one's got to get up in the morning thinking of a deviant act, merely to make certain of one's freedom.

Like Jagger and Richards, the young David Jones was roused from suburban torpor by the sounds of American rock and roll. He re-called that he "wanted to be a white Little Richard at eight or at least his sax player."

David's family background was not strictly conventional. His fa-ther, "John" Jones, was a failed music impresario and piano bar op-erator (the Boop-a-Doop in Charlotte Street, Soho) who lost his money promoting the career of his first wife, Chérie, "the Viennese Nightingale." David's mother, "Peggy" Burns, was a cinema usher-ette. Still, Bromley was Bromley. The bright lights beckoned.

For much of the 1960s, Bowie's pop career, varied but unsuccess-ful, did not yet point to the theatrical sensation he was to become. He always looked sharp but not yet extraordinary. There were false

starts: an ice-cream commercial, a jokey song entitled "The Laughing Gnome." He changed his name to Bowie, after the Bowie knife, because another Davy Jones had become famous as one of the Monkees. Then, in the late 1960s, he met two people who would change his life: the English dancer and mime artist Lindsay Kemp, with whom Bowie had an affair, and Angela Barnett, an American model whom he soon married. I saw Kemp dance once in London, in the early 1970s, in a solo piece based on Jean Genet's *Our Lady of the Flowers*, I believe. He was an extraordinary presence on stage, in whiteface, wide-eyed, delicate, flitting about, a little like Vivien Leigh in *A Streetcar Named Desire*.

Kemp taught Bowie how to use his body, how to dance, pose, mime. And it was Kemp who introduced Bowie to Kabuki. Kemp was fascinated by the *onnagata* tradition of male actors playing female roles. Kabuki is a good fit for Bowie, a theater of extravagant, stylized gestures. At climactic moments the actors freeze, as though in a photograph, while striking a particularly dramatic pose. Bowie never became a great actor, but he did become a great poseur, in the best sense of the word; he always moves with peculiar grace. Without the influence of Kemp, he might not have made the next step in his career, merging rock music with theater, film, and dance. They put on a show together called *Pierrot in Turquoise*. Bowie learned how to use costumes and lighting to the best effect. Sets would become ever more elaborate, featuring images from Buñuel movies or Fritz Lang's *Metropolis*.

But the main thing he got from Kemp was his taste for turning life itself into a performance, another Kabuki-like influence. In the old days *onnagata* actors were encouraged to dress up as women in real life too. Bowie said about Kemp: "His day-to-day life was the most theatrical thing I'd ever seen, ever. Everything I thought Bohemia probably was, he was living."

While living the Bohemian life, he and Angela had a son, whom they named Zowie (in the rock-star fashion for giving their children bizarre names), now thankfully called Duncan Jones, a well-regarded film director. It was an adventurous marriage, a kind of polymorphous perverse performance in its own right, open to all sexes. Both were keen promoters of the young rock star's image. Angela encouraged her spouse's dandyism.

They must have been quite a pair when they turned up in 1971 at Andy Warhol's studio in New York, the husband in shoulder-length blond hair, Mary Jane shoes, a floppy hat, and absurdly wide Oxford bags, and the shorter-cropped wife looking tougher, more boyish, in comparison. Bowie sang his tribute song to Andy Warhol: "Andy Warhol looks a scream / Hang him on my wall / Andy Warhol, Silver Screen / Can't tell them apart at all . . . a-all . . . a-all." Warhol was apparently polite to his guest but not entirely pleased by the wording of the tribute. Later he became a Bowie fan, and some of his actors joined the pop star's entourage.

Androgyny was central to Bowie's rising appeal—neither quite straight nor really gay, but something in between that cannot even be adequately described as bisexual (although in real life Bowie was apparently sexually active in every which way). Yamamoto, the Japanese designer, said he liked to make clothes for Bowie because he was "neither man nor woman." The image cultivated by Bowie, as he became more famous, was as a complete oddity, an isolated alien, a pop deity, enigmatic, freakish, alienated, but dangerously alluring. Japanese culture, he once said, attracted him as "the alien culture because I couldn't conceive a Martian culture." Bowie's first big hit was "Space Oddity" (1969), about a fictional astronaut: "This is Major Tom to ground control / I'm stepping through the door / And I'm floating in a most peculiar way . . ."

Filmmakers used Bowie's alien androgynous quality for their own purposes and enhanced his reputation for strangeness. Bowie's

best-known film is Nicolas Roeg's *The Man Who Fell to Earth* (1976). In this science-fiction story, Bowie plays a man from another planet who lands in the United States to become first very rich and then an alienated alcoholic obsessed by television and imprisoned by government agents in a luxury apartment. What Roeg exploits is not Bowie's acting ability, which is ordinary at best, but his image and his body language, his genius for posing.

Oshima Nagisa did something similar in his movie *Merry Christmas Mr. Lawrence* (1983), based on a Laurens van der Post novella about the experience of a British army officer in a Japanese POW camp during the Pacific war. One way—the banal way—of doing this would have been to make it into a manly story of rugged endurance. Oshima's idea was to cast Bowie as the officer and the Japanese pop/rock musician Sakamoto Ryuichi as the cruel camp commandant. Both pop icons are equally androgynous in their own ways—Sakamoto even wears makeup. In the climactic scene of the film the British officer tries to disarm his enemy by planting a kiss on his lips, an act for which the blond hero then has to undergo some ghastly tortures. Again the acting is only so-so, but the posing, the "look," is brilliant.

The first and only time I ever saw Bowie was in the early 1970s at a gay disco on Kensington High Street called Yours and Mine, under a Mexican restaurant called El Sombrero. There was Bowie, not yet world-famous, his dyed red hair flopping, dancing away keenly on his long skinny legs. He was such a weird presence that the image stayed with me, even though there was nothing especially remarkable about the occasion. In 1972, Bowie gave an interview to the British pop magazine *Melody Maker*. The interviewer, Michael Watts, wrote:

David's present image is to come on like a swishy queen, a gorgeously effeminate boy. He's as camp as a row of tents, with his limp hand and trolling vocabulary. "I'm gay," he says, "and always have been, even when I was David Jones." But there's a sly jollity about how he says it, a secret smile at the corners of his mouth.

Watts was on to something. The high camp, too, was part of an act, a pose, as was Bowie pretending to fellate the instrument of his very straight guitarist, Mick Ronson, in a concert during that same year. It was certainly a bold statement to make for a rock star, since rock still was by and large a pretty straight business. Bowie was one of the first, but it soon became quite the fashion, especially in England, for young men to affect the mannerisms of a gay style that was —post-Stonewall—quickly becoming distinctly unfashionable in the actual gay world. British rock in the 1970s, with the New Romantics, and such stars as Bryan Ferry or Brian Eno, the latter in full makeup and sporting a feather boa, became very camp indeed, even though few of these men seem to have had any sexual interest in other men.

Bowie, as we know, was a little more ambiguous. But however contrived to attract attention, Bowie's statement was seen as a coming-out that encouraged and inspired many confused young men at the time. The freakish isolated figure from another planet became a model, a kind of cult leader. In the latest issue of the gay magazine *Out*, various people tell their personal stories about Bowie's influence. Here is the singer Stephin Merritt:

> I didn't grow up with a father at all; I didn't have a father figure telling me how to approach gender, so I thought David Bowie was a perfectly good model of how to approach gender. And I still think so.

And here the perfomer Ann Magnuson:

He was the Pied Piper who took us suburban American kids to
Disneyland, reimagined as an oversexed, sequined, space-age
pleasure dome.

Or the British novelist Jake Arnott:

You know, the '70s were quite a gloomy time. But Bowie looked
fabulous, and I think there was a feeling of that's what you
could become yourself. That's what brought me to him.

Bowie wanted fame. But it happened so quickly that it almost killed
him. He described it in *Cracked Actor*, a fascinating documentary film
made in 1975 for the BBC. Bowie, pale, emaciated, his nose twitching
from excessive ingestions of cocaine, tells Alan Yentob, his interviewer,
about the terrors of fame. It was like being "in the car when some-
one's accelerating very, very fast, and you're not driving... and you're
not sure whether you like it or not... that's what success was like."
 At the height of his success, Bowie created his most famous role,
Ziggy Stardust, as a kind of alter ego. In Bowie's show, Ziggy was a
rock-and-roll messiah from outer space who is torn apart in the end
by his fans in a brilliant song entitled "Rock 'n' Roll Suicide." The
story, which is typically Bowie-esque, is a paranoid druggy science-
fiction fantasy. *Rolling Stone* magazine published a hilarious conver-
sation with William Burroughs in which Bowie tries to explain: "The
end comes when the infinites arrive. They really are a black hole, but
I've made them people because it would be very hard to explain a
black hole on stage...." Even Burroughs mights have been a little
nonplussed. But the music and the show are among the best things
ever done in rock and roll.

The problem is that Bowie got carried away a little too far into his private outer space. He began to think he was Ziggy. Quite wisely, he tried to kill him off on stage in London in the summer of 1973, when he announced that there would be no more Ziggy Stardust, and his band, the Spiders from Mars, would be terminated. But Bowie remained haunted by the character: "That fucker would not leave me alone for years."

It must be a disconcerting experience for a young man from Bromley, say, or Dartford, or Heston, or for that matter Hibbing, Minnesota, to be a rock messiah. Some—Keith Richards, David Bowie—seek refuge in drugs. Some—Jimmy Page, from Heston—dabble in black magic. Some are made of tougher stuff, like Mick Jagger, and treat their rock business in the way a CEO handles his corporation. And some just try to escape into obscurity, as Bob Dylan did for a time, and Bowie attempted to do as well.

More reflective, perhaps, than most rock musicians, Bowie gave his fame a lot of dark thought. Ziggy, he once said, was the typical prophet-like rocker who had all the success and didn't know what to do with it. In a fine song, entitled "Fame" (1975), Bowie sang: "Fame makes a man take things over / Fame lets him loose, hard to swallow / Fame puts you there where things are hollow." Bowie started quoting Nietzsche in interviews, about the death of God. Phrases like *homo superior* popped up in his songs. But he never quite lost his sense of humor. In the Burroughs interview, Bowie compares Ziggy's rock-and-roll suicide to Burroughs's apocalyptic novel *Nova Express*, and says, "Maybe we are the Rodgers and Hammerstein of the seventies, Bill!" Still, the combination of drugs and rock-star isolation also led to some very half-baked notions about Adolf Hitler being "one of the first rock stars" and how Britain needed a fascist leader.

Bowie needed to calm down, away from the temptations of superstardom. And he calmed down, more or less, in of all places Berlin.

Attracted by the allure of Weimar-period decadence, expressionist art (Bowie was always an art lover), and its geographical isolation, he lived in Berlin for several years after 1975 in relative obscurity. Helped by Brian Eno, he created some of his best music there, albums now known as Bowie's Berlin Trilogy: *Low*, *Heroes*, and *Lodger*. His voice deepened into a slightly eerie crooning style, redolent of the 1930s, or the chansons of Jacques Brel. The lyrics darkened into an edgy melancholy. The music, influenced by German technopop, had the alienating thrum of industrial noise. And sharp double-breasted suits began to replace the bodysuits and kimonos. Bowie had reinvented himself as a depressive Romantic. The moves became less histrionic, the act more suave.

How does a rock star get old? Most fade away. Some get stuck in a role, and keep going on and on: the Stones still throbbing, in a rickety kind of way, with teenage lust. Some play the old songbook: Eric Clapton as a classical musician of the blues, or Bryan Ferry as a kind of Rat Pack lounge lizard.

In 2004, it looked as if David Bowie had taken his final bows and made a graceful exit. He had suffered a heart attack backstage after a concert. And that seemed to be that. He had been married for a decade to the Somali model Iman. They had a child. They lived in New York. Bowie was a family man, working on his painting, helping his daughter with her homework, enjoying trips to Florence to see his favorite Renaissance painters, browsing in bookstores.

The rock messiah, it appeared, had finally been laid to rest.

And then he pulled a stunt. Without anybody noticing, Bowie had made another album. It was announced in January 2013 on his sixty-

sixth birthday. A video of one of the songs, entitled "Where Are We Now?," popped up on his website. And the album, *The Next Day*, could be downloaded for free online for a limited period. So did Bowie reinvent himself yet again? Is he playing yet another role? Does he even need to? Bowie not only reinvented himself over and over, inspiring other musicians, as well as countless fans. But he did more. Over his long career, Bowie invented a new kind of musical theater, whose props are on display at the V&A Museum. His influence on the art of performance has been inestimable, and will linger long after he has gone. Meanwhile, we have the music, which still has the power to astonish and delight. Is the new album a completely new departure?

Well, yes and no. The music on *The Next Day*, with its hard, almost relentless beat, sounds like something that could have been made in the 1980s. To his credit, Bowie does not even try to sound like a young man. The tone is melancholy, filled with memories. "Where Are We Now?" is an introspective look back at his Berlin days: "A man lost in time / Near KaDeWe / Just walking the dead . . ." In the video, Bowie's face appears once more looking into a mirror, but there is no trace of makeup. It is the face of a well-preserved, still-handsome man in his sixties, the wrinkles and sagging skin undisguised.

It is a highly professional album, with some haunting tunes. Here is the work of a man who seems to be well settled. There is no more posing. This is dignified, mature. But is it rock and roll? Does it even matter? Perhaps Bowie has taken the form as far as it can go, and rock is becoming like jazz, the raw energies of its youth exhausted, now entering a venerable old age.

20

DRESSING FOR SUCCESS

AT THE HEIGHT of his fame, in 1920s Paris, the Japanese painter Foujita, or Fou Fou to his friends, would draw up at the café Le Dôme in a canary-yellow chauffeur-driven Ballot touring car with a little bronze Rodin bust on the hood. The limo was a birthday gift from Foujita to his then-twenty-one-year-old mistress and later wife, "Youki" Badoud, who, dressed to the nines, would sweep into the café with her husband, as both acknowledged the waves of his adoring fans. Fou Fou, with his large gold earrings, his fringed haircut, his tattooed wristwatch, his round spectacles, and his outlandish dress, was so famous in Paris that department stores displayed mannequins of the painter in their windows. Society ladies lined up to be portrayed by Foujita. He partied with Picasso, Alexander Calder, and Kees van Dongen. His were the most talked about, most outrageously imaginative costumes worn at the legendary arts balls. Foujita even did judo demonstrations at the Paris Opéra.

This is the way Foujita is still remembered in France, as one of the most colorful figures of the Roaring Twenties, one whose art may not, in retrospect, be of the first rank but still retains an aura of exotic, Oriental modernism. Foujita died in his adopted country in

1968, after becoming a French citizen and converting to Christianity, as Léonard Foujita—a homage to Leonardo da Vinci. In his native Japan, Fujita Tsuguharu has a more complicated reputation. Even though his many pictures of cats, nudes, and bug-eyed children have been exhibited regularly and still fetch high prices, he is best known for his stint during World War II as Japan's most prolific, and to some most scandalous, propagandist for imperial militarism. There is a photograph, reprinted in Phyllis Birnbaum's *Glory in a Line*,[1] of Fujita (no longer Foujita, let alone Fou Fou) in Tokyo around 1942, minus the large earrings and famous fringe, reading *Signal*, the Nazi propaganda magazine.

Seen side by side, it is hard to imagine that *Last Stand at Attu* (1943), depicting a Japanese suicide charge on the Aleutians, was done by the same man who painted *Nude with a Jouy Fabric* in Paris (1922). One is full of violence, painted with a density to suggest an enraged horror vacui; the other is stark and sensuous. Foujita, the flaneur who went about Montparnasse in Greek tunics or outfits cut out of floral curtains, had become Fujita, cutting a dashing figure in wartime Singapore in a mock general's uniform. What remained constant in these transformations was his dandyism. His paintings, like his clothes, were often contrived for public effect, to make a splash, to strike a pose. Birnbaum relates how the artist would stand beside his *Last Stand at Attu* in a Tokyo museum, dressed in combat boots and a helmet, bowing each time a visitor dropped money for the war effort into a collection box.

Foujita always was keen on dressing up, with a particular fondness for cross-dressing, which Birnbaum duly notes without making

1. *Glory in a Line: A Life of Foujita—the Artist Caught Between East and West* (Faber and Faber, 2006).

much of it. Perhaps she should have at least made a stab. Dressing up as a courtesan at Tokyo art school parties is one thing, but turning up in front of his classmates in red underwear, claiming to be a female prisoner just escaped from a local jail, and being paraded around town with his hands tied is more intriguing. When an elderly Frenchwoman in Paris once spotted Fou Fou in his floral curtain costume and inquired whether he was a man or a woman, he replied, "Unfortunately, I am a man." And what are we to make of his habit of walking hand in hand with Kawashima, his male Japanese friend, in Paris, both dressed à la Grecque?

Perhaps Birnbaum is right to avoid psychological speculation. But if psychologizing is a temptation she manages to dodge, certain postmodern stylistic tics mar what is otherwise a well-told story. She mentions Foujita's first wife, Tomi, and the negative comments made about her in Japan. "If I were her biographer," she writes, "I would mull over their comments.... But I'm not writing the woman's story this time around." Why not? If it adds to our understanding of Foujita's life, the story of his first wife is surely worth mulling.

Still, Birnbaum does dwell, quite rightly, on the practical side of Foujita's grandstanding. He was a kind of performance artist, anticipating Andy Warhol. "When I look back on those days," he said later, "I feel that my clothing was very crazy. But at the time, I thought it was extremely artistic. I thought that I myself had to become a work of art in every way." On another occasion he came closer to the point:

Those who think I became famous because of my kappa hairstyle and my earrings should compare me to the automobile company Citroën, which spent a fortune to advertise on the Eiffel Tower with the biggest electronic device in the world. Can't you say that my way gives me clever publicity for free?

As a social and artistic climber, if nothing else, Foujita was an astounding success. Conquering Paris had been the dream of most Japanese artists who painted in the European style ever since Impressionism conquered Japan (a victory that is still evident in the work of many Japanese painters today). It could be a highly destructive dream. Birnbaum mentions the story of Saeki Yuzo (1898–1928), one of the most revered Japanese painters, whose short life illustrates the tragic misunderstandings that marked Japan's artistic confrontation with the West.

Obsessed by Vincent van Gogh and Maurice de Vlaminck, Saeki moved to Paris in 1924 in a rush of romantic passion to be a modern painter. Vlaminck, however, took one look at one of Saeki's paintings and dismissed it as derivative, academic, and dull. A Japanese artist, in his view—one echoed by most Europeans enchanted by Japanese woodblock prints—should paint in the Oriental tradition. Attempts by Japanese artists to work in the Western style were regarded as inauthentic and thus doomed to failure. Saeki, driven mad by frustrated ambition, died four years later in a mental hospital. Obscure in the West to this day, his reputation in Japan is that of a genius who paid for his art with his life.

The idea that Asians cannot enter into the traditions of Western art is a form of blinkered Orientalism. It would disqualify many of the greatest classical musicians of our time. But it must be said that the work of most Japanese painters in the Western style was, and often still is, derivative and academic. The modernist idea of expressing oneself in a totally new way, inventing styles, and struggling with one's predecessors, as Picasso did with Velázquez, say, was unfamiliar to artists of Foujita's generation, born in a culture where masters were to be emulated and schools to be joined. This did not inhibit photographers, filmmakers, playwrights, or novelists nearly as much,

since they were less fixated on foreign masters. But Japanese painters, no matter how hard they tried, rarely managed to get away from their European models.

Except Foujita. His art may not have been as good as some of his contemporaries thought, but it was distinctive. Unlike most Japanese in Paris, Foujita escaped from cultural isolation by learning to speak French, however badly, and cultivating European contacts. Not only did he make a well-received spectacle out of himself at a party thrown by Kees van Dongen by dancing in a loincloth and singing Japanese folk songs, but he was introduced to Picasso by Diego Rivera and was much impressed by Henri Rousseau's *The Poet and His Muse* hanging in Picasso's studio. "*Tiens*," Picasso is supposed to have said, "you are the first painter to have noticed this work." Quite what Picasso made of Foujita's own art is not recorded. When he saw Foujita's nude painting of Youki at the Salon d'Automne, he took a long look at the model herself and remarked: "So that's Youki. She is even more beautiful than in your painting."[2] Youki was delighted. Whether Foujita should have taken it as a compliment is less obvious.

Foujita's encounters with European modernism quickly made him realize that he had to ditch all he had learned at his art school in Tokyo and start again:

I, who did not even know the names of Cézanne and van Gogh, now opened my eyes to look out in a radically different direction.... Suddenly, I understood that paintings were free creations.... I suddenly realized that I should forge ahead, with a completely free spirit, to break new ground with my ideas.

2. Both of Picasso's reactions are described in Youki Desnos (Foujita's third wife), *Les confidences de Youki* (Paris: Opera Mundi, 1957).

Birnbaum shows convincingly that Foujita could be a serious art-
ist as well as a self-promoting party animal. He spent hours studying
paintings in the Louvre, as well as experimenting in his studio. Unaf-
flicted by the diffidence often attributed to Japanese abroad, Foujita
also picked up fashionable models. Kiki de Montparnasse, who
posed for everyone from Soutine to Man Ray, described her first en-
counter with Foujita in her memoir, whose candor was deemed so
shocking in the US that it was banned here for many years:

> I also posed for Foujita. The thing that astonished him about
> me was the lack of hair on my sexual parts. He often used to
> come over and put his nose above the spot to see—if the hair
> hadn't started to sprout while I'd been posing. Then, he'd pipe
> up with that thin little voice of his: "That's ve' funny—no hairs!
> Why your feet so dirty."[3]

Foujita was a stickler for hygiene in an environment where cleanli-
ness was in short supply. His friend Modigliani rarely changed his
clothes and shoved his excretions under the bed. Soutine's room was
so infested by bedbugs that one of them got into his ear and had to
be extricated in a painful operation. And there, in the midst of this
bohemian squalor, was Foujita, carving out a space for himself in the
Paris School. He never gave in to the French demand for Japanese
exotica—pictures of carp or temple roofs—that provided some of his
compatriots with a living. Instead, he did something much cleverer,
which at its best was startlingly original. Beginning with a base of
white paint, he drew his subjects in black lines with fine Japanese
brushes, merging the techniques of Asian ink painting with Western

3. *The Education of a French Model: Kiki's Memoirs* (Boar's Head, 1950).

oil painting, mixing the practiced spontaneity of the former with the careful layering of the latter.

Birnbaum, with good reason, places the pinnacle of Foujita's artistic achievements in the early 1920s, with such paintings as *My Room*, shown at the 1921 Salon d'Automne, *Reclining Nude with a Cat*, and *Nude with a Jouy Fabric* (of Kiki). She writes that Foujita's achievement is easiest to appreciate in the company of more colorful works by his European contemporaries: "For maximum effect, hang a Foujita among Picasso's loudly dressed harlequins, the deep red and blue of a Modigliani portrait, and a bloody beef carcass by Soutine. Beside these blasts of color, Foujita's stark paintings stand out as acts of courage."

The French certainly thought so at the time, unlike many Japanese critics, who resented Foujita's self-publicizing, which they regarded as showy and undignified (and maddeningly successful), and they dismissed his Japanese touches as cheap Japonaiserie. This was too harsh. Foujita was one of the very few painters who fused East and West in a plausible manner. But I'm not sure that even his best oil paintings have quite stood the test of time. They are decorative, skillful, and certainly original, but shallow. I prefer his ink-and-watercolor drawings, the delicate self-portraits and portraits of women, and his woodcut illustrations for books.[4] Foujita, in these pictures, was influenced by Western art, while working in a Japanese tradition without indulging in pastiche or repeating old formulas.

Foujita's remarkable success in France soon spread to other parts of the West. Among other places, he had shows in London, Amsterdam, and New York. This makes his turn, in the 1930s, toward

4. See, for example, his illustrations for Pierre Louÿs, *Les Aventures du Roi Pausole* (Paris: Fayard, 1927).

belligerent Japanese chauvinism all the more surprising. Among his less successful expatriate colleagues it was a common volte-face. Many Japanese artists, frustrated in their attempts to impress the West, turned from disdain for Japan and its artistic traditions to a vengeful loathing of the West. One famous example, mentioned in Birnbaum's book, was the poet and sculptor Takamura Kotaro. In the 1910s and 1920s, he wrote odes to his beloved Paris and expressed his "respect and love" for "the Anglo-Saxon race." A few decades later he celebrated the war on Britain and America: "America and England have been rejected by the Heaven and Earth of East Asia. Their allies will be crushed."[5]

But Foujita had little reason for such bitterness. Perhaps, however, artistic and social success were not enough to compensate for the strains of cultural assimilation. Extraordinary things came from the Japanese confrontation with the West, but often at a high personal price. Like Takamura and many others, Foujita began by rejecting Japan, which he described in letters to his first wife as "not a country for artists." The disapproval from other Japanese in Paris can only have added to his disgust. But he also remained the proud son of a military doctor, who craved recognition in his native country. It is the common fate of Japanese who have made it abroad to be accused of pandering to foreigners, of "reeking of butter." Even the great filmmaker Kurosawa Akira, who never lived outside Japan, came in for this envious treatment.

Foujita first went back to Japan in 1929, accompanied by Youki, partly to escape the French tax authorities. He was not universally welcomed. Critics accused him of caring only about money and fame. In return, perhaps out of pique, Foujita lectured Japanese artists on

5. *Dawn to the West*, translated by Donald Keene (Holt, Rinehart and Winston, 1984), p. 306.

their provincial ways. Youki recalls in her memoir how he would make special trips from Tokyo to Yokohama to buy Gauloise cigarettes from French sailors. This was not such unusual behavior for Japanese artists returning from Paris; even today you will still find painters in Tokyo sporting long hair and French berets, even if they have never set foot in the French capital.

Foujita's second homecoming in 1933, accompanied by yet another wife, a French show dancer this time, named Madeleine Lequeux, was more successful, although still with ups and downs. He had a successful show in Tokyo. But in 1936, Madeleine, after a stormy few years, died in circumstances that were never fully cleared up. Foujita found new inspiration with a Japanese woman named Kimiyo, who became his last wife. And soon, newly enchanted by the sights and sounds of his native country, the rhythms of Kabuki music, the horns of the tofu vendors, Foujita was ready for a break with Europe: "Every day I wake up with the realization, 'Oh, I'm in Japan,' and a smile, full of fondness for the land of my birth, spreads over my face."

His new enchantment with Japan produced some remarkably bad art. Japanese critics were right to dismiss his touristy pictures of sumo wrestlers and geishas as dilettantism. Stung by such criticisms, Foujita did what he had always been good at: he figured out his market. Soon this led to even worse kitsch, but it proved to be popular kitsch. He promised a wealthy collector that he would paint in record time "the world's number one painting." The result, completed in 174 hours, according to the collector who timed it, was a huge painting, sixty-seven feet long, of country life in northeastern Japan: village festivals, rice harvests, and so on. The painting is dense, colorful, and skillfully done, but, as Birnbaum says, devoid of emotional content.

The same techniques, the density of detail, the pictorial realism, would be applied a few years later to Foujita's war paintings, celebrating Japanese victories in Southeast Asia or the self-sacrificing

heroism of Japanese soldiers in China. They were what finally made his name in Japan. People were moved to tears by the sight of Foujita's pictures of carnage. Some fell on their hands and knees. "I was surprised," recalled Foujita, "because this was the first time in my life that one of my works had affected people so much that they worshiped before it." But even worship, though doubtless gratifying, doesn't quite explain why the erstwhile companion of Picasso and Modigliani became such a zealous painter of war propaganda. Birnbaum quotes the American connoisseur of Japan Donald Richie:

[Foujita] came back to Japan more Japanese than the Japanese.... It is a known cultural pattern. He reveled in the freedom abroad. That's a pattern—to revel in the freedom and at the same time to resent all those things.

This is probably true. But there was also an element of playacting about Foujita's militarism, in line with his love of dressing up. Nomiyama Gyoji was an art student when he met Foujita during the war. In an interview with Birnbaum, he recalled his astonishment at the variety of clothes he found in Foujita's wartime studio, outfits the artist had designed himself: jackets for firefighting, and various quasi-military uniforms with red boots and green double-vests. Nomiyama remembers thinking that Foujita was "just amusing himself with this war. War for him is only a source of entertainment."

On the other hand, as Birnbaum says, the wartime paintings express visions of darkness and cruelty that are unusual in propaganda art. Actually, this was less unusual in Japanese wartime movies, novels, and artworks than in similar fare in Europe or the US. The more horrific the scenes of battle looked, the more people could admire the hardships and sacrifices of the Japanese troops. But Nomiyama pointed out something else about Foujita's paintings that was un-

usual. "In Foujita's paintings," he said, "you don't feel that there is any difference between the enemy dying and Japanese dying. Everyone looks so sad."

Perhaps the most revealing comments came from the artist himself, when he declared in 1942, with evident satisfaction, that "all ties with the French art world have been severed." It would no longer be necessary to imitate foreigners:

> It is not necessary for Paris to be Japan's teacher.... As for modern French painting: the artists who drew works inspired by French liberalism and individualism linked up with Jewish gallery owners. Then strange international perverts from all over the world got together and created modern art there.

This sounds like the kind of lacerating confessions made under Stalinism, especially when he talks about the necessity to make popular art "correct in the details" and "without mistakes in the realistic effects."

The perverse thing about all this is not just the almost masochistic repudiation of everything Foujita himself had believed in but also the sense of liberation. His reputation in the West had declined considerably since the heady 1920s. But from now on he no longer had to live up to the standards of Paris, or anywhere else in the West; the common Japanese people, and not the critics or those liberal Jewish gallery owners, would henceforth be his judges. The style of the wartime paintings, however, was more derivative from Western art than his work in Paris.

As is so often the case, not just in Japan, commercial instincts proved remarkably flexible when circumstances shifted. As soon as the Americans set foot on Japanese soil, Foujita burned incriminating documents in his garden, doctored his wartime paintings, and offered to work for the occupation authorities. He even produced

Christmas cards for occupation officials, which were sent to General MacArthur and President Truman. Perhaps because of his unusual degree of opportunism, other Japanese artists began to treat Foujita as a pariah. The newly formed Japanese Art Association put him on the list of culprits who should bear responsibility for their wartime activities. Not surprisingly, Foujita quickly reverted to his pre-war disdain for Japan and infatuation with the West.

France was his preferred destination, but the French were reluctant to give the ex–war propagandist a visa. Through his connections in MacArthur's administration, Foujita managed to land some teaching jobs in New York, at the Brooklyn Museum Art School and the New School. He left Japan in 1949, and by way of a permanent farewell he prayed that the Japanese art world would one day come up to world standards. In New York, he had a show at the Mathias Komor gallery. *Time* magazine praised his pictures of animals in human clothes, but a petition signed by fifty American artists protested against the exhibition by "the fascist artist who lent himself to lying and distortion." When a French visa was granted after all, Foujita quickly decided to move back to France.

He shunned Paris, the city of his early triumphs, and secluded himself in an eighteenth-century farmhouse with Kimiyo, renamed Marie-Ange-Claire after their baptism into the Catholic Church. They became French citizens in 1955. Foujita still produced a great deal of art, notably many pictures of cats and rather vapid-looking children. In the mid-1960s, with money from René Lalou, the president of Mumm Champagne, he constructed a chapel in the Romanesque style. He claimed that this was "to atone for eighty years of sins." The frescoes, painted by Foujita, which include the artist and his wife as witnesses to the crucifixion of Christ, and the stained-glass windows are decorative in a conventional way, and full of detail, rather like his wartime propaganda paintings.

Foujita died of cancer in 1968. Birnbaum describes his last days in a Swiss hospital. Instead of the more usual hospital robes worn by other patients, Foujita posed for his visitors in a Japanese fisherman's coat, covered in images of fish and the sea.

21

THE CIRCUS OF MAX BECKMANN

We have nothing more to expect from the outside, only from ourselves. *For we are God.*

—MAX BECKMANN, 1927[1]

MAX BECKMANN WAS born in 1884 in Leipzig, and died on December 27, 1950, in New York City. He was, I think, the greatest painter to emerge from the brief but extraordinary artistic big bang of Weimar Germany. If he is less famous than some more sensational figures, it is because he was never a joiner. Beckmann went his own way, always. This is what George Grosz, a fellow New York émigré, wrote after his death: "Beckmannmaxe was a kind of hermit, the Hermann Hesse of painting, German and heavy, unapproachable, with the personality of a paperweight, utterly lacking in humor."[2]

There was perhaps some truth to this none too friendly thumbnail sketch. Beckmann was not an easygoing man. His idea of a good

1. *Der Künstler im Staat,* quoted in Max Beckmann, *Die Realität der Träume in den Bildern* (Munich: Piper, 1990).
2. *George Grosz: Berlin–New York* (Berlin: Nationalgalerie, 1994), p. 36.

evening out was to sit alone, dressed in a formal suit, at the bar of an expensive hotel, silently observing other people over the rim of his champagne glass. In his own house, he insisted on punctual appointments. If a person turned up even a few minutes early, Beckmann would come to the door and announce that Herr Beckmann was not yet at home. When he wasn't working, he read Nietzsche, Schopenhauer, Romantic poetry, or books about mysticism. In 1924, he began a series of ironic self-descriptions with the following statement: "Beckmann is not a very nice guy."[3]

As for Hermann Hesse, it is true that Beckmann was interested in metaphysical painting, in creating images to express spiritual feelings, in "rendering the invisible visible through reality." He saw the artist as God or, rather, as the creative rival of God. Grosz rather despised all this. He was a political man-about-town, inspired by the streets, a brilliant and savage caricaturist, who once described his drawings as graffiti on a toilet wall. To him, Beckmann was a plodding German dreamer who hadn't moved with the times, and "stupidly clings to the day before yesterday." In New York, said Grosz, photography, window displays, and Disney cartoons were much more exciting than painting. "Rimbaud," he said, "and the great Marquis de Sade would have loved it here.... But Beckmannmaxe, he didn't like people. A humorless man."

Whether he knew it or not, Grosz's blustering put-down revealed his own relative weakness as an artist and Beckmann's strength. Seduced by the flash of American commerce, Grosz lost much of the creative power that had made him a great satirist of Berlin between the wars. Beckmann, the visionary loner, oblivious to artistic or commercial fashion, continued to paint masterpieces in Berlin, Frank-

3. *Die Realität der Träume in den Bildern*, p. 34.

furt, Amsterdam, St. Louis, and New York City. (He was briefly a professor at the Brooklyn Museum Art School.)

Almost all of these pictures are now on display at the Centre Pompidou in Paris.[4] The exhibition does him proud. With a minimum of words, and a maximum of space around the paintings, the visitor is encouraged to look at the art as one should, at one's leisure, without the distractions of theory or overelaborate explanation.

The curators did one odd and interesting thing: they put Beckmann's first major work, *Young Men by the Sea* (1905), at the very end of the exhibition, after his last painting, *The Argonauts* (1950), as though his painting life came full cycle, which in a way it did. But young men by the sea was a recurring theme. He painted one in 1943, and at various other times too. As in most Beckmann paintings, the scene of the first *Young Men by the Sea* is a blend of naturalism and myth. The naked young men, sunk in various poses of deep meditation, while one plays a flute, could be a group of German nudists, but also Greek gods come to earth. Beckmann remarked to his wife that the flute player was similar to the Orpheus figure in *The Argonauts*, and he appears in the 1943 painting as well, as the prototypical artist.

Space, the idea of infinity—hence the prevalence of the sea—and the place of human beings in it was one of Beckmann's constant preoccupations. In a letter written in 1948, Beckmann said, "Time is a human invention, but space is the palace of gods."[5] The human figures in his first major painting, which still shows the influence of Cézanne, are posed in a fairly conventional manner. Later, to illustrate

4. *Max Beckmann: Un Peintre dans l'histoire*, catalog of the exhibition edited by Didier Ottinger (Paris: Centre Pompidou, 2002).

5. These letters became "Letters to a Woman Painter," a lecture given at Stephens College, Columbia, Missouri, in February 1948.

the fall of man, or the voyage of Ulysses, or Orpheus's descent into the underworld, the positioning of Beckmann's figures in space would become far more eccentric; hurtling into the sea, or suspended from heaven, or riding on monstrous fish.

The Argonauts, described as a reworking of his first *Young Men by the Sea*, is much more explicit in its symbolism. Jason and his fellow Greeks, the original Argonauts in search of the Golden Fleece, have been transformed into artists. On the left side of the triptych is a painter and his model, on the right is a group of female musicians, and in the middle are two nude men with the sea in the background. One of them, Orpheus, is staring into the eye of a great bird. A lyre lies by his side. The other looks toward the horizon, following his inner vision, "oblivious," in Beckmann's description, "to his earthly surroundings."[6] Between them is an old man, bearded like a biblical prophet, climbing a ladder. Beckmann described him as a god pointing the way to a higher form of existence. The picture is an affirmation of Beckmann's belief in art as a transcendental medium, hence the triptych, as though it were meant for a church devoted to the arts.

The Argonauts has been described as Beckmann's greatest work. I'm not so sure of that. The symbolism is indeed a little heavy, and if all Beckmann's work had been like this, Grosz would have had a point about the old German dreamer. I prefer Beckmann in his more sardonic, earthier, or more savage moods. Like Rembrandt and Dürer, Beckmann was a great and prolific painter of self-portraits, recording his moods, which are, it must be said, rarely lighthearted.

Here he is, in 1907, a cocky young dandy in Florence, a cigarette, as always, dangling from his right hand; and here, in 1911, curling his lips at his critics in Berlin; and there, in 1917, baring his teeth in anger at the violence he had witnessed as a medical orderly in Flan-

6. Reinhard Spieler, *Beckmann* (Cologne: Benedikt Taschen, 1995), p. 180.

ders; and there, in 1919, as the cynical boulevardier, nursing a glass of Sekt in a Frankfurt nightclub; or as a morbid clown in 1921, a tuxedoed grandee in 1927, a frightened exile in 1937, or a frail old man in a loud American shirt, the last completed just before he died in New York.

The poses and the clothes are the props of his changing existential circumstances, masks to be donned and discarded. The hands are as expressive as the faces: flopping about in the Frankfurt nightclub, open and vulnerable in his studio in 1921, carefully shaping a sculpture in Amsterdam. But they are always large, hammy things, as if to demonstrate the artist's creative vigor. Only in a very late portrait (not shown in Paris), done in St. Louis, where he taught at the arts school in 1948, when he knew he was very ill, do the hands look strangely shrunken, swathed in a lady's black gloves.

Beckmann was keen on fancy dress and circus performances, or indeed performances of any kind. He loved hanging around dance halls, frequently on his own, to watch the human masquerade. Life, in his paintings, is often depicted as a cabaret, though sometimes of a somewhat gruesome kind, with torturers as ringmasters and killers as clowns. A series of splendid prints of acrobats, dancers, and a female snake charmer, made in 1921, shows Beckmann on the title page, ringing a bell. "Circus Beckmann" reads the banner behind his head.

The point is not, I think, just to illustrate that all life is a stage. It is to show the true self behind the masks, the metaphysical self, that is, the one which, in Beckmann's vision, transcends mere appearances, something Germans call *Innerlichkeit*, inwardness, which cannot easily be described in words. This didn't stop Beckmann from trying. In his 1938 lecture at the New Burlington Galleries in London, he said, "Prior to existence a soul yearns to become a self. It is this self that I seek, in life as in art." Perhaps this doesn't get us much

further. It is easier to look at one of his self-portraits and sense what he means.

One of the most famous, painted in Frankfurt in 1927, is *Self-Portrait in Tuxedo*. Beckmann stands with his back to the window, with an aloof, rather haughty, almost scornful expression, very much the grand seigneur, one hand resting on his hip, the other holding a smoldering cigarette, as if to say: here I stand, I've arrived, I'm unassailable. The curtain behind him is brown, a favorite color that reminded him of fine cigars. But what gives this picture its extraordinary elegance is the contrast of black and white. The white shirt and white cigarette stand out against the black dinner jacket, and white light from the window splashes the hands and one side of the face, making it look a little sinister, like a moonlit skull.

Few painters—Manet comes to mind—applied black and white with such sensuality as Beckmann. But there was more to this than mere graphic effects. "Only in black and white," he said in his London lecture, "can I see God as a unity, constantly recreating himself in a great terrestrial theatre performance." God, in this case, is in Beckmann himself, God in a tuxedo.

In 1927, he was at the height of his social and artistic success. The self-portrait is a celebration of this. A "talent for self-publicity," he said, was indispensable to an artistic career. He also said, on the same occasion, that "a budding genius" had to be taught to "respect money and power." Cynicism was another one of Beckmann's poses, like the clownish hats and the aristocratic dandyism. But like everything else about this enigmatic man, it was double-edged—playful and absolutely serious. He was convinced that artists should create a new metaphysical order. But it was essential "to achieve an *elegant* mastery of metaphysics." And the artist, as high priest of the new order, should always be dressed in "a black suit, or, on festive occasions, in tails."

The tension between Beckmann's worldly and unworldly self, between his sensuality and his spiritual yearnings, his love of the world and his longing to be free from it, this is what gives his art its extraordinary power. This is the "true self" one sees behind the masks of his self-portraits. It also explains much of the symbolism in his paintings. Some images—the ubiquitous fish, the scenes of martyrdom and men falling, the phallic trumpets and spears, the large birds, like proto-angels—are borrowed from Greek myths, Christianity, Freud, and more esoteric sources, such as Kabbala and Gnosticism.

Following the Gnostics, Beckmann saw the world as a prison of lost souls, chained to sexual desires and violent impulses from which we should try to escape to a better, purer state beyond material creation—precisely what the old god, climbing the ladder, was offering the Argonauts in Beckmann's last painting. Many of Beckmann's paintings are in fact celebrations of sensuality, such as the gorgeous *Reclining Nude* (1929), on which he seems to have applied his creamy paint as though he were caressing the model's curves. But sex is also shown as an expression of violence: women are tied up, men are bound in chains, great candles are dripping all over the place, and people are flayed, throttled, and hanged. Beckmann insisted that there was beauty in all this horror, a theme to which I shall return presently.

Apart from Cézanne, whom he admired for his creation of a painterly reality, Beckmann often mentioned Blake and the Douanier Rousseau ("Homer in a porter's lodge") as fellow visionaries who inspired him. But there is, of course, a long German tradition of metaphysical painting. The spiky figures in such pictures as *Descent from the Cross* (1917) remind one of Gothic art, as do the luminous blues and reds of his paintings in the 1940s, which are like stained-glass windows. Beckmann's treatment of death and decay is reminiscent of Matthias Grünewald. And his depictions of man and the sea

bear some resemblance to the brooding seascapes of Caspar David Friedrich.

German Romanticism often teeters on the edge of morbid senti-mentality, and sometimes falls right into it. What saves Beckmann's art from sickliness, or the Gothic soft porn of such painters as Ar-nold Böcklin, is his realism. Although, unlike Grosz, he was not a satirist or a chronicler of his times, Beckmann's scenes of violence and erotic power plays were closely observed, and his paintings of the 1910s and 1920s still have a firm sense of place. The drypoint pic-tures of carnage in World War I have the immediacy of delirious re-portage. *The Grenade* (1915), showing soldiers being torn apart by a grenade attack, is as horrifying as anything by Goya.

Beckmann's experiences at the front, which led to a nervous break-down, radically changed the way he composed his images. As though real horror had made him a visionary of hell, people in the war pic-tures, but also in more allegorical paintings such as *The Crucifixion* (1917) or *Christ and the Woman Taken in Adultery* (1917), are stretched and pulled across the canvas in strange, angular, tortured shapes. His friend the publisher Reinhard Piper remembers Beck-mann saying that he wanted to use his pictures "to defy God." He wanted his pictures to "accuse God of everything he had done wrong."

But Beckmann also took an aesthetic delight in horror and may-hem. The wartime prints and paintings reveal quite starkly the ten-sion between sensuality and repulsion that marks so much of Beckmann's work. He wrote to his first wife, Minna, from the field hospital in Flanders: "I saw fantastic things. Half-clothed men streaming with blood, being bandaged in white down below in the half-light. Huge pain. New ideas of the flagellation of Christ." This was typical of his unsentimental, even brutal way of seeing beauty in the worst human suffering, but also of his propensity to convert what he saw into allegory or myth.

Beckmann used Christian images to show the terrors of war, which sometimes contained recognizable characters, including the artist himself as Jesus Christ. He did something similar in later paintings, where he expressed the collective madness of Nazism, or the human slavery to violent passions, or the loneliness of exile, in Greek or Nordic myths. None of Beckmann's paintings can be reduced to just one of these themes. Meaning is multilayered and the feelings expressed are always complex: horror and fascination, spirituality and earthiness, engagement in the world and detachment from it. This is why his pictures have a depth that Grosz, despite his great talent, rarely achieved in his work.

In the 1920s, a period of relative calm, personal happiness, and professional success, Beckmann is most down-to-earth. His paintings of Frankfurt contain fantastic elements: church spires that didn't exist, factories in the wrong places, shapes of houses, bridges, and streetlamps blown up out of proportion. But this is still an observed world, most of which actually existed outside Beckmann's own mind. Those people bathing at the Lido (1924) or dancing in Baden-Baden (1923) could well have been there, even if they were changed in Beckmann's vision into helpless, almost somnambulistic figures, unaware of the catastrophes that lay in wait for them. The dancers, packed together inside the picture frame, look in danger of suffocating, if not from a lack of fresh air, then perhaps from boredom. The swimmers are falling backward, swept away by the surf, like playthings of violent nature.

It is in the 1930s, with Hitler's rise, that Beckmann turns more and more to a world that existed entirely in his own mind, a world of myths and allegories mixed with the nightclub scenes and circus performances that continued to feed his imagination. By the time he was denounced by Hitler's artistic arbiters as a degenerate artist in 1937, Beckmann was at the top of his powers. The triptych entitled

Temptation (1936–1937) is a sadomasochistic phantasmagoria, featuring a murderous Nordic god, a sinister young liftboy in a Berlin hotel leading a crawling woman by a leash, a sexy blonde chained to a spear, a caged society woman cradling a fox and pecked by a diabolical bird, and a shackled man holding up a mirror to a voluptuous nude.

Here are Beckmann's habitual themes: violence between men and women, sensual bondage in a world of evil. But they are put into the grisly contemporary setting of the Nazi state, where former liftboys really could have power, and Nordic gods came to represent sheer malevolence. In this painting, Beckmann found the perfect balance between reality and myth, in which the metaphysical looked real and reality resembled a fantasy. He was always after this effect of dreamlike realism, and was delighted when he saw it reflected in real life. On one of his solitary visits to an Amsterdam dance hall just after the war, he suddenly spotted Cary Grant. At first, he noted in his diary, "I thought it was a scene in a movie. Strangely unreal."

Beckmann's paintings of sexual violence are never pretty, of course. He criticized Picasso and Matisse for making their art too decorative, too much like beautiful wallpaper. Not enough German *Innerlichkeit*, perhaps. But whereas Picasso could in fact be brutally aggressive in his paintings of women, Beckmann's women always look seductive. Sex is never disgusting, as it is in paintings by some of his German contemporaries (Otto Dix, say). He seems to be saying that if sex, and women, were not so beguiling, we would not feel so enslaved by our desires.

The day after Hitler's radio speech about degenerate art, on July 18, 1937, Beckmann packed his bags and moved to Amsterdam with his second wife, Quappi, never to return to Germany. His state of mind as an artistic refugee (Beckmann was neither Jewish nor overtly political) is beautifully revealed in his self-portraits of that time. One

of them, ironically entitled *Released*, shows him in chains, his ashen face a portrait of despair. On his left shoulder you can just make out the word "Amerika," the Beckmanns' actual destination before they got stuck in Amsterdam. A self-portrait painted in 1938 is one of his most beautiful. The horn, a favorite symbol of art and sexual power, is reversed and held to his ear, like a huge ear trumpet. Beckmann is dressed in what looks like a striped dressing gown but could also be a convict's uniform. In exile, he retreated into his studio on the first floor of a tobacco warehouse, the horn his symbolic receptacle of news from the monstrous world outside.

One of the peculiar things about Beckmann's paintings in Amsterdam, where he lived until he finally left for America in 1947, is that so few of them show anything of the city itself. Many are of Beckmann's singular imaginary world of myths and symbols. Others are created from memory: *Dream of Monte Carlo* (1940), for example, a nightmare gambling casino in sickly yellows and greens, filled with demonic gamblers, sluttish women, and masked men about to release bombs. Others still are claustrophobic theater scenes full of personal terrors. In the middle of a triptych, *The Actors* (1941–1942), Beckmann himself appears, wearing a crown and stabbing himself in the chest with a sword.

As a German artist in a provincial capital under German occupation, Beckmann was almost totally isolated. The Dutch took little notice of him, and the Nazis could only regard this "degenerate" artist with the deepest distrust. Other German exiles, in similar circumstances, committed suicide or lapsed into a state of depressive inertia. Not Beckmann. He painted, and painted, and painted. The fact that he had never been a joiner was surely a help.

Beckmann despised any collective activity. For a time, in the 1910s, he was a member of the Berlin Secession, but soon quit after disagreements with his fellow artists. "The sportsmaniac is the soul

of the collective man," he wrote in 1925. When asked, in 1928, what he felt about politics, he answered:

> I am a painter, or, according to a highly unsympathetic collective notion, an artist. In any case, somehow displaced. Displaced also in politics. This [political] enterprise can only become of interest to me, once it has done with the *materialist* era, and turns in a *new* way to metaphysical, or transcendental, or religious matters.

Beckmann always had been offshore: the solitary drinker at the hotel bar full of revelers.

This was true, even among fellow exiles in Amsterdam, whom he did meet from time to time. In *Four Men Around a Table* (1943), we see four German exiles, a philosopher and three painters, one of whom is Beckmann. They are jumbled together, like prisoners in a cell. The colors are somber, the mood gloomy. A huge candle illuminates the faces of three men, one holding a fish, the other two holding vegetables—a reference perhaps to the lack of food, but at the same time symbolic of their personalities. Beckmann, alone, sits in the shadow, with a mirror in his hand.

The Amsterdam paintings are among the darkest but also the best of Beckmann's works. Other famous artists of the Weimar period went into inner emigration or languished abroad. Otto Dix was reduced to painting mawkish Christmas-card landscapes in Germany. Grosz, in New York, celebrated Americana or did unsuccessful allegorical pictures of Nazi Germany. Ernst Ludwig Kirchner died, a broken man, in 1938. Emil Nolde stayed in Germany but was not allowed to paint. But Beckmann, like Max Ernst, another survivor, carried his world in his head, and that is what you see in his Amsterdam paintings.

Even after the war was over, and Beckmann was able to exhibit again, the darkness of his visions did not immediately let up. Men and women are still chained together in iron cages, and the carnival figures in grotesque masks are still in evidence. So are the ladders, as a means to ascend to higher things, and the phallic swords. But there is hope of a new beginning, a new life in the new world, and something of that optimism begins to shine through.

One of the most moving paintings, *The Cabins*, was painted in 1948, after he had moved with his wife to the US. Inspired by their voyage aboard the *Westerdam* from Rotterdam to New York, the painting is a kind of X-ray of life on an ocean liner, but with strange metaphysical touches: here a young woman is combing her hair, there a couple is making love, there a person is drawing a ship, and there an angel is displaying herself, it seems, to a kind of slave driver with a whip. Cutting right through all this is an old sailor, Beckmann himself, tied to a giant fish.

This fish, in Beckmann's art, as well as in myths, is a symbol of fertility, of sexuality, of knowledge, but also of the soul. It is, in this painting, as if Beckmann is sailing to the New World with his creative soul intact. He was sixty-three, and despite some old-fashioned European doubts about the superficiality of American culture, he was excited by what he saw. In New York, he wrote, "The tower of Babylon has...become the mass erection of a monstrous (senseless?) will. So I like it."

The color and energy of the US appealed to Beckmann's sensual side. His paintings become brighter. *The Town*, painted in New York in 1950, contains the familiar Beckmann symbols: severed heads, phallic candles, swords, and what look like two giant black dildos. But it is not a hellish scene. Death is very much there, of course. A dark figure with a grotesque protruding tongue, like the corpse of a hanged man, points to another world beyond the frame of the picture.

But there is still life, in the beautiful nude woman inviting sex, as an American minstrel plays his guitar by her bedside.

And yet Beckmann felt too old, too tired, and too ill to give in any longer to what he liked to call the illusions of desire. The war years had damaged him, mentally and physically, and he had a serious heart condition. It is always interesting to see how a great artist faces his mortality. Picasso tried to defy the onset of impotence and the closing in of death in a last bravura performance of furious eroticism. Beckmann, partly no doubt inspired by his mystical readings, saw death more as a release, a liberation even, a journey to another world. He told his wife, Quappi, that death just meant a change of clothes, a "metaphysical move." He would be naked as the figure in *Falling Man* (1950), tumbling into a blue, watery abyss.

It is tempting, as some writers on Beckmann have done, to see intimations of his death in the last paintings. Christiane Zeiller, one of the contributors to the catalog of the Paris exhibition, suggests that the old god in *The Argonauts* is pointing the way to the world of the dead. Others have speculated that Beckmann's last self-portrait, painted in 1950, of the artist dressed in a bright blue jacket, standing in front of a canvas while smoking a cigarette and staring, not at the viewer but at some distant spot, is a picture of an old man's vision of his own death.

It is possible. All we know for sure is that Beckmann finished *The Argonauts* on December 26. The next day he left his apartment at 38 West 69th Street, to go to an exhibition of new American art. One of the paintings on show was his *Self-Portrait in Blue Jacket*. On the corner of Central Park West and 61st Street, he had a heart attack and died.

22

DEGENERATE ART

WHEN ERNST LUDWIG KIRCHNER put a pistol to his head in Davos, Switzerland, on June 15, 1938, he left more than a thousand oil paintings, several thousand pastels, drawings, and prints, as well as many wood carvings and textiles. Only a fraction of his work was shown at an extraordinary exhibition at the Museum of Modern Art in New York.[1] But this fraction probably comprises the very best of his oeuvre. A handful of paintings, executed just before and during World War I, of Berlin streets filled with elegant whores, some in black war-widow garb, are accompanied by a number of exquisite drawings and woodcuts, some on the same subject matter, some of nudes, and some of a variety of urban scenes.

The most famous painting is simply entitled *Berlin Street Scene* (1913). The long and sordid story of its provenance—originally acquired by a Jewish shoe manufacturer named Hess, then passed on in a series of murky transactions after the Hess family had to flee from the Nazis, only to emerge in German museum collections after the

1. "Kirchner and the Berlin Street," an exhibition at the Museum of Modern Art, New York, August 3–November 10, 2008. Catalog of the exhibition edited by Deborah Wye (Museum of Modern Art, 2008).

war before being returned to the original owner's heirs, who sold it to Ronald Lauder's Neue Galerie in New York for $38 million—is the subject of an entire book recently published in Germany.[2] Painted in feverish blue, red, and yellow streaks, the picture shows two prostitutes (cocottes in the Berlin jargon of the time), dressed to the nines, casting lizard-eyed looks at the blurred crowd of men around them, one of whom looks away, a cigarette dangling from his crimson lips. It has been suggested that this man might be the artist himself, alone, aloof, cut off from the crowd.

Kirchner's paintings, drawings, and prints of Berlin streets with cocottes on the prowl have become icons of the twentieth-century metropolis, fast, mechanical, dense, anonymous, and full of erotic possibilities. The artist created with his brush or chisel what his friend the expressionist writer Alfred Döblin did with his pen, most notably in his great novel Berlin Alexanderplatz: fragmented images of buildings and streetcars, the jazzy syncopation of masses of people rushing hither and thither, their pale city faces turned yellow and green by flickering headlights, streetlamps, and neon signs. An element of danger is suggested by the jagged edges of sidewalks and the sharp toes of the prostitutes' boots.

In her informative and clearly written catalog essay, Deborah Wye says that Kirchner "made the unusual choice of the prostitute as his primary symbol" of metropolitan life. In fact, it wasn't so unusual. The prostitute has been a symbol of urban decadence ever since the Whore of Babylon, and Wye herself, quoting from a German source, explains why this has been especially true in modern times: "What holds for them also holds for the mass-produced goods of the time:

2. Gunnar Schnabel and Monika Tatzkow, The Story of Street Scene: Restitution of Nazi Looted Art, translated by Casey Butterfield (Berlin: Proprietas, 2008).

they 'flaunt, entice, provoke desire.'" The thing about big cities, from Babylon to Berlin, is that every desire can be satisfied with the right amount of cash—except, perhaps, true love.

The Berlin street paintings have come to define Kirchner's work. The later paintings of Swiss Alpine landscapes are of less interest, and his earlier portraits and nudes, though often remarkable, are not quite so well known.[3] It is interesting to compare Kirchner's reputation with Emil Nolde's. Both were part of the same artistic circles and marked by similar enthusiasms. Nolde, too, depicted typical Berlin scenes of cabarets, nightclubs, and dancers, but is now much better known for his brooding, almost abstract land- and seascapes.

There seem to have been at least two great breaks in Kirchner's career. The first occurred when he moved to Berlin in 1911, leaving behind the cozy bohemia of expressionist Dresden. The second was when he left Germany in 1917 to settle in Switzerland. So the great Berlin period lasted only six years. How to reconcile those years of frenzied urban activity with the periods before and after? Or was there more continuity than meets the eye? Therein lies one of the fascinations of Kirchner's art and life.

Born in 1880 in Lower Franconia, Kirchner was the son of well-to-do bourgeois parents; his father, Ernst, was an engineer and a professor. Like many young men from well-to-do bourgeois families, Kirchner rebelled against his comfortable background and tried to find a more

3. The large exhibition in 2003 at the National Gallery of Art in Washington was the first Kirchner show in the US in thirty years.

authentic, more natural, more artistic way of living in bohemian circles that liked to "go back to nature" by walking around in the nude, whether in artists' studios or in idyllic rural settings, such as the Moritzburg lakes around Dresden. Some of the bohemians also enjoyed roughing it a little by living among "real" people in poor urban areas.

Kirchner founded *Die Brücke* (the Bridge) in Dresden with fellow expressionists, such as Karl Schmidt-Rottluff, Erich Heckel, Max Pechstein, and Otto Müller. Following Van Gogh and the French fauvists, especially Matisse, the German expressionists celebrated emotional spontaneity and "naturalness" by experimenting with wild brushstrokes and bold primary colors. The call of the "primitive"—African masks, American "Negro music," tropical islands, and so on—was also part of the quest for authenticity. And here, too, they took the cue from Paris: Gauguin, Picasso, and, of course, Matisse.

Photographs of Kirchner's Dresden and Berlin studios show how this quest spilled into the artist's life as well: drapery decorated with couples having sex, objects from Africa and Oceania, the artist and various models dancing in the nude. The *Brücke* artists worked together, lived together, made trips together, and made love together, freely exchanging partners and models. They were, in Kirchner's phrase, "one big family." The aim was "free drawing of free individuals in free naturalness."

The French were clearly an inspiration. Yet perhaps as a form of self-defense, Kirchner in particular stressed how German his art was and denied, in the face of much evidence to the contrary, the influence of his contemporaries in France. When he was living in Davos in 1923, to recuperate from his many nervous breakdowns (made worse by bouts of excessive drinking), Kirchner mused in his diary that he

was "Germanic like no other artist." This was true, up to a point. Kirchner often mentioned Dürer as an inspiration. The name *Die Brücke* came from Nietzsche's dictum that man was a bridge, not an endpoint. The cult of natural behavior was part of a larger movement in early-twentieth-century Germany: *Wandervögel* hiking through mountain and dale, nudists frolicking on Baltic beaches. And then there was the tendency to spiritual brooding.

Kirchner, unlike, say, Nolde, was not attracted to National Socialism, despite his naive and short-lived hope in the early 1930s that the Führer might be good for Germany. But in his spiritual moods he came close to falling into the clichés of Romantic German chauvinism. Germanic art, he said, including his own, "is religion in the widest sense of the word." It is the "expression of [my] dreams," transcendental, profound, art as suffering and redemption, and never art for art's sake, as practiced in France. The French, rationalistic, civilized, urbane, cynical, could only reproduce, describe, or depict nature, and never express it directly. Thus, in Kirchner's view, "we can say that we [Germans] form the soul of humanity."

Much of this is poppycock. But then Kirchner was known to be a bit of a mythomaniac whose words should never be taken at face value. In any case, the Berlin street scenes are hardly typical expressions of German soulfulness; on the contrary, they are a direct response to the cynical here and now. And the here and now of Berlin in the early 1910s was not easy for Kirchner. Largely through his own fault, *Die Brücke* was disbanded in 1913, leaving Kirchner feeling cast adrift and sorry for himself. His career did not flourish. A large international show of modern art held in Berlin did not include his work. And fretting about becoming too bourgeois in his habits, he fell into depression, took too much veronal, and drank a liter of absinthe a day.

Yet he produced amazing paintings, drawings, and prints. It is tempting to ascribe their genius to the artist's unhappiness, a temptation encouraged by the artist's own words:

> They [the paintings] originated in the years 1911–14, in one of the loneliest times of my life, during which an agonizing restlessness drove me out onto the streets day and night, which were filled with people and cars.

He often compared his lonely state to that of the cocottes whom he painted, women who provoked desire but remained unloved.

Certainly, the pictures of hard-bitten women trawling in the nighttime city, painted or etched in splintery, distorted shapes, or sketched quickly as "hieroglyphs," in the artist's word, appear to convey the shock of a dreamer confronted with the coldness of metropolitan life. They seem a far cry from the idyllic studio settings or nudes-dancing-in-nature pictures of the Dresden period. The colors are more artificial. Even the nudes look different. The Berlin girls, Kirchner remarked, with their "architectonically constructed, severely formed bodies," were different from the "soft Saxon physique" of his earlier models.

But they are still beautiful. Unlike pictures of similar scenes by Kirchner's contemporaries, such as Otto Dix or George Grosz, his work is never marked by physical revulsion. The pastel drawings of his girlfriend, a cabaret dancer named Erna Schilling, posing nude in his Berlin studio, are positively loving. But even the two cocottes in *Two Women on the Street* (1914), described by Deborah Wye as "ugly and threatening in their anonymity," have an elegance usually absent in the pictures of disgust by Dix or Grosz. The black hats and black war-widow's veil, typical of wartime hookers, give their elegance a

sinister frisson.[4] Kirchner's Berlin streets may be full of loneliness, bad skin, and cynical intentions, but they are never full of hatred, least of all for women.

This is true of the street scenes (whether in oil, pastel, or ink), of the nudes, and also of the more openly erotic pictures done in Berlin. Page 42 of the MoMA catalog shows two paintings by Kirchner, one of a fully clothed man in a black suit standing in a room with a nude woman contemplating her own bottom in a mirror, *Nude from the Back with Mirror and Man* (1912), and the other, called *Couple in a Room* (1912), of a man fondling a nude woman, who is smoking a cigarette, dressed in a black see-through shift. The colors are muted, the painting is nervy, the atmosphere lewd. The third illustration on that page shows Grosz's *Circe* (1927), a watercolor-and-ink picture of a man with the snout of a pig sticking his tongue into the lipsticked mouth of an equally porcine naked hooker in high heels. The Kirchner paintings, in spite of their loucheness, show his love of the female form and his pleasure in sexual display. Grosz, brilliant as always, shows little but loathing.

Where is the continuity in Kirchner's work? Wye points out that "there are clear allusions" in *Two Women on the Street* "to the tribal masks that for *Brücke* artists inspired radical new forms while also referencing basic instincts." I think this is right. She goes on to say that these women "seem utterly dehumanized by their profession." Perhaps so. But Kirchner takes such delight in the basic instincts that he can't help celebrating them even in heartless Berlin. After all, the

4. There are different accounts of why these clothes were worn. Wye writes that streetwalkers "took up this disguise either to shield themselves from the police or to elicit sympathy." Norbert Wolf says the police insisted that the hookers look "ladylike." On the other hand, the carnage of war produced genuine war widows who had to sell themselves to survive.

jungle of the Potsdamerplatz or the Leipzigerstrasse can be seen as nature too, not as innocent as the rural lakes of Saxony, perhaps, but hardly less lively; if anything, more so. The cocottes may be beasts of prey who make money out of basic instincts, but their erotic performance is as fascinating to the artist, and as vital, as the sexual games in bohemian Dresden.

———

Kirchner was not cut out to be a soldier. Nonetheless, in a fit of patriotism he signed up for military service in 1915. *Self-Portrait as a Soldier* (1915), his face a mask of anguish, his right arm a bloody, handless stump, incapable of ever making another picture, shows Kirchner's terror of going to war. A series of colored woodcuts, made in that same year, on the theme of Peter Schlemihl, the man who sold his shadow, are brilliant and quite terrifying. Panicked and depressed, Kirchner was in such a poor mental state that he was discharged after two months in the artillery and ordered to get psychiatric treatment.

After sojourns in various German institutions, Kirchner ended up in that great Alpine sanatorium, the little town of Davos, where he lived out his years. The Nazis had paid him the tribute of classifying much of his work as "degenerate," including, astonishingly, some of his Swiss work. Perhaps to a Nazi philistine, Kirchner's style—the bold colors, the distorted figures—might have looked unwholesome, but the pictures of country folk and mountain vistas are a world away from the streets of Berlin. Still, his 1920 painting of Swiss farmers having dinner (*Bauernmahlzeit*) was displayed in 1937 to the official ridicule of Nazi officials at the Degenerate

Art show in Munich, along with *Berlin Street Scene* and other masterpieces.⁵

Even paintings done during the Weimar period in Berlin, which he visited from time to time, had lost much of the old fervor. One in particular, called *Street Scene at Night* (1926–1927), looks more like a well-designed advertising poster for a visit to the big city.

To be sure, these late paintings are not as bad as Dix's picture-postcard landscapes, painted during his time of "inner emigration," after the Nazis took over and declared him a degenerate artist too. But like Grosz and Dix, Kirchner seems to have needed a constant ingestion of bracing Berlin air to bring out the best in him. The Alpine life calmed him down and weakened his art. His best work was done many years before. To be cast out of the German art world as a degenerate, because of that very work, hurt him deeply. Drugs did the rest. "Now," he wrote some time before his violent death, "one is just like the cocottes I used to paint. Blurred, then gone the next moment."

5. Grotesquely, the Swiss painting was described at the Munich exhibition as "German farmers—Yiddish perspective."

23

GEORGE GROSZ'S AMERIKA

ON MAY 26, 1932, George Grosz boarded the *New York* at Cux-
haven, bound for the United States. He arrived on June 3. From his
hotel (the Great Northern on 57th Street), he wrote letter after letter
to his wife, Eva, in Berlin:

A new, unbelievable world...for me it is and remains...the
finest city in the world—Paris: I shit on it. Berlin, well all right
(home, language, unlike anywhere else, it can pass). Rome: pig-
sty. Petersburg: revolting! Moscow: a plebeian village! London:
Hats off! Cool respect. New York: the city!!!!!!![1]

Four months later he was still ecstatic. A letter to his old friend
Otto Schmalhausen: "It is wonderful now in New York. The air is
Indian summer-fresh—you feel the presence of the harbor—it is the
season for seafood—I eat big deep sea oysters every evening at the
Lexington restaurant—Boy what a world!!!...Fresh huge healthy
America!"[2]

1. George Grosz, *Briefe: 1913–1959* (Reinbek: Rowohlt, 1979), p. 148.
2. Grosz, *Briefe*, p. 163.

Grosz returned to Germany in October, but came back to New York the following year, this time with his wife and two sons. He stayed until 1959, painting, drawing, and teaching rich women at the Art Students League on 57th Street. "The boys," Peter and Martin, grew up as Americans. Grosz became a US citizen in 1938. Twenty-seven years: this means that Grosz spent more time in the US as an artist than in his native Berlin. Yet he is famous for his Berlin pictures. His American period is commonly regarded as a failure. One of the many merits of the superb Grosz retrospective in Germany[3] is that it offers a chance to assess the American work. Grosz himself didn't consider it a failure at all. Or at least that is what he said. He began full of optimism:

> Everything here, so it seems to me, is—compared to Germany—fresher... I really feel like working. Have painted lots of good stuff. Just as "critical" as I was in Germany—but I think it is (in the best sense) more human, livelier. I often look at Breughel, whose beautiful work you gave me. (Letter to Wieland Herzfelde, June 1933)[4]

There might already be a hint of defensiveness here, as though he were afraid of criticism that his Americophilia had taken the sting out of his art. It is still thought that America made Grosz go mushy. His rather charming drawings and watercolors of New York street scenes indeed lack the harshness of his Berlin work. The faces are softer, more sympathetic. In his early German drawings, he deliber-

3. "George Grosz: Berlin–New York," an exhibition at the Neue Nationalgalerie, Berlin, December 21, 1994–April 17, 1995; and the Kunstsammlung Nordrhein-Westfalen, May 6–June 30, 1995. Catalog of the exhibition edited by Peter-Klaus Schuster (Berlin: Neue Nationalgalerie/Ars Nicolai, 1994).

4. Grosz, *Briefe*, p. 174.

ately exaggerated the ugliness of German types: the fat necks, the broken veins, the big rumps, the piggy eyes, the thick, pouting lips wrapped around stumpy cigars. He said his vision of Germany had been inspired by graffiti on the walls of public toilets. One of his favorite words (and subjects) was *kotzen*, to vomit. His art was, as it were, vomited onto the page. (Hannah Arendt, on the other hand, once remarked that Grosz's drawings of Weimar Berlin were pure reportage.) In New York, his eye was caught by the youthful energy of American crowds. He particularly loved the grace and flashy elegance of rich Negroes in Harlem. The Americans in his drawings of the early 1930s don't slouch, or march, or leer, as his Berliners do; there is a youthful spring in their step.

This was the way he saw New York, but it was also the way he wished to see New York. He wanted to be an American illustrator, not a caricaturist. He was famous for his "hate-filled caricatures" and knew that most people "considered the period in which they were drawn my best." But he did not want to be "a kind of legend, a relic from the Roaring Twenties." He wanted to please the editors of glossy magazines, the kind of people who said to him: "Not too German, Mr. Grosz! Not too bitter—you know what we mean, don't you?"[5]

He knew, and he found it liberating. He was glad to be in a country where he did not feel any hate. He had grown tired of hating, of politics, of satire. The German poet and translator Hans Sahl, who became friends with Grosz in the US, wrote that Grosz always had been pulled in opposite directions as an artist. There was the political Grosz, the Hogarth of his time, the satirist who wanted to shock people out of their complacency by holding up a ghastly mirror. His other desire was to "paint as beautifully as Rubens or

5. All the above quotes are from Grosz's autobiography, *A Small Yes and a Big No*, translated by Arnold J. Pomerans (Allison and Busby, 1982), p. 184.

Renoir, sensually, concretely, while exploring forms with an almost academic precision."[6] The US freed Grosz from his Hogarthian demons and allowed him to be the "pure" artist. As Grosz put it in his autobiography:

> How it happened I find hard to explain; let me just say that, as far as I could tell, the natural artist in me came to the surface. In any case I was suddenly sick and tired of satirical cartoons and of pulling faces, and felt that I had done enough clowning to last me a lifetime.[7]

The difference in style is indeed visible, even in genres that Grosz had practiced all his life: his erotic pictures, for example. Unfortunately none of Grosz's German erotic watercolors were on show in Berlin. Some are in the Kronhausen collection in San Francisco. They show hefty women dressed in Scottish kilts or maid's uniforms being taken from behind by gloating men with large, beet-red penises. These drawings have an obscene beauty: a combination of lust and disgust—the key, in my view, to much of Grosz's best work. The American erotica are no less graphic: the same outsize genitals, like those in Japanese prints, the same fleshy women on their hands and knees, offering up their large, pink bottoms. But here the women are more Rubenesque, the obscenity is tempered by a more academic concern for fine painting. The subject is still lust, but the effect is somehow less lusty.

This may simply be a sign of age. It is also true that the relative failure of Grosz's more academic work—his landscape paintings, say—had little to do with his move to the US. His attempts to express

6. Hans Sahl, *So Long mit Händedruck* (Neuwied: Luchterhand, 1993), p. 15.
7. *A Small Yes and a Big No*, p. 184.

beauty instead of grossness were often boringly conventional during his years in Europe, too. The landscape of Pointe Rouge, Marseille (1927), could have been done by a talented Sunday painter. Grosz had told his dealer, Alfred Flechtheim, that he wanted to paint something that was not "revolting." He thought this would make his art more commercial (*verkäuflicher*). He wrote to his friend Marcel Ray that he wanted to be free of "this exaggerated cult of *détails*." But it was precisely the revolting *détails* that made Grosz's drawings of the 1910s and 1920s powerful.

It is interesting to compare Grosz's attempts to be conventional with the work of his contemporary Otto Dix. Dix, too, was at his best when he was most disgusting: the carnage in World War I, the filthy old whores in cheap Berlin brothels. When Dix painted "beautifully"—portraits of his wife and children, for example—he became cloying, kitschy, a Christmas-card artist. Both Dix and Grosz needed the stimulation of their loathing to produce their best work. Loathing was the one thing Grosz did not feel in America; he didn't want to feel it; he couldn't afford to feel it. Loathing is what he had wished to leave behind.

But it didn't quite work out that way. Despite his eagerness to please the American glossies, Grosz was still Grosz, haunted by dark visions and suffering severe depressions. A drink was never far from his side. Some of his letters read like the ravings of a brilliant drunk. And some of the American paintings are among the darkest, most horrific things he ever made. They are depressing in a way that even his most grotesque Berlin drawings never were. In a painting entitled *The Moon has set, and the Pleiades* (1944), a tired figure (the artist himself) trudges through the mud during a nocturnal rainstorm. He looks battered, bloody, without hope. A drawing called *Shattered Dream* (1935) shows a man slumped over a rock, a broken glass in one hand, a bottle, leaking booze, in the other. He looks as if he has

just been sick. Immediately behind him is the wreckage of a boat, with the shattered remains of a cross, a paintbrush, and a book. Farther behind him is a city in ruins, and farther still the mirage of Manhattan skyscrapers.

The feeling of personal despair that went into these paintings was shared by many, perhaps most, émigrés and refugees cast adrift in a strange and indifferent new world. Grosz was onto something real and interesting. And yet the paintings lack the power of his earlier work. They seem rhetorical, unconvincing, without life. The same is true, in my view, of his allegorical paintings of the European catastrophe. Here Grosz modeled himself not on Rubens or Brueghel but on Goya and Bosch. In *God of War* (1940), Mars is represented as a demonic Nazi, surrounded by the symbolic paraphernalia of contemporary horror: a swastika, the head of a tortured man, a child playing with a machine gun. In *The Mighty One on a Little Outing Surprised by Two Poets* (1942), we see Hitler standing in an icy landscape, holding a bloody whip behind his back, like the tail of Beelzebub. The two poets, one playing on a broken lyre, the other scribbling on bits of torn paper adorned with swastikas, are monstrous old graybeards worshiping at the knees of the Führer. Then there is his most famous painting, entitled *Cain, or Hitler in Hell* (1944), which —like many of his paintings—is composed from elements of older drawings. Hitler is depicted as a haunted figure, mopping the sweat off his brow, sitting on a heap of corpses, as the world is bubbling and burning in the background like a hellish cauldron.

The subjects of these paintings were no doubt deeply felt, and the imagery is horrific enough. But they refuse to come to life. What is depicted not only lacks realism (as is only natural in allegories) but reality. Grosz wrote in 1946 (to Elisabeth Lindner) that he was not especially interested in representing "reality." There was no reason for his "nightmares to compete with photography. They are wit-

nesses of my 'inner' world—ruins in me, populated by my own luna-
tics, dwarfs and wizards."[8] Other denizens of Grosz's inner world
are the "stick people," figures made up of nerves and intestines, who
are, in the artist's words, "without any hope or purpose," moving
about grotesquely in a kind of danse macabre.

The problem with these allegories is the problem of his "commer-
cial" landscapes: the *détails* are missing, the small things of daily life,
recreated by the artist, that make the work more than just painted
rhetoric. The nightmares lack immediacy because they are not ob-
served, and Grosz, I think, needed to observe closely what he painted.
He was not comparable to Goya, or even to Max Beckmann, who
painted marvelously wherever he was, in Berlin, Amsterdam, or St.
Louis. Grosz's inner life was not enough to feed his art. He needed
the buzz and the smell of the streets. And not just any streets but the
streets he knew best, of late Wilhelminian, early Republican Berlin,
where he could play the dandy, the agent provocateur, the Dadaist
clown. It was hard for him to play these roles in New York. As he
said in an interview quoted by Christine Fischer-Defoy in the exhibi-
tion catalog: "I became kind of conformist in America. I didn't want
to stand out."

Here, too, Grosz was probably exaggerating. For he never stopped
playacting—his autobiography, written in 1946, is a hilarious but
very unreliable document. His roles were getting increasingly stale,
however. They belonged to a vanished world. He had frequented the
Dada group in Berlin during World War I, and his wonderfully zany
Dadaist sense of humor still permeates his letters to fellow exiles,
who shared the same memories and understood his jokes. In these
letters, written in an inimitable and untranslatable mixture of Amer-
ican English and Berlin slang, one can still sense the afterglow of the

8. Grosz, *Briefe*, p. 375.

Weimar Republic. But reading them, I could not help thinking of the shattered dandyism of Beau Brummell and his friends, who tried to keep up appearances in shabby French seaports after being thrown out of the salons of Regency London. The demented Brummell would hold imaginary soirées in empty hotel rooms.

Grosz knew very well that he would never be an American artist. But he also knew there was no way back to the Berlin he had left behind. Like so many other émigré artists, he was caught between worlds. "Life here," he wrote in 1936, "is so different, and sometimes one feels so depressed and uncomfortable—but then a cool ocean breeze comes blowing round the corner—and one is an American once again: how are'ye—how are'ya doin'—just fine, just fein!"[9]

The sadness of Grosz in America is not only that his roles were of another place and another time but that they were not understood. He tried to revive his image as the Dada clown in a famous collage he made in 1957. It shows the artist's face, in clown's makeup, on the body of a showgirl, with Manhattan in the background. In his left hand, Grosz, "*der Clown von New York*," carries a bottle of bourbon.

In May of that same year, Grosz gave a speech in New York, after receiving the gold medal for graphic arts from the American Academy of Arts and the National Institute of Arts and Letters. The speech, published in the catalog, is a distressing document. He tells the audience how moved he is by this token of recognition. And he tries to explain his artistic philosophy. It is a spirited defense of figurative art in an age of abstract expressionism. He describes the limitations of satire and explains his desire to be an artist of nature. It is a cry from the heart, a desperate apologia pro vita sua, but the audience thinks he is clowning and interrupts his speech with howls of

9. Grosz, *Briefe*, p. 230.

laughter. As the audience howls, he begins to dance around the microphone, like a mad Indian. Pegeen Sullivan, Grosz's dealer in New York, cried with embarrassment. But the painter Jack Levine thought the spectacle was just great—a Dada happening straight from the Weimar Republic.

Oh, spiffing world, oh funfair,
Blessed freakshow,
Watch out! Here comes Grosz,
The saddest man in Europe,
"A phenomenon of sadness."
Stiff hat in the back of the neck,
No slouch!!!!
Nigger songs in the skull,
Colorful as fields of hyacinths,
Or turbulent D-trains,
Clattering across rattling bridges
Ragtime dancers,
At the fence, waiting in the crowd,
For Rob. E. Lee.

—GEORGE GROSZ[10]

Grosz's American dream came to him very early on. As a small boy in a garrison town in Pomerania, where his mother ran the officers' mess, he read American stories about Buffalo Bill and Nick Carter. And like every German boy (still), he read Karl May's Wild West

10. In *Pass Auf! Hier Kommt Grosz: Bilder Rythmen und Gesänge 1915–1918* (Leipzig: Verlag Philipp Reclam Junior, 1981).

novels about Old Shatterhand, the German-American hero, and his loyal Indian friend Winnetou. He also loved James Fenimore Cooper's stories, which earned him one of his many nicknames, "Leatherstocking."

Barnum and Bailey's circus, complete with General Tom Thumb in full dress uniform, came to town. Then there were those fabled men who had tried their luck in the US, and come back to visit the old country, impressing the young Grosz with their padded shoulders, patent-leather shoes, and easy manners. America was a fantasy land of wild adventures, fabulous riches, cowboys and Indians, wide-open spaces. One can still taste the atmosphere of these turn-of-the-century German-American dreams in May's old house, now a museum, in a suburb of Dresden. "Villa Shatterhand" is stuffed with Western paraphernalia: Indian headdresses, trapper's hats, Colts, Henry rifles, and bad oil paintings of life on the prairies. When May wrote his tales of the Wild West, he had never set foot in America.

In 1916, like his friend and fellow Dadaist John Heartfield (Helmut Herzfeld), Grosz chose to Anglicize his given name when he signed his drawings for Berlin magazines. This was a gesture of contempt for the anti-British and anti-American propaganda of World War I. But Grosz's Americanism was also one of his many public poses. In true Dadaist fashion, the posing was part of his art. Like Karl May (not, I hasten to say, a Dadaist), he liked to be photographed in different guises: as an American gangster brandishing a revolver, or as a boxer, or as a kind of Mack the Knife, about to stab his wife with a dagger.

One of his drawings of 1916 was titled *Picture of Texas for My Friend Chingachgook*, a picture of squinting, corncob-pipe-smoking horsemen and an imperturbable Indian. There is also a magnificent drawing of New York City called *Memory of New York*, a crazy jumble of skyscrapers, elevated trains, and neon signs. Of course,

Grosz had no memories of New York, any more than James Fenimore Cooper's fabled Indian was his friend. These were part of his elaborate fantasies. He liked to present himself as George Grosz, the American artist, or, on occasion, as "Dr. William King Thomas," American doctor and mass murderer—this was when he wasn't pretending to be a Dutch businessman or a Prussian aristocrat. One of his poems begins with the line: "I shoot off my gun, early, when I step out of my log cabin." There was a picture on the wall of his studio of Henry Ford, with the inscription (written by Grosz himself): "To George Grosz, the artist, from his admirer, Henry Ford."

Childish stuff. But Grosz was not the only one with such dreams. America was in the Berlin air, like the shimmy, the "nigger songs," and the jazz music of Mr. Meshugge and his band, playing at the Cafe Oranienburger Tor. Thomas Mann called Berlin the "Prussian-American metropolis." Even Bertolt Brecht, who was hardly an admirer of Yankee capitalism, fantasized about America. (Grosz much admired Brecht's American-style suits.) But just as Brecht's song about whiskey bars and the moon of Alabama belongs to Berlin, not the actual US, Grosz's drawings of Manhattan skyscrapers and Texas saloons fit with his other work in Germany. They are German in a way that his later allegories about the European apocalypse were never part of the American scene. Grosz, "the American artist," was German in the way the Rolling Stones are British, even, or perhaps especially, when they imitate Americans.

Wieland Herzfelde shrewdly described Grosz's American poses and drawings as "a kind of satire of his own wishful dreams."[11] This, too, is not unlike European rock stars singing about Memphis, Tennessee, in exaggerated, shit-kicking style. Someone should write a book one day about the American fantasies that are part of European

11. *Pass Auf! Hier Kommt Grosz*, p. 76.

popular culture. Grosz would merit a major chapter. Then, barely a decade after Grosz's death, American pop culture repaid the compliment by turning pre-war Berlin into an erotic fetish: "Life is a cabaret, old chum," and so on.

Love and ridicule, like lust and loathing, are always close together in Grosz's work. In an essay that established Grosz's name in Berlin, the writer Theodor Däubler wrote that Grosz was "never elegiac: out of his cowboy-romanticism, and his longing for skyscrapers, he created a perfectly real Wild West in Berlin."[12] Perhaps this is why these drawings are convincing, whereas the oil paintings of his nightmares in New York are not. In 1916, he tried to make his American fantasies look real, not real in the photographic sense but concrete, palpable, as though sketched from life.

Even his most allegorical works of the Berlin period are full of beautifully observed details. *Pillars of Society* (1926) is a good example. One of the four pillars of the Weimar Republic is the porcine priest, blindly preaching as the buildings burn and the soldiers rampage behind him. The other three are the journalist, with a bedpan on his head; the politician, with a pile of steaming shit instead of a brain; and the monocled military officer, with the tin-pot mirage of a Wilhelminian cavalry officer emerging from his empty skull. The message of the painting is as unambiguous as, say, a 1960s protest song by Bob Dylan. But that is not what makes it a work of art. It is the details that count: the stiff white collars, the mustaches, the marble-topped café table, the duel-scarred cheeks.

Hans Sahl recalls meeting Grosz after the war, at an exhibition of the work of Edvard Munch, in Munich. Grosz, sporting a monocle, was loudly denouncing Munch for the sloppy way he painted clothes.

12. This essay appeared in 1916, in a magazine called *Die weissen Blätter*, an internationalist journal that discovered Franz Kafka.

"A great painter," he said to Sahl, "must also be a great tailor. He must know how to make shirts, gloves, ties, walking sticks."[13] Grosz knew what he was talking about. He was always fastidious, in his work and about his personal appearance. There is a small drawing, made in 1917, of a man washing the blood off his hands, after having severed the head of his female victim with an ax. There is a curious fussiness about the scene: the woman's lace-up shoes neatly placed under the bed, the killer's pocket watch laid on the table, and his jacket and cane, carefully folded and tidied away. This murderer knew how to take care of himself.

Grosz was a dandy. He liked to sit alone at the Café des Westens, powdered and rouged, dressed in a chocolate-brown suit, his cane, topped with an ivory skull, beside him. He affected the detachment of the dandy, the contempt for the bourgeois world, particularly the world of the German bourgeois, the *Spiesser*. Wolfgang Cillessen remarks in his catalog essay that Grosz needed the contrast of German ugliness to set off his own cultivated elegance. Grosz: "To be German is always to be tasteless, stupid, ugly, fat, stiff; to be unable, at the age of forty, to climb a ladder, to be badly dressed. To be German means to be a reactionary of the worst kind; it means that of a hundred people, only one will keep his whole body clean."[14]

But Grosz was not as detached as all that. Nor was he just a preacher against German depravity, even though another one of his roles was that of the moralist. There is a self-portrait of Grosz posing as a stern German schoolmaster, pointing a warning finger. It is entitled *Self-Portrait as a Warner* (1927). A moralist cannot be completely detached. True dandies don't warn, they just display their style. But Grosz had, in Cillessen's happy phrase, a "voluptuous fascination"

13. Sahl, *So Long mit Händedruck*, p. 20.
14. Quoted in the catalog, p. 270.

with the objects of his scorn. This is what made him such a master of satire, a true disciple of Hogarth, whom Grosz so much admired. Berlin of the 1920s may have been vulgar, grasping, heartless, and full of *Spiesser*, but it was sexy, too. For some, some of the time, life was indeed a cabaret. Even the *Spiesser*, in a crude, swinish way, were sexy. It was that sexiness that Grosz managed to capture in many of his drawings.

Take his pictures of brothels, with their thick, leering customers pawing and tickling half-dressed whores. There is an element of loathing in these drawings and watercolors, maybe even of warning. But also of voluptuous fascination. The way his artist's eye undresses women in the streets, and sees through the walls of tenement buildings, is meant to expose the hypocrisy of bourgeois city life, the filth behind the respectable façade, but it is also a form of voyeurism, of delight in what his X-ray view reveals. What is true of whores and pimps is true of the beery men at their regular café tables, or the fat, complacent bourgeois families, sitting around pianos or Christmas trees, or even of the grotesque priests and hideous bankers: this was Grosz's world. He knew it intimately. He was part of it. He was—as he admits in his autobiography—a bit of a *Spiesser* himself.

Grosz was a political artist in the sense that he used his art as a polemical weapon. But he was an agitator more than a propagandist, a moralist more than a political thinker. He joined the German Communist Party, but began to lose faith in progress and the proletarian revolution by the early 1920s—a trip in 1922 to the USSR didn't help. By the time he left for the US, he had lost it completely. He once said that the larger the crowd he went with, the more of an individualist he became. Brecht recognized this, and never saw Grosz as a reliable Party man. Grosz was not so much in favor of communism, or social democracy, as against the smug, fat face of German authority. This suited his Communist friends, editors, and publishers fine.

Grosz lost faith not only in communism but also in the efficacy of political art. In his autobiography, he wrote that he "had gradually come to see that the propaganda value of art had been highly overrated, that politically committed artists mistook its effects on themselves for the reaction of the 'beloved proletarian masses.'"[15] He still did marvelous drawings, watercolors, and some paintings after 1923, but nothing, in my view, ever reached the savage beauty of his *Ecce Homo* collection, or the malice of the "lavatory graffiti" drawings of 1916 and 1917. He later considered satire a minor art, but it was there, and not in his attempts at fine art, that he excelled. He lifted the art of shocking the bourgeois to a level of greatness.

At his best, he was so good that his pictures still have the power to shock. Pausing at the Nationalgalerie in front of some drawings made in 1921, I overheard a conversation between three Germans, all aged around sixty: two paunchy men and a woman in a green felt hat. Looking at a picture of obese, cigar-smoking worthies, who were wearing chamber pots on their heads, the woman said, "Revolting!" Her friends agreed. One of the men boomed that he couldn't understand "this nonsense about *Spiesser,* as though everyone who is normal and decent were a *Spiesser.*" "Quite so," said the other man just as loudly, "quite so." Then, suddenly, he was struck by a thought: Was Grosz a Jew? "No, no," said his friend, "no, no, not a Jew, no, no, not that."

Grosz began to realize in the US "that caricatures are prized chiefly in periods of cultural decline, that life and death are too fundamental to be subjects of mockery and cheap jibes."[16] This is a little too disparaging of the satirist's art, but Grosz was right about the last part. The Third Reich was not a laughing matter. For satire to

15. *A Small Yes and a Big No*, p. 189.
16. *A Small Yes and a Big No*, p. 185.

work, or indeed to be possible at all, a certain amount of political and social freedom is needed. And people have to be shockable. The Weimar Republic, with its veneer of bourgeois respectability, its free press, its licentiousness, its greed, and its bumbling politicians, was a perfect target for wicked mockery. As the radical journalist Kurt Tucholsky said, "It is crying out for satire."

But when the *Spiesser* turn into killers, there is not much a satirist can do, for there is no one left to shock. The reality of Hitler's Germany was more shocking than any lampoon could be. Grosz did his best in his allegorical paintings, but he failed, because that was not his style, and because the real thing was too overwhelming. His Berlin had already begun to disintegrate some years before he left Germany. By 1930, the Weimar Republic was tottering. A week after Grosz arrived for the second time in New York, Hitler became chancellor of Germany. The republic that had filled Grosz with such voluptuous loathing was gone. In 1946, he looked back on the earliest years of his career with nostalgia:

> Yes, I loved Dresden. It was a good, romantic time. And after that, Berlin. My god, the air was full of stimulation. It was lovely to sit at the Café Josty. The old and new Sezession. It's all gone. Only dust remains. Tree stumps, filth, hunger and cold. We, who still experienced the "old," or at least the last years of Wilhelminian civilization, can compare, and the comparison, I'm afraid, does not favor our own time. (Letter to Herbert Fiedler, February 1946)

Grosz had never really wished to go back. But his wife wanted to live in Germany again. And so it was that a week after his sad speech and Indian dance at the National Institute of Arts and Letters in 1959, they returned to Berlin. Grosz was surprised at how American

the city had become. He also found life slower and more relaxed: "One feels that of every 100 Berliners, 101 are pensioners." He sent a postcard to Rosina Florio, the director of the Art Students League, begging her to ask him back to New York. She was on holiday when the card arrived. By the time she read it, Grosz was dead. After a night of heavy drinking, he had choked on his own vomit.

24

MR. NATURAL

THE TYPICAL CRUMB flavor—wild, sardonic, and exuberant—is exemplified by a little picture story reprinted in the *Handbook*,[1] entitled "The Adventures of R. Crumb Himself." It shows the hero going for a walk downtown, coming across the National School of Hard Knocks. He enters the establishment, gets kicked by a mother superior, beaten by a policeman, stomped on by a professor, and just as the nun is about to chop off his penis with an ax, he chops off her head instead. Buying a bomb from a sinister man in a dark ally, Crumb then blows up the School of Hard Knocks and enrolls in a different place called the National School of Hard Knockers, a nubile girl on each arm, his penis hardening, mouth drooling: "So I'm a male chauvinist pig.... Nobody's perfect... R. Crumb—"

Crumb comics are often very funny, inventive, full of dark fantasies, aggression, and a certain degree of tenderness. Does this make him "the Brueghel of the last half of the twentieth century," as Robert Hughes, the art critic, claims?[2] Paul Morris, of the Paul Morris

1. R. Crumb and Peter Poplaski, *The R. Crumb Handbook* (MQ Publications, 2005).
2. Hughes said this in Terry Zwigoff's documentary *Crumb*.

Gallery in New York, also includes Louise Bourgeois in a list of artists whose works, in his view, "have a relationship" with Crumb's. These comparisons show how much the barriers between so-called fine art and popular art have come down. The best of the comic strips are now shown on museum and gallery walls. As I write this article, the work of nine American cartoonists, including Crumb, is on display at the Pratt Gallery in New York. And Crumb has had shows in several European museums.

Hughes sees affinities between Crumb and Brueghel because Crumb "gives you that tremendous kind of impaction of lusting, suffering, crazed humanity in all sorts of desired gargoyle-like allegorical forms." Probably so. But then so does Bosch, or Goya, or Picasso, or, for that matter, the Marx Brothers. Although it is good that a critic of fine art recognizes a master of comics, the comparison doesn't quite explain the eccentric nature of Crumb's talent.

Crumb himself, though highly aware of artistic traditions, does not make the same claims for himself. In fact, he slyly lampoons them. Perhaps in response to Hughes, he drew a picture of himself in a seventeenth-century painter's smock, gazing at a distinctly twentieth-century urban American skyline, saying, "Broigul I ain't . . . let's face it." At the end of *The R. Crumb Handbook* is another self-portrait of the artist, looking more than a little crazed, pen poised over paper, and a glass of something at hand. It is entitled: "R. Crumb's Universe of Art." On the right is a list called "Fine Art!" and on the left are "Cartoonists" and "Illustrators." Among the cartoonists/illustrators are Harvey Kurtzman, Wallace Wood, Thomas Nast, Crumb's brother Charles, and Crumb's wife Aline Kaminski Crumb. The fine artists include Bosch, Rembrandt, Rubens, Goya, Daumier, Hogarth, James Gillray, Van Gogh, Edward Hopper, and George Grosz.

Crumb greatly admires all these people. He has said so on many

occasions. But the selection is interesting. It is not immediately clear where he would place himself. Perhaps in both categories. Or maybe such groupings are arbitrary anyway, but then, why bother making them? Cartoonists like Kurtzman and Nast, not to mention his own brother Charles, are often mentioned by Crumb as major influences on his work. Then so are Hogarth and Gillray. Grosz, too, regarded Hogarth as a model. He once told the diplomat and art collector Harry Kessler that he wanted to be "the German Hogarth." Kessler wrote that Grosz loathed abstract painting and "the pointlessness of painting as practised so far." Art for art's sake didn't interest him, at least in his Berlin years. He wanted art to be didactic, active, political, like Hogarth or religious art, a function "lost in the nineteenth century."[3]

I'm not sure what Crumb would make of this. But his graffiti-like cartoons of animal greed and cruel lust in twentieth-century America are closer in spirit to Grosz than any other artist I can think of. Like Grosz, Crumb is a born satirist who brandishes his pencil like a stiletto. But he is funnier than the German artist, and wackier. Grosz, quite a pornographer himself, shared Crumb's love of sturdy female posteriors. And like Crumb, the artist himself usually played a leading part in his pictorial fantasies. But none of Grosz's pictures shows quite the same high spirits of Crumb, the triumphant nerd conquering those hordes of willing Amazons. Grosz wallowed in obscenity; erotic pleasure came with a certain amount of disgust; one may indeed have fed the other. In comparison, Crumb's orgies look almost innocent.

Probably neither "fine art" nor "illustration" is an apt description for the type of art in which both Grosz and Crumb excelled. And there is nothing wrong with that. Such classifications are for critics,

3. Count Harry Kessler, *The Diaries of a Cosmopolitan, 1918–1937* (Grove, 1999), p. 64.

not artists. But the artist can make it a problem when, flattered by admirers, or stung by critics, or just out of boredom, he tries too hard to become a "fine artist."

Henri Cartier-Bresson was a photographic genius, but nothing more than a skillful draftsman. Yet he gave up the former to pursue the latter. Grosz's venomous drawings of Weimar Berlin are unforgettable. His pretty watercolor pictures of New York are not. Yet there he was—not entirely by choice, it's true—a mediocre fine artist in the United States. R. Crumb now lives in the south of France, by all accounts, including his own, a contented family man, far away from the urban blight of the US that enraged and inspired him.

He still draws cartoons of his personal quirks and anxieties, and pictures of things he enjoys: athletic girls, old-time jazz and blues players, his wife Aline, dinners with family and friends. Like Robert Hughes, he disdains much of what passes for fine art in the market today. Interviewed by Hughes at the New York Public Library in April 2005, Crumb expressed his annoyance about an Andy Warhol silkscreen going for a fortune, while he spends hours, even days, slaving to get a drawing just right.[4] It also irritates him that he is still stuck with the reputation of "a Sixties man." He regards the work of that period as "too sloppy," and wishes he had spent more time on his draftsmanship.

And yet perhaps those "sloppy" cartoons, dashed off in a haze of dope and LSD to be printed in cheap underground papers (*Zap Comix, Snatch, Big Ass Comics, The East Village Other*), were his best work. Some artists can produce great work from their own heads, whatever the time and place. Most cartoonists and illustrators need a subject or a milieu to inspire them. Crumb, to be at his creative peak, may have needed the edge of 1960s America, just as Grosz needed the

4. The transcript from the "Live at the NYPL" program is available at www.nypl.org.

rich brutality of Weimar Berlin. There is no shame in this. Crumb is undoubtedly a great artist. The question is what made him so great.

———

One of three sons and two daughters of a taciturn marine sergeant prone to sudden acts of violence (he smashed Crumb's collarbone when the boy was only five) and a devout Catholic mother on amphetamines, Crumb grew up around military bases in Philadelphia and Oceanside, California, and later in Milford, Delaware. His parents, in his words, had "never cracked a book." Fine arts museums were unheard of. Crumb, like his brothers, soaked up the TV and comics culture of the 1950s: Howdy Doody, Donald Duck, Roy Rogers, Little Lulu, and the like. While on LSD in the 1960s, Crumb thought of his mind as "a garbage receptacle of mass media images and input. I spent my whole childhood absorbing so much crap that my personality and mind are saturated with it. God only knows if that affects you physically!"

Millions of Americans were exposed to the same things. Most of them went on to lead unremarkable lives. The Crumb brothers became very strange indeed. Charles, the eldest, was a precocious author of comic strips, who pressed his younger brother into following the same obsession. As an adult, Charles barely ever left the family house, didn't bother to wash, got seriously depressed, and finally killed himself. Max, the youngest, has lived in a San Francisco flophouse for more than two decades, where he impales himself on beds of nails and draws pictures of naked young girls. Robert is the only one who "made it," in a more or less conventional sense.

His artistic gift was clear early on, even though his high school art teachers failed to see the point of the homemade comics he produced with Charles, full of bosomy female vampires. In 1962, Robert left

for Cleveland, Ohio, where he found work drawing cute anniversary cards for American Greetings. It was a respectable nine-to-five job, with a strict dress code. He married a local girl. A housing loan could be arranged through the parents-in-law. In 1967, he realized that it was all a mistake and made for San Francisco, inspired, like so many of his age, by Jack Kerouac's *On the Road*. And besides: "I wanted to fuck a lot of girls, and in fact, ultimately, I got my share."

Although Crumb took LSD and spoke the lingo of Haight-Ashbury, he was, on the surface, far from being a typical 1960s man. As far as he was concerned, rock and roll lost its interest as soon as middle-class white kids began to play it. All those doodling guitar solos of acid-rock stars were unbearable to him. Crumb much preferred old blues and jazz, and became a voracious collector of 78 rpm records. In dress, too, Crumb was not quite a man of his time. While others wore kaftans and beads, Crumb stuck to dapper jackets, porkpie hats, and slacks, like a jazzman of the 1950s. If there is one mood, apart from lust, that defines Crumb's work, it is nostalgia. But in fact this was also very much a feature of 1960s culture.

A great deal of rock music of the 1960s and early 1970s was soaked in nostalgia for a preindustrial Americana. There was, in an age of extraordinary mass-produced affluence, a deep longing for the handmade, the artisanal, the simple good life. "Plastic" was a general term of abuse for anything in the modern world that was deemed to be hateful: suburban mod coms, TV personalities, and so on. Country rockers, folk singers, tie-dye weavers, and other enthusiasts of the organic and the "real" imitated the styles of an earlier, rougher, more rustic or proletarian culture. Bob Dylan, in his first steps to stardom, pretended to be a hobo. The Rolling Stones, nice suburban English boys all, pretended to be Edwardian rakes or black men from the Deep South. Crumb adopted the comic style of pre-war funny papers.

Like Dylan, however, he transformed the style of a bygone era into something rather different and personal. Both artists reworked popular, even proletarian arts and came up with something that could be played at Carnegie Hall or pinned on the walls of a fine arts museum. This was not because they felt superior to the popular artists whom they admired. Crumb certainly didn't use the techniques of a fine artist. On the contrary, it was more that, like Dylan, he used a popular idiom to express feelings and ideas normally reserved for more sophisticated forms, such as poetry or the novel. Sexuality, autobiography, and political rage were not things that comic book artists dealt with before Crumb came along.

One exception, possibly, was Harvey Kurtzman, the creator of *Mad* magazine, whom Crumb idolized. Kurtzman broke the mold of heroic war pictures with *Two-Fisted Tales*, his comic strip about the horrors of the Korean War. And there was a lot of soft-core sex in his *Little Annie Fanny* cartoons for *Playboy*. But these, done in cooperation with such cartoonists as Will Elder, were not nearly as personal as Crumb's work, or as bold.

Crumb used comics in the way certain art photographers used photos, as a kind of confessional journal of his own life, especially his erotic life. In a sense, his medium is richer in possibilities, for although a photographer can express his or her feelings in pictures, it is very difficult to express an inner life. We know from the photographs of Nan Goldin, say, what her friends look like, how they loved, and how some died. We know about her own love life. We get the pictures of her milieu. What we don't get to see are her most intimate anxieties and fantasies.

Like the anxieties and fantasies of most people, Crumb's aren't always pretty. As is doubtless true of many men, his sexual desires contain a great deal of aggression, even perversity. Maybe the urge to jump on the backs of Amazons in tight jeans and ride them like horses

is somewhat specialized, but no more so than many urges of *l'homme moyen sensuel*. Crumb is certainly not alone in raging against his slavery to sexual desire, as well as celebrating it, or against the female sex that tempts, torments, and delights him. Nor is he immune to racial prejudice, or misanthropy, or pet hatreds, not least of himself. In *The Many Faces of R. Crumb*, an autobiographical comic published in 1972, the self-mocking artist goes through a variety of changes: "Crumb the long-suffering patient artist-saint," or "Crumb the cruel, calculating, cold-hearted fascist creep," or "Crumb the misanthropic, reclusive crank," or "media superstar, monumental egotist and self-centered SOB," or "sex-crazed fiend and pervert," and so on. Until in the last picture, he gives us a melancholy wave from his desk, a pen in his left hand, a half-finished comic strip in front of him: "The enigmatic, elusive man of mystery. Who is this Crumb?—It all depends on the mood I'm in!!"

It is possible that Crumb's comic character appeals mostly to fellow nerds, and that, as John Leonard once put it, "pop nostalgia clings like a kudzu weed to everyone who ever grew up feeling alien-freaky—i.e., all of us who somehow knew we were born to die uncool."[5] But I think that is too narrow a view. All comic characters, from Don Quixote to Charlie Chaplin to Woody Allen, are losers of a kind. One reason we love them is that it is always comforting to know there are people worse off than we are. But also because there is a loser in all of us. It's just that few people have the courage or genius to turn their least attractive features into art.

To call Crumb a misogynist or a racist is to miss the point. By exposing violent impulses in himself and the society around him, he does not advocate or glorify violence. A man can be a perfectly decent human being and still harbor all kinds of feelings and thoughts

5. "Welcome to New Dork," *The New York Review of Books*, April 7, 2005.

that would not pass scrutiny. To be civilized is to keep such instincts under control. Crumb simply shows that he, and by extension all of us, are made of many parts, some of them not so nice. "I was just being a punk," he said about his work in the 1960s, "putting down on paper all these messy parts of the culture we internalize and keep quiet about." Here, too, Grosz comes to mind. As his pornographic drawings show quite clearly, Grosz was as lecherous as the porcine plutocrats he satirized so savagely. But his best work, of the 1920s, also reveals what happens when our basest instincts become political. That is when civilization breaks down. I think it was Jean Genet who once said that Nazi Germany didn't interest him because sadism was no longer subversive but had been institutionalized.

The danger of turning your life into an artistic chronicle is that success can lead to mannerism. What was once a refreshing kind of honesty becomes a shtick, repeated over and over, becoming slicker and slicker, losing all spontaneity along the way. This, to his credit, has not quite happened to Crumb. As soon as his public image hardened into celebrity, he moved to the relative obscurity of the south of France. His newer work, including his self-mocking cartoons about being exhibited in museums, is still personal and honest, but it has lost a certain edge. Crumb himself observed that "most cartoonists have about a ten-year run of inspiration or creativity."

Like a certain kind of Romantic poet, the confessional artist as an angry young man can burn himself out quickly. In the case of Crumb, it is not just that he has found bourgeois comfort with his wife Aline. He may be striving too hard for a kind of respectability, trying to shake off his role as a punk. One of his mature works is an illustrated introduction to the stories of Franz Kafka, reissued in 2004 as *R. Crumb's Kafka*.[6] One can see why Crumb would be a natural artist

6. Written by David Zane Mairowitz, and published by ibooks.

to illustrate Kafka, the nerdish, neurotic artist par excellence. For a Catholic army brat, Crumb seems to have a remarkable affinity with Jews—he married two Jewish women. Aline, herself a considerable cartoonist, is usually depicted as a lewd version of Barbra Streisand. Yet the connection with Kafka doesn't really come off. Crumb is too respectful of Kafka, perhaps, or maybe a cartoon version of Kafka was not a good idea anyway. Although much more sophisticated, the book still seems too much like those Illustrated Classics that many people of my generation, including myself, were discouraged from reading by parents who worried about our literary development. Crumb's comic drawing simply doesn't match Kafka's literary style. The book does them both a disservice.

Nor am I sure that pinning pages from *Zap Comix* onto a museum wall is the best way to show off Crumb's work. Instead of elevating his art by tearing it out of the comic book and putting it in a museum, it somehow diminishes it. Crumb recognizes this. He told Hughes that his drawings were "done for print...the finished thing is the printed thing." Crumb is at his least interesting when he forgets this. His pen portraits of women and family life are funny and well executed. They are just not as interesting as the rougher, wilder comics.

Of course, one has to be careful with this line of criticism, lest one sound like Philip Larkin complaining that black American jazz musicians lost their primitive appeal when Miles Davis and Charlie Parker started experimenting with bebop and cool jazz. It is not that genres have to be strictly separated, or that photographers or jazz musicians or cartoonists cannot produce great works of art. Nor is it a matter of crude ranking. A great cartoon or photograph is far superior to a mediocre oil painting, just as Paul McCartney's pop songs are vastly better than his *Liverpool Oratorio*. Crossing boundaries of genre only works if the new departure matches the artist's particular tal-

ent. Davis and Parker weren't Dixieland musicians trying to be pretentious; they did what they were good at.

Crumb deserves great credit for daring to experiment, for trying different things. His later work—the portraits, the illustrated Kafka, the pictures of his domestic life—cannot simply be dismissed as the doodling of a tired old man. He never stopped trying to stretch the boundaries of the cartoonist's art, formally as well as in content. But he is not a great draftsman, and the content of his most recent work is not as surprising and powerful as it once was. Sometimes, as his beloved blues recordings so amply show, artists produce the best results when they draw strength from the limits of the forms they have chosen.

25

OBSESSIONS IN TOKYO

MISHIMA YUKIO'S SUICIDE in 1970 was a messy affair. First he plunged a short sword into his stomach, then a handsome young man from his private militia tried to cut off his head with a samurai blade and botched it three times before another follower completed the job. One way of looking at this bloody event is as a piece of performance art. Mishima had made sure the press would be there, at the Ichigaya military base in Tokyo, to record his call for an imperial restoration before he committed suicide. Mishima had asked a close friend at NHK, the national broadcasting company, whether the TV station might be interested in a live broadcast of his ritual disembowelment. The friend took this as one of Mishima's morbid jests. It wasn't.

Death had long been an artistic obsession of Mishima's. In 1966, he directed a short film, *Patriotism*, in which he played the part of a young army officer in the 1930s committing seppuku (only foreigners say hara-kiri) to the music of Wagner's *Liebestod*.

A year before his death, Mishima wrote a play based on a legend about a young Cambodian king who started building a beautiful temple, caught leprosy before it was finished, and rotted to death as the temple was completed. Mishima saw this story as "a metaphor

for the life of an artist who transfuses a work of art with his entire existence and then perishes."[1]

Two months before his suicide, Mishima posed for a portfolio of pictures by the fashionable photographer Shinoyama Kishin, to be entitled *Death of a Man*. The photographs show Mishima as Saint Sebastian tied to a tree, his naked torso pierced with arrows, Mishima drowning in mud, Mishima's head sliced by a hatchet, Mishima run over by a cement truck.

The novelist's brutal death, though eccentric, was actually part of a wider culture. It came as the culmination of two decades in Japan during which visual artists, dancers, actors, filmmakers, poets, and musicians had been testing the limits of physical artistic expression: street performances, "happenings," public action painting, sado-masochistic theater, and so on. Rather like in China today, the Japanese avant-garde art of the 1950s and 1960s often focused on the human body, sometimes in rather intense ways. Mishima's suicide had pushed this type of performance art to a limit beyond which it would be difficult to go. Thus, his violent death is as good a way as any to mark the end of an era of artistic ferment, scandal, and experimentation.

When I first went to Japan, in 1975, the key figures of the avant-garde were still around: Terayama Shuji was still making films and putting on plays, Takemitsu Toru was composing music for films and concert performances, Hijikata Tatsumi was directing his Ankoku Butoh dance troupe, Yokoo Tadanori still made art, and Isozaki Arata was in his prime as an architect. But the former enfants terribles had become rather grand figures, with entourages and international reputations. The whiff of scandal had dissipated, with the

1. See John Nathan's excellent biography, *Mishima*, reissued in paperback by Da Capo in 2000, p. 251.

possible exception of Oshima Nagisa's hard-core cinematic master-piece, *In the Realm of the Senses* (1976), about the true story of an obsessive erotic affair between a maid and an innkeeper, which ends with the maid strangling her lover and cutting off his penis. The film was butchered by the Japanese censors and led to a much-publicized court case.

Mishima, who had collaborated in various ways with most of these artists, was a legend. People still spoke of him with awe. This was odd in one respect: Mishima had become a figure of the extreme right, an ultranationalist who wanted to revive the samurai spirit and the cult of the Japanese emperor. He was exceptional in this way; other artists at the time certainly had no interest in reviving the sam-urai spirit, and in some cases were even linked to the radical left, which exploded in acts of "anti-imperialist" violence in the early 1970s.[2]

And yet Mishima and other artistic rebels, though starkly divided in their ideals, had a common target, described by Mishima as a "lukewarm land" that had become "drunk on prosperity" and fallen into "an emptiness of spirit."[3] The bourgeois conformism of postwar Japan—with its worship of the television set, the washing machine, and the refrigerator (the "Three Sacred Treasures"); its slavish imita-tion of American culture; its monomaniacal focus on business; and the stuffy hierarchies of the academic and artistic establishments—had become insupportable to free-spirited Japanese, whatever the nature of their politics.

There was another source of popular discontent. Students, and initially millions of other citizens too, rebelled in the 1950s and

2. One example was the massacre of twenty-six people by members of the Japanese Red Army at Lod Airport in Tel Aviv in 1972.
3. Nathan, *Mishima*, p. 270.

1960s against the US–Japan security treaties that turned Japan into a huge base for US military excursions in Asia, first in Korea, then in Vietnam. The treaties suited the Japanese elite; American wars were good for business. But they were deeply resented by many citizens. On one extraordinary occasion, in May 1969, Mishima debated with student radicals at Tokyo University. Dressed like a stylish tough in a black knit shirt and a tightly wrapped cotton waistband, Mishima told the two thousand assembled students that if only they would support the emperor, he would "gladly join hands" with them.[4]

The students were unimpressed. But so were the soldiers of the Self-Defense Force when Mishima harangued them, minutes before slitting his own stomach, about the warrior spirit and the need to die for emperor and nation. At least the students listened to the famous writer. The soldiers only jeered.

———

If 1970 makes a certain sense as the closing year of the Japanese avant-garde on show at MoMA, 1955 is about right as the mark of its beginning.[5] For 1955 was the year when the two conservative parties, the Liberals and the Japan Democratic Party, merged to dominate Japanese politics for the rest of the century. Japan would be a US-backed bastion against communism in Asia—an "unsinkable aircraft carrier," in the words of one postwar Japanese prime minister. The middle class was deflected from political protest by promises of sta-

4. Nathan, *Mishima*, p. 249.
5. "Tokyo 1955–1970: A New Avant-Garde," an exhibition at the Museum of Modern Art, New York City, November 18, 2012–February 25, 2013. Catalog of the exhibition edited by Doryun Chong (Museum of Modern Art, 2012).

bility, security, and ever greater prosperity. Activism had ended in an abdication to creature comforts.[6]

Before the middle of the 1950s, the modern arts in Japan were very much preoccupied with the wartime catastrophe and its aftermath, the US occupation. Most artists were staunchly left-wing, sometimes affiliated with the Communist Party, and ideology permeated their work. There are some good examples of this in the MoMA exhibition. The so-called "reportage painting" school of artists drew on their background of making militarist propaganda in the 1940s, as well as on pre-war influences from European surrealism. This hybrid style, exemplified by Yamashita Kikuji's oil paintings of corpses drowning in blood, or Ikeda Tatsuo's more socialist realist paintings of brawny proletarian fists clutching shovels, was typical of the intense political engagement of artists who had direct experiences of the war.

It is a common belief that the Japanese are almost congenitally incapable of facing the horrors of the war they unleashed. Some of the art in the MoMA show should help to dispel that caricature. Take a look, for example, at Hamada Chimei's rather beautiful etchings of wartime desolation: ruined Chinese villages with speared heads and body parts; a female cadaver with a stake up its vagina. This is less reportage than a kind of surrealist protest art.

Many Japanese artists and intellectuals in the 1950s rebelled against the overwhelming American influence of the immediate postwar by looking to Europe, especially France, for ideas. Sartre, Camus, and Merleau-Ponty were widely read. French berets and long

6. The political aspects of the Japanese avant-garde are discussed in great detail in William Marotti, *Money, Trains, and Guillotines: Art and Revolution in 1960s Japan* (Duke University Press, 2013).

hair became the common badges of the thinking man. The French action painter Georges Mathieu visited Japan in 1957, and demonstrated his art wearing a kimono. The Bauhaus was another source of inspiration. But the main point was to be engagé, and the main sponsor of engaged art was a most peculiar one: the conservative Yomiuri newspaper company, which had been the most zealous promoter of wartime propaganda only a few years before. To scrub this blot off its reputation, the Yomiuri did its best to promote avant-garde shows and events under a radical manifesto that promised an "art revolution"; Japanese society would be "democratized" through art.

Much of the actual art was derivative, and to younger artists, who were still children during the war, not radical or new, or original, enough. From the middle of the 1950s, new groups of artists emerged who were bored by political ideology and had an aversion both to slavish Westernization and the higher forms of Japanese tradition, which had ossified into a museum culture and were tainted by wartime chauvinism. The new art would be instinctive, physical, outdoors, irrational, a Japanese Neo-Dada or Anti-Art. The influential poet and critic Takiguchi Shuzo wrote in 1954: "Perhaps we haven't completely digested the movements and principles of Western art. Japanese contemporary art must exist in our guts and bones."[7]

And so, to pick one example, the performance called "Challenging Mud" was born, in 1955, contrived by an artist named Shiraga Kazuo of the Gutai group, formed in Osaka. At the first Gutai art exhibition in Tokyo, Shiraga, naked but for a pair of boxer shorts, dived into a pile of mud and started violently thrashing about, injuring himself in the process. A photograph of the resulting mess can be

7. Quoted in *Japanese Art After 1945: Scream Against the Sky*, edited by Alexandra Munroe (Abrams, 1994), p. 86.

seen at the MoMA show.[8] It is all that is left of this work. But of course the point is not the artwork itself; it wasn't made to last. The aim was to blast a way to a new type of artistic expression that would be "revolutionary for the whole world—East and West."[9]

Another major figure of the Japanese Neo-Dada was Shinohara Ushio, who would literally attack the canvas in public performances, like a boxer or a sword fighter, or throw balls of paint about. Compared to Shinohara's "boxing art," the American action painters of the period were rather tame (and usually better painters, too). But the finished work was not the issue; the performance was all. It was as if Japanese artists wanted to strip off the thick crusts of Chinese, Japanese, and Western artistic influences, accumulated over many centuries, and start again with the body, with those Japanese guts and bones.

An important feature of these experiments was the degree of cooperation among artists from various disciplines. Shinohara boxed with his canvases in a building designed by Isozaki Arata, who was associated with a form of uniquely Japanese avant-garde architecture called Metabolism.[10] The Metabolists, a group of young architects affiliated with the great Japanese master Tange Kenzo, had radical ideas on reshaping the modern city in a nonmonumental fashion. A bit like the artistic performances of the Neo-Dadaists, buildings and cityscapes would not reach a final form but mutate like living organisms.

Music played an important part, too. Takemitsu Toru was one of the Neo-Dadaists. Like the Metabolist architectural schemes and the

8. The Guggenheim Museum in New York City will be showing more from the Gutai group in a show called "Gutai: Splendid Playground," February 15–May 8, 2013.

9. Yoshihara Jiro, founder of the Gutai group, quoted in *Japanese Art After 1945*, p. 91.

10. For a fascinating analysis of the Metabolists, see Rem Koolhaas and Hans Ulrich Obrist, *Project Japan: Metabolism Talks* (Taschen, 2011).

action art, musical composition would be subject to chance and the unforeseen circumstances of any given performance. John Cage, himself influenced by Asian mysticism (especially the *I Ching*), was a much revered figure in Tokyo. Cage's long visit to Japan in 1962 had such an impact that Japanese called it the *Keji shokku* ("Cage shock"). And then there was dance. In an essay on the period, Isozaki recalled a party at his house in 1962, when the dancer Hijikata Tatsumi and the action painter Shinohara Ushio climbed onto the roof and improvised wild dances in the nude. The police intervened. And Isozaki, as the host of the party, was asked to prove that his guests had been engaging in "art" and not "pornography."[11] Hijikata's troupe Ankoku Butoh, meaning "Dance of Darkness," expressed eros and death in the spirit of the Marquis de Sade and Hans Bellmer, as well as the Shinto rituals of his native region in the rural northeast. Hijikata's first public performance was based on Mishima's novel about homosexual love, *Forbidden Colors*. He went on to become a leading figure in the Japanese avant-garde.

Improvised street performances, later known as "happenings," were not unique to Japan. They were part of a worldwide trend of spontaneity, of art that could not be bought and sold. But each place gave these events its own cultural twist. Japan has a long carnivalesque tradition of festivals and dances, mostly to do with Shinto rites of fertility, which can be wild, sexy, morbid, and often grotesque. Hijikata's slow dances of decay and rebirth, wearing little but a strapped-on phallus, were very much in this line. So was much in the spirit of *ero, guro, nansensu*—erotic, grotesque, nonsense—that marked a previous period of Japanese artistic and political ferment in the 1920s. The jazz-inspired poetry of Shiraishi Kazuko, often ex-

11. *Japanese Art After 1945*, p. 28.

pressed in public happenings, was part of this tradition. And so were the "rituals" performed by the group Zero Jigen, from Nagoya—marching naked in the streets, or impaling themselves with pins. All this was designed to shock people out of their bourgeois complacency. Carnival has often functioned as a form of political protest in Japanese history, a physical expression of revolt when other ways are blocked. Celebrations of sexual freedom sometimes took the place of political confrontation. This happened, for example, in the 1860s, just before the Meiji Restoration put an end to the old political order and modernized Japan along Western lines. A millenarian craze, called *eijanaika*, meaning "who cares"—"Who cares if we take our clothes off," "Who cares if we have sex"—began in the Kansai region around the old capital Kyoto. Ordinary citizens took to the streets, cross-dressing or not dressed at all, dancing in a frenzy. The craze quickly spread to other parts of Japan, before ending in mob violence.

Something like this occurred in the *ero, guro, nansensu* 1920s, and again in the early 1960s, in the narrower confines of the Japanese art scene. Much of what happened was born from political disillusion. Protests against the renewal of the US–Japan security treaty in 1960, bringing hundreds of thousands of people into the streets of Tokyo, snake-dancing, chanting, fighting the riot police, had failed. The treaty was rammed through the Diet by a prime minister, Kishi Nobusuke, who had been arrested in 1945 as a war criminal.[12]

The art curator Alexandra Munroe, in an essay for a previous exhibition of Japanese avant-garde art, at the San Francisco Museum of Modern Art in 1995, described how members of the Neo-Dada responded on the eve of the treaty's renewal. They were in the studio of one of the artists, Yoshimura Masunobu:

12. Richard Nixon, one of Kishi's golf partners, claimed him as a good friend.

The members stripped naked, some with bags tied over their heads, and danced wildly. Yoshimura attached a giant erect penis made of crushed paper bound with string to his loins, and painted his stomach with a gaping red diamond-shape of intestines—as if he had just committed *harakiri*—and marked the rest of his body with white arrows.[13]

Yoshimura Masunobu's sculpture is on display at the current MoMA show, as are the works of other Neo-Dada artists. But the paintings and sculptures that emerged from the action of the late 1950s and early 1960s are perhaps the least interesting products of that fascinating period. Okamoto Taro, who studied in Paris in the 1930s and knew many of the Surrealists, was a hugely influential figure in the Japanese art world, not least because of his writings, but his paintings and sculptures, though distinctive, do not strike me as first-rate. Other oil paintings on show, by Shiraga Kazuo, Ay-O, Ishii Shigeo, Fukushima Hideko, or Kitadai Shozo, seem competent but are rarely outstanding. The various objects wrapped in thousand-yen notes by Akasegawa Genpei are of Japanese art-historical interest, because they provoked the authorities into suing the artist for years on the spurious grounds of counterfeiting. Also of historical interest is the installation piece by Kudo Tetsumi of penises hanging limply from the walls, showing the sense of impotence that followed the failed political protests of 1960.

But painting, derived from Western traditions of "fine art," or indeed the modernist versions of that same tradition, was never the most interesting aspect of modern Japanese culture. And since so

13. *Japanese Art After 1945*, p. 152.

much of the artistic revolt of the 1950s and 1960s was deliberately ephemeral, one can't expect much of permanent or monumental importance. It is obviously impossible to recreate the excitement of the performances and happenings of the past in a museum show. All that is left are flickering images on video screens, a few blueprints, and some photographs. The catalog of the MoMA show, rather unattractively designed, doesn't help much either. Who would wish to wade through prose such as this: "Within the discursive network on the art of a given sociohistorical context, it is not uncommon to encounter a set of concepts that provide a pivotal hinge for various artistic praxes, but are then..." and so on.

Fortunately, a festival of independent Japanese films screened at MoMA to coincide with the avant-garde exhibition allows us to see a great deal more, including some of Hijikata's dance performances, Mishima's *Patriotism*, Terayama's excellent short films, and even a curious little movie, entitled *Cybele*, directed by the American critic Donald Richie, starring members of Zero Jigen being chastised by a dominatrix.[14] One of the most interesting movies, from a historical point of view, is Oshima Nagisa's record of sexual rebellion, street theater, and political revolt in *Diary of a Shinjuku Thief* (1968), starring Yokoo Tadanori, whose poster art was as important in the 1960s as Hijikata's Ankoku Butoh, Takemitsu's music, and Isozaki's architecture.

To me, the most fascinating thing about Japan at that time was the rediscovery of neglected aspects of Japanese culture, more in tune with the carnivalesque happenings: the subsoil, as it were, of Japanese tradition—the erotic side of Shintoism, the matriarchal cults of rural life, the low life of Japanese cities, the popular expressions of

14. Art Theater Guild and Japanese Underground Cinema, 1962–1984, a film series at the Museum of Modern Art, New York City, December 6, 2012–February 10, 2013.

sex and violence that once produced the Kabuki theater—in short, the very opposite of fine art and high culture, traditional or modernist. What emerged was a celebration of the "primitive," what Japanese call *dorokusai*, reeking of mud.

Highly sophisticated artists, such as Okamoto Taro, or the architect Tange Kenzo, started digging for inspiration into the prehistoric Jomon period (5000–300 BC), before culture was tamed and refined by Buddhism, Confucianism, and the Sinified aristocracy. Okinawa, like the rural northeast, was thought to have retained some of the primitive energy of premodern Japanese culture. In 1961, Okamoto wrote a book about Okinawa entitled *The Forgotten Japan: Theory of Okinawan Culture*. The American sculptor Isamu Noguchi encouraged this tendency during his stays in Japan. He tried to convince the Japanese that their oldest arts and crafts were more interesting, more avant-garde in spirit, than the pale imitation of modernist international artistic trends. This was not always well received. Some Japanese artists and critics regarded Noguchi as a condescending foreigner, indulging in a new form of Japonaiserie with his Jomon-inspired sculptures and his paper lanterns. Perhaps *nostalgie de la boue* is more convincing when it springs from the native soil.

Filmmakers, such as Imamura Shohei, set their movies in rural locations in the northeast, or in Okinawa, or in the slums of Tokyo and Osaka, among peasants, petty gangsters, and cheap whores. Avant-garde theater groups, like Terayama's Tenjo Sajiki, or Kara Juro's Situation Theater, mixed up the rough vitality of strip shows and country fairs with ideas derived from Antonin Artaud and Maurice Merleau-Ponty. Pitching their tents on riverbanks or next to Shinto shrines, they saw themselves as the spiritual heirs of the early Kabuki troupes, when theater was disreputable and associated with outcasts and prostitutes.

Moriyama Daido, Tomatsu Shomei, and other photographers stalked the red light districts around US military bases, or the burlesque theaters and bars in the Shinjuku district of Tokyo, for images that reeked of mud. The now world-famous pictures of the sexual Tokyo underworld by Araki Nobuyoshi, many of them taken after 1970, are products of the same trend. Graphic artists, too, rebelled against high-minded modernism. One of the most prominent, Awazu Kiyoshi, like Hijikata a native of the northeast, described his role as a designer as that of a wandering outcast. The designer's mission, in Awazu's words, was "to extend the rural into the city, foreground the folklore, reawaken the past, summon back the outdated, and confront the most belated 'rear-garde' with the city."

All this goes back, in spirit if not necessarily in form, to the merchant culture of the Edo period (1603–1868) when woodblock print artists, actors, courtesans, and prostitutes formed part of an interlocking world, raffish but artistically rich and alluring. The 1960s avant-garde was just as collaborative. Some of Takemitsu's best music was written for movies by such directors as Oshima. The poet Shiraishi Kazuko was married to the filmmaker Shinoda Masahiro, whose scripts were written by Terayama, and posters designed by Yokoo. The photographer Hosoe Eikoh collaborated on extraordinary books with Mishima and Hijikata, picturing the latter as a kind of rural demon in the muddy rice paddies of his native region.

Some of this—Hosoe's photographs, posters by Yokoo—can be seen at the MoMA show. But to my mind not nearly enough. For the exhibition demonstrates what exhibitions of Japanese modern art of the 1920s and 1930s also make clear: that the Japanese excel in graphic arts, photography, architecture, drama, cinema, dance. The unashamed use of popular art and entertainment, even the embrace of commercial art, seems to bring out the best in Japanese artists,

perhaps because of the long tradition of what might be called refined popular culture. Most painting looks rather wan in comparison.

When Yokoo, bored perhaps with his huge success as a poster artist celebrating underground theater, gangster movies, and scandalous dancers, reinvented himself as a fine artist of oil paintings in 1981, after seeing the Picasso show at MoMA, he lost much of his verve. Mishima was a great admirer of Yokoo's graphic art. Yokoo, Mishima said, revealed the dark things that lurk inside the Japanese that people prefer not to see. This led to a very lively culture, and perhaps to Mishima's death.

26

A JAPANESE TRAGEDY

THE GREAT POET Matsuo Basho, traveling in the northeast of Japan in 1689, was so overcome by the beauty of the island of Matsushima that he could only express his near speechlessness in what became one of his most famous haiku:

Matsushima ah!
A-ah, Matsushima, ah!
Matsushima ah!

Matsushima, known since the seventeenth century as one of Japan's "Three Great Views," is actually an archipelago of more than 250 tiny islands sprouting fine pine trees, like elegant little rock gardens arranged pleasingly in a Pacific Ocean bay. Because these islands functioned as a barrier to the tsunami that hit the northeastern coast with such horrifying consequences on March 11, 2011, relatively little damage was done to this scenic spot. Just a few miles up or down the coast, however, entire towns and villages, with most of their inhabitants, were washed away into the sea; 2,800 people are still missing.

I decided to go on a little trip to Matsushima because I had never seen this particular "Great View," even though I had in fact been

there once before, in 1975. Then, too, I set out from the harbor in a boat filled with fellow tourists—all from Japan. As we took a leisurely cruise into the bay, a charming guide gave us a running commentary on the islands we were supposed to be gazing at, their peculiar shapes, names, and histories. The problem was that no matter how keenly we craned our necks in the directions indicated by the guide, we could not see a thing; we were in the midst of a thick fog. But this did not stop the guide from pointing out the many beauties, or us from peering into the milky void.

It was a puzzling experience. My familiarity with Japan was still limited. I didn't quite know how to interpret this charade. Why were we pretending to see something we couldn't? What did the guide think she was doing? Was this an illustration of the famous dichotomy that guidebooks say is typical of the Japanese character, between *honne* and *tatemae*, private desires and the public façade, official reality and personal feelings? Or was it the rigidity of a system that could not be diverted once it was set in motion? Or was the tourists' pretense just a polite way of showing respect to a guide doing her job?

I still don't really know. But since then I have seen other instances of Japanese conforming in public to views of reality that they must have known perfectly well were false, to protect "public order" or to "save face." Japan is a country where the emperor is rarely seen naked.

———

One thing revived by the "3/11" earthquake, tsunami, and nuclear disaster is the culture of protest, which had been pretty much moribund since the great anti–Vietnam War and antipollution demonstrations of the 1960s. In his collection of essays, *Ways of Forgetting, Ways of Remembering*, John Dower describes these 1960s protests as

a "radical anti-imperialist critique [added] to the discourse on peace and democracy."[1] There hasn't been much of that in Japan of late.

But now, since the nuclear meltdowns at the Fukushima Daiichi reactors, thousands of protesters gather in front of Prime Minister Noda Yoshihiko's Tokyo residence every Friday demanding an end to nuclear power plants. Even larger gatherings of up to 200,000 people have been demonstrating in Tokyo's central Yoyogi Park, as part of the "10 Million People's Action to Say Goodbye to Nuclear Power Plants." Eight million have already signed. This has had at least some cosmetic effect. First the government announced that nuclear energy would be phased out by 2040. This has been softened since to the promise that this plan would at least be considered.[2]

The atmosphere at the protests is not unlike that of the Occupy Wall Street demonstrations in the US: passionate, peaceful, festive, and sprinkled with an element of nostalgia by the conspicuous presence of veterans of the 1960s. One of the leading figures is the novelist and Nobel laureate Oe Kenzaburo, aged seventy-seven.

Oe is keen to draw parallels between 3/11 and the past, though not with the protests in the 1960s, when petrochemical and mining companies were spewing their poison onto the land. Rather, he recalls the summer of 1945, when the Japanese became the first victims of atomic bombs. Oe sees modern Japanese history, and its nuclear disasters, through the "prism" of Hiroshima and Nagasaki: "To repeat the error by exhibiting, through the construction of nuclear reactors, the same disrespect for human life is the worst possible betrayal of the memory of Hiroshima's victims."[3]

1. *Ways of Forgetting, Ways of Remembering: Japan in the Modern World* (New Press, 2012).
2. When the conservative Liberal Democratic Party came back to power in 2012, the government became more supportive of nuclear energy once again.
3. "History Repeats," *The New Yorker*, March 28, 2011.

Other Japanese have heard different echoes from the last world war. The ninety-four-year-old writer Ito Keiichi, for instance, was moved by the spirit of self-sacrifice he observed in the firefighters, soldiers, and nuclear plant workers who had tried, often at considerable personal risk, to contain the damage at the stricken nuclear reactors. They reminded him of the self-sacrificial sense of duty displayed by Japanese soldiers and civilians during the war. This is not a sentiment that many Chinese, who saw the Japanese military spirit at first hand, might readily share, but in Japan it still has a certain resonance. The authors of the slight but very useful book *Strong in the Rain*, Lucy Birmingham and David McNeill, report that Japanese TV commentators sometimes compared the heroes of Fukushima to kamikaze pilots.[4]

I cannot imagine Oe's eyes moistening at the thought of kamikaze pilots, but his focus on Hiroshima, like Ito's sentiments about wartime Japanese sacrifices, might fit something Dower identifies as a common trait in Japan, something he translates as "victim consciousness," or *higaisha ishiki*. What is meant is the tendency to focus on the suffering of the Japanese, especially at the hands of foreigners, while conveniently forgetting the suffering inflicted by the Japanese on others.

It is certainly true, as Dower says, that most Japanese associate the war with Hiroshima, and not, say, with the Nanking Massacre, the Bataan Death March, or the brutal sacking of Manila. Yet Oe's sentiments, and those of his fellow antinuclear protesters, cannot be reduced to "victim consciousness." National self-pity is not at the core of their protest. Their point is, rather, that both Hiroshima and Fukushima were man-made disasters. And their rage is fueled by a long history of government deceit, of being consistently lied to, specifi-

4. *Strong in the Rain: Surviving Japan's Earthquake, Tsunami, and Fukushima Nuclear Disaster* (Palgrave Macmillan, 2012).

cally about nuclear power; it has to do with being made to conform to official views of reality that have turned out to be patently false.

Doctoring reality for propaganda purposes is not only a Japanese practice, of course. News of the terrible consequences of the atom bomb attacks on Japan was deliberately withheld from the Japanese public by US military censors during the Allied occupation—even as they sought to teach the benighted natives the virtues of a free press. Casualty statistics were suppressed. Film shot by Japanese cameramen in Hiroshima and Nagasaki after the bombings was confiscated. *Hiroshima*, the famous account written by John Hersey for *The New Yorker*, had a huge impact in the US, but was banned in Japan. As Dower says: "In the localities themselves, suffering was compounded not merely by the unprecedented nature of the catastrophe...but also by the fact that public struggle with this traumatic experience was *not permitted*."

But Dower also points out another consequence of the wartime destruction of Japan: an almost religious faith in science to get Japan back on its feet again, or even, just before the war was finally over, to allow it to retaliate. This included the misguided hope that Japan might have its own bomb. One of the most famous documents written by a Hiroshima survivor is Dr. Hachiya Michihiko's *Hiroshima Diary*, which could only be published in the 1950s, after the occupation was over. Dr. Hachiya describes scenes in a hospital just days after the bombing. Horribly mangled and mutilated patients are dying of diseases that were barely understood. A rumor spreads that Japan has attacked California with the same kind of bomb that struck Hiroshima. There is jubilation in the ward.

What put paid to any celebration of nuclear power in Japan, however, was the American H-bomb test at Bikini Atoll in 1954. By a slice of ghastly irony, the only victims of this explosion in the Pacific were Japanese fishermen, whose boat had strayed too close. This inspired

the first *Godzilla* movie, reflecting widespread Japanese fears of a nuclear apocalypse. And it was the beginning of the antinuclear movement. As Dower observes, the Japan Council Against Atomic and Hydrogen Bombs was not just supported by the left in Japan but in its early stages by the conservative parties too.

It was also during the 1950s, however, that some Japanese conservative politicians began to push for nuclear energy. Oe singles out for particular opprobrium the right-wing nationalist and later prime minister Nakasone Yasuhiro and the conservative newspaper tycoon Shoriki Matsutaro. Shoriki is still known as the grand old man of postwar Japanese baseball and the "father of nuclear power." He was not a prepossessing figure. Classified after the war as a "Class-A" war criminal, Shoriki was blamed as well for massacres of Koreans in Tokyo when he was a police official in the 1920s. Strongly pro-American after the war, possibly working with the CIA, he was responsible for importing US nuclear technology to Japan. The first reactors were built in the 1960s by the General Electric Company. Before the 2011 earthquake, about 30 percent of Japanese electricity was generated by nuclear energy.

This is not much compared to France, where the figure is closer to 70 percent. But in the minds of Oe and other Japanese leftists, protest against Japanese nuclear policy is more than a matter of ecology. Given the political history of such figures as Shoriki and Nakasone, and their ties to the US, it is precisely the "anti-imperialist critique [added] to the discourse on peace and democracy" described by Dower that motivates some of the protesters. In Oe's words: "The structure of the Japan in which we now live was set [in the mid-1950s] and has continued ever since. It is this that led to the big tragedy" of Fukushima in March 2011.[5]

5. "Japan Gov't Media Colluded on Nuclear: Nobel Winner," AFP, July 12, 2012.

There is a lot of truth to this. But the building of nuclear power plants in Japan, in some places very near lethal seismic fault lines, cannot be blamed only on a few right-wing conspirators with shady wartime pasts. Despite the early protests, most Japanese ended up supporting nuclear energy, partly perhaps because of the common faith in science, partly because it seemed like the best option in an archipelago critically short of natural resources.

Still, Oe is certainly correct to point his finger at the structure of Japan. A much too cozy relationship between government bureaucrats, national and local politicians, and big business allowed the Tokyo Electric Power Company (TEPCO) to monopolize energy in large areas of Japan, including the northeastern coast where the disaster struck. This also entailed a virtual monopoly on the truth: nuclear power was good, the reactors were safe, there was nothing to worry about—even when, as happened several times in the 1970s, 1980s, and after an earthquake in 2007, pipes were leaking radioactive steam, safety regulations were ignored, and fires broke out.

TEPCO's monopoly was not brutally enforced. It was more a matter of soft power. The acquiescence of local communities was bought with corporate largesse lavished on schools, sports fields, and other amenities. Research chairs at top universities were funded by TEPCO. Vast advertising budgets were spent on the national media. Journalists and academics were asked (and presumably well paid) to act as consultants. But venality is not the only or perhaps even the most significant way by which the Japanese establishment is co-opted.

The largest mainstream newspaper companies, despite some differences in political tone, can be depended on to echo a kind of national consensus established by the same web of government and business interests of which the mainstream press forms an integral part. This is just as true of the national broadcasting company, NHK, which is often compared to the BBC but has none of its feisty independence.

The so-called *"kisha* [press] club system," where specialist report-
ers from the major national papers are allowed exclusive access to
particular politicians or government agencies, on the understanding
that these powerful sources will never be discomfited by scoops, un-
authorized reports, or special investigations, breeds a kind of jour-
nalistic conformity that is hardly unknown in more freewheeling
democracies (think of the aftermath of September 11) but is institu-
tionalized in Japan. The mainstream press does not really compete
for news. What it does much too often instead is faithfully reflect the
official version of reality. One reason for this is quite traditional. In
Japanese history, as in China or Korea, the intelligentsia—scholar-
officials, writers, teachers—were frequently servants rather than crit-
ics of power.

Not all the press in Japan is mainstream, of course. And there are
mavericks, naysayers, and whistle-blowers in Japan too. Unlike in
China, they don't disappear into the maw of a political gulag but are
marginalized in other ways. In their book, Birmingham and McNeill
point out various instances of how this works. During the nuclear
disaster at Fukushima, NHK never included a critic of nuclear energy
in its exhaustive daily broadcasts. Even the commercial television
channel Fuji TV no longer invited an expert back after he let slip,
quite accurately, that there was danger of a meltdown at the Fuku-
shima Daiichi reactors.

This expert, named Fujita Yuko, had committed the cardinal sin
of bucking the official consensus that the public should be reassured
that everything would be fine. Already long before the 2011 disaster,
academic critics of the nuclear consensus were demoted or otherwise
pushed aside. Between 2002 and 2006 severe safety risks had actu-
ally been reported at the Fukushima plant by several people, includ-
ing company employees. These whistle-blowers, in Birmingham and
McNeill's words, "bypassed both TEPCO and Japan's Nuclear and

Industry Safety Agency (NISA), the main regulatory body, because they feared being fired. The information was ignored." According to the former governor of Fukushima prefecture, the informants were treated like "state enemies."

Again, none of this is unknown in other countries. It is just harder in an insular, well-ordered society, where everyone should know their place, and the comforts and perks of conformity are considerable, to crack the façade of official truth.

Dower quite rightly stresses the brilliance of Japanese wartime propaganda. Everyone, from popular cartoonists to kimono designers, from the best filmmakers to the most respected university professors, was mobilized behind the war effort. When Frank Capra, to prepare for his own propaganda films in Hollywood, was shown Japanese movies made in the 1930s during the war in China, he said, "We can't beat this kind of thing. . . . We make a film like that maybe once in a decade." The official truth behind the Japanese war was not aggressively racist, as in Nazi Germany, or even imbued with the fascist love of violence. What Japan was supposedly fighting for was the liberation of Asia from Western imperialism and capitalism. Japan represented a new Asian modernity, based on justice and equality. Even many left-wing Japanese intellectuals were able to subscribe to this.

There were dissidents, even in those days. Many of them were Communists, who spent the war in jail. And some writers with well-established reputations could afford to retreat into "inner emigration." But on the whole, writers, journalists, academics, and artists conformed. This was sometimes enforced, not least by the sinister "Thought Police" who were always ready to pounce on domestic

critics. But oppression in wartime Japan was not as heavy-handed and violent as it was in Germany. It didn't have to be. Exile, unlike in Germany, was not really an option for most Japanese; few had either the contacts or the language ability. The thought of being excluded, or driven to the margins of society, was threatening enough for most people to rally around the national cause. The intricate social web of press clubs, advisory committees, state-sponsored arts and academic institutions, and mutually helpful bureaucrats, soldiers, business-men, and politicians was flexible and inviting enough to co-opt even many of those who were privately skeptical about the Japanese war.

A typical case was that of Mori Shogo, a respected member of the editorial board at the *Mainichi* newspaper during the war. The *Mainichi* is still one of the three major news organizations. (The oth-ers are the liberal-leaning *Asahi* and the more conservative *Yomiuri*.) Mori was not a dissident but a patriot who was devastated by the Japanese wartime defeat. During the war, he conformed to the offi-cial truth: Japan was liberating Asia, military defeats were really vic-tories, and so on. What is fascinating about the diary he kept in the immediate aftermath of the war is the sudden spark of independent thinking.[6]

Mori complains about the hypocrisy of American press censorship during the occupation: "We newspaper men had a difficult time dur-ing the war, when we were fettered by the militarists and the bureau-crats. Now, under the occupation of the US Army, we can expect another period of hardship." But the problems were not just those imposed by General MacArthur's "Department of Civil Informa-tion" (a misnomer, if there ever was one). Mori describes a meeting, in the fall of 1945, of senior *Mainichi* editors to discuss the "press

6. Mori Shogo, *Aru Janaristo no Haisen Nikki* (The Postwar Diary of a Journalist) (To-kyo: Yumani Shobo, 1965).

club system." Should this comfortable cartel of the major media, mutually agreeing on what news to report, be continued, or should the papers begin to compete in a free market of news and ideas? Mori favored the latter option. But he was in a minority. The old system continued.

And so it was that in the spring of 2011, after the worst natural calamity to hit Japan since the Great Kanto Earthquake of 1923, or, to go along with Oe, the worst man-made disaster since Hiroshima and Nagasaki, the Japanese mainstream press decided to stick together and pass on the official truth, given out by government officials and TEPCO executives, that there was no danger of a meltdown at the Fukushima Daiichi plant. Not only that, but reporters from the major newspapers and broadcasters retreated together, like a disciplined army, from the worst-stricken areas after the first hydrogen explosion in Fukushima Daiichi on March 12. The official reason was that their companies would not allow them to take risks. McNeill, who was there, mentions Japanese who had other explanations.

An emeritus professor from Kobe College, Uchida Tatsuru, gave the *Asahi* newspaper his take on the journalistic retreat. There had been no attempt to investigate the disaster zone because the main papers were afraid to compete, to do anything different from the others. He claimed that this reminded some readers of the war, when the media consistently published complete fabrications about Japan's disastrous military operations.

One of the heroes in the Fukushima story is Sakurai Katsunobu, the mayor of Minamisoma, a town fifteen miles from the Fukushima Daiichi plant. He complained to Japanese journalists that "the foreign media and freelancers came in droves to report what happened. What about you?" Cut off from information and essential food and medical supplies, he felt that his town was being abandoned. Out of desperation he turned to something that would not have been possible

in previous crises. On March 24, Mayor Sakurai put a camcorded message on YouTube, with English subtitles, begging for help: "We're not getting enough information from the government and Tokyo Electric Power Co." He asked journalists and helpers to come to his town, where people were faced with starvation.

The video "went viral." Sakurai became an international celebrity. Aid poured in from all over the world. And foreign as well as freelance Japanese reporters did come.

Birmingham and McNeill mention one Japanese freelancer, named Teddy Jimbo, the founder of an Internet broadcaster called Video News Network. His television images from the earthquake zone were seen by almost a million people on YouTube. Meanwhile, NHK was still sending out reassuring messages on national TV, backed by a nuclear expert from Tokyo University named Sekimura Naoto, who told viewers that a major radioactive disaster was "unlikely" just before an explosion at one of the reactors caused a serious nuclear spill.

Sekimura is also an energy consultant to the Japanese government. Later, much too late, NHK and other broadcasters finally bought some of Jimbo's footage. In his words, quoted by Birmingham and McNeill:

> For freelance journalists, it's not hard to beat the big companies because you quickly learn where their line is.... As a journalist I needed to go in and find out what was happening. Any real journalist would want to do that.

No less than in China or Iran, the Internet has proved to be a vital forum for dissident voices in Japan. Another, older source of critical views is the varied world of the weekly magazines, some serious and some sensational entertainment. The weeklies came into their own after World War II as an alternative to the major media, even though

some of them are actually published by the big newspapers. And they do not mince their words. One journal, *Shukan Shincho*, called the TEPCO executives "war criminals."[7] But even the magazines can quickly run into the limits of what is permissible. *AERA*, a weekly magazine published by *Asahi*, had a masked nuclear worker on the cover of its issue dated March 19, 2011, with the headline "Radiation Is Coming to Tokyo." Even though, as Birmingham and McNeill point out, this was not untrue, the magazine was deemed to have gone too far. An apology was published and one of the columnists fired.

So there are gaps in the official truth of Japan. One of the unintended consequences of the 3/11 catastrophe has been the widening of these gaps. Fewer people believe what they are told. Cynicism toward officially sponsored experts has grown. Some see this as a problem. In March, *Bungei Shunju*, a prominent political journal, published an anniversary issue of the earthquake. One hundred well-known writers were asked to comment on 3/11. One of them, the novelist Murakami Ryu, lamented the lack of trust that resulted from the disaster, trust in government and the energy industry. It would take years, he said, to regain the trust of the Japanese people. Murakami is sixty and enjoys a reputation for being cool, even a bit of a bad boy.

Nosaka Akiyuki, one of the best postwar Japanese novelists, born in 1930, is a survivor of the bombing raids in World War II.[8] He had a rather different view of the question of trust. Reflecting on the of-

7. Quoted by McNeill in "Them Versus Us: Japanese and International Reporting of the Fukushima Nuclear Crisis," in *Japan Copes with Calamity: Ethnographies of the Earthquake, Tsunami and Nuclear Disasters of March 2011*, edited by Tom Gill, Brigette Steger, and David H. Slater (Peter Lang, 2013).
8. His masterpiece, *The Pornographers*, translated by Michael Gallagher (Knopf, 1968), deserves another attempt at English translation.

ficial penchant for hortatory slogans ("Japan, do your best!" "United we stand!"), he advised the younger generation to think for itself: "Don't get carried away by fine words. Be skeptical about everything, and then carry on."[9]

And yes, I did see the islands of Matsushima the second time around. The skies were clear. I listened to the guide explaining the splendid sights. The tourists around me didn't seem to be paying much attention to what she said. Well, well, I thought, Japan has changed. Then I realized they were all Chinese.

9. *Bungei Shunju*, March 2012.

27

VIRTUAL VIOLENCE

ASAKUSA, IN 1929, had seen better days. Asakusa usually has. That is the elegiac charm of this district in the east of Tokyo, flanking the Sumida River, the scene of *The Scarlet Gang of Asakusa* by Kawabata Yasunari, written in the late 1920s. Since the late seventeenth century, a warren of streets just north of Asakusa, named Yoshiwara, had been a licensed brothel area, whose denizens, ranging from famous courtesans to cheap prostitutes, catered to townsmen, but also to samurai, who sometimes found it necessary to disguise their identities by wearing elaborate hats.[1] Asakusa itself really came into its own as a hub of pleasure in the 1840s. By the late nineteenth century the grounds of Asakusa Park, with its lovely ponds and miniature gardens, and its Senso temple dedicated to Kannon, the goddess of mercy, were given over to all manner of entertainments: a Kabuki theater, jugglers, geisha houses, circus acts, photography booths, dancers, comic storytellers, performing monkeys, bars, restaurants, and archery stalls where young women were reputed to have offered a variety of services.

1. The Yoshiwara still exists in name, though it has been sadly reduced to a few streets of tawdry massage parlors, knows as "soaplands," after the Turkish embassy protested against their earlier designation as *Torukos*, or Turkish baths.

Asakusa's wildest days are said to have been in the 1910s, after the Russo-Japanese War, when Russian girls, performing Gypsy numbers in dance revues, known as "operas," added an exotic tang to the Sixth District, where most of the theaters were. The main attraction was to show off women's legs. Reviews featuring young women performing sword fights were designed for this purpose also. Some of the opera houses actually provided the real thing. An Italian named G. V. Rossi was brought over from London to stage operas at the grandly named Imperial Theater, only to find a scarcity of singers. In his production of *The Magic Flute*, the same singer had to play both Pamina and the Queen of the Night, with a stand-in on hand when the two had to appear in the same scene.[2]

The first movie houses in Japan were in Asakusa, as was Tokyo's first "skyscraper," the Twelve-Story Tower, or Ryounkaku. Soon the silent movies, accompanied by splendid storytellers known as *benshi*, became more popular than music halls or theater, and Charlie Chaplin, Douglas Fairbanks, and Clara Bow became the stars of Asakusa. As is usually true of entertainment districts, even the best of them, Asakusa was marked by an ephemeral quality, by a sense of the fleetingness of all pleasure, which was perhaps part of its allure. But Asakusa, in the twentieth century, really did live on the edge; the entire quarter was almost totally destroyed twice: first in the Great Kanto Earthquake of 1923, which hit just as people were cooking their lunches and incinerated the mostly wooden houses in a horrific firestorm; and again in the spring of 1945, when American B-29 bombers demolished much of the city and all of Asakusa, causing the deaths of between 60,000 and 70,000 people in a couple of nights.

2. For a loving description of those days, see Edward Seidensticker, *Low City, High City* (Harvard University Press, 1991).

After the 1923 earthquake, the famous park was a charred waste-
land, the Twelve-Story Tower no more than a ruined stump, and the
opera palaces were rubble. Only the Kannon temple survived. It was
thought by some that the statue of a famous Kabuki actor striking a
heroic pose had held off the approaching flames. (The temple did not
survive the American bombs, however, and had to be reconstructed.)
And yet, fleeting as its pleasures may have been, Asakusa could not
stay down for long. The movie houses and opera halls were rebuilt,
and the park, with its pickpockets, prostitutes, Kannon worshipers,
dandies, and juvenile delinquents, sprang back to life. In 1929, the
Casino Folies was opened, located on the second floor of an aquar-
ium, next to an entomological museum, or Bug House, which had
somehow survived the devastation of 1923.

The Casino Folies, named after the Folies Bergère in Paris, was
not especially wild, although it was rumored—apparently without
any basis in truth—that the dancing girls, sometimes in blond wigs,
dropped their drawers on Friday evenings. But it spawned not only
talented entertainers, some of whom later became movie stars, but
great comedians too. The most famous was Enoken, who stars in
Kurosawa's 1945 film *The Men Who Tread on the Tiger's Tail*. Ev-
erything that was raffish and fresh about Asakusa between the wars
was exemplified by the Casino Folies, a symbol of the Japanese jazz
age of "modern boys" (*mobos*) and modern girls (*mogas*). The cul-
tural slogan of the time was *ero, guro, nansensu*, "erotic, grotesque,
nonsense." Kawabata was one of the writers whose early work was
infused by this spirit, and it was his book that made the Folies fa-
mous. He hung around Asakusa for three years, wandering the
streets, talking to dancers and young gangsters, but mostly just walk-
ing and looking, and reported on what he saw in his extraordinary

modernist novel *The Scarlet Gang of Asakusa*, first published in 1930.[3]

The novel is not so much about developing characters as about expressing a new sensibility, a new way of seeing and describing atmosphere: quick, fragmented cutting from one scene to another, like editing a film or assembling a collage, with a mixture of reportage, advertising slogans, lyrics from popular songs, fantasies, and historical anecdotes and legends. There is much *ero*, *guro*, *nansensu* there, related in the chatty tone of a congenial flaneur, telling stories about this place or that, and who did what where, while trolling the streets for new sensations. This fragmentary way of storytelling owes a great deal to European expressionism, or "Caligarism," after the German movie *The Cabinet of Dr. Caligari*. However, as Edward Seidensticker, quoted in Donald Richie's excellent foreword, points out, it also owes much to Edo period stories.

Kawabata himself professed to hate his early experiment in modernist fiction and quickly went on to develop a very different, more classical style, but he still made an important contribution to the Japanese Roaring Twenties. Besides the novel, he also wrote the film script for Kinugasa Teinosuke's expressionist masterpiece, *A Page of Madness* (1926). One of the most remarkable things about *The Scarlet Gang of Asakusa* is that it was serialized in a mainstream newspaper, *Asahi Shimbun*, which is, as Richie says, as though *Ulysses* had been picked up by the London *Times*. This testifies to the high-mindedness of the Japanese press—almost unimaginable today—but also to the willingness of the Japanese public to accept avant-garde literature in a popular newspaper; it probably helped that the

3. Translated from the Japanese by Alisa Freedman, with a foreword and afterword by Donald Richie and illustrations by Ota Saburo (University of California Press, 2005).

avant-garde expressionism was mixed with accounts of Asakusa's low life.

Mixing high and low is of course part of modernism. Like many artists in the 1920s, Kawabata was interested in detective fiction and Caligarism is often marked by a fascination with violent crime. The use of slang and the references to popular culture of the time must have made *The Scarlet Gang of Asakusa* extremely difficult to translate, and Alisa Freedman has done a superb job, even though the full flavor of the original can never be fully reproduced.

The narrator/flaneur introduces the reader to various characters, low-life types like Umekichi, who skins stray cats to sell their pelts; and his girlfriend Yumiko, who poisons an older lover on a riverboat by kissing him with arsenic; and Haruko, dressed in gold crepe; and Tangerine Oshin, "the heroine of every bad girl worth the name," who had "done" 150 men by the time she was sixteen. These are the people who drift into the Scarlet Gang. But there are others, more of the *guro* than the *ero* variety: the man in the Asakusa fairground with a mouth in his belly, smoking through his stomach; or the female tramps who dress like men; or the children who clean public toilets because they love modern concrete. The narrator is only interested, he writes, in "lowly women." The lowest kind of prostitutes are the teenagers, known as *gokaiya*, who sleep with ragpickers and bums. Tangerine Oshin was one of them.

In true modernist fashion, it is never clear to what extent these people are meant to be real, or pure figments of the narrator's imagination. In fact, the narrator is the first to point out the fictional quality of his story. Artifice is the point. Yumiko, after disappearing from the story for a long stretch, returns near the end of the novel as a hair-oil seller. Selling oil, in Japanese, means fibbing, making up a story. Yumiko and the narrator discuss how the story should go on.

The writer compares his story to a boat, like the boat on which Yumiko entertained her lover before murdering him, meandering, without a plotted course. This is where traditional Japanese storytelling meets modernism. Both share this quality.

None of the characters in Kawabata's novel has the depth of such modernist antiheroes as Franz Biberkopf in Alfred Döblin's *Berlin Alexanderplatz* or Joyce's Bloom. Compared to them Yumiko and the others are as flimsy as rice paper. It is in conveying atmosphere that Kawabata, like so many Japanese literary flaneurs, excels. Here is the first sentence of chapter four:

> While she did her Spanish number (and I did not make this up—this is a true story), I clearly saw that the dancer on stage carried on her biceps needle marks from a recent injection, though a small piece of adhesive tape had been stuck on top. In the grounds of the Sensō Temple at around two in the morning, sixteen or seventeen wild dogs let out a terrific howl as they all rush after a single cat. That's what Asakusa is all about. You come to sniff out the scent of a crime.

Or this, about a character the writer is thinking of including in his story:

> Another one I would add, a truly sad foreigner, was the leader of the water circus troupe that came from America that year. Someone put up a hundred-foot ladder on the burnt-out ruins of the Azuma Theater, and the troupe leader jumped from the top into a small pond. There was a large woman who jumped from fifty feet like a seagull, and she really did look like one, too. Beautiful.

Casual, quickly noted in passing, a little sexy, absurd: *ero, guro, nansensu*. This spirit was all but snuffed out by the late 1930s, when militarism suppressed everything frivolous and pleasurable. And then the bombs finished Asakusa off entirely. Materially at least. For once again, vitality would not be denied. Donald Richie, as a young American with the Allied occupation, met Kawabata in Asakusa in 1947. Neither spoke the other's language. They climbed up the old Subway Tower building and surveyed the wreckage. Richie writes in his afterword:

> This had been Asakusa. Around the great temple of the Kannon, now a blackened, empty square, had grown...places where, I had read, the all-girl opera sang and kicked, where the tattooed gamblers met and bet, where trained dogs walked on their hind legs and Japan's fattest lady sat in state.
>
> Now, two years after all this had gone up in flames...the empty squares were again turning into lanes as tents, reed lean-tos, a few frame buildings began appearing. Girls in wedgies were sitting in front of new tearooms, but I saw no sign of the world's fattest lady. Perhaps she had bubbled away in the fire.

Kawabata said nothing much at the time. Richie had no idea what the older man, dressed in a winter kimono, was thinking. Richie said "Yumiko," and Kawabata smiled and pointed at the Sumida River.

Asakusa today is pretty much like the rest of Tokyo, dense, commercial, a jumble of neon-lit concrete buildings, with the neighborhood around the Kannon temple filled with nostalgic souvenir stores selling trinkets for the tourists. The old Sixth District still has some movie houses and the odd seedy strip joint, but the action has long moved on to the western suburbs of the city—Shinjuku, Shibuya, and

beyond. What happens there, in the twenty-first century, when so much culture takes place no longer in the streets but in the virtual reality of personal computers, is the subject of "Little Boy," the exhibition of Japanese pop art currently at the Japan Society in New York.[4]

———

The curator of "Little Boy" is Murakami Takashi, the most influential visual artist in Japan today. He is a painter of cartoon images both childlike and sinister, a highly successful designer (of Louis Vuitton bags, among other things), a maker of mildly pornographic dolls, an artistic entrepreneur, a theorist, and a guru, with a studio of protégés that is a cross between a traditional Japanese workshop and Andy Warhol's Factory. His main idea is to reverse Warhol's project of turning banal, mass-produced, commercial images into museum art. Murakami wants instead to make art out of advertising, *manga*—Japanese comic strips—animation films, computer games, etc., and push it back into the market-driven world of mass culture.

Trained as a painter of *Nihonga*, or modern Japanese-style figurative painting, and an expert on the classical Kano School of painting, which dominated Japanese art between the fifteenth and eighteenth centuries, Murakami believes that Japanese art never distinguished high from low in the manner of European art. The West, he argues, established a hierarchy, which raised a barrier between high art and "subculture," a barrier that Murakami believes never existed in Japan. To escape from the humiliating and sterile enterprise of copying

———

4. "Little Boy: The Arts of Japan's Exploding Subculture," an exhibition at the Japan Society, New York City, April 8–July 24, 2005. Catalog of the exhibition edited by Murakami Takashi (Japan Society/Yale University Press, 2005).

Western high art, Murakami and his followers wish to rediscover a truly Japanese tradition in the junky world of virtual "neo-pop."

Since much of this theorizing comes in the manner of manifestoes, a certain exaggeration is perhaps to be expected. It is not true that traditional Japanese art was not subject to hierarchy. In fact there was a strong sense of high and low. Cultivated aristocrats who attended Noh performances would not have been seen dead in the baroque and raucous Kabuki theaters. The refined scroll and folding-screen paintings of the Kano School, mostly done in the Chinese literati style, were bought by upper-class samurai, most of whom would have treated woodblock prints of courtesans and merchants as the height of vulgarity.[5] Some rich merchants cultivated a taste for "high" art too, but they would have been regarded as snobs, just as samurai with a bent for low life would have been seen as dissolute (hence their need for disguise in the Yoshiwara quarter).

It is true, however, that even court painters of the Kano School made little distinction between decorative and fine art. And mastery of past styles, or the style of masters, was on the whole more highly prized in Japan than individual innovation. There have been great individualists and eccentrics in Japanese art, to be sure, but the Romantic European ideal of expressing the unique personality of the artist in wholly new ways was not always understood when Japan first encountered the Impressionists, and the effort to emulate that ideal has stymied many Japanese painters ever since. In this sense, perhaps, Murakami is indeed working in a Japanese tradition. His designs for Louis Vuitton bags and his acrylic paintings are all part of the same artistic vision.

Certain aspects of both Murakami's own art and that of his

5. For excellent examples of high art, see "The Kano School: Orthodoxy and Iconoclasm," an exhibition at the Metropolitan Museum of Art, December 18, 2004–June 5, 2005.

colleagues are immediately apparent. One is the infantile quality of much of the imagery: the wide-eyed little girls; the cute, furry animals; the winking, smiling mascots that one normally finds on candy boxes and in comic strips for children (which, by the way, are avidly consumed in Japan by adults too). The word, much used to describe young girls and their girlish tastes, is *kawaii*. The Hello Kitty doll is *kawaii*, as are little pussycats, or fluffy jumpers with Snoopy dogs. *Kawaii* denotes innocence, sweetness, a complete lack of cynicism or ill will.

In the "Little Boy" exhibition the remarkable thing about the childlike drawings of young girls by Kunikata Mahomi, or the computer-generated prints by Aoshima Chiho, or Ohshima Yuki's plastic dolls of prepubescent girls, or Nara Yoshitomo's paintings of wide-eyed children is that these supposedly *kawaii* images are actually not innocent at all, and sometimes are full of malice. When you look at them carefully, you notice a strain of sexual violence. Everything about Aoshima's wide-eyed, nude girl lying on the branch of an apricot tree is *kawaii*, apart from the fact that she is tied up. In another picture by the same artist, cartoonish little girls are sinking into the earth in an apocalyptic-looking shower of meteors. Ohshima's plastic dolls at first look like the cute little pendants on a nine-year-old's school satchel; but on closer inspection they are objects of pedophile lust, half-naked children in suggestive poses. Murakami's own painting in pink acrylic of a smoky death's head with garlands of flowers in the eye sockets turns out to be a stylized version of the atomic-bomb cloud.

In other works, the violence is more overt. Aoshima's *Magma Spirit Explodes. Tsunami Is Dreadful* shows a *kawaii* girl as a monster spewing fire, rather like a traditional Buddhist vision of Hell. Komatsuzaki Shigeru is obsessed with the Pacific War, which he depicts in a weird mixture of comic-strip exaggeration and hyperreal-

ism. There is much of the souped-up heroic quality of wartime propaganda art in his paintings, which is surely deliberate.

The sense of catastrophe, of apocalyptic doom, in much Japanese neo-pop imagery, echoing the popularity of Japanese animation films and computer games about world-destroying wars and Godzilla-type monsters, is explained by Murakami as a reflection of Japan's ill-digested wartime past. The horrors of Hiroshima and Nagasaki, smothered in silence during the US occupation, have left a kind of unresolved, largely repressed rage. Japan's own atrocities have not been forthrightly faced either. Murakami argues that the US has successfully turned Japan into a pacifist nation of irresponsible consumers, encouraged to get richer and richer while leaving matters of war and peace to the Americans.

"Postwar Japan was given life and nurtured by America," writes Murakami in one of the catalog essays:

We were shown that the true meaning of life is meaninglessness, and were taught to live without thought. Our society and hierarchies were dismantled. We were forced into a system that does not produce "adults."

Part of this state of permanent childhood, in Murakami's view, is a sense of impotence, fostered by the US-written pacifist constitution, which robs Japan of its right to wage war. Murakami writes:

Regardless of winning or losing the war, the bottom line is that for the past sixty years, Japan has been a testing ground for an American-style capitalist economy, protected in a greenhouse, nurtured and bloated to the point of explosion. The results are so bizarre, they're perfect. Whatever true intentions underlie "Little Boy," the nickname for Hiroshima's atomic bomb, we

Japanese are truly, deeply, pampered children. . . . We throw
constant tantrums while enthralled by our own cuteness.

This, we gather, is Murakami's explanation of the images of tied-
up little girls, exploding galaxies, atom-bomb clouds, Pacific War
battles, and angry prepubescent children with tiny bodies and enor-
mous heads—the overheated fantasies of frustrated Peter Pans,
dreaming of national and sexual omnipotence, while playing the key-
boards of their personal computers in the cramped quarters of subur-
ban apartments. This is the culture of *otaku*, literally "your home"
but used to describe the millions of nerdish fantasizers living inside
their own heads, filled with the mental detritus of comic strips and
computer games. Not responsible for the real world, the Japanese,
Murakami believes, have retreated into a virtual one, which can be
blown to smithereens with the click of a mouse. It is all about the
war, the bomb, General MacArthur's emasculation of Japan, and
American capitalism.

Murakami and other theorists of this persuasion link these infan-
tile "tantrums" and dreams of omnipotence to the actual violence of
Aum Shinrikyo, the quasi-Buddhist cult, whose followers murdered
unsuspecting Tokyo subway passengers in 1995 with sarin gas while
waiting for Armageddon. They, too, used apocalyptic fantasies to
explode the meaninglessness of the postwar greenhouse. The differ-
ence is that these deluded men and women, many of them well-
educated scientists, led by the half-blind guru Asahara Shoko, really
believed they could find utopia by waging war on the world.

One thing that Aum Shinrikyo, with its paranoid visions of a
world governed by a secret cabal of Jews, has in common with the
theorists of *otaku* neo-pop is a deep self-pity. One of Murakami's
most avid admirers, a cultural critic named Sawaragi Noi, writes to
him ecstatically that "the time has come to take pride in our art,

which is a kind of subculture, ridiculed and deemed 'monstrous' by those in the Western art world." The crowds at the opening night of the show in New York suggested otherwise, as did the hyped-up press coverage. But Sawaragi goes on to say, "Art is made by monsters at odds with the everyday life we live." To which Murakami adds: "We are deformed monsters. We were discriminated against as 'less than human' in the eyes of the 'humans' of the West."

All this strikes me as wildly exaggerated. No one disputes that the atomic bombings were a terrible catastrophe or that the pumped-up postwar prosperity of Japan did much to bury the traumas of the wartime past. That overdependence on US security—combined with a de facto one-party state—has led to a kind of truncated political consciousness is at least plausible (I have argued this myself). And the humiliation of feeling dominated by Western civilization for more than two hundred years cannot be dismissed. But to explain contemporary Japanese culture entirely through the prism of postwar trauma is much too glib.

Most modern art movements, waving their banners and manifestoes, like to think they are onto something totally new. But the combination of grotesque violence and sexual perversity is hardly new. In fact, there is more than a little *ero-guro* in Japanese neo-pop. Nor is the fascination for very young girls, tied up or not, a novelty; Kawabata was obsessed by this theme all his life. Variations of *ero*, *guro*, *nansensu* appear at different stages of Japanese art history. The middle of the nineteenth century, just when Asakusa came into its licentious own, was a rich time for it. The Kabuki stage was given to dark tales of violence by such playwrights as Tsuruya Namboku, and woodblock artists like Yoshitoshi did prints of tortured women, suspended in ropes, and the like. We know about the 1920s, but the 1960s, too, were an *ero-guro* time, when poster designers, photographers, filmmakers, and playwrights borrowed heavily from the 1920s.

Even though the oversize, indeed grotesque proportions of human genitalia in premodern Japanese erotic art give a very different impression than the childlike humanoids in current art, a feeling of impotence goes back much further than General MacArthur's occupation. It might have something to do with the traditional constraints that have been a constant feature of Japanese society. Who knows, it may even have something to do with overbearing mothers, smothering their (male) toddlers with too much care, before the social handcuffs are applied and early childhood becomes a lost Eden to be pined for until death.

I think Murakami, Sawaragi, et al. are right about one thing: the impotence they protest is political, apart from anything else. Sawaragi draws our attention quite rightly to the failure of the left during the 1960s to challenge the power of the state, and the security treaty with the US in particular. They tried. Students were mobilized in large numbers to demonstrate against the treaty and the Vietnam War, but political radicalism was made irrelevant in the end, not by police brutality so much as the blandishments of ever greater material prosperity. When radical energy could no longer find an outlet in politics, it turned inward, first to extreme violence inside the protest movement itself, and then to *ero-guro*. It is interesting to see how many artists turned from political radicalism to pornography in the 1970s.

In a way, it was always like this. Japan under the shoguns was close to being a police state, with no room for political dissent. Instead, men were allowed to let off steam in the designated pleasure districts, whose courtesans became the stars of popular art and fiction. Kawabata's Asakusa was a late echo of this. There were periods of rebellion, of course, but when these came to an end, crushed by the authorities, *ero-guro* would usually gather force.

But the latest generation of artists and consumers, represented in

the "Little Boy" show, appears to have lost the physical energy of their forebears in the 1840s, 1920s, and 1960s. *Otaku* and *yurui*, another term often used by neo-pop theorists, meaning "loose, lethargic, slack," denote a lack of vigor. The eroticism in contemporary Japanese art is virtual, not physical, narcissistic, and not shared with others. It, too, takes place entirely inside the *otaku* heads. Here, I think, there is a new departure, which is not uniquely Japanese.

The virtual world, in art and life, is perfect for a generation that has broken away from collective effort, be it political, artistic, or sexual. This is why the novels of Murakami Haruki are so successful, in East Asia especially, but also in the West, where the *otaku* culture is spreading. His characters are disengaged from society, often isolated, living out their private fantasies in a world of their own. This began, in the 1960s, as a quiet revolt against the extended family with all its duties. Traditional arrangements were increasingly being replaced by nuclear families in suburban bedroom communities. But things have progressed since then. Since family is the main symbol of constraint, people tend to interpret individualism in a narrow way, as a retreat into solipsism, where no one can touch you.

The other escape route from traditional life has been to recreate the family in an alternative way, as theater troupes and hippie communes did everywhere in the 1960s. Murakami Takashi has followed this model, with himself as the patriarch of a family of artists. And yet many of these artists show all the signs of deep self-absorption. The world they express is oddly bloodless, indeed a bit slack, in fact rather monstrous, a grotesque world where all sex and violence are unreal. That it often looks so pretty makes it all the more disturbing.

28

ASIAWORLD

TO STAND SOMEWHERE in the center of an East Asian metropolis, Seoul, say, or Guangzhou, is to face an odd cultural conundrum. Little of what you see, apart from the writing on billboards, can be described as traditionally Asian. There are the faux-traditional façades—Japanese bamboo screens, golden Chinese dragons, Korean farmhouse walls—of certain restaurants providing local cuisine, but you can see those in London or New York City too. The architecture is mostly in the postmodern or late-modernist style, high-rise buildings with curtain glass walls, concrete office blocks, shopping malls, and hotels in granite or marble. You could be in Cincinnati. And yet...you are not. There is something non-Western, indeed something distinctly East Asian about these cityscapes that is hard to put your finger on.

Perhaps it is the advertising, or the hustle-bustle of the raucous entertainment areas, or the myriad small stores that cluster around the high-rise buildings like mushrooms on trees. In Tokyo, the old street plan has been more or less preserved, which lends a kind of phantom historicity to the city, but this is much less true of Beijing or Wuhan. Perhaps it is precisely the absence of visible history that looks distinctive. The same might be said of many cities in the United States,

but somehow Pusan, Nagoya, and Chongqing resemble one another more than they do Cleveland or New York. They are monuments, in constant flux, of modern Asian life. But what makes the contemporary Asian style distinctive? What does Shenzhen, a mere village between Hong Kong and Guangzhou twenty years ago, and now a sprawling metropolis of more than three million people, tell us about the nature of post-Maoist China?[1] One clue, I think, is the extraordinary proliferation in East Asia of theme parks. They are to East Asian capitalism what folk-dancing festivals were to communism.

Japan and China are now the main homelands of theme parks, more so even than the United States. New ones appear all the time and are sometimes as quickly abandoned as they were built, or even before they were finished: on the highway from Beijing to the Great Wall is a half-finished theme park that looks like a Babylonian ruin; the money ran out before it could be completed. Driving past it in 2003, I was reminded of the huge skyscraper in Pyongyang intended to be the highest building in Asia, the Babylonian tower of Kim Il Sungism, which still stands there, unfinished, an empty shell, probably a premature ruin forever. Not only did the money run out but the building was so shoddily and quickly constructed, with such inferior material, that it is hopelessly unsafe.

Anyway, there they are, a small-scale Dutch town on the coast near Nagasaki, Austrian villages in Hokkaido, a simulacrum of Stratford-upon-Avon in northern Japan, models of famous Asian temples in the middle of Beijing, a replica of the White House in a small town near Guangzhou, Tibetan monasteries, Italian palazzi, Egyptian pyramids and French châteaux, a Disneyland near Tokyo, a Disneyland planned in Hong Kong, and on and on. What is curious

1. Now grown to about ten million.

is not just the insatiable taste for these fantasy places but the fact that they often blur almost seamlessly into the "real" urban landscape. In Shenzhen, a brand-new residential "European city" looks out upon a theme park, named Windows on the World, with its Eiffel Tower, its Colosseum, and its Potala.

A variation of the theme park is the golf course, an equally controlled artificial landscape. Golf courses have proliferated almost as fast as theme parks in East Asia. One whole city, named Zhuhai, opposite Macao, has been designed as a kind of residential golf course, a leisure city to complement the feverish working environment of Hong Kong and Shenzhen, an urban culture given over to tourism. The golf range is Nirvana promised to all those who do well in East Asian capitalism.

If Chicago and New York were the models for Shanghai in the 1920s, the postwar cities of China and Japan bear a greater resemblance to the zanier parts of Los Angeles. So much of what you see is a copy of somewhere else: hotels in the shape of French castles, exquisite Chinese teahouses on the fifteenth floor of concrete towers, coffee shops in subway stations made up to resemble German taverns or palatial rooms in Versailles. Many Asian cities, especially Tokyo, look like gigantic stage sets, filled with representations of history, foreign places, or fantastic ideas of the future. All great cities live on fantasies and dreams; rarely has virtual reality become so pervasive, and sophisticated, as in East Asia.

Chinese cities still have some traditional buildings, but many of them have been reconstructed in modern materials. Others were never there in the first place but were modeled after other temples, or reassembled, like artfully recreated antiques, from the components of different temples from various regions in China. Tokyo, and indeed almost every Japanese city of any size, is an amalgamation of

European, Japanese, Chinese, and American styles. As the critic and expert on Japan Donald Richie remarked: Why have Tokyo Disneyland, if the city is already so much like Disneyland itself?

Even the modern buildings, especially in China, are often from somewhere else. The standard procedure for architects in China is to show their clients sample books with pictures of buildings in the US, Hong Kong, Japan, or Singapore, and the client takes his pick. The Dutch architect Rem Koolhaas wrote: "We could...say that Asia as such is in the process of disappearing, that Asia has become a kind of immense theme park. Asians themselves have become tourists in Asia."[2]

There is a possible explanation for this phenomenon in traditional Chinese and Japanese aesthetics. Eighteenth-century Chinese gardens, with their elaborate and artful miniature landscapes, often alluding to famous sites, real or imagined, were the models for equally fantastic English garden parks, filled with fake Gothic and classical ruins, as well as chinoiserie bridges and pagodas. The Qing emperors actually built a kind of theme park near Beijing, the Yuan Ming Yuan, which contained European gardens and houses, some of them designed by the Italian Jesuit Giuseppe Castiglione, as well as Chinese fantasies. This extraordinary complex of garden-palaces was severely damaged by British troops in 1860, led by Lord Elgin (of the famous marbles). The remains were looted and further destroyed over the years by Chinese, as well as Europeans. There is talk now of reconstruction: a theme park replica of a theme park.

Los Angeles, as I said, could serve as a model for the modern urban versions of all this, but there is a difference between China and the US. In America, worlds of virtual history are created because the

2. *The Great Leap Forward*, a book on the Pearl River Delta, by Rem Koolhaas and his Harvard Design School Project on the City (Taschen, 2001), p. 32.

history of urban culture is so recent. China and indeed the rest of Asia are steeped in history. So why are Chinese officials prepared, or even eager, to tear down physical evidence of an actual past and replace it with copies? Why do they appear to be happier with virtual history? And what lies behind the ubiquitous taste for Western theme parks, for creating an ersatz version of abroad at home? If the Americans build theme parks to compensate for a lack of history, Chinese build them to compensate for a willful destruction of history.

Again, tradition might serve as a partial explanation. Chinese have forever been rebuilding and reconstructing old landmarks. What counts as "old" is not so much the building itself, as the site. Thus a Chinese guide will point to a painted concrete pagoda erected last year and extol its ancient provenance. But there is more going on, I believe, in the taste for theme parks, something with a more political agenda.

Modernization in East Asia, beginning in the late nineteenth century, has been a far more disruptive and destructive process than in Europe. Because modernization was equated with Westernization, efforts to modernize China or Japan often meant a wholesale rejection of local culture and tradition. One of the first things the Japanese did after the Meiji Restoration in the 1860s was tear down medieval castles and Buddhist temples. This practice was soon stopped, but the replacement of Japanese traditions with Western ones, in dress, artistic expression, or public architecture, went on relentlessly. There were always countervailing forces, of course, and much of Japanese classical culture remains, albeit in a somewhat fossilized form. Nonetheless, a modern Japanese, transported back a hundred years by time machine, would recognize almost nothing of his own hometown, and would even have trouble reading the newspapers. The same is true of a modern, urban Chinese, indeed more so. And all the ravages of war and nature notwithstanding, the

damage done to visible history in both nations has been largely self-inflicted.

———

In China, as in Japan, intellectuals have often oscillated between reactionary nativism and total Westernization. The so-called May 4th Movement of 1919 was many things, ranging from revolutionary socialism to American pragmatism, but the common thread was an attempt by intellectuals to liberate China from its past. Chinese tradition, especially its Confucian aspects, was seen as a stultifying relic, hindering progress, blocking Chinese minds. The way forward, it was thought, was to wipe away these ugly cobwebs and absorb the ideas of John Dewey or Karl Marx. Rarely has a generation of artists and intellectuals anywhere hacked away at the roots of its own culture with such zeal. Many strange things then grew in the ruins of Chinese tradition.

Mao Zedong took cultural iconoclasm to new extremes. He unleashed campaigns to destroy everything that was old: old temples, old art, old books, old language, old thoughts. Possession of a Ming vase at the height of the Cultural Revolution was enough to be branded a stinking reactionary and beaten to death. Mao, although obsessed with history, wanted to turn China into a tabula rasa so he could remake it according to his own, often Soviet-inspired ideas. His hero was the Emperor of Qin, a third-century-BC despot, remembered for starting the construction of the Great Wall and the destruction of the Confucian classics. He was the first great book-burner in history.

Mao wanted total control of his people. This meant controlling the environment, urban and rural, as well as people's minds. All Chinese were forced to subscribe to Mao's vision of utopia, and of Chinese

history too. In a way, Mao turned the whole of China into a grotesque theme park, where everything seen, spoken, or heard had to conform to his fantastical dictates. This may sound like a far-fetched, even bizarre comparison. Theme parks, after all, are a harmless entertainment, not usually associated with mass murder. But I do believe there is something inherently authoritarian about theme parks, especially the men who create them. Every theme park is a controlled utopia, a miniature world, where everything can be made to look perfect. The Japanese businessman who built the squeaky-clean Dutch town near Nagasaki did so because he disapproved of the messiness, the dirt, the chaos, and the sheer human unpredictability of Japanese city life. His proudest achievement in his own fake town was the construction of a machine that turned sewage into drinking water. The thing about theme parks is that nothing is left to chance.

The late Chinese leader Deng Xiaoping, who injected a strong dose of capitalism into Communist China, replaced Mao's extreme vision with one of his own. His slogan was "To Get Rich Is Glorious." He, too, was a Chinese Communist who had no love for traditional culture, freethinking, or indeed liberalism. But he realized that he needed private enterprise, strictly controlled by the Communist Party, to modernize China and restore the nation to its former glory. Billboards sprang up during his rule in the 1980s with pictures of another utopian vision: a China of huge cities, crammed with high-rise buildings, crisscrossed by wide boulevards, and dotted with enormous squares and rigidly designed parks. This vision still owed much to Soviet dreams, but also to more Asian models, such as Hong Kong and especially Singapore. What Deng decided to do was to create model capitalist cities in the coastal areas by government diktat, shielded as much as possible from the rest of China, where people might be too easily contaminated by the limited but inevitable exposure to Western ways. The bordered enclaves of Shenzhen and other

Special Economic Zones were built as capitalist theme parks whose architecture and landscape only followed economic and social needs to a certain degree. First, these enclaves had to be made to look like great, wealthy, businesslike cities, even if half the skyscrapers had to remain empty of people and the superhighways relatively free of cars.

Great cities, especially port cities, are windows to the outside world. They are where the local and the foreign intersect, where people of all creeds and races trade goods and information. Someone once said that the mark of a great cosmopolitan city was the presence of a Chinatown, as a sign of cultural diversity and immigration. Hong Kong could be described as a huge Chinatown itself, a city of Chinese emigrants. In any case, the influx of foreign influences in great port cities is difficult to control; with total control, the cities die.

China's great twentieth-century cities were mostly on the south coast—Canton (Guangzhou), Hong Kong, and, a little farther north, Shanghai. That was where foreign knowledge entered the country, where Chinese thinkers and artists came to establish reputations and foreigners to trade. It was also from the southern cities that the Chinese diaspora fanned out to Southeast Asia, Europe, and the United States. Contact with foreign ideas offered political and philosophical alternatives to Chinese traditions. Revolutionary politics thrived in the streets of Canton and Shanghai. Sun Yat-sen, the father of China's republican revolution, was from the Cantonese region. One reason why Chinese mandarins of the Qing court resisted British opium traders in the south was their desire to control the Chinese merchants and middlemen, who might acquire too much power and become disobedient.

The defeats in the Opium Wars were a great humiliation to the celestial empire, but the consequences were not wholly against the Chinese government's interests. For treaty ports became semicolo-

nial enclaves, where contacts with the outside world could be contained. Shanghai, in particular, became a window to Japan and the West, a stage set of modern life, a place of no great historical distinction, a kind of tabula rasa almost, where anything new could be tried and discarded in a foreign environment. Here, as well as in other coastal cities, was the platform for China's modernization, which, to a large extent, meant Westernization. The famous Bund still looks a little like a 1920s theme park of Western styles: neoclassical, neo-rococo, neo-Renaissance, anything as long as it was neo.

Western imperial attitudes may have been arrogant and exploitative, but since the inhabitants of these urban enclaves in China were shielded by foreign laws, they could breathe and think more freely than would have been possible elsewhere in China. It was precisely this fresh spiritual and intellectual air, as well as such typical manifestations of raw capitalism as prostitution, that enraged the puritanical Roundheads of Mao's revolution. Following Mao's version of Communist ideology, they sought to dissolve the distinction between country and city. And so, after the revolution, Shanghai had to be strangled. Resources were relocated to the rural hinterlands; no new infrastructure was built; and the city was deliberately cut off from the wider world outside, which had always provided its raison d'être. As a result, Shanghai began to look more and more like a dilapidated museum city, frozen in time, physically a metropolis but without metropolitan life.

An essential part of Deng's idea of state-controlled capitalism in the 1980s was not only the revival of Shanghai but the recreation of urban enclaves on China's southern coast, to regenerate the economy and modernize China. Shenzhen today plays a role similar to Shanghai's in the 1920s, except this time the Chinese, and not foreign imperialists, are in charge. Unlike pre-war Shanghai, however, where

there was a market for everything, including ideas, freedom in the new urban enclaves is more restricted. Old Hong Kong and Shanghai were far from being democracies, but they did offer the freedom of thought and expression that John Stuart Mill considered the essential basis for civil liberties.

This was not part of Deng's vision of modern society. His new cities in the south, which are still growing at the staggering rate of 7.4 square miles a year, allow for commercial freedoms, ruled less by law than by corrupt networks of Party officials and their friends, but not for intellectual or artistic liberties. And the window on the world does not consist of a large presence of foreigners, or anything like a truly cosmopolitan culture, but of theme parks, where all the famous sites of the world can be seen in strictly controlled conditions. Shenzhen, and even Shanghai and Guangzhou, are cities offering every material product of the good life—the latest fashions from Tokyo and New York, all the world's cuisines, luxury apartments, fine hotels, and flashy shopping malls—but nothing that resembles Mill's notion of a marketplace of ideas.

Singapore offers one model for this type of authoritarian modernity. A lesser-known model might be Manchukuo, the ultramodern Japanese puppet state in Manchuria during the 1930s and early 1940s. Nothing about this venture was what it seemed to be: an emperor, the hapless Henry Pu Yi, who didn't really reign; a government that had no sovereign rights; a model of multicultural tolerance and racial equality, which was neither tolerant nor equal; a blueprint for a new Asian identity, which existed only in the minds of its Japanese engineers. Manchukuo was an authoritarian utopia, a kind of theme-park colony, which was undoubtedly modern in a material sense: the trains were sleeker and ran faster than those in Japan; the buildings were higher and the parks better laid out; the modern hotels were

finer, the movie and broadcasting studios better equipped, and the administration worked better than anywhere else in Asia. And yet there, too, the missing ingredient was the one thing you can't fake: freedom of the human mind.

Singapore is also modern in the material sense, ruled along the ultra-rationalist lines laid down by the ex–prime minister Lee Kuan Yew. He once called the citizens of Singapore "digits," as though politics were a mathematical problem. Total control of the digits, of their economic activities, their political choices, and even to some extent their private lives, was always Lee's goal. Singapore, once likened to a Disneyland with the death penalty, is truly a place where nothing is left to chance. The languages people speak at home, the ideal marriage partners for educated Chinese women, eating habits in public places, are all subject to elaborate guidelines, more or less forcefully imposed.

In a way, Singapore is a caricature, a miniature representation of Chinese politics. Lee's mandarins make sure that all Singaporeans conform to an authoritarian version of Confucian ethics, once widely touted as Asian values: thrift, hard work, obedience to authority, sacrifice of individual to communal interests, and no criticism of government policies, except "constructive" ideas on how to impose them more efficiently. They had to be called Asian values, because Lee is officially opposed to Chinese chauvinism. Himself educated as a colonial Englishman, Lee had to invent an Asian tradition to suit his political ideas and to give Singapore a common "identity." Like Chairman Mao, albeit without committing mass murder, Lee tried to control foreign influences, as well as ideas of the past. As in China, most of what remained physically of Singaporean history has been demolished, except for the odd street here and there, tarted up for the tourists. One such place, which used to be a raffish street full of

transvestites, was destroyed and then rebuilt in a sanitized version of its old self, indeed precisely like a theme park, advertised in the tourist trade as a slice of Oriental nightlife.

Singapore is a model of modern rationalism, a rich urban enclave in Southeast Asia, whose shopping malls and department stores contain all the name brands of West and East, a city of plush golf courses, smooth highways, superb restaurants, and perfectly efficient leisure resorts, where the old exotic customs of Malays, Chinese, and Indians can be enjoyed in the safety and comfort of a perfectly clean environment. Here, then, in this controlled material paradise, capitalist enterprise and authoritarian politics have found their perfect match. If all physical needs can be catered to—and Singapore comes as close to that blissful state as anywhere in the world—what need is there for dissent or individual eccentricity? You would have to be mad to rebel. And that is precisely how those few brave or foolhardy men and women who persist in opposition are treated, as dangerous madmen who should be put away for the comfort and safety of all the digits.

This is pretty much what Deng had in mind when he cleared the rubble of Maoism. If there ever was a blueprint for post-Maoist China, it would have looked like Singapore. This new Asian model, which also owes something to South Korea when it was being run by military regimes, and to Pinochet's Chile, is a challenge to those who still take it as a given that capitalism inevitably leads to liberal democracy, or, in other words, that a free market in goods automatically results in a free market in ideas. In the case of Chile, South Korea, and Taiwan, this turned out to be true, but there was nothing inevitable or automatic about it. Military regimes collapsed when the middle classes rebelled, or at least stopped supporting them. So far, there is little sign that a similar democratic transformation will happen soon in China or Singapore.

In fact, the authoritarian capitalist regime in post-Maoist China

has been astonishingly successful in co-opting the middle class to its political ends. There is, of course, nothing inevitable about this either. Chinese in Taiwan and Hong Kong have shown that there is no inherent cultural reason for the Chinese to prefer authoritarian to democratic government. Koreans, too, come from the same Confucian tradition, indeed from a particularly authoritarian version of it, and they have fought successfully for a more liberal political system.

Taiwan is actually an interesting case, since it is indisputably Chinese, and its politics once had many theme-park elements too. When the Nationalist Party, led by Chiang Kai-shek, and later by his son, Chiang Ching-kuo, ruled Taiwan as the last bastion against communism, it still pretended to rule the whole of China. Up to the 1980s, ancient representatives from mainland Chinese provinces were still rolled into the national assembly, snoozing in their wheelchairs. And such institutions as the Palace Museum, housing the Qing imperial collection, were meant to show that the Nationalists still represented Chinese civilization. The Taiwanese democracy movement, however, led by local Taiwanese, had no interest in ruling China, not even a miniature China. Taiwanese dissidents and activists simply wanted to establish a democracy in Taiwan. As soon as they succeeded, Continental pretensions and phony symbols—though not, thank God, the superb Palace Museum—quickly disappeared.

———

Japanese politics may not be flawlessly democratic, but Japan has had a relatively liberal system longer than any other East Asian country. Nonetheless, even postwar, democratic Japan developed a de facto one-party system, which is not as oppressive as Singapore's but has made a similar pact with the middle class. Since the early 1960s, the Japanese have been promised a lifetime of secure employment and

a doubling of their income every year. Acquiescence to the political status quo was demanded in return. Not everyone benefited to the same extent, but enough did for the system to work. Governed by bureaucratic mandarins, more or less corrupt Liberal Democratic Party politicians, and the representatives of big business, Japan is a paternalistic state that conforms in many respects to the Confucian tradition: obedience in return for order, security, and a full bowl of rice.

Intellectuals, so often the source of political dissent, have traditionally enjoyed the status in Confucian societies of loyal advisers to the rulers. In theory, if the rulers strayed from the correct path, it was the duty of learned men to point out the error of their ways. In practice, you had to be a brave man to do so. Some always were that brave, and often paid a heavy price. The tradition of the intellectual as a freethinker, independent of the state, is relatively new in East Asia, and Chinese free spirits still pay a heavy price. This is why Deng and his successors were able to harness most intellectuals to the cause of economic reform, just as it was easy for the Japanese government in the 1930s to bring Japanese intellectuals to Manchukuo to work on socioeconomic issues, supposedly to liberate Asians from the evils of Western imperialism and capitalist exploitation. The Chinese government has also been quite successful in promoting the idea that to be critical of the system is to be unpatriotic, especially when that system offers so many social and material benefits to the educated urban elite.

Many young, entrepreneurial Chinese, perhaps faute de mieux, have even convinced themselves that greater prosperity and a freer market can be a substitute for cultural and intellectual freedom. A property developer in Beijing once explained to me that "commercialization" was the best way to build a free, modern society. She was the perfect example of the post-Maoist yuppie: partly educated in

Britain, with work experience on Wall Street, dressed in the latest European fashion, driven by ambition and nationalist pride. She liked to quote Andy Warhol's views on the dissolving borders between commerce and art. Her latest project was an architectural theme park at the Great Wall, where eleven hot Asian architects were commissioned to build modernist villas, to be rented for vast amounts of money to rich individuals or companies, such as Prada or Louis Vuitton, who would hold "events" there to promote their products.

Status, stability, patriotism, and wealth, then, have proved to be sufficient reasons for the growing middle class to accept a paternalistic, authoritarian form of capitalism without much protest. The fact that any form of organized protest in China immediately leads to heavy punishment is, of course, another reason for political obedience. The big cities of China are really monuments to this kind of modern society—technocratic, affluent, but politically, as well as intellectually, sterile. It hardly needs to be pointed out that foreign businessmen are happy with this state of affairs. Dealing with corrupt officials may be tiresome, but that can be left to middlemen. And blessed is the absence of awkward trade unions, opposition parties, political dissent, and other messy manifestations of more open societies.

Will the Singaporean system last in China? Or will it crack because of what Marxists call internal contradictions? The widespread demonstrations of 1989 against official corruption and for more civil liberties were a warning that stability can never be taken for granted. But capitalist authoritarianism has already lasted longer in China than I had expected, and the end is not really in sight. Without middle-class rebellion, it is hard to see how it will come. There are reasons, nonetheless, why the system may be much more fragile than it looks. Singapore is small enough to create a stuffy middle-class city-state. China now has a growing urban elite. But most Chinese

live in the much less prosperous hinterlands. Farmers and workers, often laid off in large numbers from bankrupt state enterprises, are not the beneficiaries of East Asian technocracy. Their daughters flock to the southern cities to work as virtual slaves in Chinese or foreign-owned factories, or as prostitutes in the blossoming sex industry. Their sons roam the country as itinerant construction workers, without rights or protection. Since they are unable to organize themselves, their voices are muted, and their sporadic explosions of angry protest can be contained.

But technocracy will always be hostage to economic fortunes. In the case of a severe depression, several things might happen. The sporadic protests may lead to a nationwide uprising. A discontented middle class might join in, even though fear of mob rule makes this an unlikely prospect. On the other hand, the urban elite may lead an organized rebellion against the corrupt one-party system. Or perhaps something closer to what happened in 1930s Japan might be the pattern, especially if the frightened rulers try to deflect domestic unrest into aggressive chauvinism directed at Taiwan, Japan, or the West. Variations of fascism are a possibility.

The establishment of a liberal democracy after the Communist Party finally loses its power cannot be ruled out. But more violent, less liberal solutions remain more likely. None of them will be pleasant, and all of them will be dangerous. Then again, things might simply remain the same, and China, as a continent-size Singapore, will be the shining model of authoritarian capitalism, saluted by all illiberal regimes, corporate executives, and other PR men for an emasculated, infantilized good life: the whole world as a gigantic theme park, where constant fun and games will make free thought redundant.

SOURCES

Earlier versions of the essays in this book appeared as follows:

Chapter 1: *The New York Review of Books*, April 8, 1999
Chapter 2: *The New York Review of Books*, June 14, 2007
Chapter 3: *The New York Review of Books*, July 19, 2007
Chapter 4: *The New York Review of Books*, January 17, 2008
Chapter 5: *The New York Review of Books*, October 21, 2004
Chapter 6: *The New York Review of Books*, December 20, 1990
Chapter 7: *The New York Review of Books*, February 19, 1998
Chapter 8: *The New York Review of Books*, December 17, 2009
Chapter 9: *The New York Review of Books*, November 25, 2010
Chapter 10: *The New York Review of Books*, October 14, 2010
Chapter 11: *The New York Review of Books*, November 21, 2002
Chapter 12: *The New York Review of Books*, February 15, 2007
Chapter 13: *The New York Review of Books*, April 7, 2011
Chapter 14: *The New York Review of Books*, January 12, 2012
Chapter 15: *The New York Review of Books*, July 15, 2010
Chapter 16: *The New York Review of Books*, November 19, 1987
Chapter 17: *The New York Review of Books*, January 13, 1994
Chapter 18: *The New York Review of Books*, February 16, 1995
Chapter 19: *The New York Review of Books*, May 23, 2013
Chapter 20: *The New York Review of Books*, March 15, 2007
Chapter 21: *The New York Review of Books* December 19, 2002
Chapter 22: *The New York Review of Books*, December 4, 2008
Chapter 23: *The New York Review of Books*, July 13, 1995
Chapter 24: *The New York Review of Books*, April 6, 2005
Chapter 25: *The New York Review of Books*, January 10, 2013
Chapter 26: *The New York Review of Books*, October 21, 1999
Chapter 27: *The New York Review of Books*, June 23, 2005
Chapter 28: *The New York Review of Books*, June 12, 2003